The Adobe® Photoshop® Lightroom™ Book

The Complete Guide for Photographers

Martin Evening

ADOBE
PRESS

Adobe

The Adobe® Photoshop® Lightroom™ Book
The Complete Guide for Photographers

Martin Evening

This Adobe Press book is published by Peachpit

Peachpit
1249 Eighth Street
Berkeley, CA 94710
510/524-2178
800/283-9444
510/524-2221 (fax)

Peachpit is a division of Pearson Education

Find us on the Web at www.adobepress.com

To report errors, please send a note to errata@peachpit.com

Project Editor: Pamela Pfiffner
Production Editor: Connie Jeung-Mills
Copy Editor: Anne Marie Walker
Cover Design: Charlene Charles-Will

ISBN-13: 978-0-321-38543-7
ISBN-10: 0-321-38543-8

9 8 7 6 5 4 3 2 1

Printed and bound in the United States of America

Dedicated in memory of Bruce Fraser.

Foreword

We all want to make better pictures. This is probably the reason you picked up this book, and it is the very reason we began building Adobe Photoshop Lightroom—to help you make your pictures better. But before we can make better pictures, we have to understand the tools, right? Frank Lloyd Wright once said that every aspiring architect should first work as a tradesman, *until he understood the nature of the materials*. Because it is only when you understand the nature of your tools and materials that you can truly become fluent and creative within your chosen medium.

Collectively, photographers have had about 150 years to think about workflow. We have been thinking about it, developing it, and (with luck) perfecting it for that entire time. And yet, with the advent of digital imaging, the idea of workflow seems to be completely new. As a working photographer I had developed a well-understood and established workflow for making my pictures. It spanned the entire range of effort from labeling my film, to processing it, sorting the results, printing and delivery to the client, and finally cataloging it for storage. Basic metadata (usually notes made on poly-sleeves using a felt-tipped pen) that included the date and client's name was applied to every shoot and to every photo binder, but other than that, metadata was a relatively unknown concept. We didn't think of writing the date on the sleeve as *applying metadata*. But I was always able to easily find my pictures because there was only one original copy of each photo, and because a very basic grouping into three-ringed binders by subject (which had a strong correlation to date) was all that was needed to enable me to reach into my archive and put my hands on any given photo in only moments.

It's funny how things changed once we started putting our pictures into the computer! It wasn't a sudden change… since we still really only had one physical original—the actual piece of film. But for those pictures we chose to scan into the computer, it seems we started finding that we had multiple copies showing up here and there. And then later, to our growing horror, finding that many of those copies were in old formats or were sized, sharpened, and color corrected for a specific printer. Where was the "original"? You still have that original scan… don't you? Just what is the original, you might be asking. You could always scan it again with that new scanner and create yet another starting point! All of a sudden we find that operating systems are actually coming and going, formats are swinging in and out of fashion, and storage media is forever changing, too. How long have *you* been in the business? Do you have a box of old SCSI cables packed away somewhere? Any SyQuest discs? You begin noticing the word *"permanence"* popping up here and there.

With versions, formats, and backups all proliferating and becoming more jumbled by the day, we began to call this problem the Gerg Syndrome, named after the guy at Adobe who first identified the problem. In the early days of brainstorming on what was then known as the Shadowland project, we spent quite a bit of time thinking about how we might actually go about solving this particular problem. And this was before *viable digital capture* was really raising its ugly head on the scene. Most photographers were still shooting film, at least for their serious projects.

At this time we still had a relatively easy-to-understand workflow. Digital imaging brought its own complexities to our workflow, but those complexities were manageable. The number of photographs you chose to scan and bring into the computer was still very small relative to the number of actual exposures you were probably making. And all the storage, sorting, and delivery were still pretty much confined to the physical world. It was the day you set aside your film and picked up a digital camera that the world changed. Suddenly, *100 percent of your workflow* landed squarely on your digital desktop. Whether you saw it clearly at that moment or not (quite possibly not...), and worse, whether you liked it or not, a seismic shift had just occurred in your workflow. Now everything is in your computer. Input. Sorting. Selection. Processing. Delivery. Archiving. It's the whole enchilada now. Your entire workflow is digital. Your pictures are just bits now. Are you ready for the new world?

What's the best way to import my pictures? What metadata do I need? What's the best way to process a given picture? How should I back up my library? There are many, many new questions. But there is no reason to let the brave new world scare you. Photoshop Lightroom was designed from the beginning to be the best application out there to help you take your digital photographs through an easy-to-learn workflow, all the way from end to end. Do you need a qualified guide? Martin Evening has been a member of the team from the beginning. He understands Lightroom, and the new workflow. With Martin's expert guidance, you'll soon find that you have precisely the tools you need to turn your concentration back where it belongs—*on making better pictures*!

George Jardine
Pro Photography Evangelist
Adobe Systems Inc.

Introduction

Work on the Adobe Photoshop Lightroom program began toward the end of 2003 when a small group of Adobe people, headed by Mark Hamburg, met up at photographer Jeff Schewe's studio in Chicago to discuss a new approach to raw image management and editing that would be built to meet the specific needs of all those photographers who were "going digital" and who needed a better way to work with their growing libraries of photographic captures. It was shortly after this that I was invited to join the early alpha test program and help thrash out what Lightroom (or Shadowland as it was known then and Photoshop Lightroom as it's called now) should be. As we all discussed our various digital photography workflows it became increasingly obvious why there needed to be a better way of managing and processing our photographs. Lightroom underwent some pretty major changes in those early stages, with the team trying out different workflow ideas, not to mention numerous interface changes. Even in the later stages of the development process when Adobe released Lightroom as a public beta, the changes kept coming to the point where at times it felt like I had revised this book three times over. (Although the software's official name is Adobe Photoshop Lightroom, for brevity's sake I will refer to it hereafter simply as Lightroom.)

Back in the early days of Lightroom's development I remember taking a car journey from a conference in Laguna Beach back to Los Angeles with my friend and fellow author, Bruce Fraser. During the trip we talked among other things about Shadowland, and Bruce was quite enthusiastic about it, saying then "I think Adobe would probably like us both to write a book each about the new program." Some of you reading this will be aware that Bruce sadly passed away in December of 2006. He had been too ill to continue working for much of that year, and the last thing on his mind was writing more books. Even so, he was still keenly involved in helping guide the Shadowland development process, and at one critical point teamed up with Jeff Schewe to support Mark Hamburg at a point where Lightroom's future was looking uncertain. Bruce was dearly loved and respected by all: the many readers of his books, my editor Pamela Pfiffner (who was previously married to Bruce), and of course his family, friends, and widow Angela. We all loved him dearly. This is why I have dedicated this book to a man I admired greatly and from whom I learned so much.

This book represents the culmination of three years work in which I have worked actively with the Lightroom team, offering feedback and suggestions on new features. I have called this "the complete guide" to Photoshop Lightroom, because I think you will find that just about every

detail of the program is covered. I have to confess that when I first started on this project I never imagined the first edition of the book would end up being 352 pages in length, and I really had no idea then just how much extra work would go into making version 1.0 of Lightroom as complete as it is today. There were times when I had my doubts, but it is a program I now enjoy using and working with on a daily basis.

How to Use This Book

Lightroom is principally aimed at anyone who takes photographs with a digital SLR camera. When I set out to write this book, I had very much in mind both amateur photographers as well as professional users. I have taken the trouble to explain fundamental aspects of digital imaging such as white balance and exposure in simple, easy-to-understand terms, so that no one reading this book should ever feel too left out. This book is intended to be the ultimate reference guide to Lightroom and help you get the maximum benefit out of the program.

I suggest that you approach the book by reading it in chapter order, starting with the introduction in Chapter 1. This provides not just an overview of the main features in Lightroom, but also some insights into how to work with the Lightroom interface and configure the preference settings. Chapter 2 covers the import process and how to get your images into the Lightroom library, and Chapter 3 discusses how to manage the view modes and library contents. This chapter does go into a lot of detail about how to use metadata, which is necessary if you want to manage your library completely. If you like, you can cut short reading everything that's written here and return later, since you might want to dive straight into Chapter 4 on image processing in which I describe all the different ways you can apply image adjustments to your photographs. I also offer some unique insights into how the various tools work and how to apply them. Chapter 5 explains how to use the Print module with guidelines for printing via a Mac or PC computer. Chapter 6 is all about presenting your work, either as a slideshow or via the Web. I conclude the book with an Appendix in which I provide some additional material on the Lightroom program with technical information for the more advanced users.

Overall, I am very excited about Lightroom, and I hope the book provides inspiration and insights into how you can get the most out of Lightroom. As it says in Rule 5 of the Lightroom Five Rules Help dialog: Enjoy!

Martin Evening, January 2007.

Acknowledgments

I would like to thank my editor, Pamela Pfiffner, for prompting me to get started on this project and for her advice and help during the planning stage of this book. My involvement with Lightroom began several years before the first announcement of the program, and in that time I have been helped a lot by the engineers and other members of the team who worked on the program. Lightroom is really the brainchild of Mark Hamburg, but none of it would have been possible without additional help from the rest of the engineering team. In particular, I would like to thank Thomas Knoll, Michael Jonsson, and Zalman Stern (who worked on the Camera Raw engineering); also some of the other engineers: Troy Gaul, Melissa Gaul, Tim Gogolin, Seetha Narayanan, Eric Scouten, Kevin Tieskoetter, Andrew Rahn, Phil Clevenger (who designed the Lightroom interface), and Andrei Herasimchuck who helped guide Lightroom through the early stages. I would also like to thank product manager Tom Hogarty and product evangelist George Jardine for the huge amount of support and help they have given me. Thanks also go to Addy Roff, Mala Sharma, and Jennifer Stern on the Photoshop and Lightroom marketing teams, plus George Jardine, Ian Lyons, Andrew Rodney, Jeff Schewe (the Godfather), and Rod Wynne-Powell who all helped to tech edit the book for me.

It has been an interesting experience to see a new program emerge from scratch and has been a pleasure to share the development process in the company of a great group of alpha testers and fellow authors who were willing to share their knowledge about the program with each other. From this group I would most like to pay tribute to Peter Beardsworth, Richard Earney, Katrin Eismann, George DeWolfe, Bruce Fraser, Peter Krogh, Karl Lang, Sean McCormack, Michael Reichmann, Seth Resnick, Daniel Sroka, David Schloss, and Michael Tapes who in addition to the tech editors already mentioned made valuable contributions to Lightroom's development.

A book like this would be rather boring to read through without having some decent photographs to illustrate it with. To supplement my own photography I would therefore like to thank Greg Gorman, George Jardine, Craig Robertson, and Jeff Schewe for letting me use their photographs, which are all individually credited throughout this book. And lastly, I would like to thank my wife Camilla for being so understanding and patient while I was glued to the computer!

Contents

4 Image Processing 111

5 Printing 229

6 Presenting Your Work 261

Appendix .. 305

Index .. 331

1

Introducing Adobe Photoshop Lightroom

Welcome to Adobe Photoshop Lightroom, an image processing and image asset management program that is designed to meet the needs of digital photographers everywhere. This book will help explain all the main tools that are in Lightroom and provide inspiration and advice on how to get the most out of this new program. It also offers tips on how to set up your computer and how to get the best results from your digital camera files.

The Lightroom program has been designed from the ground up to provide today's digital photographers with the tools they most need. This is reflected in the way Lightroom separates the various tasks into separate modules, is able to process large numbers of images at once, and lets you archive and retrieve images quickly. But before I get into too much detail, let me begin by explaining a little about the basic concept of Lightroom. Then I'll move on to an overview of all the main features and how you might go about using these in a typical digital photography workflow.

What Is Adobe Photoshop Lightroom?

Adobe Photoshop Lightroom, which I'll hereafter refer to simply as Lightroom, is essentially a high-quality image processor and image database management system rolled into one, with a modern interface and fast image processing capabilities. The guiding light behind Lightroom's development is its chief architect Mark Hamburg who up until recently had been the chief scientist working on Adobe Photoshop. For the past few years Mark and the rest of the team at Adobe have been looking closely at how photographers work digitally and the problems they face when processing and managing large numbers of digital images. Lightroom is the result of this research. Lightroom is not so much a single, monolithic application, but instead should be viewed more as a suite of application modules that combine to provide an ideal workflow for digital photographers.

Keeping Things Simple

One of the early goals of the Lightroom project was to remove complexity. Right from the start, the founding principle of Lightroom was to provide "unreasonable simplicity." Lightroom's tools are therefore designed to streamline the image management and editing process, and to make the user experience as smooth and simple as possible. The program aims to provide photographers with the tools they most need and eliminate the call for complicated workarounds. You will find that for the most part, Lightroom has managed to do this. It does not have complex preference dialogs nor demand that you do anything special to optimize the program settings before you get started. For example, there are no color management settings dialogs to configure, since the color management in Lightroom is carried out automatically without requiring too much user input. On the whole, Adobe has been successful in this regard, but as the program has evolved, these principles have sometimes been compromised with the introduction of more and more options and new features.

Modular Design

Lightroom was created from scratch, which has allowed the engineers to build upon their experience and knowledge of how Photoshop works to produce a brand-new program that is purpose-built for modern-day image processing requirements. The Lightroom program

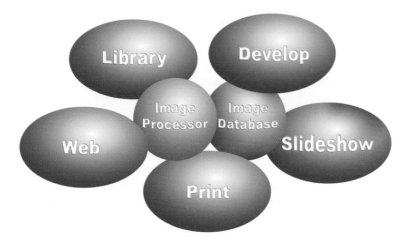

Figure 1.1 *Lightroom is engineered using a modular architecture system. At the heart of Lightroom are its image processor and image database. Lightroom is designed so that all individual modules are able to tap into these two core components of the application. This is what gives Lightroom its speed and adaptability.*

NOTE

A number of filter-like features are available in Photoshop, such as Liquify and Vanishing Point, that have to be implemented via a separate modal dialog. The downside of this approach is that the modal plug-ins do not have access to the central Photoshop image engine to carry out the image processing work. They are like applications that have to work within the Photoshop application, and this explains why most modal plug-ins act quite sluggish compared to when you are working directly in the main Photoshop program. Lightroom's modular architecture means that as new features are added they will all have equal access to the image processing and image database engines in Lightroom.

is composed of individual, self-contained modules built around a core that contains an advanced image processing engine and image database engine (**Figure 1.1**). Each module can be thought of as offering a unique set of functions, and in Lightroom 1.0 you will see five separate modules: Library, Develop, Slideshow, Print, and Web. This modular approach will make it easier in the future to add new features and maintain them. For example, if at some point it is decided that Lightroom needs to have an image warping module, the Lightroom engineers will be able to design a new self-contained module that performs specific, new tasks. From an engineering point of view this enables Lightroom to run more efficiently because each module can have direct access to the central engines at the core of the program. And if there are flaws or bugs in any particular module, these will only show up in the functionality of the module: They will not compromise or affect the performance of any of the other modules. One of the reasons Adobe Photoshop rose to such prominence as an image editing application was because of the way Adobe openly encouraged third-party companies to create their own filter plug-ins for Photoshop. Lightroom will continue that tradition by providing third-party companies with the information they need to create their own modules. It is too soon to tell if this will result in lots of new third-party modules for Lightroom, but rest assured that as new modules are added, Lightroom will never risk becoming bloated. Theoretically, it should in the future be quite easy to turn off or remove the modules you don't need.

NOTE

You can use the following Mac shortcuts when switching between individual modules (PC users should use Ctrl Alt plus the number).

⌘ Alt –1 to select Library

⌘ Alt –2 to select Develop

⌘ Alt –3 to select Slideshow

⌘ Alt –4 to select Print

⌘ Alt –5 to select Web

⌘ Alt ↑ to go back to the previous module.

In addition, G selects the Library module in Grid mode, E selects the Library module in Loupe mode, and D selects the Develop module.

NOTE

There is certainly no shortage of "experts" who love to argue that the raw processor program they use produces superior results compared to everything else. I won't argue or deny the quality and potential of other raw processing programs, such as Capture One from Phase One and the proprietary software that is bundled with certain digital cameras. Who am I to try to dissuade people of their heartfelt opinions if they are satisfied with the results they are getting? But Adobe Camera Raw does have some unique features not found in other raw converter programs. More important, the Camera Raw image processing as implemented in Lightroom benefits from a more streamlined workflow.

Lightroom Performance

As long as the computer you are using exceeds the minimum requirements provided on page 9, you will have all that's needed to get started with the program, although Lightroom's performance will be relative to the size of your image captures. The basic specifications may be fine for 5–6 megapixel camera captures, but if you are shooting with an 11–16 megapixel camera, you will definitely want to use a modern, dual core processor computer with a minimum of 1.5 GB RAM in order to get the best performance from the program. With the right computer configuration you can quickly navigate a collection of images, zoom in and out, and apply image adjustments with ease. Image library searches are fast and the Lightroom interface is designed to make it easy to update the metadata and narrow down your search selections within the content area. Wherever possible, Lightroom utilizes the cached image data used to generate the previews. As a result you will find it takes no time at all to generate a slideshow or a Web photo gallery. And when you are in the Print module, it will only take a few seconds to generate the file to print out a set of contact sheets in draft mode. This is because Lightroom is able to print directly from the high-quality image previews instead of having to rerender each image from a master file.

Adobe Camera Raw processing

If you are accustomed to using the Adobe Camera Raw plug-in via the Adobe Bridge/Photoshop dialog, some of the controls in Lightroom's Develop module will already be familiar. Lightroom shares the same Adobe Camera Raw (ACR) processing engine that is used in Photoshop and Bridge. The Adobe Camera Raw processing engine was originally developed by Thomas Knoll, who with his brother John Knoll, created the original Photoshop program. The Adobe Camera Raw plug-in has since evolved to become one of the best raw processing tools on the market, supporting more than 150 different proprietary raw file formats, including most notably the full Canon range of digital SLRs. And Thomas has now been joined by Zalman Stern and Michael Jonsson (formerly of Pixmantec) who have both made a significant contribution with their work on Camera Raw. Michael, incidentally, was also the main engineer who worked on the Capture One raw processing application, before going on to create the highly successful Raw Shooter program. Evidence of his contribution can be seen in Lightroom's new raw editing features such as the Recovery and Fill Light sliders.

Color controls

The Develop module's image adjustment controls are easy to access, and pressing D always takes you directly to the Develop module. Lightroom is mainly intended for working with raw images, but the image adjustment controls in the Develop module can also be applied to TIFF, PSD, or JPEG images that are in RGB, Grayscale, or Lab mode (but note that Lightroom image adjustments are always carried out in RGB). The Basic and Tone Curve panels provide intuitive controls with which you can easily adjust the white balance and tones in any photograph. And the Grayscale Mixer offers an adaptable approach to black-and-white conversions whereby you can adjust the balance of color information that is used to create a monochrome version of a color original. As you dig deeper you will discover that the split tone controls work nicely on color images as well as black-and-white converted pictures, and with a little experimentation you can easily produce quite dramatic cross-processed type effects. The Develop module also provides a greater range of controls over the colors and tones in your photographs. For example, when you adjust the luminance of a color in the HSL/Color/Grayscale panel, the sliders behave exactly the way you would expect them to, so you can easily darken colors selectively. Or if you want to darken the color of a sky, you simply adjust the Blue and Aqua Luminance sliders.

It is worth pointing out that all the Develop adjustments in Lightroom are nondestructive and are recorded as edit instructions that are stored with the image. That means a single raw master file can be edited in many ways and printed at different sizes without having to make lots of different pixel image versions from the original. Any image edits and ratings you make in Lightroom will also be recognized in current versions of Bridge and Photoshop. The same is true of labels and meta-data. Any metadata information that is added to an image via another program that can be recognized by Lightroom will be preserved and updated in Lightroom. For example, if you add keywords and assign a colored label to an image in Bridge, these changes will be transferred to Lightroom and updated in the Lightroom library—although this does raise the question of which setting is correct when a single image has been modified in two separate programs. In this situation, Lightroom informs you of any conflicts and lets you decide (see the accompanying Note on updating settings in Lightroom).

NOTE

An Adobe Camera Raw adjustment made in one Adobe program will always preview identically in any other Adobe program. If an image is altered outside Lightroom, a warning exclamation mark will alert you and let you decide whether to stick with the current image setting or update the new one that was applied outside Lightroom.

NOTE

Smarter ways to search a computer archive are now emerging, such as the Spotlight feature on the Macintosh system, which bypasses the need to navigate by folders when you are searching for a specific file.

The Lightroom Workflow

The modules and controls are all presented in a logical order, from the import stage through to managing the images in the Library module, processing them in the Develop module, and finally exporting files for output or outputting images via the Slideshow, Print, or Web modules.

Managing the image library

Lightroom has been designed to offer a flexible workflow for all types of photographers that meets their different requirements. When you work with Lightroom, you begin by explicitly choosing the images you would like to add to the Lightroom library. From there the way Lightroom manages those images is actually not that much different from working with any other type of browser program. Most browser programs are like a glorified finder and are mainly useful for inspecting the contents on a computer and allowing you to see everything that is on a drive or in a specific folder. The main difference with Lightroom is that you always strictly control which images are imported into the library. Images can be imported from a camera card (or directly from the camera) by copying them to a folder. Or, you simply import images by pointing to the folder they are already in, a task Lightroom calls "import by reference." After images have been imported into Lightroom, any folder or filename changes, file deletions, or moving of files are all mirrored at the system level. So when deleting, you have the option to move the file to the trash for permanent deletion. Working with the Folders panel in Lightroom is therefore not dissimilar from working with a hierarchical folder list tree view in a browser program. But in Lightroom the list tree in the Folders panel reveals just the images you requested to be in the library and nothing else.

Of course, hierarchical folder management is fine if you know in which folders your images are stored. But when you start working with many thousands of pictures, you will soon find it is no longer practical to rely on a folder hierarchy as the main means of navigation. Lightroom can store all your images in neat folders, but its real power as an image asset manager comes when you use the Find, Collections, Keyword Tags, and Metadata Browser panels to search for images in the library. And if you get into the habit of entering descriptive information each time you import a batch of images, this too will enable you to search your archive more easily and more quickly by using different search criteria.

Where does Photoshop fit in?

For many years now, Photoshop has pretty much dominated the pixel image editing market, and the program has constantly been adapted to meet the varying demands of lots of different types of Photoshop customers, from graphic designers to illustrators to special effects artists working in the motion picture industry. Although Photoshop is a very powerful image editing program with a wide range of tools to suit everyone's requirements, it has also become increasingly more complex. When the two Knoll brothers, Thomas and John, first created Photoshop, they could hardly have predicted then what Photoshop users in the future would be doing with their program, much less predict the technological demands that digital capture would make on Photoshop. Photoshop started out as a program for editing single images in real time, and the legacy of this basic Photoshop architecture has led to various compromises being made as the number of features in Photoshop have expanded.

Many Photoshop authors love to write about what they describe as "simple Photoshop techniques," but then proceed to take up eight pages with step-by-step instructions (before anyone gets too upset, I confess that I have been just as guilty as anyone else when it comes to writing about Photoshop!). And then there are all those bits of con-tradictory advice, such as "don't use Convert to Grayscale to convert a color image to black and white," or "don't use the Brightness and Contrast dialog to adjust the brightness and contrast." But sometimes it is almost impossible to avoid going into such detail because to write any less would only cause more confusion. Plus, some features, such as the aforementioned Brightness and Contrast command, have been in Photoshop for so long that it would be unwise to remove them now. Lightroom, however, is unencumbered by such legacy issues. You don't have to follow complex workarounds to achieve the best results, and the controls in Lightroom do exactly what you expect them to.

Because Lightroom was built from scratch, its engineers designed a program that not only addresses current demands but anticipates future needs. Take, for example, image adjustments. If you apply con-secutive image adjustments in Photoshop, you progressively degrade the image. Lightroom, on the other hand, allows you to make as many adjustments and changes as you like, but only applies these as a single adjustment at the point where you export the image as a fixed pixel TIFF, PSD, or JPEG image.

NOTE

Once you start bringing images into Lightroom, you won't necessarily find yourself locked into working exclusively in Lightroom the way you are with some other programs. Lightroom is flexible enough to allow you to work simultaneously with Bridge or other image browser programs.

The Adobe Camera Raw plug-in used by both Bridge and Photoshop does provide the same level of flexibility, but only up until the point where you render a raw file as a pixel image to be edited in Photoshop. But Lightroom allows you to preserve an image in its raw state throughout. You can also make prints at any size you like without having to fix the image data as a pixel image.

Integrating Lightroom with Photoshop

At this early stage it is too soon to judge if Lightroom will ever become a complete replacement for Photoshop, but Lightroom can currently be used to perform many of the tasks that up until now were once carried out exclusively in Bridge and Photoshop. Lightroom is perfect as a front-end application for importing new images into the computer and renaming them. From there you have all the controls you need for carrying out image edit selections, grouping and renaming them, plus making basic and advanced develop setting adjustments. The speediness of the program allows you to quickly print draft mode contact sheets, run a slideshow presentation, or generate a complete Web gallery and upload it to your server.

Photoshop is still important for major image retouching and performing other essential production tasks such as CMYK color conversions, although this may all change in the future. One way to integrate Lightroom with Photoshop is to use Lightroom to manage all the image importing, image selections, and initial image adjustments. When you're ready to retouch the master images, export these in one go using the Export command. From there on you can work on the images in Photoshop and Bridge. Once you have completed all the retouching and editing in Photoshop, you just import the derivative, master files into the Lightroom library using the import by reference method (rather than copying them into the library). This allows you to use Lightroom to maintain a library archive of all the raws and masters, and keep the raw and derivative files on separate drives and then back up each drive separately. And for printing, you will most likely prefer the Lightroom Print module interface for making the final print outputs.

What You'll Need

Lightroom is designed specifically for photographers working with digital photos, so above all you will need a camera of course! Lightroom can process JPEG, TIFF, or raw images, but if your camera is capable of capturing raw images, I advise you to shoot in raw mode whenever possible. Lightroom currently supports more than 150 different raw camera formats.

You will require a computer that meets the minimal specifications listed at the bottom of this page. Although it is possible to run Lightroom on a three-year-old laptop computer with just 1 GB of RAM memory, you will notice a substantial improvement in performance with a more up-to-date computer. Lightroom will certainly benefit from having as much RAM as possible, and it is recommended that you have, if possible, at least 1.5 GB of RAM installed on your computer. Although you don't need much hard disk space on your computer to install and run Lightroom, you will need to give serious consideration to how you will store all your image archive files. Some people can easily shoot 5 GB worth of images (or more) in a single day. And if you export some of those files as rendered TIFFs or PSDs, you can see how your storage requirements might grow considerably in a short amount of time. For more information on computer systems and backup strategies, see the Appendix.

TIP

To see if the raw files from the camera you shoot with are supported in Lightroom, go to the Adobe Photoshop Web site at www.adobe.com/products/photoshop/cameraraw.html.

A few cameras that are capable of capturing raw images using the Digital Negative (DNG) format are also available. Because DNG is a self-contained raw format, it is the ideal format to use when exporting images with the raw data preserved within the file.

Macintosh

G4, G5, or Intel Macintosh processor running at 1 GHz or higher

Mac OS X 10.4.3 or later

768 MB of RAM (1 GB recommended)

1 GB or more of hard disk space

Color monitor display with 1024 x 768 resolution or greater

Windows

Intel Pentium 4 (or compatible) processor

Windows XP Professional or Home Edition with Service Pack 2 (SP2)

768 MB of RAM (1 GB recommended)

1 GB or more of hard disk space

Color monitor display with 1024 x 768 resolution or greater

NOTE

Lightroom's performance will always be relative to the size of your master image files. The minimum specifications outlined here may suffice if you are only editing raw or JPEG files from a 5 or 6 megapixel camera. If you want to process files larger than this, you almost certainly need a faster computer with a lot more RAM.

Introducing the Lightroom Interface

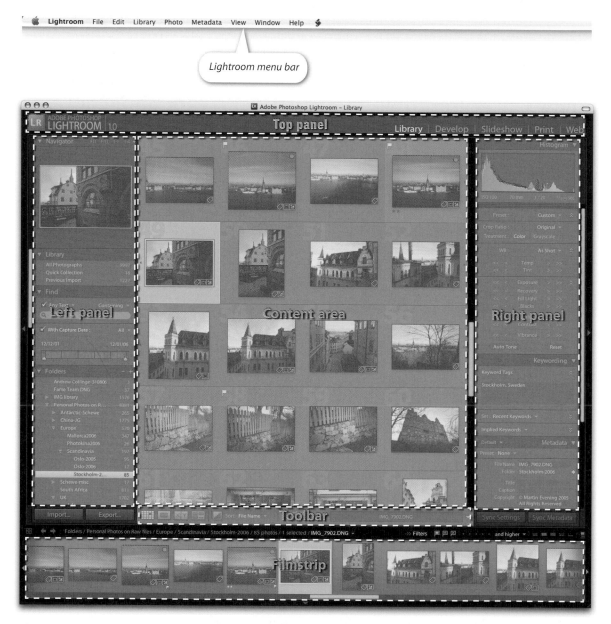

Figure 1.2 *The Lightroom interface. Note that the color scheme of the program interface is neutral gray and black, which allows you to focus on image content and color without distracting colors that influence color perception.*

Lightroom menu bar

As with any application, the main menu commands are located in the Lightroom menu bar at the top of the screen. If you are in absolute full-screen mode, the menu bar will be hidden, but can be revealed by simply rolling the mouse to the top of the screen.

Top panel

The top panel section in Lightroom contains the module picker, which allows you to switch between the different Lightroom modules. The Library module is where you preview and manage your shoot collections. Develop is for processing images. Slideshow enables you to output image collections as onscreen presentations. The Print module is for outputting images to print. And the Web module allows you to generate Web sites from Lightroom. The top-left section contains an Identity Plate that you can customize via the Lightroom ⇨ Identity Plate Setup menu. For example, you can replace the Adobe Photoshop Lightroom logo with your own name or add a company logo graphic instead.

Content area

The Content area is the main portion of the interface where you will work with the images that have been imported into Lightroom. In the Library module Grid mode (as shown here), you will see the images displayed as thumbnails in a cell grid layout. In the Library module Loupe mode or Develop module, you will see images displayed at a fit-to-view or 1:1 scale size. In other modules such as Print and Slideshow, you can see previews of how images or screen pages will look when they are output from Lightroom.

Toolbar

The toolbar is common to all Lightroom modules and contains various tool options.

Right panel

The right panel mostly contains the controls for adjusting an image, the information about an image, or image layout settings. In the Library module you can apply Quick Develop settings and synchronize these across multiple images. The Develop module lets you make more advanced image adjustments, whereas in the Slideshow and Print modules the right panel features all the controls governing the layout and output. The Panel options can be expanded or collapsed by clicking the Panel bar. Alt –clicking a panel bar toggles expanding to show the contents of that panel only or expanding to show all panels. You can also use the ⌘ key (Mac) or Ctrl key (PC) in combination with a keypad number (1, 2, 3, etc.) to toggle opening and closing the individual panels in the order they are listed from the top down.

Left panel

The left panel is mainly used for managing images and presets. In the Develop, Slideshow, and Print modules, it is used for storing and quickly accessing saved settings. For example, if you are working in the Develop module, you can save custom Develop settings as presets, where they can be readily applied to other images. In the Library module, the left panel takes precedence as the main panel for managing folders, collections, and keywords plus image filtering and searches.

Filmstrip

The Filmstrip is located at the bottom of the screen and contains thumbnails of all the images currently displayed in the Library, highlighting any that are selected. The Filmstrip thumbnails can be accessed via all the other modules, which allows you access to individual images or subselections of images without having to switch back to the Library module.

Installing Lightroom

The Lightroom installation process is quick and easy. All you need to do is to load the installation CD and start installing Lightroom. **Figure 1.3** shows the Macintosh installation dialog. Simply drag the Lightroom icon across to the Applications icon in the window and the installation process will almost be complete. **Figure 1.4** shows the first dialog in the PC installation process. Keep clicking the Next button and follow the installation instructions until you see the dialog that shows the Finish button.

The first time you launch Lightroom you will need to read and agree to the terms and conditions of supply. Once you have done that, whether you are on a Mac or PC, the installation process should be fairly swift and straightforward. If you are installing Lightroom and updating an

Figure 1.3 *The Lightroom installation dialog on the Mac.*

Figure 1.4 *The Lightroom installation dialog on the PC.*

existing database, you may be asked at this stage if you would like Lightroom to run a verification process to test the integrity of your current database.

After you have successfully launched the program, select the Lightroom preferences on the Lightroom system menu. In the General preferences, go to the Default Library section and choose a location for the default library file. This designates where the Lightroom folder containing the Lightroom database, metadata, and preview library files will be kept. The default setting points to the Users Pictures folder on the main hard disk. If you want the Lightroom Library folder to be stored somewhere else such as on a dedicated external drive, now would be a good time to choose a new folder location. You can also choose to have multiple library files. Notice that there is a Choose button that allows you to switch libraries via this Preferences panel (see the accompanying Tip on choosing a library file during startup). But to start with, you might want to work with just the one Lightroom library. Another important option is "Automatically backup library." Set this to however often you would like to back up the master library file. **Figure 1.5** shows the Backup settings and the splash screen dialog, which appear to remind you when and where to back up your Lightroom image library. Other preference settings are shown in **Figure 1.6** and **Figure 1.7**.

TIP

If you run out of hard disk space, you can move the Lightroom Library folder to another, bigger hard drive. Open the Lightroom preferences and use the General preferences to locate the new folder location. You can also select a new Library folder location by holding down the Alt key (Mac) or Ctrl key (PC) during startup. A navigation dialog appears that will then allow you to set the location for the Library folder.

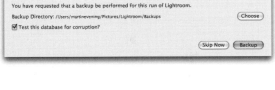

Figure 1.5 *In the Lightroom General preferences you have checkable options to display the splash screen during startup and automatically check for program updates. In the Library preferences you can set up an automatic library file backup routine. Below that are the completion sound alert options. You will often see warning dialogs with a "Don't show again" check box at the bottom of the dialog. If you click the "Reset all warning dialogs" button here, you can restore all the warning alerts. And at the bottom are various reset buttons that can be used to restore Lightroom settings such as "all warning dialogs" and "naming token presets."*

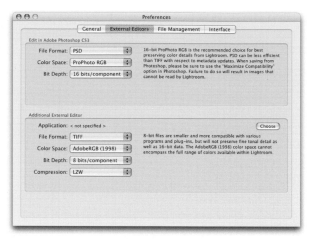

Figure 1.6 *In the Lightroom External Editors preferences you can customize the pixel image editing settings for Photoshop plus one other external, pixel editing program (such as Adobe Photoshop Elements or Corel Paint Shop Pro). These are the file format, color space, and bit depth settings that are used whenever you ask Lightroom to create an Edit copy of a library image to work on in an external pixel editing program.*

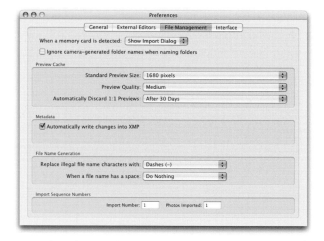

Figure 1.7 *In the Lightroom File Management preferences I set the "When a memory card is detected" setting. This forces the Import dialog to appear automatically whenever you insert a camera card into the computer. In the Preview Cache section you can set the preview pixel dimensions to whatever is most ideal for your display size. The preview cache can take up a lot of hard disk space, and the size of the cache depends on the default standard preview size and preview quality. Plus, the preview cache will keep growing as you add more pictures to the Lightroom library. The preview cache also includes 1:1 previews; because they are higher-resolution previews, they take up even more disk space, so there is a preference to discard these after a certain amount of time has elapsed. If you check the "Automatically write changes into XMP sidecar files" option, it allows you to synchronize Lightroom settings when exporting files to another computer running Lightroom.*

A Quickstart Guide to Lightroom

Let's start with a quick overview of how to use Lightroom, beginning with a look at how to customize the interface, followed by a look at a typical Lightroom workflow.

Identity Plate Options

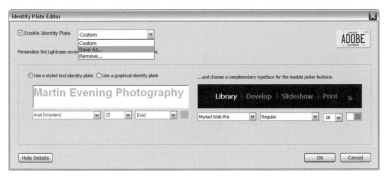

Figure 1.8 *After you have configured a custom Identity Plate, remember to open the Custom pull-down menu and choose Save As to save these settings as a saved template design.*

1. The top panel in the Lightroom interface contains the Lightroom Identity Plate and module selectors. If you go to the Lightroom menu and select Identity Plate Editor, you will see the dialog shown here. This allows you to enable the Identity Plate, which then appears in the top-left section of the Lightroom interface, replacing the normal Adobe Photoshop Lightroom logo (**Figure 1.8**).

2. The standard Identity Plate is styled text that shows the name registered as the computer administrator displayed using a default system font. If you click the Font Panel button (Mac), a Font dialog opens and allows you to choose a different font type and font size. Note that If you are using the PC Identity Plate Editor, you can edit the font characteristics within the Identity Plate Editor dialog.

NOTE

PSD files can only be added via
the Identity Plate Editor using the
Macintosh version of Lightroom 1.0.

3. If you select the "Use a graphical Identity Plate" option, you can
add an image logo by pasting or dragging a PDF, JPEG, GIF, PNG,
TIFF, or PSD image into the Identity Plate area. The logo image you
place here cannot be more than 60 pixels tall, but can contain
transparent pixels. A graphical Identity Plate can be added to
Slideshow and Web module templates, but be warned that a 60-
pixel tall logo may be far too small for most print layout template
designs that use an Identity Plate. You can also customize the
appearance of the module selector names by browsing the Font
menus to select a new font and font size. And if you click the two
little color swatch icons (circled), you can change the font colors
as well.

4. Now let's see how the top panel looks after customizing both the
Identity Plate and Lightroom module selectors.

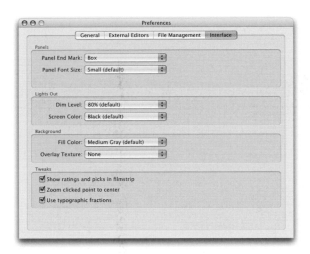

5. With the Lightroom Interface preferences you can customize the appearance of the interface when using the Lights Out and Lights Dim mode (discussed later in step 13 on page 24). You can also customize the background appearance when viewing an image in Loupe mode.

6. In this example, the Background Fill Color is set to White with the Overlay Texture set to Pinstripes.

Importing Images into Lightroom

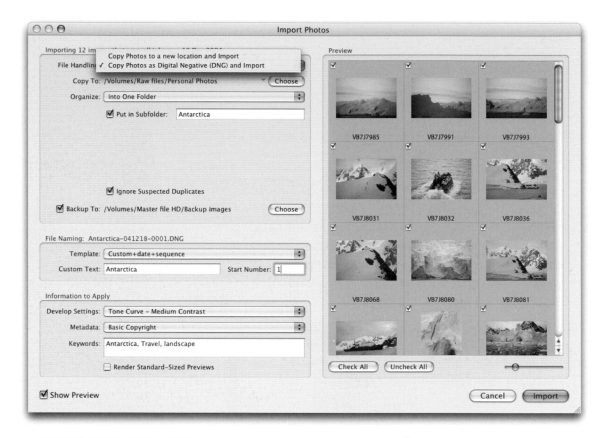

7.

7. To get images into Lightroom, click Import in the Library module. The Import Photos dialog opens as shown here (there is a Lightroom preference that will automatically open the Import Photos dialog when a new camera card is detected). If you are importing from a camera card, you can decide whether to make a straight copy of the images from the card or convert them to DNG files as they are copied. Images can also be renamed and backed up to a second drive during the import stage. Notice that Lightroom encourages you to enter a subfolder name. Giving meaningful names to imported shoots plays an important role in the way Lightroom can help you keep track of your image files. The same is true if you add keywords and other metadata at this stage. This information will further help with the management of your Lightroom library. After you have configured the dialog, click Import to start importing.

NOTE

Chapter 2 in this book is devoted to importing images. But for now, let me point out that there are two main ways of bringing images into the Lightroom library. Copying or moving files will physically make a copy to the Lightroom Library folder. You mostly use this method to import images from a card. A copy by reference lets the images stay where they are and merely creates a reference of where they are stored. You mostly use this method to import images that are already on the computer's hard disk.

Viewing the Library

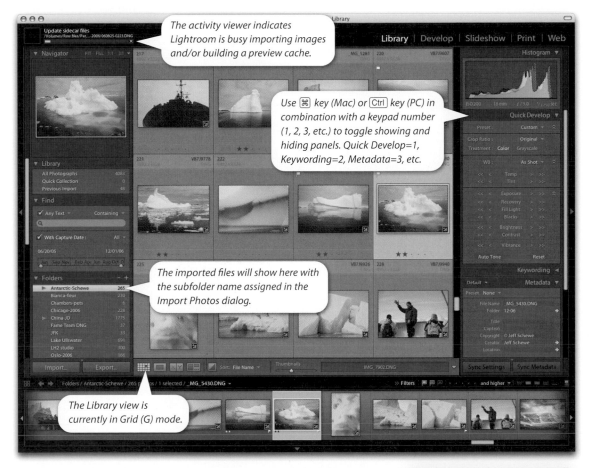

The activity viewer indicates Lightroom is busy importing images and/or building a preview cache.

Use ⌘ key (Mac) or Ctrl key (PC) in combination with a keypad number (1, 2, 3, etc.) to toggle showing and hiding panels. Quick Develop=1, Keywording=2, Metadata=3, etc.

The imported files will show here with the subfolder name assigned in the Import Photos dialog.

The Library view is currently in Grid (G) mode.

8. The imported images are now shown in the Library module with the Grid view selected. The activity viewer in the top-left corner indicates that Lightroom is actively carrying out background processes such as importing images or building thumbnails. If more that one operation is taking place at a time, you will see the grouped status indicator (**Figure 1.9**). If you click the arrow to the right, you can toggle the status indicator between each of the tasks that are in progress and the grouped indicator. The imported images will appear in order of preference within the grid cells, and you can make selections of images by using either the Library Grid or the Filmstrip at the bottom. Plus you can rearrange the order of the images in the grid by dragging and dropping, and the order sequence will be carried through to the other modules.

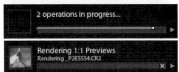

Figure 1.9 *The status indicator shows the progress of background processes such as importing images or rendering previews.*

This image is currently displayed using the Fit to view Loupe mode. A single click will magnify the image to a 1:1 or custom zoom view. Click to return to the previous view.

The panel behavior is currently in "solo" mode, where only one panel will open at a time (see Tip below).

You can right-click to access the contextual menu options for the panel tracks and use this to hide and reveal individual panel tracks in any of the Lightroom modules.

The Library view is currently in Loupe (E) mode.

The scroll bar

© Jeff Schewe 2006

TIP

You can open and close the Lightroom panels by clicking anywhere on the panel tab. If you Alt –click a panel tab, you can switch to a solo mode of operation, where clicking an individual tab will open that panel only and close all the others. Alt –click a panel again to restore the normal panel behavior.

9. Now let's switch to viewing images one at a time using the Loupe mode, where we can toggle viewing the images at a base magnification that can be set to either Fit or Fill the width of the content area. The magnified loupe view can be set from a 1:4 to an 11:1 zoomed pixels view (yes, Lightroom goes to 11!) You can switch modes by clicking the Loupe view mode button or by pressing the E key. Or, just double-click an image to switch from the Grid view to seeing the selected image displayed in Loupe mode. The arrow keys on the keyboard let you quickly shuttle through all of the images in the current image selection. To scroll through a selection without scrolling the images, drag the scroll bar in the Filmstrip.

Simplifying the Interface

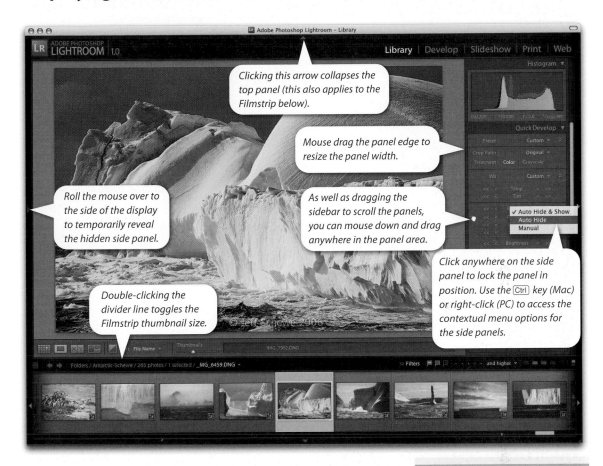

Clicking this arrow collapses the top panel (this also applies to the Filmstrip below).

Mouse drag the panel edge to resize the panel width.

Roll the mouse over to the side of the display to temporarily reveal the hidden side panel.

As well as dragging the sidebar to scroll the panels, you can mouse down and drag anywhere in the panel area.

Click anywhere on the side panel to lock the panel in position. Use the Ctrl key (Mac) or right-click (PC) to access the contextual menu options for the side panels.

Double-clicking the divider line toggles the Filmstrip thumbnail size.

10. Now let's look at ways to make Lightroom's interface simpler to work with, and learn how to hide interface components and place more emphasis on the images. Start by pressing the Tab key. This will temporarily hide the two side panels and allow more room for the image to be displayed in Loupe mode. But you can still access the side panels by rolling the mouse cursor over to the edges of the screen. Do this and the panels will be revealed one at a time. Notice how the panels temporarily overlay the image below, but you can still access the panel controls as usual. If you click the little arrow on the side of the screen in the middle, you can lock these panels independently, in which case the image will center adjust to reveal the entire image area again. Press Tab and both panels will be revealed once more. Panel rollover behavior can be modified via the contextual menu (see above).

TIP

The default side panel behavior is controlled by Auto Hide & Show—the side panels auto reveal and hide as you roll the cursor to the side of the screen. The Auto Hide option hides the panels, and they will only be revealed (overlaying the image) when you click the side arrow. In Manual mode you can toggle between hide/reveal and image resize in the content area.

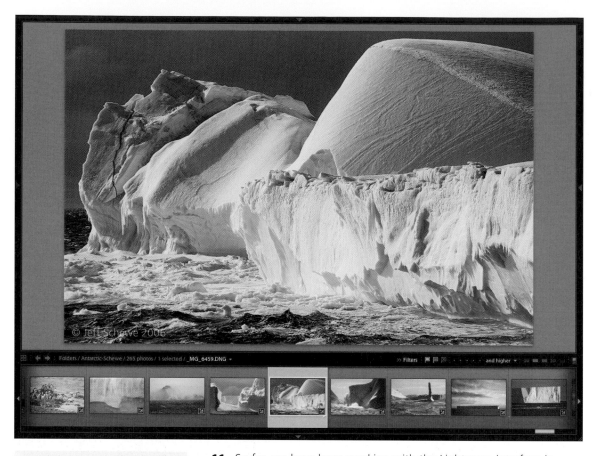

TIP

If you ever get stuck in a situation where you need to reset the interface layout, press ⇧Shift Tab a couple of times to restore everything back to the default layout.

11. So far, we have been working with the Lightroom interface in Document Window mode. If you press the F key, the interface switches to full-screen mode and expands to fill the whole screen. Press F a second time, and the interface switches to absolute full-screen mode where the system menu bar disappears and Lightroom overrides any operating system rollover behaviors. For example, on the Macintosh, the absolute full-screen mode overrides the Dock as you roll the mouse cursor to the bottom or side of the screen. But you can still access the system menu bar by rolling the mouse cursor to the top of the screen. Press the F5 key to toggle between hiding and showing the Lightroom menu bar. Press the F6 key to hide and show the Filmstrip at the bottom. In addition, you can use ⇧Shift Tab to hide and show everything!

Zooming In

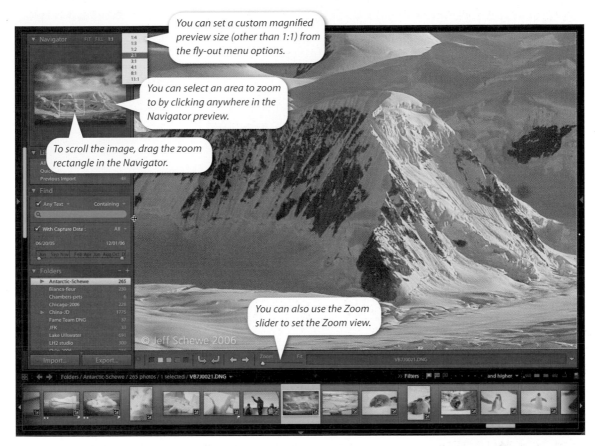

You can set a custom magnified preview size (other than 1:1) from the fly-out menu options.

You can select an area to zoom to by clicking anywhere in the Navigator preview.

To scroll the image, drag the zoom rectangle in the Navigator.

You can also use the Zoom slider to set the Zoom view.

12. Let's stay in the full-screen Loupe mode with the side panels hidden and roll the mouse over to the left of the screen to reveal the left panel, which can be locked into position (see step 10). Click anywhere in the picture, and the image zooms smoothly to a 1:1 or custom magnified pixels view. Click the image again, and it returns to fit the normal screen view. You can also use ⌘ + to zoom in and ⌘ - to zoom out. Use the tilde key (~) to toggle between the Grid and Loupe view modes. And whether you are in Grid mode or Loupe mode, if you press Z, the image will instantly display at the 1:1 (or custom) magnified view mode. Press Z again and the image reverts to the Library Grid view. In the Navigator panel, click inside the image preview to select an area to zoom to and drag the rectangle within the Navigator to scroll the image.

Dimming the Lights

© Jeff Schewe 2006

13. Lightroom has a Lights Dim and a Lights Out mode. These two viewing modes allow you to dim or hide the interface so you can focus more on the photographs, yet still have easy access to the interface when you need it. To see how these work, press the L key once. This switches Lightroom to Lights Dim mode (you could choose Window ⇨ Lights Out ⇨ Lights Dim, but pressing the L key is easier to remember). The Lights Dim mode just darkens the interface so you can still see (and access) all the Lightroom controls and menu items. Press L a second time to take you to the Lights Out mode, and then press L again to take you back to the default viewing mode. Note that if you roll the mouse to the top of the screen, you will always be able to view the menu bar at normal brightness.

Using the Develop Module

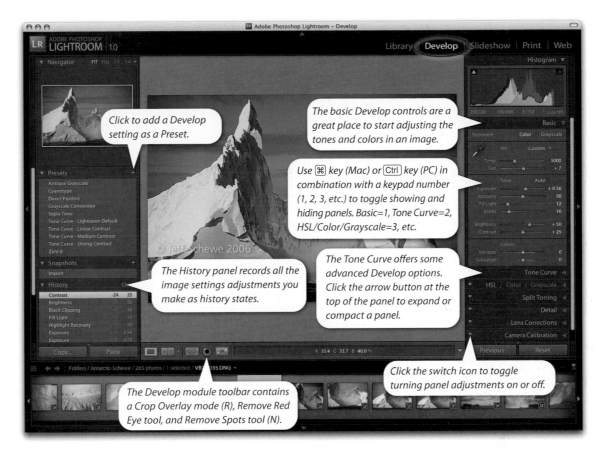

Click to add a Develop setting as a Preset.

The basic Develop controls are a great place to start adjusting the tones and colors in an image.

Use ⌘ key (Mac) or Ctrl key (PC) in combination with a keypad number (1, 2, 3, etc.) to toggle showing and hiding panels. Basic=1, Tone Curve=2, HSL/Color/Grayscale=3, etc.

The History panel records all the image settings adjustments you make as history states.

The Tone Curve offers some advanced Develop options. Click the arrow button at the top of the panel to expand or compact a panel.

The Develop module toolbar contains a Crop Overlay mode (R), Remove Red Eye tool, and Remove Spots tool (N).

Click the switch icon to toggle turning panel adjustments on or off.

14. Now click Develop to take you to the Develop module where you can start adjusting color, tonal range, image cropping, and sharpness. If you are accustomed to working with the Adobe Camera Raw plug-in in Bridge and Photoshop, you will already be familiar with the Basic controls. There is a lot you can do to correct an image by using just these Basic panel adjustments, but Lightroom also offers Tone Curve, Crop & Straighten, HSL/Color/Grayscale, Split Toning, Detail, Lens Corrections, and Camera Calibration panel controls. You can save your favorite Develop settings as Presets that can then be applied to other images (**Figure 1.10**). With Presets you can choose to save everything or save selected items only. Lightroom ships with a small selection of Develop presets to help you get started. Try rolling over the list in the Presets panel to see how they look in the preview before applying them to the actual image.

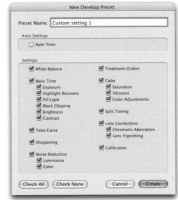

Figure 1.10 *You can save your favorite Develop settings such as sharpening and luminance as a preset.*

Retouching a Photograph

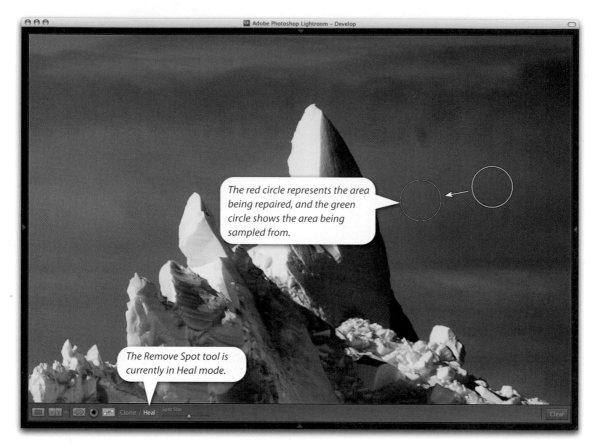

15. The Develop module toolbar contains some basic image editing tools for retouching photographs. When the Crop tool is selected (use R as a shortcut to select the Crop tool), the Crop & Straighten panel becomes active, and you can apply a crop to an image and use the straighten tool to straighten horizon lines in a picture. You can use the Remove Red Eye tool by simply dragging across the eyes to remove the red reflection from a flash photograph. Shown here is an example of the Remove Spots tool being used in Heal mode. These tools can be used to carry out basic image spotting, just as you would normally do in Photoshop except the spotting you do is recorded as "edit instructions." Essentially, this means that after you do any retouching, you have the freedom to make further changes to any other Develop module settings, such as changing the white balance.

Synchronizing the Develop Settings

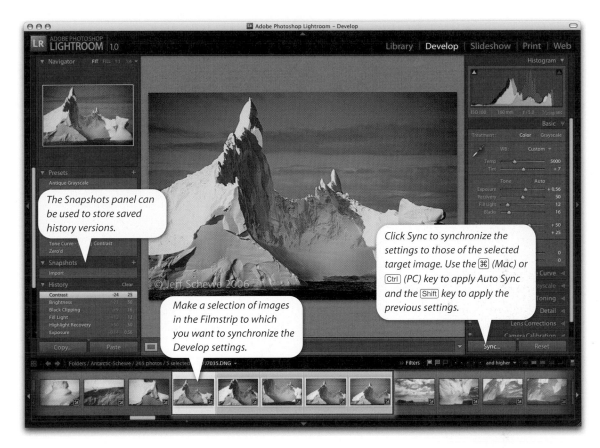

The Snapshots panel can be used to store saved history versions.

Make a selection of images in the Filmstrip to which you want to synchronize the Develop settings.

Click Sync to synchronize the settings to those of the selected target image. Use the ⌘ (Mac) or Ctrl (PC) key to apply Auto Sync and the Shift key to apply the previous settings.

16. After making a few adjustments to an image you might want to synchronize those settings with other photographs that were taken from the same shooting sequence. To do this, select all the images you want to synchronize via the Filmstrip. Make sure that the image you want to synchronize from is the "most selected" image, and then click Sync to synchronize all of the selected images with this image (**Figure 1.11**). Note that Lightroom offers unlimited undo options, so you can always choose Edit ⇨ Undo or ⌘–Z any time you need to revert to a previous step. If you want to redo a step, use ⌘⇧Shift–Z. The History panel offers even more flexible control, allowing you to preview and select specific history steps to go to, which also remain stored with the image. Selected history states can be saved as snapshots via the Snapshots panel.

Figure 1.11 *Develop settings such as the Spot Removal, Crop, and Straighten settings, can be selectively synchronized across other images.*

Reviewing Images

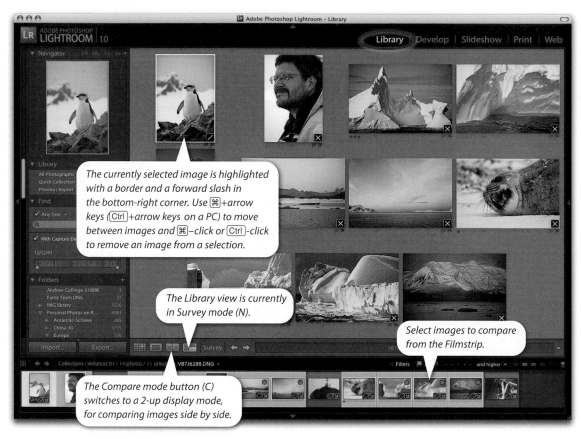

The currently selected image is highlighted with a border and a forward slash in the bottom-right corner. Use ⌘+arrow keys (Ctrl+arrow keys on a PC) to move between images and ⌘–click or Ctrl-click to remove an image from a selection.

The Library view is currently in Survey mode (N).

Select images to compare from the Filmstrip.

The Compare mode button (C) switches to a 2-up display mode, for comparing images side by side.

TIP

Remember that the tilde key (~) can also be used to toggle between the current and previous view mode.

TIP

Use ⌘–D (Mac) or Ctrl–D (PC) to deselect a Library selection of images, and use ⌘⇧Shift–D (Mac) or Ctrl⇧Shift–D (PC) to select the most selected (or active) photo only.

17. If you want to compare a select group of images, go to the Library module and make a selection of photographs either from the Library Grid or from the Filmstrip and click the Survey mode button (or press N). Note that if you are in the Library module and make a multiple image selection via the Filmstrip, Lightroom automatically switches to display the images in Survey mode. While you are in Survey mode, the selected images auto-resize to fit within the working area. If you want to inspect a particular image close-up, double-click to open it in Loupe mode and double-click or press N to return to viewing it in Survey mode. When you are in Survey mode, you can ⌘–click (Mac) or Ctrl–click (PC) on an image to remove it from the current selection. The Compare mode (C) lets you compare the target image with all others in the selection in a 2-up display mode.

Assigning Ratings and Quick Collections

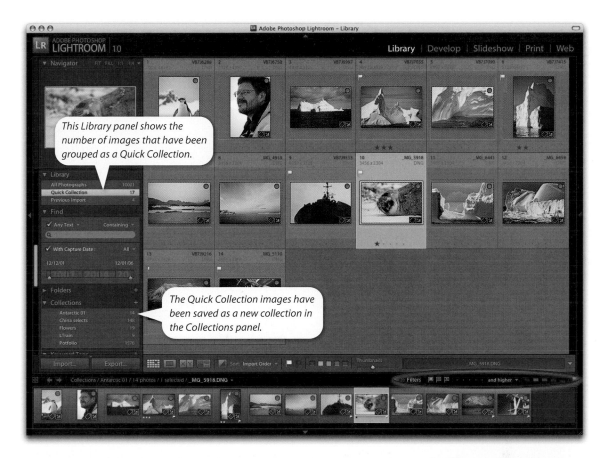

This Library panel shows the number of images that have been grouped as a Quick Collection.

The Quick Collection images have been saved as a new collection in the Collections panel.

18. Let's assume you have made a selection of images, but you want to refine them further. You can do this by making them into a Quick Collection. If you return to the Library Grid view, the currently selected images will be highlighted, and you can save this current selection as a Quick Collection by pressing the B key. Quick Collections are useful for marking favorite images and for combining selections from separate folders. Go back to step 9 and inspect the images one at a time in Loupe mode, but this time assign number ratings to the shots. To rate the images, press 1 to 5 on the keyboard. Use the] key to increase the current file rating or [to decrease the current file rating. You can also use 6 through 9 to assign color labels to images. In the example shown here, the selected image and the one before it were both assigned a yellow label.

NOTE

The Find panel lets you filter images by conducting a text-based search for any matching metadata. The calendar view section lets you narrow down a search using date criteria. And in the Filmstrip you can use the Filters controls (circled) to filter images in the content area by ratings higher than, lower than, or by a specific rating only. Or you can filter by flagging or color labels.

Preparing a Presentation

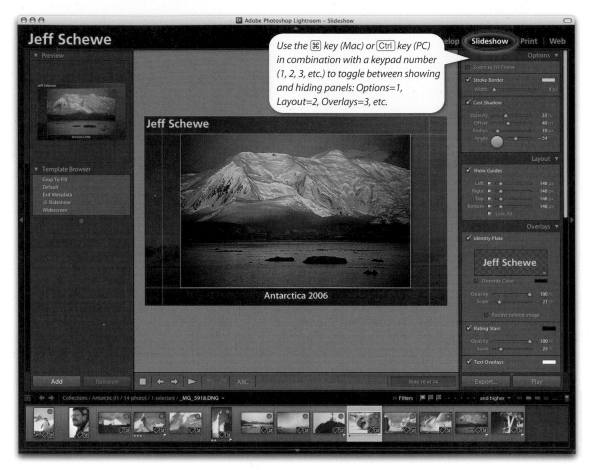

19. After creating a collection of images, let's look at how you can use a collection to create a screen presentation. The Slideshow module has a Template Browser with a choice of ready-made templates that you can use for making an onscreen slideshow. And there are plenty of options that allow you to create your own custom templates. The Options and Layout panels let you decide how to present, position, and embellish the image frame area. You can use the Overlays panel to add an image to the background and the Backdrop panel to add your Identity Plate logo. You can even choose music to accompany a slideshow via the Playback panel.

Creating a Web Photo Gallery

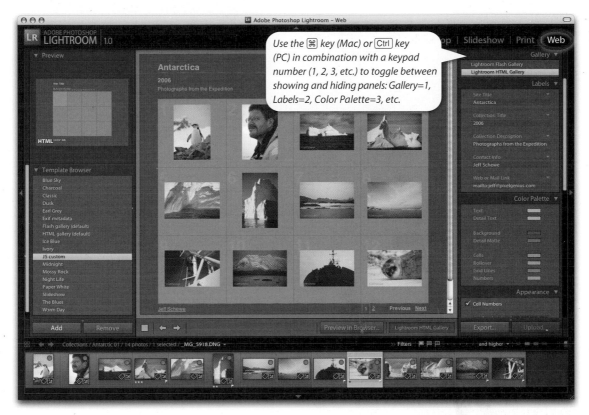

20. The Web module can generate Web photo galleries using HTML or Flash gallery styles. This screen shot shows a preview of the current Quick Collection using a custom template based on the HTML Gallery template, which is selected from the Template Browser panel. As with the Slideshow module, the Web module options allow you full control to modify and create your own Web photo galleries. The preview displayed in the content area only takes a second or so to generate and actually shows you a Web browser view of a fully coded Web site. When you are happy with the way the site looks, you can click the Upload button to specify where Lightroom should upload the complete site files and folders. You only need to configure the FTP settings for your server once, and then add the settings as an FTP preset (**Figure 1.12**). After you have configured your server settings and saved them as a preset, it becomes an easy process to upload new Web photo galleries to a saved favorite server location.

Figure 1.12 *The Configure FTP File Transfer dialog.*

NOTE

When you select one of the Flash templates, Lightroom checks to see that you have the latest Adobe Flash Player installed. If you don't, it will provide a link for you to install it.

Printing a Contact Sheet

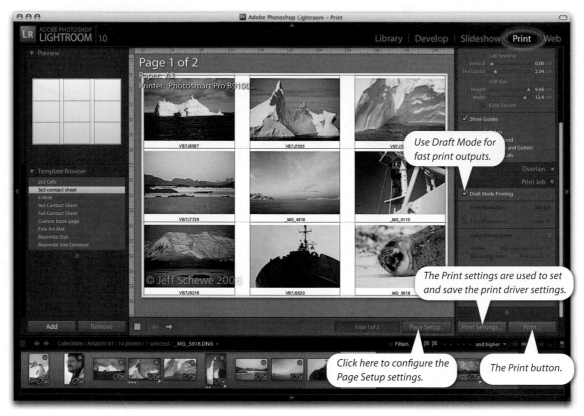

Use Draft Mode for fast print outputs.

The Print settings are used to set and save the print driver settings.

Click here to configure the Page Setup settings.

The Print button.

Figure 1.13 *Here is a view of an HP Print dialog. Because the Managed by Printer option was selected in Lightroom, I made sure the correct media type was selected, and that ColorSync (Mac) or ICM (PC) was switched on.*

21. Let's look at the Print module. In the example shown here, I kept the same selection of images active and then selected a modified contact sheet template from the Template Browser panel. Lightroom displays a preview of the contact sheet that contains the currently selected images. The Info overlay indicates that you are looking at page one out of two printable contact sheet pages. For speedy printing, go to the Print Job panel and check the Draft Mode Printing box, which is ideal for fast contact sheet printing. The simplest way to make a color accurate print is to leave the Profile setting set to Managed by Printer. Then click the Print button. Make sure in the system Print dialog that appears, you also switch on the ColorSync option (Mac) or ICM (PC) in the Color Management section, along with the correctly matched media/paper type in the Print settings (**Figure 1.13**).

Making a Final Print

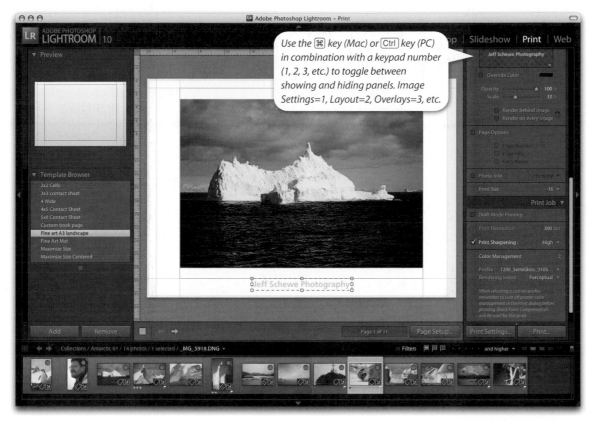

Use the ⌘ key (Mac) or Ctrl key (PC) in combination with a keypad number (1, 2, 3, etc.) to toggle between showing and hiding panels. Image Settings=1, Layout=2, Overlays=3, etc.

22. If you want to make a high-quality print output, try selecting one of the single page templates. Depending on how you want the image to appear on the page, you might want to click the Page Setup button to configure the printer for landscape or portrait printing. When you go to the Print Job panel, you need to disable Draft Mode Printing and choose a sharpen setting suited to the type of output you are making. You could continue to make a print using the same settings as before, but if you happen to have a custom print profile for your printer, you can click the Profile options to select the desired print/paper profile. Click the Print Settings and enter the same system print settings that were used to create the profile target (with ColorSync/ICM switched off). This locks the print settings to the current setup. Now Alt–click the Print button to bypass the system Print dialog and go straight to making a print.

TIP

As you create custom print settings, they can be saved with the Print Templates. Hold down the Ctrl key (Mac only), or hold down the right mouse button (both Mac and PC), and then select a print preset and choose "Update with current settings" from the contextual menu. This saves the page setup and print settings to the print template preset. This can really make printing a lot more foolproof. After you have saved all your print settings to a template, there is no need to reconfigure them when you select that template again.

Exporting Images

23. You can use Export whenever you want to apply the Lightroom settings to an image and export that photograph (or collection of images) as a JPEG, PSD, TIFF, or DNG file. To export from Lightroom make a selection of images either in the Library Grid or in the Filmstrip, and then choose File ⇨ Export (or click the Export button). The Export dialog opens. Here you can determine which folder the images are exported to, how you might want to rename them, and which file format you want the files to be in. Note that when the TIFF, PSD, or JPEG options are selected, you can choose which RGB color space to use, constrain the pixel dimensions, and set the pixel resolution for the exported images.

Working Through the Book

This more or less concludes the introduction to working with Lightroom. In the remainder of the book you will explore each aspect of the program in greater depth. Lightroom has been designed almost exclusively for digital photographers. This makes my task slightly easier, because being a photographer I have a clearer idea of what other photographers will find important and useful to know. To this end I have structured the book to match a typical workflow, starting with the import and export of images to and from Lightroom. At the beginning of this chapter I described how the philosophy behind Lightroom was to offer "unreasonable simplicity." If Adobe has been successful in this mission, you should find that much of the Lightroom program is fairly self-explanatory. For example, if you go to the Help menu, you will see a Shortcuts item for whichever module you happen to be using at the time. **Figure 1.14** shows the shortcuts for the Library module. In keeping with the spirit of Lightroom I have tried as much as possible to avoid discussing the technical workings of the program and have focused on discussing what Lightroom does best: managing, editing, and printing photographs. And if you really want to know more about how Lightroom works, I have reserved a technical section at the back of the book in the Appendix to elaborate on features like the Lightroom native RGB space. I have also included several pages devoted to side topics that relate to working in Lightroom, such as how to choose an optimum setup for your managed photos folder. You will also find lots of quick tips in the page margins.

TIP

To find out all the latest news about Adobe Photoshop Lightroom, go to the Lightroom News Web site: http://lightroom-news.com.

Library Shortcuts

View Shortcuts

~	Toggle between Grid and Loupe
Esc	Return to previous view
Return	Enter Loupe or 1:1 view
E	Enter Loupe view
C	Enter Compare mode
G	Enter Grid Mode
Command + Return	Enter Impromptu Slideshow mode
F	Cycle to next Screen Mode
Command + Shift + F	Return to Normal Screen Mode
L	Cycle through Lights Out modes
J	Cycle Grid Views

Panel Shortcuts

Tab	Show/Hide the side panels
Shift + Tab	Hide/Show all the panels
T	Hide/Show the toolbar
Command + F	Activate the search field
Command + \	Return to the previous module

Ratings Shortcuts

1–5	Set ratings
6–9	Set color labels
0	Reset ratings to none
[Decrease the rating
]	Increase the rating
Command + Up Arrow	Set Ranking to Flagged
Command + Down Arrow	Set Ranking to Neutral

Photo Shortcuts

Command + Shift + I	Import photos
Command + Shift + E	Export photos
Command + [Rotate left
Command +]	Rotate right
Command + E	Edit in Photoshop
Command + -	Zoom out
Command + =	Zoom in
Z	Zoom to 100%
Command + G	Stack photos
Command + Shift + G	Unstack photos
Command + R	Reveal in Finder
Delete	Remove from Library
Command + Delete	Move photo to Finder trash
	Also removes from the Library
Command + Shift + C	Copy Develop Settings
Command + Shift + V	Paste Develop Settings
Command + Left Arrow	Previous selected photo
Command + Right Arrow	Next selected photo

Quick Collection Shortcuts

B	Add to Quick Collection
Command + B	Show the Quick Collection
Command+Shift+B	Clear Quick Collection

Figure 1.14 *It is always worth selecting the Shortcuts item in the Help menu—⌘-I (Mac) or Ctrl-I (PC)—to find out more about the shortcuts for each module.*

2 | **Importing**

Now let's look at the different ways to bring images into Lightroom and manage those files successfully. Lightroom is designed to help you organize and catalog your images from the very first moment you import your capture files into the program. And from there on, Lightroom provides a flexible system of file management that can free you from the rigid process of having to organize your images within system folders. Although Lightroom does still use a folder system for storage, it manages your images on a global scale by using metadata. A good example of how such a system works is to look at the way music files are managed on an Apple iPod with the iTunes software. If you are familiar with importing music via iTunes, you know that it doesn't matter what folders if any the MP3 files are stored in, as long as they are stored in the same central music folder location. When you select a track to play, you search for the music by the metadata, such as the song or album title. Lightroom works in exactly the same way by encouraging you to use relevant naming for your folder imports and add keywords and other metadata to everything at the time of import. Through the use of careful filenaming, custom metadata and keywords you can make image searching equally as fast and easy as playing music on your iPod. But let's begin by looking at the various ways you can import your images into Lightroom.

Importing Images

Importing Images from a Card

The following steps show you how to configure Lightroom to automatically import, rename, and manage your image captures each time a camera card is inserted into a card reader connected to the computer.

1. Before importing, open the Lightroom Preferences dialog. The top section lets you decide how Lightroom responds whenever a memory card is detected. If the Do Nothing option is selected, you will have to import the images manually by choosing File ⇨ Import—⌘⇧Shift I (Mac) or Ctrl⇧Shift I (PC). If you select Show Import Dialog, Lightroom automatically launches the Import Photos dialog shown in step 3 each time a memory card is inserted into the computer.

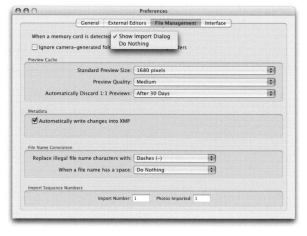

2. To start importing images into Lightroom, insert a memory card into the computer. The camera card mounts on the Desktop.

EOS_DIGITAL

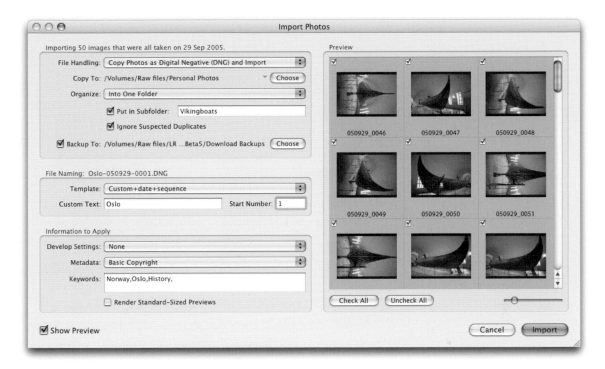

3. Because of the way the Lightroom Preferences were configured,
Lightroom automatically opens the Import Photos dialog every time
a card is inserted. When you check the Show Preview box, the
Import Photos dialog shows thumbnail previews of all the images
you are about to import and allows you to choose in advance
which images to import. If you're importing from a camera card,
the quickest option is to select "Copy photos to a new location
and import." Alternatively, you can select the "Copy Photos as
Digital Negative (DNG) and import" option. The latter makes a
duplicate copy of all the images on the memory card, converts
them to DNG, and saves them to the folder designated in the
Importing section. I won't go into detail about how to configure
all the Import Photos options just yet, but at this stage it is a good
idea to enter an appropriate name for the destination subfolder
that will suitably describe the collection you are about to import.
Also, you should add metadata information that would be useful
to apply in bulk, such as choosing keywords relating to the subject
matter, and a Develop setting to apply to the images as they are
brought into Lightroom (**Figure 2.1**).

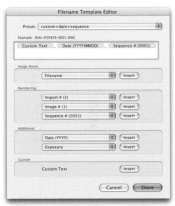

Figure 2.1 *You can create your own
custom renaming schemes and save
these as a custom template for use in
the File Naming section.*

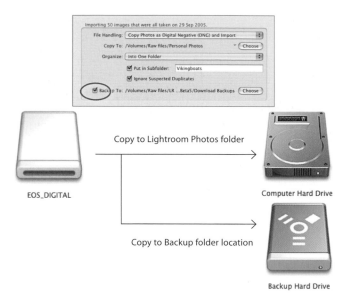

Copy to Lightroom Photos folder

EOS_DIGITAL

Computer Hard Drive

Copy to Backup folder location

Backup Hard Drive

4. You can also specify a secondary folder to copy the images to. Select the Backup To check box and then click the Choose button to specify a backup folder. This option should be mandatory whenever you are importing valuable images and want to ensure you have a backup of all your imports. After you have renamed and edited the master selection of images, and have backed up these images in their modified state, you no longer need to keep the initial backup copy files. But nonetheless it is a wise precaution at this stage to temporarily store more than one copy of each master file.

5. After you have configured the Import Options and clicked the Import button, Lightroom imports the files from the card to the Lightroom library. As the images are imported, the thumbnails start to appear one by one in the library content area. You will also see the import progress shown in the status indicator in the top-left corner. Oftentimes, there may be at least two processes taking place at once: the file import and the preview rendering. The progress bar gives you a visual indication of how the import process is progressing. And if more than one operation is taking place at a time, you will see the grouped status indicator (like the one in the figure above on the left). If you click the small arrow to the right, you can toggle the status indicator between each of the tasks in progress, plus the grouped indicator.

NOTE

When you choose Copy Photos as DNG and then import, the DNG convertor should report a problem whenever it is unable to convert any supported raw file that has a raw file extension (including the Canon .TIF extension). However, this does not guarantee that all file corruptions will be reported. Only those that the Lightroom Adobe Camera Raw processor is able to detect will be reported.

6. Normally, you should not encounter any problems when importing files from a camera card. But if you choose the Copy Photos as DNG option, you will be alerted to any corruptions in the files as they are imported.

7. After you have successfully imported all the images to the computer and backup drive (if applicable), you can safely eject the camera card and prepare it for reuse. However at this stage I usually prefer to completely delete all the files on the card before removing it from the computer. That way when you reinsert the card in the camera, you won't be distracted by indications that there are still images left on the card, which might cause you to wonder whether or not you removed all the images from the card. I would also advise you to always reformat the card (in the camera) before you start capturing more images. This is good housekeeping practice that will help reduce the risk of file corruption as fresh capture data is written to the card.

Importing Images from a Folder

Lightroom can also import images from an existing folder on the computer. You have the option to either copy the images to the library (as shown in the previous example) or create a link that references the files in their current location. When importing images from a folder, it is usually more common to import them by referencing the files in their current location.

1. If you want to manually import images from an existing folder, you can do so by clicking the Import button or using the keyboard shortcut ⌘⇧Shift I (Mac) or Ctrl ⇧Shift I (PC). If a camera card disk happens to be mounted on the computer, you will see a choice of import source options.

2. If you click on the named camera card button, Lightroom takes you straight to the Import Photos dialog shown in step 3 on page 39. If you click the Choose Files button, a navigation menu opens from which you can choose a folder of images to import. If there is no camera card mounted on the computer, you will simply see a normal file navigation dialog (as shown above).

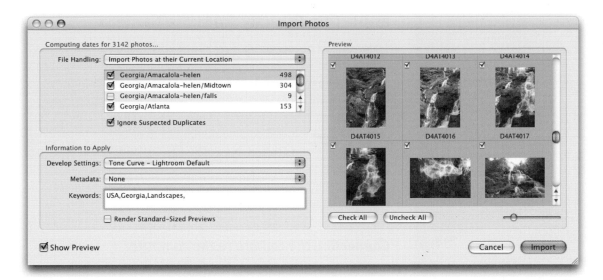

3. When you import images from a folder, the Import Photos dialog changes. The folder I am about to import from contains several subfolders of images, and in the example shown here I have highlighted only a few subfolders to import from.

4. If you choose to manually import images (either by reference or by copying) from an existing folder on your computer, they may contain files that Lightroom cannot process. In that case you will encounter the warning dialog like the one shown above. Lightroom is able to import all the supported raw file formats plus RGB, Lab, and grayscale images saved using the TIFF, JPEG, or PSD file formats. Non-raw images can be in 16-bits or 8-bits per channel mode, but PSD files must be saved from Photoshop with the Maximum Compatibility option switched on (**Figure 2.2**). If there are no compatibility problems, the files will be imported into Lightroom.

Figure 2.2 *To ensure that your layered Photoshop format (PSD) files are recognized in Lightroom, make sure that all PSD files saved out of Photoshop have the Maximum Compatibility option switched on in the Photoshop General preferences. If you are unable to import PSD files into Lightroom, try switching this option on in Photoshop and resaving the PSDs, overwriting the originals.*

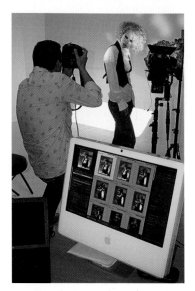

Figure 2.3 *Here I am at work in the studio, using a Canon EOS 1Ds Mark II camera in tethered mode to bring photographs directly into Lightroom on an iMac computer.*

Importing Directly from the Camera

If you are able to connect your camera directly to the computer, Lightroom lets you import image files straight from the camera. Photographs can be quickly brought into Lightroom, bypassing the need for a camera card and having to configure the Import settings every time you import a batch of images. This is referred to as "tethered shooting," although to do this Lightroom needs to rely on other software that can communicate with your camera and download captured files to a specified folder location. With the software in place, you can configure Lightroom to automatically import these images into the library (**Figure 2.3**).

Connecting the camera to the computer

To shoot in tethered mode you need the ability to connect your camera to the computer. Ideally, you want the fastest connection possible. Most existing professional digital SLRs offer a FireWire (IEEE 1394) connection (although many cameras are now moving toward USB 2.0), which in practice allows you to shoot and download at about the same speed as you can with a fast camera memory card. The only downside is that you must have your camera connected to the computer via a FireWire cable, and this can restrict the amount of freedom you have to move about without pulling the cable out, or worse still, pulling a laptop computer off the table! Another option is to shoot wirelessly. At the time of this writing, wireless units are available for some digital SLR cameras that will allow you to transmit images directly from the camera to a base station linked to the computer. Wireless shooting offers you the freedom, up to a certain distance, to move about without the restrictions of a tethered cable. But the current data transmission speeds with some cameras are a lot slower than those you can expect from a FireWire connection. Rapid shooting via a wireless connection can work well if you are shooting in JPEG mode, but not if you intend on shooting raw files only. But that may change in the future.

Camera capture software

Lightroom is able to appropriate the tethered shooting component of the camera communication software, and from there directly take over the image processing and image management. Here's how it works: The camera communication software can be configured to download the files to a specific folder location. When the files appear in this "watched" folder, Lightroom can be configured to immediately copy

the files into the Lightroom library. And because the files are simultaneously deleted from the watched folder, you effectively bypass the camera software and the images appear directly in Lightroom.

At this point in time I can confirm that it is possible to use Lightroom in conjunction with the Canon Viewer Capture software designed for the range of Canon EOS cameras. Over the next few pages I have outlined the steps needed to set up a Canon EOS camera such as the EOS 1Ds Mark II to auto import files directly into Lightroom. Nikon users will find that Nikon Capture includes a Camera Control component that works the same way as the Canon software and establishes a watched folder to download the images to. The latest version of Nikon Capture supports all the D Series cameras as well as the Nikon Coolpix 8700. Alternatively, you might want to consider buying Bibble Pro software from Bibble Labs (www.bibblelabs.com). Bibble Pro (version 4.7 at this writing) enables tethered shooting with a wide variety of digital cameras, and again allows you to establish a watched folder for the downloaded images. Unfortunately, I have not yet been able to test these other programs. Whichever program you use, you should be able to adapt the following steps to work with Lightroom.

The steps that follow demonstrate how to use the Auto Import feature with the Canon EOS Viewer Utility program in tethered mode. Although you won't need to use the program to view and process the imported files, you will need to leave the EOS Viewer Utility running in the background to interact with the connected camera.

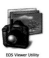

EOS Viewer Utility

1. Launch the EOS Viewer Utility and click the Preferences button. Under "Folder to display at startup," click Browse to select a watched folder and then click OK. Quit the program for now (you will need to relaunch for the new folder destination to be recognized).

NOTE

Here is an interesting technology to look for in the future: Eye-Fi is about to introduce a product called Eye-Film, which is a media card incorporating 802.11b/g Wi-Fi and 1 GB of Flash storage. Eye-Film will come in the form of an SD card (a Compact Flash Type-II adapter will allow digital SLR users to put these in cameras without an SD slot). When you start shooting, the card transfers photos from within your camera to any computer with Wi-Fi support. With Eye-Film, the originals remain on the card and are transmitted to the computer. So far only JPEG files can be transmitted in this way. For more information, go to www.eye.fi.

NOTE

The Canon EOS Viewer Utility described on these pages is software that should have come with your camera and can also be downloaded free of charge from the Canon cameras Web site: www.canon.com (look for the download library section on the site). There is also the self-contained Canon EOS Utility, which is the only program that works with basic Canon digital SLRs such as the Rebel series. In my experience the combination of using EOS Viewer Utility plus EOS Capture has allowed me to work faster in tethered mode with the EOS 1Ds Mark II.

2. On the Lightroom File menu select Auto Import ⇨ Enable Auto Import to allow Lightroom to bring in files automatically. Go to the Auto Import menu again and choose Auto Import Settings.

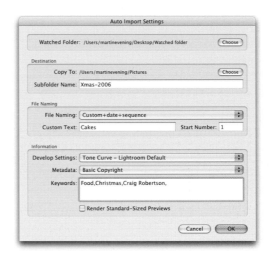

3. The Auto Import Settings dialog allows you to configure the Import settings for the auto imported files. These settings will be applied to all the images that are about to be captured and for the duration of the shoot (you should reconfigure these settings on a job-by-job basis). Click the Choose button and select the same watched folder as was selected in step 1. Then go to the Destination section, choose a master destination folder location, and enter a Subfolder Name to be used for the current session. In the example shown here, I selected the same custom File Naming template as was used before, entering some descriptive Custom Text for the file renaming scheme. I also selected a bulk metadata template and a custom Develop Settings template. I then added some custom Keywords to apply to all the files as the shoot session files were imported.

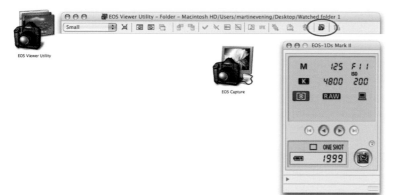

TIP

It should be possible to configure the Auto Import settings once at the beginning of a shoot and have everything you photograph subsequently be handled completely automatically. But of course, things can never be guaranteed to run so smoothly! Keep in mind that if you update the Develop settings used in the Auto Import, you need to reselect them again before you continue shooting. Having a camera tethered to the computer can in some cases drain the battery a lot faster. With the setup I use, I find it is a good idea to always keep the camera connected, but to switch the camera off between shots.

4. You are almost ready to shoot. Make sure the camera is tethered to the computer and switched on. Launch EOS Viewer and click the Connect to Camera button (circled), which launches EOS Capture. You can now use the camera as you normally would by pressing the shutter release, or use EOS Capture to capture pictures remotely by clicking the blue camera button in the dialog.

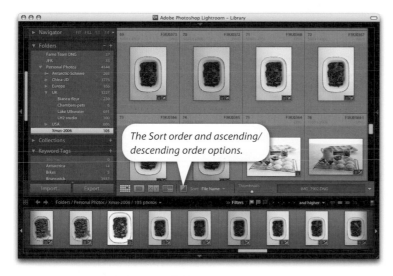

The Sort order and ascending/descending order options.

TIP

When you shoot using the tethered mode. it is useful to see new images appear at the top of the content area as they are imported. To enable this feature, choose View ➯ Sort ➯ Descending. You may want to switch the sort order back to Ascending for normal editing. If the Ascending/Descending toggle action appears to be broken, it may be because you have a Custom sort order selected. Make sure the Sort order option is set to Import Order.

5. As you start shooting, the EOS Viewer Utility brings the camera files directly into the watched folder you selected in step 1. From there, Lightroom recognizes that a new image has been added to the watched folder and imports these captures to a new folder using the Auto Import settings. After configuring Lightroom for Auto Import in a tethered setting, you should be able to take pictures all day with the camera connected to the computer and have the images processed automatically using the settings entered in step 3.

TIP

Note that this method of importing works with both Mac and PC computers, but the Library module must be active.

Importing Images via Drag and Drop

Another way to import images into Lightroom is to simply drag and drop files from a camera card or folder into the Library module. It does not matter which folder (if any) is selected, since this method of import will open the Import Photos dialog to allow you to determine how the images will be imported.

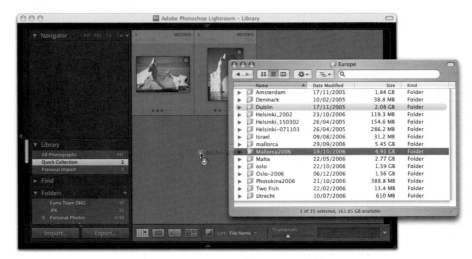

1. To drag and drop images into the Lightroom library, locate the images you want to import and then drag them into the library grid.

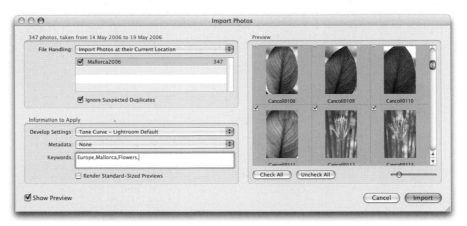

2. This action again opens the Import Photos dialog and lets you decide how you want the files to be imported.

Importing Photos by Copy

Let's look more carefully at the two ways in which images are imported: by copying from a device or folder and by referring to a source file. **Figure 2.4** shows the Import Photos dialog seen when importing images from a camera card. There are two file handling options: The "Copy photos to a new location and import" option makes a duplicate copy of all the images on the memory card and stores them in the designated "Copy To" folder and subfolder. The "Copy Photos as Digital Negative (DNG) and import" option copies the files from the card and at the same time converts them to the DNG file format. This option offers more peace of mind, because the DNG file format is widely regarded as a more versatile and therefore more appropriate file format for the long-term archival storage of raw camera files. The DNG conversion process also conveniently flags any files that happen to be corrupt as they are imported. On Page 40 I showed you how the camera files were copied to the designated Lightroom Photos folder and backed up to a secondary hard drive. The "Backup to" option is therefore extremely useful, because you never know when a hard disk failure might occur. If you copy the original camera files to two separate hard drives at the import stage, the chances of losing all your camera files due to disk failure or human error will be greatly diminished.

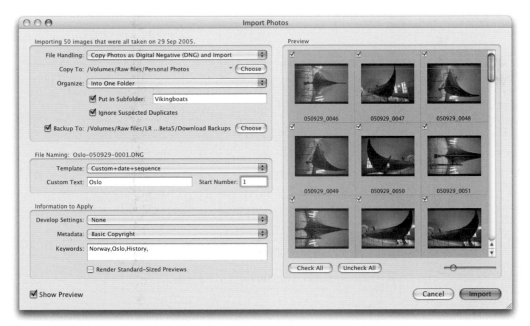

Figure 2.4 *The Import Photos dialog when importing images from a camera card.*

Figure 2.5 *If you double-click to change the name of a top-level folder, you will only be able to change the way the folder name is displayed in Lightroom.*

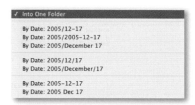

Figure 2.6 *When you click the Organize menu, you are offered a choice of ways to organize the imported images within the destination folder. You can segment the imports into one folder as shown in Figure 2.8 (top), or use one of the date segment options shown in Figure 2.8 (bottom).*

Figure 2.7 *If there are a large number of images to import, the date calculation dialog may appear, indicating that Lightroom is reading in the capture date metadata of all the files that are available to be imported.*

Organizing files imported by copy

If you import files by copy, you need to decide how they should be organized as you add them to the library. My personal preference is to import all the files from a folder or card and group them using the Into One Folder organization structure (**Figures 2.5** and **2.6**). No matter what is on the card, all the imports will be placed in a single folder location. And if you check the Put in Subfolder option, you can create a new folder within the Copy To folder directory, and the imported files will eventually all appear inside the new folder in the Library Folders panel.

If you select one of the By Date segmenting options, and the pictures you are importing were shot over two or more days, Lightroom displays the files by segmenting them into their separate shoot dates (**Figure 2.8**). This allows you to import files by select dates only using the naming structure shown in the Organize Import list.

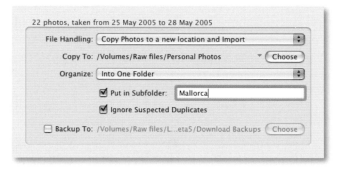

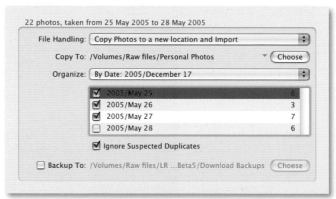

Figure 2.8 *If you select the Into One Folder organize option (top), all the images from the import source will be amalgamated into a single destination folder. If you select one of the segment by date options (bottom), Lightroom will organize the imported files by date, using one of the selected date organize options listed in Figure 2.9.*

Renaming options

If you want to manage and track your image files successfully, it is important to rename them, and ideally this should be done at the import stage (although you can always select Library ⇨ Rename Photos to do this later). The File Naming section has a pop-up menu that contains several file renaming templates that are ready for immediate use (**Figure 2.9**). For example, if you select the "Custom Name – Sequence" template, you can enter text in the Custom Text field and the imported files will be renamed using this text followed by a sequence number starting with the number entered in the Start Number box. The sample filename at the top of the File Naming section gives an advance indication of how the chosen renaming will be applied to the imported files.

If you choose the Edit option, it opens the Filename Template Editor (**Figure 2.10**). This allows you to customize and save your own File Naming template designs using tokens or data descriptors such as date. In the example shown here, I clicked the Insert button next to the Custom Text item in the dialog to add a Custom Text token at the beginning of the File Naming template. Next, I went to the Additional section and selected a series of Date format tokens, each time clicking "Insert" to add one of these to the template. Then I went to the Numbering section and added a four digit Sequence number token. This template was then saved and added to the File Naming template list.

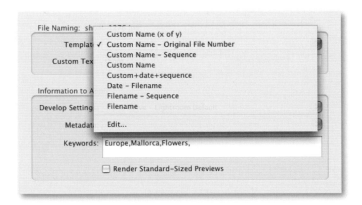

Figure 2.9 Here is the File Naming template list, including the Custom+date+sequence template that was created from the settings shown in Figure 2.10. The Custom Name (x of y) template numbers the imported files using a sequence number (x) followed by a number for the total number of images in the sequence (y). The Original File Number option preserves and uses the sequence number that was added by the camera.

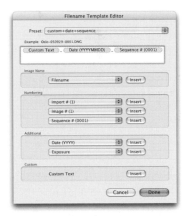

Figure 2.10 The Filename Template Editor dialog.

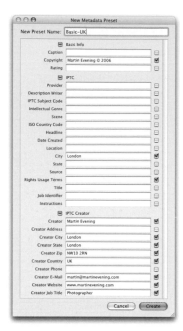

Figure 2.11 *The New Metadata Preset dialog allows you to fill in the information sections shown here, which conform to the standard IPTC format that is recognized throughout the industry.*

NOTE

Notice that as you type in keyword terms, Lightroom is able to auto-complete your entries by referring to the current Keyword Tags panel contents.

Adding Information During an Import

As you import new images by copying them to the Lightroom library, you can batch add Develop settings and metadata as you do so (**Figures 2.11** and **2.12**). Figure 2.12 shows the Develop Settings menu at the top, which allows you to select a saved Develop setting and apply it to all the images as they are imported. The Develop settings include all the settings you currently have saved in the Develop module Presets list—extremely useful when importing files from the camera.

Sensible folder naming and filenaming can certainly make it easier to retrieve images later, but as your library grows you will begin to appreciate the benefit of using keywords and other metadata to help track down your images, especially when searching a large library collection of photographs. The Library module offers a number of ways to search for a specific image or groups of images. For example, the Metadata Browser panel can help you search for files using criteria such as by "Camera," "Lens," or "File Type." This method of searching requires no prior input from the user of course, but in the Import Photos dialog you can go to the Metadata menu and choose a preconfigured Metadata template to add bulk metadata. This can be configured by choosing New from the Metadata menu and filling out the items in the New Metadata Preset dialog shown in Figure 2.11. Metadata presets are therefore useful for instantly adding common information such as your contact details and image copyright status. The Keywords section is used for adding shoot-specific metadata, such as the name of a location or a common descriptive term for all the images you are about to import. Adding bulk metadata at the time of import can assist you when conducting searches for specific images. The metadata information entered at this stage will be applied to all derivative files.

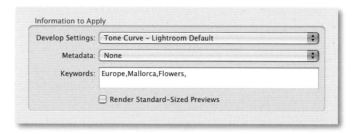

Figure 2.12 *The Information to Apply section of the Import Photos dialog.*

Importing Existing Photos from Folders

If you are importing images from a preexisting folder of images, the Import Photos dialog presents you with different options. In most cases, choosing the option "Import Photos at their Current Location" is the fastest and most practical solution. Although you could choose "Copy Photos to a new location and Import." This is useful if you want to import and make a backup copy of the original master files at the same time. Or you could choose the option "Move Photos to a new location and Import." This is useful if you want to move files from an intermediary location to a new location and delete the original files. Unless you have an expensive, high-capacity RAID (Redundant Array of Independent Disks) server, it is unlikely you will have the storage capacity to keep every library image on a single drive.

My work setup includes two large-volume disk drives. One is used for importing all new images with the copy and import option and is an archive drive for storing all my digital negative files. I use importing files by copy to bring all new images into the library from the camera card onto this drive. The second drive is used for storing the derivative files. These are all the layered PSD or TIFF files that I have retouched. As I work on the selected images from a shoot, I find it helps to separate out the derivative files in this way. And in Lightroom it is easy to move the TIFF Edit files from a folder location on one drive to a folder on the second drive. But quite often I export a selection of images as PSDs or TIFFs to a new master folder on the second drive. Once I have done that I can import these master images into Lightroom using the "Import Photos at their Current Location" option (**Figure 2.13**).

NOTE

Importing photos by reference is most useful for initially building up your Lightroom library from scratch. When you first start using Lightroom, you will want to add images to the library that are already on your computer system. You don't have to follow the exact way I do this by having one disk drive for camera imports and another for derivative files. It does not really matter how your files are currently organized. You can use the "Import Photos at their Current Location" method as the quickest way to add existing images to the library without having to copy all those files to a specific location.

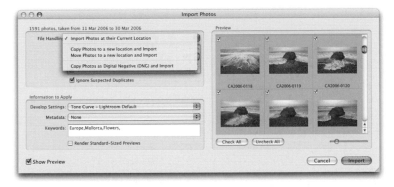

Figure 2.13 *Here is the Import Photos dialog for importing photos from an existing folder. Importing by reference is the best and fastest option. The other options mirror the import by copy options that are available when importing from a card.*

How Imported Images Are Organized

As images are imported, the folders that have been designated or referenced appear listed in the Folders panel. The Folders panel display is in some ways like a normal list tree folder view that you would find in a file browser program, but there are some important differences to note. The Folders panel will only display the image folders that have been imported into the current library. The folders are primarily displayed in alphabetical order rather than in a hierarchical order where the drives are listed in the list tree view and you expand the folder hierarchy to see the contents of each drive. **Figure 2.14** shows that the Folders panel displays a complete list of all the folders in the current library as a complete alphabetical list but that the folder view contains images that are stored on two separate drives.

But in all other respects, the way you manage the folders in the Folders panel is exactly the same as the way you would manage folders at the system level or when using a browser type program. When working with the Folders panel, you can rename folders, change the hierarchy order, move files and folders from one location to another (**Figure 2.15**), and delete files or folders. Whatever you do in Lightroom will always be reflected at the system level and vice versa. If you make any changes at the system level, such as rename a folder, these changes

NOTE

Folder management has come a long way from the early days of the Lightroom beta. But for version 1.0 at least, some caution is advised when using Lightroom to move images from one drive to another. The auto-detection of changes made at the system level isn't as robust as it might be, especially on the PC.

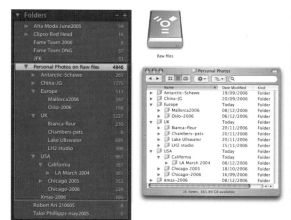

Figure 2.14 *The Folders panel displays the folders of all images that have been imported into Lightroom so far. In the example shown here, a Lightroom library shows where I imported folders from two separate drives. On the left, you can see how the contents of the Personal Photos folder on the "Raw files" drive are all grouped identically in the Folders panel. On the right you can see how the contents of the "Master file HD" drive relate to the contents displayed in the Folders panel.*

will be replicated in Lightroom and the Folders panel will update accordingly (**Figure 2.16**). The benefit of this approach is that you can more easily switch between working in Lightroom and working in a file browser program such as Adobe Bridge.

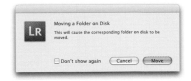

Figure 2.15 *If moving a Folder via Lightroom means moving the files to a new disk location, Lightroom alerts you to this, meaning that the move process may take a little longer to accomplish than expected. There may be a further warning if there is not enough room on the destination drive.*

Figure 2.16 *If for some reason the link is broken between a thumbnail in a folder and its source image, the Folder listing will be highlighted in red and a question mark appears in the top-right corner of the thumbnail. You can restore a link by double-clicking the thumbnail. A navigational dialog opens (revealing the last known location for this particular file) to let you relocate the correct image and restore the link. Do this for one image and all the other files in that folder should relink.*

Image Management by Metadata

Lightroom takes full advantage of the metadata already contained in the image files and the metadata that is added as you import your pictures into Lightroom. It then helps you use this information to make the searching for and grouping of images faster and easier to accomplish. In many respects, the way Lightroom lets you work with your image library is more like iTunes in that it uses the image file metadata for the image organization and management. This process kicks in as soon as you import new images and are offered the chance to enter a new folder name and add custom keywords. These are all vital pieces of metadata information that will help Lightroom keep track of the images in the library.

TOKYO
14 724 KM

AMSTERDAM
9 635 KM

LONDON

SYDNEY
11 642 KM

RIO DE JANEIRO
6 055 KM

NEW DELHI
9 296 KM

NEW YORK
12 541 KM

3 | Managing the Library

What sets Lightroom apart from other image converters is its ability to manage the descriptive content of the image library. While most people are naturally impatient to get their photographs into a program and start editing them, there is much to be said for keeping your images in a well-organized catalog system where they can be retrieved easily at a later date. This chapter discusses the Library module controls and its layout, as well as the library management features in Lightroom.

It is in no way mandatory that you follow all of the advice offered in this chapter, as each person will have his or her own particular image management requirements. You may find that you just want to use the Folders panel to catalog your library images and that is enough to satisfy your needs. But one of the key facts you will learn in this chapter is that the time invested cataloging an image collection can pay huge dividends in the time saved when tracking down those pictures later. The image management tools in Lightroom are far from being a complete asset management solution, but they do offer something for everyone. Some people may find the tools in this initial version of Lightroom insufficient. But even so, the data you input via Lightroom is fully accessible in other more advanced image asset management programs.

The Library Module Panels

When the Library module is selected, the image library contents are displayed in the content area using either the Grid view, which gives you an overview of multiple images, or Loupe view, which shows a magnified view of single images, or the Compare view, where all the images in a current selection are shown in the content area. The Library controls are split between the left and right panels (**Figure 3.1**). The Library panel provides you with a fast way to view the contents of the entire library, a Quick Collection of images, or the Previous Import of recently acquired images. The Find panel looks simple enough, but it offers powerful search capabilities for finding specific images and narrowing down selections by name or by date in the content area as well as filtering the number of lists shown in the Folders, Collections, and Keyword Tags panels.

The Folders panel lists all the imported folders in the library by name in alphabetical order. The Folders panel only displays the folders of those images that have been explicitly imported or referenced to Lightroom. After images have been imported, you can edit the folder names, add new folders, and move images from one folder to another. You can also use the Folders panel to search and select specific folder collections, but as you will see, this is not your sole means of navigation. There can only be one physical copy of each image in the library, and a library image can only ever exist in one folder (or else it's unclassified). The Collections panel allows you to create a group of images from the library and save it as a named collection. However, an individual image can exist in any number of collections. You can also make Quick Collections by pressing the B key to mark favorite images. These can then be viewed by selecting Quick Collection in the Library panel. The Metadata Browser panel lets you filter images by metadata that is usually automatically embedded at the time of shooting, such as the camera model, date, file type, and the lens that was used.

The Keyword Tags panel lists all the current keywords in use, which can also be grouped into categories. Keywords are applied to images by dragging and dropping keywords onto selections in the content area, dragging images onto keywords, or by making a selection and adding keywords via the Keywording panel on the right. Other metadata information, such as the camera's EXIF data, can be viewed via the Metadata panel, which offers several data list view options. You use this panel to add custom IPTC data such as the title, caption, and copyright tag.

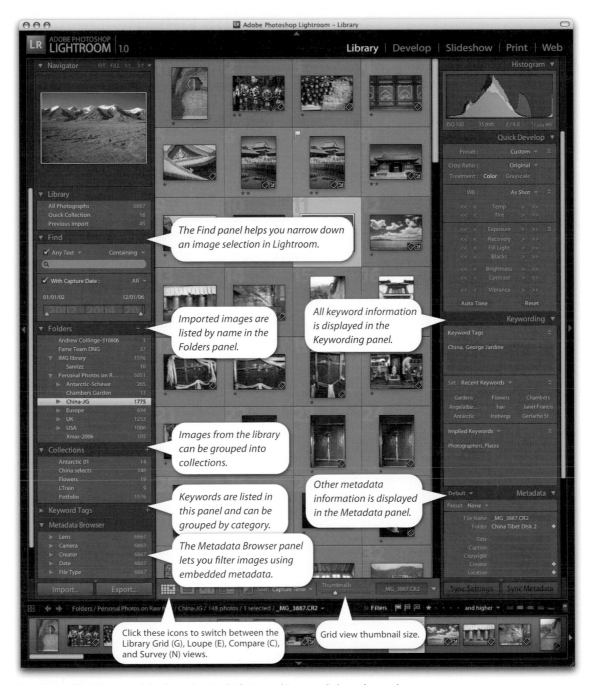

The Find panel helps you narrow down an image selection in Lightroom.

Imported images are listed by name in the Folders panel.

All keyword information is displayed in the Keywording panel.

Images from the library can be grouped into collections.

Keywords are listed in this panel and can be grouped by category.

Other metadata information is displayed in the Metadata panel.

The Metadata Browser panel lets you filter images using embedded metadata.

Click these icons to switch between the Library Grid (G), Loupe (E), Compare (C), and Survey (N) views.

Grid view thumbnail size.

Figure 3.1 *The Library module; shown here in Grid view and its expanded panel controls.*

Working with the Library

After you have imported your images into Lightroom you will want to browse through them and decide which ones you want to reject and which ones you want to keep, and which ones to apply ratings and labels to distinguish which ones are your favorites. But before discussing how to do that, let's focus on the image collection and folders.

Since the very early days of managing documents on a computer, it has been common practice to organize files by placing them in separate system folders. This worked well enough when photographers were scanning in just a few images at a time and slowly building an image archive. But these days, photographers are typically capturing hundreds of new images every day. A folder system of management can work well enough for the person who is organizing the hierarchy of folders, but therein lies the weakness of such a system. As an image collection grows in size, you have to be extremely careful about how you plan your organization so you know where all your files are when you need them. Suppose you were to fall ill and someone, such as a coworker needed to locate a specific image. How easy would it be for him or her to find that image on your computer? In such situations, what is required is a cataloging system that can manage your images and keep track of where they are all stored. Several programs are available that can do this, the most noted being iView Media Pro, now owned by Microsoft. Lightroom does not have the full functionality of iView, but it does offer a reliable method of cataloging your images from the moment they are brought into Lightroom.

Library Toolbar

The basic Library module toolbar contains the Grid, Loupe, Compare, and Survey view buttons and sort order controls (**Figure 3.2**). In addition to this, the toolbar can be customized to display the keyword stamp, rating, flagging, labels, rotation, navigation, slideshow playback, and thumbnail size controls. The Library module toolbar can also be customized to display differently in the Grid and Loupe views.

Figure 3.2 *The top toolbar shows the full range of options for the Library module toolbar. These can be customized by clicking on the toolbar options and selecting the various items from the list shown here.*

Library Panel

In the previous chapter you learned the difference between importing by copy, where images are moved to a new folder location, and importing by reference, where images are referenced in their current location. As you import images into Lightroom, you add more images to the library. As your library collection grows in size, the contents of your library may be distributed over several different drives. Even so, you can access the entire library of images at any time by clicking the All Photographs button. You can also click the Quick Collection button to show the current collection contents or click the Previous Import button to select the most recently imported photos (**Figure 3.3**). Learn more about Quick Collections on page 102.

Folders Panel

The Folders panel in Lightroom is the primary way you'll categorize the images that have been imported into the Lightroom library. The Folders panel provides front-end management for all the folders that make up your library collection. The one rule you have to bear in mind is that there can only be one master version of an image in the Lightroom library. That means you can't make copies of the master image or assign images to more than one folder. After your images have been imported into the Lightroom library, those images can be grouped into folders any way you like. Any changes you make to the folder structure in Lightroom will be reflected at the system level as well. The system files and folders will always correspond with the heirarchy of the Folders panel in Lightroom. Similarly, as you move folders around or rename them at the system level, these changes will always be recognized and updated in the Lightroom Folders panel. **Figure 3.4** shows how I grouped the folders that contained photographs shot in various locations and organized these into parent folders such as Europe, UK, and USA. This structure can make it easier for you to locate specific images when navigating the library via the Folders panel. In this example, note that the Personal Photos folder contains a total of 10,647 images. Within that folder is a Europe folder containing 674 images, and within that folder is a Mallorca2006 folder containing 347 images. As well as rearranging the hierarchy of folders, you can freely move images from one folder to another. Next, I show you how to add new folders to the Folders panel, how the folders structure can be improved after importing images into Lightroom, and how to reorganize folders into a more streamlined order.

Figure 3.3 *The Library panel allows you to select All Photographs, a current Quick Collection, or just the most recently imported images from the Previous Import. All Photographs shows two numbers: the number of visible images followed by the total number of images in the library.*

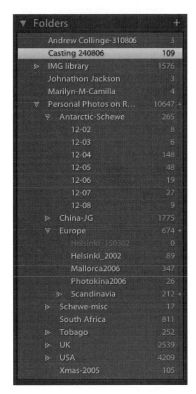

Figure 3.4 *The folders listed in the Folders panel are like system folders and are used to categorize the contents of the Lightroom library. If a folder name is colored red, it indicates there are problems with the image links in that folder. The plus sign next to a folder name indicates that some of the images in a folder are for one reason or another, hidden.*

Creating a new folder

You can change the name of a folder by double-clicking its name in the Folders panel, and then making selections of images and moving them from one folder to another. Here are the steps required to create a new folder and move images between folders.

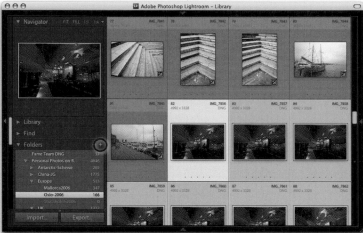

1. To create a new folder, click the plus icon in the Folders panel header (circled). The Create New folder dialog opens. In the example shown here, I made a subselection of images from a folder named *Oslo-2006* and created a new folder called *Stockholm-2006* as a child of the same *Europe* parent folder.

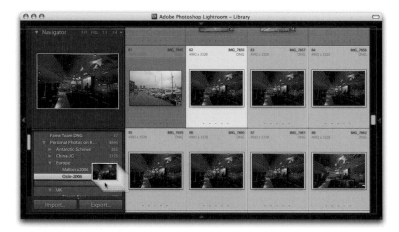

2. After creating the new folder, I dragged the selection of images from the Oslo folder to the new Stockholm folder. A warning appears reminding you that these files will be physically moved in your system.

Lightroom folders and system folders

If you rename a Lightroom folder, its corresponding system folder will be renamed as well. Also, if you apply system level folder changes or use a file browser program to manage the folders, Lightroom will automatically keep track of those changes. However, Lightroom is unable to automatically detect new images that are added to a system-level folder unless that image has been explicitly imported into Lightroom first.

NOTE

For a more detailed explanation of how the Lightroom library works, refer to the Appendix at the back of the book.

1. Here is a view of the Folders panel compared to folders managed at the system level. The *Oslo-2006* and *Stockholm-2006* folders are both stored at the same route level as the empty *Scandinavia* folder.

2. In the Folders panel in Lightroom, I moved the Oslo and Stockholm folders into the Scandinavia folder. Note that the change is mirrored at the system level as well.

Navigating the Library

Now let's focus on the content area and discuss how to navigate your library selections and use the custom interface options.

Grid View Options

As images are imported, low-resolution thumbnails appear in Grid view in the Lightroom window. If you checked the Render Standard-Sized Previews option at the import stage, the initial rendering may take a little longer but you will see better quality previews. If the camera you used to capture the images has camera orientation embedded in the metadata, the thumbnails automatically rotate correctly to portrait or landscape accordingly. Otherwise, you can use the rotate buttons to turn the thumbnails or use the keyboard shortcuts (⌘[) rotate left and ⌘[] rotate right; use the Ctrl key if on a PC).

To open the Library View Options, go to the View menu, select View Options (or press ⌘J [Mac] or Ctrl J [PC]) and choose Grid View. There are two modes for the Library Grid View: Compact Cells and Expanded Cells (**Figures 3.5** and **3.6**). The General view options allow you to select items that are common to both view modes, such as the Quick Collection Markers.

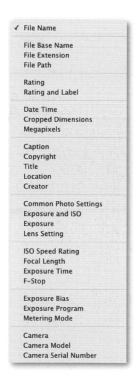

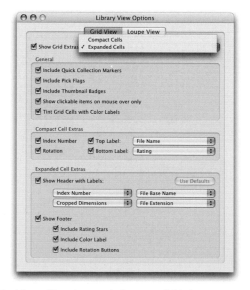

Figure 3.5 *The label options available in Compact Cell Extras in the Library View Options menu.*

Figure 3.6 *The Library View Options dialog is available from the View menu, or you can open this dialog by pressing ⌘J (Mac) or Ctrl J (PC). Shown here are the Grid View options.*

If an image has been added to a Quick Collection, it will be identified in the Grid views with a filled circle in the top-right corner. You can also click inside this circle to toggle between adding or removing an image from a Quick Collection. The Pick Flag icons indicate if an image has been identified as a pick (⚑) or as a reject (⚑); flags are applied in the Library module toolbar. The Thumbnail Badges are the small icons in the bottom-right corner. Three types of icons are displayed. If you double-click the icon with the label tag (◪), it automatically takes you to the Keywording panel in the Library module, where you can start editing or adding to the keywords linked to this particular image. If you double-click the rectangle icon (▦), it takes you to the Develop module with the Crop overlay made active. If you double-click the plus/minus icon (▦), it also takes you directly to the Develop module. It is worth me pointing out a very useful shortcut here. If you Alt–double-click a grid cell, it takes you directly to the Develop module. If you Alt–double-click the Develop module image, it takes you directly back to the Library Grid view. The option "Show clickable items on mouse over only" in the Library View Options dialog refers to the Quick Collection markers and rotation buttons. When this is checked, clickable items will only be revealed as you roll the mouse over a grid cell. When the Tint Grid Cells with Color Labels option is selected, the whole of the shaded cell area is colored.

The Compact Cells view is shown in **Figure 3.7**. This view displays in its Top Label the grid cell Index Number (the large dimmed number in the cell background), plus one custom item from the list shown in Figure 3.5. The Bottom Label can display the cell Rotation buttons plus one more custom item, which by default is set to show the current image rating. The image rating is displayed using stars with 5 stars as the highest rated and no stars checked as the lowest. Although you can assign ratings by clicking the dots in the grid cell area, the more common way to assign ratings is by entering numbers or using square bracket keys on the keyboard.

The Expanded Cells view is shown in **Figure 3.8** is the default view when you first install Lightroom. A single Show Header with Labels check box is provided for turning the header display options on or off in the Expanded Cell Extras section. Notice that unlike Compact Cells there is room for two rows of information that you can customize using criteria from the four pull-down menus shown in Figure 3.5. You can add items to the footer by checking rotation, rating, and color options. That concludes all the customizable options for the grid cells, but note that pressing ⌘⇧Shift H (Mac) or Ctrl ⇧Shift H (PC) toggles between showing and hiding all the items in the grid cells.

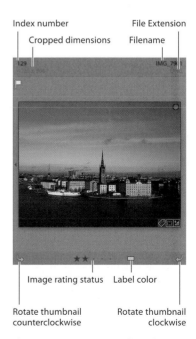

This is a "flagged pick" image

A filled circle indicates the image has been added to a Quick Collection

Filename

Index number

IMG_7901.DNG

Image rating status

Figure 3.7 *Here is an enlarged view of a Library grid cell in Compact Cells mode.*

Index number File Extension

Cropped dimensions Filename

129 IMG_79

Image rating status Label color

Rotate thumbnail Rotate thumbnail
counterclockwise clockwise

Figure 3.8 *Here is an enlarged view of a Library grid cell in the Expanded Cells view.*

Library Grid Navigation

The Grid view is the main interface for image browsing (**Figure 3.9**). You can make the thumbnail size bigger or smaller by dragging the Thumbnails slider at the bottom. You can navigate through the thumbnail images by clicking an individual grid cell or by using the arrow keys on the keyboard to progress through the images. As explained in Chapter 1, "Introducing Adobe Photoshop Lightroom," the Library Grid is displayed in the main content area, and the side panels can be hidden by double-clicking a panel's inner edges or just clicking the side bar arrows, which will collapse the panels to the edge of the screen. Panels then are revealed by rolling the mouse cursor towards either side of the screen, or locked in place by clicking the side bar arrow. An even easier way to manage the Library Grid view is to use the Tab key, which toggles displaying the content area with both side panels in view and enlarging the content area to fill the width of the screen completely.

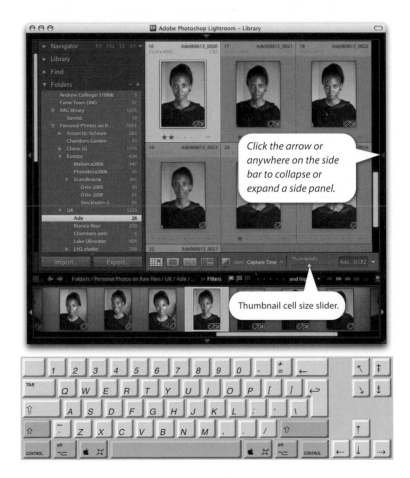

Click the arrow or anywhere on the side bar to collapse or expand a side panel.

Thumbnail cell size slider.

Figure 3.9 *The library contents displayed in Grid view. Note how the content area image selection, showing all the images in the Ade folder, is also duplicated in the Filmstrip below. You can navigate the grid either by clicking on an image in the grid or Filmstrip, or by using the highlighted arrow keys on the keyboard shown beneath (the main image) to move from one image to the next. The Home and End keys can be used to jump to the first or last image in the grid, and you can also scroll through the grid by using the Page Up and Page Down keys.*

Working in Loupe View

Lightroom has two viewing modes: Standard Loupe view and close-up Loupe view. Standard Loupe view either fits the whole of the image within the content area or fills the content area with the narrowest dimension—Fit or Fill (**Figure 3.10**). Close-up Loupe view can be at 1:1 magnification or a custom view setting such as 2:1. The simplest way to get to the Loupe view is to double-click an image in the grid or Filmstrip. If you have more than one image currently selected, the image you double-click fills the screen. The selected group will still be preserved in the Filmstrip, and you then can use the left and right arrow keys only to navigate through the selected images. If you double-click the Loupe view image, you will return to the Grid view once more. In the accompanying Notes I have listed some of the other keyboard shortcuts you can use for switching views.

NOTE

You can use alternative keyboard shortcuts to navigate between the Grid and Loupe views. Pressing the tilde key (~) allows you to toggle between the Grid and standard Loupe views. The G key always takes you to the Library Grid view from whichever module you are currently in. Likewise, the E key always takes you to the Library module Loupe view. The ⌘+ key combination takes you from Grid to Loupe view and the ⌘− key combination takes you from Loupe back to Grid view.

NOTE

The Library Grid shows the selected image thumbnails surrounded by light gray, and the Filmstrip shows them with a thin white border. Within any selection there will always be a primary, or most selected image (this will be the image displayed in the Navigator and content area). In the grid or Filmstrip, the primary selected image is the one shaded a slightly lighter gray than all the other selected thumbnail cells.

A selection is a temporary collection of images, and selections can be used in many different ways. For example, you might want to make a selection and apply a rating to all the selected images at once. Or you might want to select a group of images in order to synchronize the Develop settings. In which case you would synchronize the settings to whichever is the most selected image.

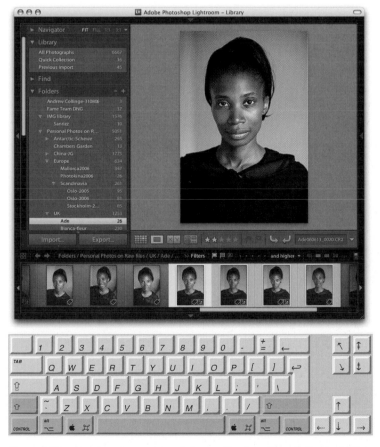

Figure 3.10 *Here is an image shown in Loupe view. An active selection is visible in the Filmstrip, where you should use the left/right arrow keys to navigate a selection.*

Loupe view options

The Loupe View options within the Library View Options let you customize what is displayed when you switch to the Loupe view. In **Figure 3.11**, I customized the Loupe View options for Loupe Info 1 to overlay the image with the File Name, the Date Time, and Cropped Dimensions. This appears briefly when an image is first displayed in the Loupe view (**Figure 3.12**).

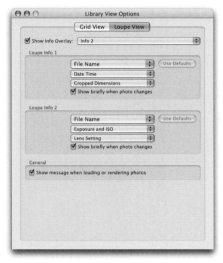

Figure 3.11 *Two Loupe Info settings are available for you to configure in the Library View Options dialog.*

Figure 3.12 *Here is how the information is displayed for Loupe Info 1 when you view images with the Show Info Overlay option selected. If the "Show Briefly when photo changes" option is selected, the Info fades out after a few seconds.*

Loupe view navigation

From the standard Loupe view you can magnify the image preview in a number of ways. A further click zooms the Loupe view preview to a 1:1 magnification, centered on the mouse. Another click takes you back to the previous Loupe view. So if you click on the preview in Figure 3.12, near the left eye, you will see the zoom preview shown below in **Figure 3.13**.

At this stage you can scroll the image by clicking and holding anywhere in the preview area then dragging. In the top-left corner of the Library module is the Navigator, which offers you an alternative way to navigate your images. In the magnified view shown in Figure 3.13. The rectangle in the Navigator represents the area that is currently visible in the content area, relative to the whole image. You can drag the rectangle to quickly scroll the image with a minimum amount of mouse movement. Assuming you have the navigate arrows (circled) active in the toolbar, you can use them to navigate through the current Filmstrip selection. The Zoom view slider lets you magnify the image even more.

NOTE

When you are in the close-up Loupe view, you can use the Spacebar to toggle between the close-up and standard Loupe views. You can also use the Z key to toggle directly between the grid and close-up Loupe views.

TIP

The close-up Loupe view is very handy for comparing image details. You can navigate from one image to the next in a selection, using the keyboard arrow keys, and inspect the same area of each image in close-up view.

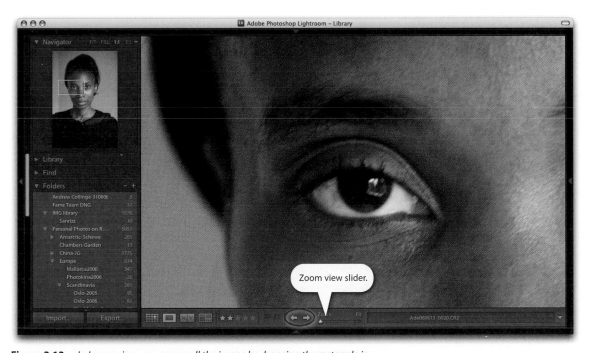

Figure 3.13 *In Loupe view, you can scroll the image by dragging the rectangle in the Navigator, which indicates the area currently being magnified. You can also use the Zoom view slider to quickly adjust the zoom level.*

Figure 3.14 *Here is a view of the Navigator panel, showing all the available custom Zoom view options. These can range from 1:4 (25%) to 8:1 (800%) and all the way up to 11:1. But as in the movie* This Is Spinal Tap, *I suspect the real zoom value here is in fact closer to 10:1.*

NOTE

In the Lightroom Interface preferences, the "Zoom clicked point to center" option provides a subtle difference in zooming behavior. When deselected, zooming in close will fill the screen to best fit the content area. When it is selected, where you click will always be centered on the screen.

Loupe zoom views

As mentioned earlier, there are actually four different Loupe views. They are in order of magnification: Fit view magnifies the standard Loupe view to fill the available content area both horizontally and vertically; Fill view magnifies the standard Loupe view to fill the width of the available content area onscreen, cropping the top and bottom of the picture as necessary; close-up Loupe view offers the standard 1:1 view; another close-up mode offers customizable magnification levels. The Library Navigator displays a zoom view readout in the top-right corner. You can extend the range of the close-up Loupe options by scrolling the readout to select a zoom view from the Navigator fly-out menu (**Figure 3.14**). The combination of the ⌘ key (Mac) or Ctrl key (PC) with the plus or minus keys cycles through all four main zoom views. It's important to understand that the Loupe zoom essentially offers two zoom modes: a standard and a close-up view. Using the Navigator you can set the standard view to be Fit or Fill, and the close-up view can be set to either a 1:1 or one of the custom magnified views. Depending on how these two view modes are configured will establish how Lightroom behaves when you use either a single click or the Spacebar to toggle between view modes.

Working in Survey View

If you have a multiple image selections active, you can switch to viewing all of them at once by clicking the Survey view button in the Library module toolbar. Alternatively, you can switch to Survey view while in any module at any time by using the N key. If you are working with an image in Loupe view and adding an image to the current image selection via the Filmstrip, you will also automatically switch to seeing all of the images in the selection in Survey view. Whenever you are in Survey view, the content area is used to preview the selected images as large as possible within the content area. **Figure 3.15** shows a Survey view of all the images that have been selected via the Filmstrip. (We'll discuss the Filmstrip a bit later in this chapter.) The arrangement and size of the individual previews dynamically adjust according to the number of images selected and the amount of screen real estate available in the content area.

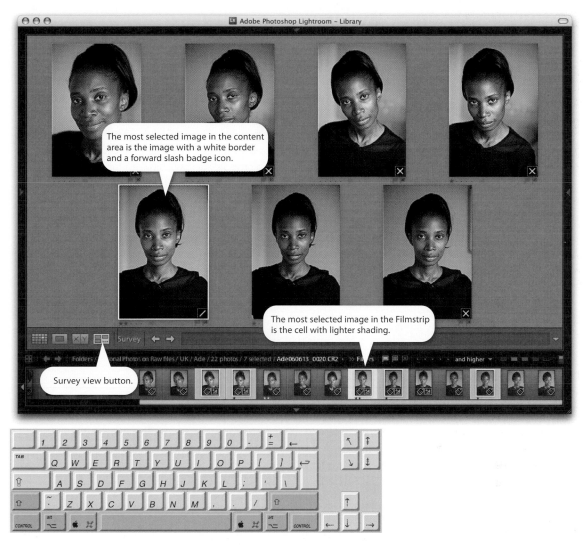

Figure 3.15 *Shown here is an image selection made via the Filmstrip in the Library module Survey view. To navigate through the selected images, use the left and right arrow keys only, as shown highlighted above.*

The primary, or most selected, image is shown with a white border. Navigate through the images displayed in Survey view by click-selecting individual images or by using the left and right arrow keys only. You can remove images from a Survey view selection by ⌘–clicking (Mac) or Ctrl–clicking (PC) images you want to deselect either in the Filmstrip or in the content area. The image previews will automatically resize to make full use of the content area.

Working in Compare View

If you click the Compare option in the toolbar, Lightroom displays the current selected image as the Select image (**Figure 3.16**). In the Filmstrip, the selected image next to it is a Candidate image. With this setup, the Select image will remain locked. You can use the keyboard arrow keys to navigate through the remaining images in the selection to change the Candidate image view and compare different Candidate images with the current Select. A white border indicates which image is active, and you can use the Zoom view slider to adjust the Zoom setting for either image. When the zoom lock is switched on, you can lock the level of magnification and synchronize the zoom and scrolling across both image views. When you have decided which image is the favorite Select, click the Done button to display the current Select image in the Loupe view.

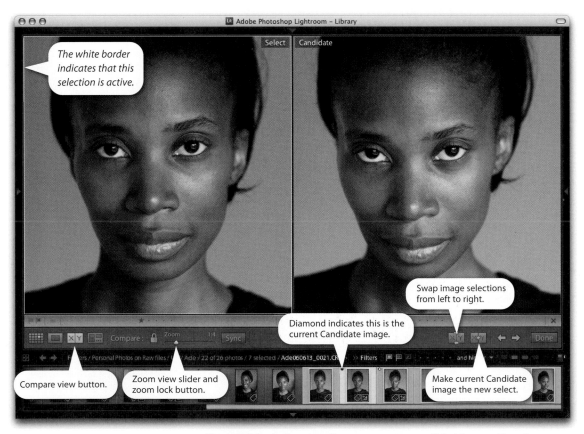

Figure 3.16 *In Compare view you can compare a Select image with various Candidates. You can use the left and right arrow keys to navigate through alternative shots in the Filmstrip.*

Working with the Filmstrip

Located at the bottom of the screen, the Filmstrip provides a secondary view of the library contents (**Figure 3.18**) and is always accessible as you move between modules in Lightroom. The Filmstrip therefore offers a constant link between the images that are selected in the current Library view and when working in the other Lightroom modules. As with the Library Grid, it allows you to select images to work on. Drag and drop editing is possible via the Filmstrip, and any drag and drop changes you make will also be reflected in the Library Grid. Custom sort order changes such as this are remembered whenever you save a selection of images as a collection.

The Filmstrip allows you to navigate through your images just as you do in the Library Grid view. For example, you can press the left or right arrow keys to progress through the folder thumbnails one at a time or hold down an arrow key to speed navigation through the thumbnails and see the Loupe preview update as you do so. Or, you can drag the Filmstrip's slider bar to scroll more quickly.

You don't get to see the same amount of extra information in the Filmstrip as is displayed in Grid view, although in the Lightroom interface preferences is a "Show ratings and picks in filmstrip" option that allows you to make these two items appear at the bottom of the thumbnail cells in the Filmstrip.

Figure 3.17 *In the Lightroom Interface preferences section there is a Tweaks section at the bottom where you can choose to display ratings and picks in the filmstrip thumbnail cells.*

Figure 3.18 *The Filmstrip sits at the bottom of the Lightroom interface screen and is present in all the Lightroom modules. The Go Back/Go Forward buttons let you skip between the current and the previous Lightroom views.*

TIP

You can assign ratings to batches of images by making a selection in the grid or Filmstrip and then assigning a rating either with the keyboard shortcuts or by going to the Photo menu and checking Set Rating, followed by the rating value. Using the keyboard shortcuts will always be much quicker.

Another way to rate your images is to click the empty dots in the cell grid just below the thumbnail. But I don't recommend you do this because it can be a really fiddly operation, especially when using a large monitor display with a fine-pitch screen resolution.

TIP

Clicking on a rating dot resets the image rating to zero. So if an image has a two star rating and you click the second star, the rating resets to zero. You can also adjust the ratings by clicking a star and dragging with the mouse.

Refining Image Selections

Rating Images

Your next step in managing your images is to decide which photographs you like best by assigning a rating to each image. Image ratings are normally used to progressively mark the pictures you like best from a shoot. In the days when I shot film I used a pen to mark the shots worth keeping with a cross and the ones I liked best with two crosses. These same editing principles can be applied when using the rating system in Lightroom to edit images from a shoot. The most effective way to rate your images is to use the keyboard numbers 0 through 5 to assign a specific rating, or you can use the right square bracket key] to increase the rating or the left square bracket key [to decrease the rating of an image (**Figure 3.19**).

Figure 3.19 *Here I am in the process of rating a collection of images. The most convenient way to rate images is to navigate with the keyboard arrow keys and use the 0–5 keys to apply number ratings (use* Shift *+ number to apply a rating and move to the next photo), or use the] to increase the image rating or the [to lower the image rating. Pressing 0, of course, doesn't create a star but rather resets the rating to zero.*

The rating system allows you to quickly filter a selection of images. In **Figure 3.20**, after making a first pass rating selection, I used the Filter rating control in the toolbar to display in the content area only those images with a one star rating or higher. With Lightroom you have the potential to rate your images on a scale from 0–5. I suggest you use a zero rating for images that have yet to be rated or are unsuitable for further consideration and use a one star rating for pictures that are not obvious rejects. During a second pass I use a two star rating to mark the favorite images that are candidates for final selection. I may later use three stars to mark the final choice images, but I prefer not to assign higher star ratings too freely because this leaves me some extra headroom to assign higher ratings later to distinguish which shots have a higher importance. At this point in time, I have a fairly large library of images that will surely grow over the next 10–20 years. I want to be careful as to how I allocate my four or five star ratings. These ratings should be reserved to mark the portfolio master shots only.

Figure 3.20 *After applying all your ratings to the images, you can use the Filter Rating controls in the Filmstrip to narrow down the selection to display the rated images only.*

Filtering images via the Filmstrip

A Lightroom image library can be thought of as having a pyramid-type structure in which the zero-rated images are the most numerous, fewer images have a one star rating, and even fewer images have a five star rating (**Figure 3.21**). Meanwhile, library image searches can be filtered by selecting Folders or Keywords via their respective panels, or by using the Library Filters panel to search by both, entering a specific term in the search field. When you filter by folder, filter by collections, or by metadata in combination with a ratings filter, you can quickly narrow down a selection of images from any library to find the specific pictures you want.

Figure 3.21 *An illustration showing the library contents classified into a pyramid shape structure.*

I will discuss filtering by metadata a little later, but for now let's look at the Filmstrip top panel in more detail, and in particular, consider how you can use the Filmstrip controls to filter out images according to their rating, pick status, and label color (**Figure 3.22**). The Folders section displays the current folder path directory. Click the triangle at the end and a list of recently visited folders appears, allowing you to quickly select a folder or collection. The Filters section can be expanded or collapsed by clicking the chevron icon just to the left of the word "Filters." The Filter section contains the "Filter based on flag status"

selectors, which can filter by showing "all Picked images only," "all unflagged images only," or "all rejected images only" (click these flag icons again to undo these selections). To use "Filter based on rating," click on a star rating to filter the images and choose from one of the options shown in the drop-down menu: to display images of the same rating and higher, or lower, or that rating only. To use "Filter based on color label," click on a color label to filter the images accordingly. These buttons work independently: Click the red button to display all red label images. Then click the yellow button to add yellow label images; click the red button again to remove the red label images from the filter selection.

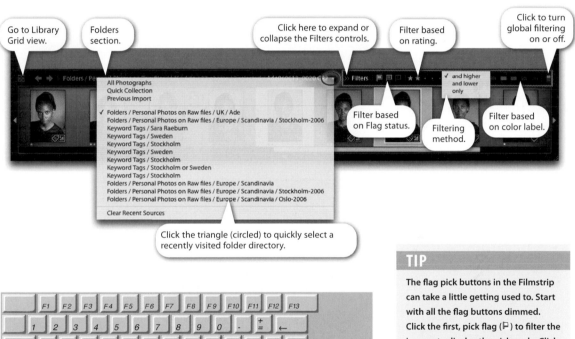

Go to Library Grid view.

Folders section.

Click here to expand or collapse the Filters controls.

Filter based on rating.

Click to turn global filtering on or off.

Filter based on Flag status.

Filtering method.

Filter based on color label.

Click the triangle (circled) to quickly select a recently visited folder directory.

Figure 3.22 *The Filmstrip controls. You can toggle between hiding/showing the Filmstrip by clicking the arrow at the bottom of the interface or by using the F6 function key. You can navigate through the images in the Filmstrip by using the left/ right arrow keys.*

Flagging Picks and Rejects

The flag controls on the toolbar provide a simple method for marking favorite and rejected photographs (**Figure 3.23**). You can then use the Filters controls in the FIlmstrip to narrow down the display of your flagged selections.

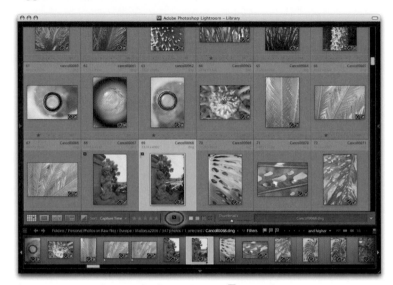

Figure 3.23 *Use the reject flag button (or press X) to mark an image as a reject. Click the middle flag option in the Filmstrip to hide the rejects and show the picks and undecideds.*

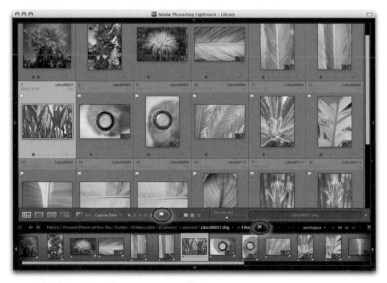

Figure 3.24 *Use the flag pick (or press P) to mark your favorite images. Here I clicked the filter flag picks only button to see my favorites.*

Working with Color Labels

Ratings and picks are used to mark images as rejects, keepers, or favorite shots. Color labels, on the other hand, can be used to separate images into different groupings (**Figures 3.25** and **3.26**). Whereas ratings indicate how much you like or don't like an image, color labels can provide an overlapping means for classifying images into categories that have nothing to do with how much you rate an individual image. For example, on a wedding shoot you could use red labels to classify photos of the bride and groom, yellow labels for all the family group shots, and green labels for the informal reportage style photographs. Peter Krogh, in *The DAM Book: Digital Asset Management for Photographers* (O'Reilly), describes how he uses color labels to assign negative ratings to his images. He uses red to mark images that have yet to be rated, yellow to mark the outtakes (which even though they won't be used, he doesn't want to delete them yet), and the green label to mark images that definitely need to be trashed. Then he uses the blue and purple labels for making ad hoc temporary selections, such as when making a shortlist of candidate shots to send to a client. Color labels can be assigned by clicking a color label button on the toolbar, or you can use keyboard numbers to quickly assign labels as follows: red (6), yellow (7), green (8), blue (9). No keyboard shortcut is available for purple.

NOTE

If you use color labels in Bridge to classify your photos, the color label settings are preserved when you import them into Lightroom or modify a Lightroom imported image via Bridge. However, this assumes that the Bridge labelling system matches Lightroom. If not, you may need to customize Bridge 2.0 preferences.

TIP

Color labels can be assigned via the Photo menu by choosing Set Color Label, followed by the label color. You can even type in a color label by name in the Color Label field of the Metadata panel. A simpler way is to click a color label on the toolbar or use the keyboard numbers to quickly assign labels.

Figure 3.25 *If you go to the Metadata menu and choose: Color Label Set ⇨ Edit, you can create and save your own custom interpretations of what the label colors mean or refer to. Start by using the Review Status set that comes with the program.*

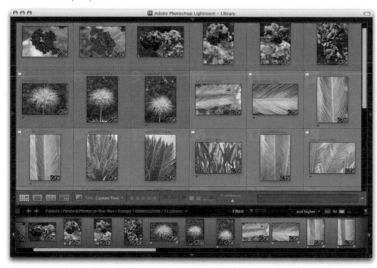

Figure 3.26 *In this example I made a selection of flower images from a folder and clicked the red label button on the toolbar to label these red. Next, I made a selection of leaf images and clicked the green label button on the toolbar to label these green. Then I clicked the red and green filter buttons in the Filmstrip to filter out these red and green label images only.*

Figure 3.27 *The Photo ➪ Stacking submenu, which can also be accessed via the contextual menu. Right-click in the content area and navigate to Stacking in the menu list.*

Figure 3.28 *The Auto-Stack by Capture Time dialog.*

Grouping Images into Stacks

Lightroom lets you group images into stacks, just as photographers used to group slides on a lightbox into piles of related photographs. You can do this manually by selecting a group of images from the grid or Filmstrip and choosing Photo ➪ Stacking ➪ Group into Stack or press ⌘G (Mac) or Ctrl G (PC). From there you can press S to Collapse Stack so that all the stacked images are represented by a single thumbnail cell. Press S again to expand the stack. Note that the number of images in a stack is indicated by the number in the upper-left corner of the cell. If you need to unstack the stacked images, choose Photo ➪ Stacking ➪ Unstack or press ⌘⇧Shift G (Mac) or Ctrl ⇧Shift G (PC).

But enough of all these Photo menu instructions. The easiest way to access the Stacking submenu is to use the contextual menu: Right-click in the content area to quickly access all the submenu items (**Figure 3.27**). If you want to remove an image or selection of images from a stack, select the image or images first and then use the contextual menu to choose Remove from Stack. Similarly, you can use this menu and choose Collapse All Stacks or Expand All Stacks.

Whenever you choose Photo ➪ Create Virtual Copy, the virtual copy (or proxy) image will automatically be grouped in a stack with the master image. (Virtual Copy is discussed in Chapter 4.) Also, when you choose Photo ➪ Edit in Photoshop, there is a preference for stacking the edit copy photo with the original.

You can also choose which photo best represents the images in a stack. If you are using stacks to group a series of related photos, it may be that the first image you shot in a sequence is not necessarily the best picture to use to represent all the other pictures in the stacked group. You can expand the stack and select the photograph you like most in the series and press ⇧Shift [to move the image up the stacking order. Note that the ⇧Shift] command moves an image down the stacking order. Or to make things simpler, select the image you want to have represent all the images in the stack and choose the Move to Top of Stack command (⇧Shift S).

My favorite feature in the Stacking menu is the Auto-Stack by Capture Time item (**Figure 3.28**). This allows you to automatically group a whole folder of images into stacks based on the embedded capture date and time metadata. In the example shown on the page opposite, I used the Auto-Stack feature to automatically group a series of photographs into stacks.

1. Here is a Library view of a folder of images I want to group together automatically. I right-clicked in the content area and chose Auto-Stack by Capture Time. I then adjusted the Time Between Stacks slider to group all images that were shot within a minute of each other.

2. Now the images in the content area are stacked, but all the stacks remain expanded. To collapse a stack you can click the badge icon in the top left-corner, which also indicates how many images are in the stack, and click again to expand the stack. You can also right-click and choose Collapse All Stacks to close all stacks.

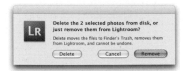

Figure 3.29 *This dialog appears whenever you use the* Delete *command. The default option is to Remove, which simply deletes the link from the Lightroom library database. Click the Delete button if you are sure you want to remove the selected images from Lightroom permanently.*

Removing Images

After completing an image selection edit, you then need to consider what to do with the images that don't make it past a zero rating. Should you keep them or delete them? I prefer not to delete them—you never know when a reject image might still be useful. For example, there have been situations where clients have not agreed with my first round edit choices and have requested to see more shots. There have also been times where I have taken a photograph and not thought too much of it, only to discover later that the picture has a greater significance than I had realized at the time I took it. On client jobs I may shoot a hundred frames or more of each subject. After an initial edit I separate out the zero rated images, export them as DNG files, archive them to disk, and then remove them from the Lightroom library, leaving only the raw files with a one star rating or higher. For all other shoots, such as personal shots where the pictures are more varied, I only delete the obvious outtakes, such as where the flash failed to fire or a picture that is badly out of focus.

If you select an image in the grid or Filmstrip and choose Photo ⇨ Delete Photo (Delete), the dialog appears and offers you three options (**Figure 3.29**). If you click Remove, it simply removes the library link in Lightroom. The file will be removed from the library database, but the original will remain on the computer hard disk. If you click Delete, it physically removes the photo from the Lightroom library and at the system level moves the file to the trash. But even so, this operation does not completely delete the file just yet. To permanently remove files from the hard disk, you need to go to the Max OS X Finder and choose Finder ⇨ Empty Trash (⌘⇧Shift Delete Mac) or choose Empty Recycle bin (PC). You can also click Cancel to cancel out the delete/remove operation.

Deleting the rejects

You can delete just the rejects, too. Go to the Photo menu and choose Delete Rejected Photos. If you choose this command or press ⌘Delete (Mac) or Ctrl Delete (PC), the photos that have been marked as rejects using the Reject Flag command (X) will be marked for deletion. With this single command you can send all your rejected photos directly to the trash, ready to be deleted.

Library Management

With a folder-based organizational system your ability to search for files depends on your ability to memorize the folder structure of the hard drive and know where everything is stored. Anyone who is responsible for maintaining a large image archive knows that this method of file management soon becomes unwieldy. What is needed is a cataloging program that can keep track of everything. Therefore, the trend these days is to use file management by metadata, where you search for a file by searching its attributes rather than trying to remember which folder you last put something in.

As your image library grows you will come to rely on Lightroom's Library module panels such as the Find, Keyword Tags, and Metadata Browser panels to narrow down the selections of images in Lightroom. Some examples have already been provided, such as the use of the Filmstrip Filters to narrow down a selection to show ratings just of one star or higher, or two star images only, and so on. You have also looked at how to use the Folders panel to manage the image library. But the real power of Lightroom is its database engine, which enables you to carry out specific searches and help you find the images you are looking for more quickly.

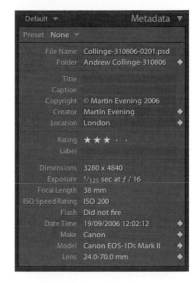

Figure 3.30 *Here is the default view of the Metadata panel information, which shows just the basic file info metadata.*

Working with Metadata

Lightroom is able to search the database quickly by using the metadata information that is linked or embedded in the images. The metadata used in Lightroom falls into several types. Informational metadata, such as the EXIF metadata that tells you things like which camera was used to take a photograph along with other technical information such as the lens settings and image file type. Custom metadata is used to enter information about who shot the photograph, how to contact the creator of the photograph, and the rights usages allowed. Another type of metadata is the custom information you enter to categorize your images (**Figure 3.30**).

As explained earlier, the way Lightroom uses this metadata is fairly similar to the way a program like iTunes categorizes your music collection. For example, when you search for a music track on an MP3 player such as an iPod, instead of searching for tracks by folders, you search for them using the metadata information embedded in the individual music files. In the case of MP3 files, they mostly have the necessary metadata information already embedded when you buy a music track.

TIP

In the Lightroom Interface preferences you can select "Use typographic fractions." When checked, fractions will use proper fraction characters or superscript and subscript characters.

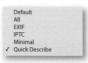

Figure 3.31 *The Metadata panel view options let you select different metadata information display modes.*

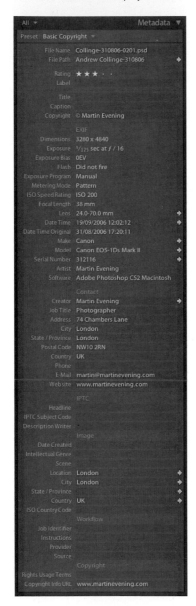

Figure 3.32 *The Metadata panel, showing the All information view.*

You can also use iTunes software to automatically locate the metadata information via an online database.

In the case of Lightroom the catalog information usually has to be added manually by the person who took the photographs. This process requires that you spend your time entering this information. But the trade-off is that the time invested in cataloging your images in the early stages will reap rewards in the time saved when retrieving your files later. In most cases you only need to configure essential metadata once to create a custom metadata template, and then you can specify that Lightroom apply this bulk metadata automatically to a set of imported photos. You can take metadata cataloging further and assign custom metadata information to individual images. It really all depends if this is important for the type of work you do. However, the effort spent manually adding metadata has to be proportional to how useful that information will be later.

Metadata Panel

Let's look at the Metadata panel. Figure 3.30 on the previous page shows the default Metadata panel view, which displays a condensed list of file and camera information. At the top is a Preset menu with the same options as those found on the File Import menu. You can click New to create a custom metadata preset setting (see "Metadata presets"). Below are fields containing basic information about the file such as the File Name and Folder. Note that when you are browsing an image via the library or a filtered selection, if you click on the Folder field or the arrow alongside it, you go directly to a Grid view in the content area.

Below that are the Title, Caption, Copyright, Creator, and Location fields. These fields are editable. When you click in a blank field, you can enter custom metadata directly, such as the image title and copyright information. You then see the image Rating and Label information, followed by basic EXIF data items. This data is informational only and indicates details about things like the file size dimensions, the camera used to take the photograph, camera settings, lens, and so forth.

Click the arrow in the top-left corner to access the Metadata panel view options (**Figure 3.31**). You can then select different metadata panel views, such as the All information view (**Figure 3.32**).

Metadata presets

You certainly don't want to spend too much of your time repetitively entering the same metadata. This is where the metadata presets (which I also like to refer to as templates) are useful, because you can add all at once the metadata information that is (or needs to be) applied on a regular basis. To create a new metadata template, click the Preset panel in the upper left of the Metadata panel and choose Save as New Preset to open the New Metadata Preset dialog (**Figure 3.33**). The Metadata Preset was previously set to None as seen in **Figure 3.34**, so the New Metadata Preset dialog opens with blank fields ready to edit. If you want to edit an existing preset template, select that template first and then select Save as New Preset. You can then save the revised template using the previous name to overwrite the old one or save it using a new name. In the future when you select an image or a group of images, you can click Preset, select the saved template, and apply it to selected images.

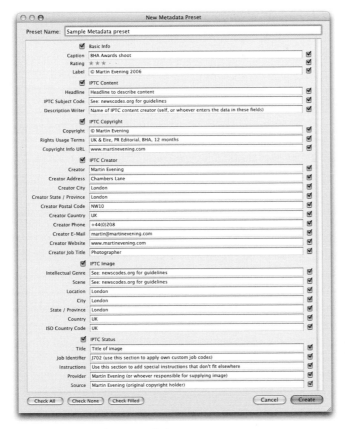

Figure 3.33 *New Metadata Preset dialog.*

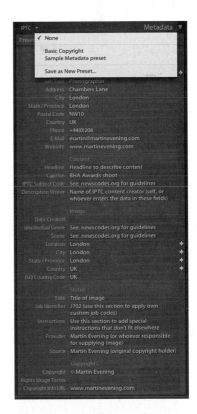

Figure 3.34 *The Metadata Preset menu is accessed via the Metadata panel.*

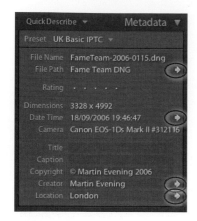

Figure 3.35 *The arrow buttons that appear in the Metadata panel views provide useful quick links. If you click the File Path arrow, you go directly to the system folder containing the current selected image. If you click the Date Time arrow, the Edit Capture Time dialog opens. If you click the Creator arrow, all the library images in the content area will be filtered to reveal all images that share the same creator name. And if you click the Location arrow, you filter out images sharing the same location. In other Metadata panel views, such as the "All" view, you will see many more arrows; these too will act like filters to display images that match the same criteria.*

TIP

For help in understanding how to complete some of the advanced IPTC fields (such as IPTC Subject Code), try visiting the newscodes.org Web site.

Recall that the metadata presets are also available and editable via the Import Photos dialog. You therefore have the choice of applying the metadata items listed in Figure 3.33 at the import stage and as needed via the Metadata panel. The editable items you see listed conform with the latest International Press Telecommunication Council (IPTC) standard file information specifications, used worldwide by the stock library and publishing industries. The items listed in the Metadata Preset dialog are not as comprehensive as those found in Photoshop, Bridge, or iView Media Pro, but they do conform to the IPTC metadata standard. Therefore, the metadata information you input via Lightroom will be recognizable when you export a file and use any of these other programs to inspect it. Conversely, Lightroom is only able to display the metadata information it knows about. It won't be able to display all the data that might have been embedded via Bridge or iView. Should this be a cause for concern? For those who regard this as a shortcoming of Lightroom, it may well prove to be a deal breaker. But for others, the metadata options that are available should be ample.

Figure 3.33 provides some suggestions on how to complete the Basic and IPTC fields. It is not mandatory that all the listed fields be completed, just fill in as many as you find useful. Most of the fields in this panel are fairly self-explanatory. How you complete the main IPTC section will vary from shoot to shoot, although many of the terms will remain the same, such as the Provider, Country, and Rights Usage Terms. The IPTC section allows you to enter information that is specific to the image, such as who provided the photograph. But note the distinction between this and the Description Writer field, which refers to the person who entered the information, and might be a picture library editor, your assistant, or a work colleague. The remaining fields can be used to describe when and where the photograph was shot, job reference (such as a client art order), and so on.

The IPTC creator section normally contains your contact details, and these will most likely remain the same until you move or change your email address. It is a good idea to begin by creating a metadata template that lists your copyright information under Basic Info and completing all the IPTC creator sections (**Figure 3.35**). Save this as a basic metadata preset and apply this template to each set of new images that you import into the library. This way you can ensure that after every new import, all the images carry complete copyright and contact information.

Synchronizing Metadata Settings

You will often want to apply or synchronize the metadata settings from one image to other images in the library. To do this, make a selection of photos and click the Sync Metadata button; the Synchronize Metadata dialog opens (**Figure 3.36**). The button options in this dialog can help you select which items you want to synchronize. You can then click the Synchronize button to synchronize the metadata information in the most selected image with all the others in the selection. You can also select an image and press ⌘ Alt ⇧ Shift C (Mac) or Ctrl Alt ⇧ Shift C (PC) to Copy Metadata settings and then use ⌘ Alt ⇧ Shift V (Mac) or Ctrl Alt ⇧ Shift V (PC) to Paste Metadata settings to another selected image or group of images.

Synchronizing metadata with external programs

It is also important to keep the metadata information synchronized between Lightroom and external programs such as Bridge (**Figure 3.37**). In the File Management preferences is an option to automatically write all changes into the XMP metadata. This will automatically write to the XMP block header in the original file, or in the case of proprietary raw files, write changes to .xmp sidecar files. If you need to explicitly export the metadata, select the Metadata menu and choose XMP ⇨ Export XMP Metadata to File. If changes have been made to a file's metadata outside of Lightroom, you can import the metadata by selecting Metadata ⇨ XMP ⇨ Import XMP Metadata from File.

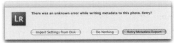

Figure 3.37 *A warning exclamation mark in the top-right corner of a grid cell indicates a mismatch in the associated image file metadata. This is not as serious as it looks. It just means that the metadata has probably been changed or updated by an external program. Click the exclamation mark icon to open the dialog shown below the picture. The question is, do you want to "Retry Metadata Export," which will update with the last used Lightroom metadata settings, or do you want to "Import Settings from Disk," which will update the settings using the externally modified settings information.*

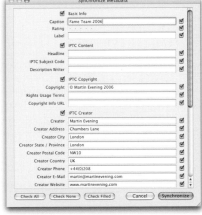

Figure 3.36 *If you make a selection of images and click the Sync Metadata button, the Synchronize Metadata dialog opens.*

Capture Time Editing

If you know that the camera time and date settings are incorrect, you can address this by selecting Metadata ⇨ Edit Capture Time, or by clicking the arrow next to the Date Time item in the Metadata panel (**Figure 3.38**). This allows you to amend the time and date settings for an individual image or a group selection of images. If you are editing the capture time for a selection of images, the dialog preview displays whichever is the most selected image in the sequence and notifies you that the capture times for all the images in the current selection will be adjusted relative to the date and time of this image.

The Edit Capture Time feature is useful for a couple of reasons. One is that the internal clock on your camera may be wrong. Did you forget to set the internal clock correctly when you first bought your camera? If this is the case, you can select the "Adjust to a specific date and time" option and reset the date and time accordingly.

When you travel abroad, do you always remember to set the camera for the correct new time zone? If you select the "Shift by set number of hours (time zone adjust)" option, you can compensate with the time zone differences for date and time entries that would otherwise be correct (unless of course you find it desirable that the dates and times of all your captures are recorded relative to a single time zone).

If you ever need to revert to the original embedded date and time, you can select the "Change to file's creator date" option to reset the original capture date and time setting.

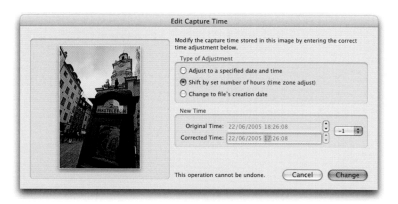

Figure 3.38 *The Edit Capture Time dialog.*

Image-specific Data

Metadata presets provide you with an easy way to automatically add metadata to images in batches and avoid having to repetitively enter the same data. So you might find it useful to create several different metadata templates for the different types of shoots you normally do. Let's say you are a sports photographer and are often required to photograph the home football team whenever the team plays a game at the local stadium. You could save yourself a lot of time by creating a template with the name of the football team plus location information and apply this template every time you photograph a home game.

The metadata presets offer a useful way to batch apply unified sets of metadata either at the import stage or later via the Metadata panel. As you start applying metadata to individual images or small groups of images you gain the ability to differentiate them further to reap the benefits of having a carefully cataloged image database. Applying image-specific terms now helps you later when making targeted image searches. The Metadata panel also allows you to edit individual metadata items. For example, in **Figure 3.39** you can see the Metadata panel in the IPTC view mode, where I clicked the Country field and entered a new country name. You can do this when a single image is selected or batch update a multiple selection of images. You can also use the Headline and Caption fields to add image-specific information. The Headline field might be used to describe a photo shoot, such as *Xmas catalog shoot 2006*, or *White on white fashion shoot*. A caption might be used to provide a brief description of a scene, such as *Crowds lining the streets at local festival parade*. These custom bits of information can be essential when submitting images to a picture library, and are particularly useful when you take into account that the value of an individual photograph can be increased as more information about the photograph is added. But even with a small-scale setup, you may find it rewarding to methodically catalog your photographs with basic metadata information.

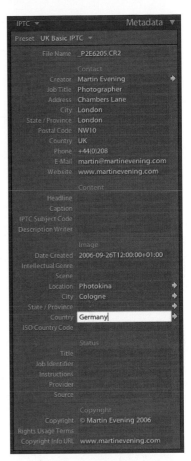

Figure 3.39 *The Metadata panel in IPTC mode.*

TIP

When entering date information in the Metadata panel IPTC section, always enter the date in the following format: MM/DD/YY. The date field will then complete the date information as shown here, including the time zone information.

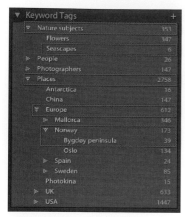

Figure 3.40 *In this example, the Bygdøy peninsula keyword is a subset of Places > Europe > Norway and also appears as Seascapes, a subset of Nature Subjects.*

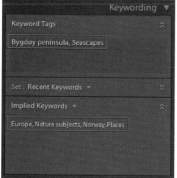

Figure 3.41 *The directly assigned keyword tags appear in the Keywording panel. Note how the implied (parent) keywords are listed below in the Implied Keywords section.*

Keyword Tags and Keywording Panels

The most effective way to categorize your images is to label them with keyword information so you can use the Find panel to search for pictures by typing in specific keyword terms and using the Keyword Tags panel to target specific groups of related images.

You can add keyword metadata via the Import Photos dialog as you import your images or edit the keywords later via the Library module Info panel. **Figure 3.40** shows how I have sorted the keywords in the Keywords panel into a hierarchy, which makes it easier for me to locate specific photographs. Notice how the keywords have been sorted into categories such as *Nature subjects* and *Places.* In the *Places* keyword category is a keyword subcategory called *Europe* and within that *Norway*, and then a subkeyword: *Bygdøy peninsula*. You will find that it pays to establish a proper keyword hierarchy that suits the content of your library, and that the Keyword Tags panel is very useful when searching for specific images. When you click on a keyword category or individual keyword, the content area or Filmstrip displays just those images that match the selected keyword criteria. And because you can assign multiple keywords to associate the image with different criteria, you can cross-reference your images in many ways. To show you what I mean, in **Figure 3.41** you can see one of the images from the grid cell layout that was selected after clicking the *Bygdøy peninsula* keyword. Note that this image also contains the keyword *Seascapes*. So you could search for this image via the Keywords panel using either *Places > Norway > Bygdøy peninsula* or *Nature subjects > Seascapes*.

To start using keyword metadata, you can either add new keywords to the Keywords panel in anticipation of the keywords you will need, add new keywords as you import images into the library, or add and edit keywords via the Info panel. Whichever method you use, once a keyword has been added, it will be listed in the Keyword Tags panel. Then you can arrange the keywords into a suitable hierarchy. Once a keyword is logged into the system, Lightroom auto-completes keywords for you as you start typing in the first few letters for a new keyword entry. Apart from making it quicker to enter new data, this helps you avoid duplicating keyword entries through careless spelling or typos. Lightroom also auto-assigns the correct hierarchy. So if I add the keyword *Seascapes*, the *Seascapes* keyword will be assigned under the *Nature subjects* category in the Keyword Tags panel. The following example shows how this works.

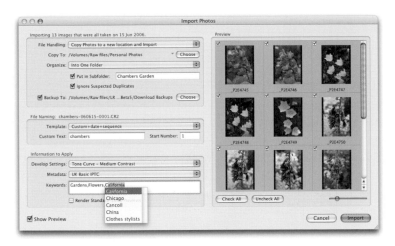

1. In the Import Photos dialog you enter keywords that will be applied as images are imported. Note how Lightroom auto-completes a keyword entry if similar keywords already exist. In this example, I typed in "C" but didn't want California or any of the keywords offered, so I added the keyword "Chambers."

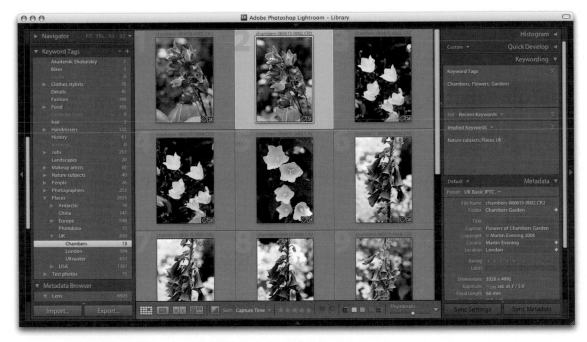

2. After the images have been imported I can search for them by using the Keywords panel. When I click the *Chambers* keyword, I can see the entire Chambers Garden import.

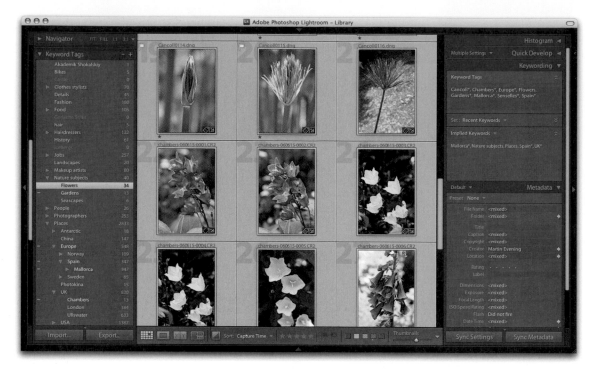

3. But I can also search for the same images using other keyword criteria. Initially, I included the keyword *Flowers*. So when I searched by *Nature subjects > Flowers,* the content area showed the images I had just imported plus any other images that also contain the keyword *Flowers*.

Keyword categories

How you categorize library images is entirely up to you, but if you submit work to an external photo library, you will most likely be given guidelines on the acceptable keywords and categories to use when annotating photographs for submission. These guidelines are normally supplied privately to photographers working directly with the picture agencies. But there are online resources that you can refer to that describe how to use what is known as a "controlled vocabulary," which ensures that the keyword terms used to describe the images conform to prescribed sets of words universally used by others working in the same branch of the industry. When you get into complex keywording (and I do know photographers who assign images with 50 keywords or more), it is important to be methodical and precise about which terms are used and their hierarchy.

TIP

As images are removed from the library and keywords consequently become unused, you can clear them from the Keyword Tags panel by selecting Metadata menu ▷ Purge Unused Keywords. So that you don't remove these keywords accidentally, a warning dialog appears asking you to confirm this action.

Keyword categories can also be used to catalog images in ways that are helpful to your business. For my commercial shoots, it's useful for me to keep a record of who worked on which shot. Some catalog programs let you set up a custom database template with user-defined fields. In Lightroom you can set up keyword categories for the various types of personnel and add the names of individuals as a subset, or child, of the parent keyword category. **Figure 3.42** shows how I created keyword categories for *Clothes stylists*, *Hairdressers,* and *Makeup artists*. Inside those categories I created subcategories of keywords listing the people I work with regularly. Once I have established such a keyword hierarchy, all I have to do is enter the name of one of the people listed and Lightroom auto-completes the keyword metadata entry in addition to correctly placing the keyword within the established hierarchy. This type of organization is also useful for separating library images by job/client names. When the keyword names are in place, you should find it fairly easy to keep your library updated without having to repeatedly type in all the information.

Applying and managing keywords

As you saw earlier, keywords can be applied at the time of import. After images have been imported you can use the Keywording and Keyword Tags panels to manage, edit, and apply keywords to the library images. Let's look at how to work with the Keyword Tags panel. You can add new keywords by clicking the plus icon in the upper-right corner of the panel bar. The Create Keyword Tag dialog opens, where you type in the new keyword you want to add (**Figure 3.43**). If you select a keyword category title first, you have the option of checking a box to create a keyword that is a child of a keyword category. For example, in Figure 3.43 I selected the *Norway* keyword category and then clicked the plus icon to add a new keyword. I then had the option to add the *Bygdøy peninsula* keyword as a child of *Norway*. If you want to delete a keyword, select it and click the minus icon in the panel bar to remove it. You can apply keywords to images in the library Grid view content area in a couple of ways. **Figure 3.44** shows how you can apply a keyword to a selection of images by dragging a keyword to the image selection. The good thing about this method is that it is easy to hit the target as you drag and drop the keyword. The downside is that you have to correctly time your dragging action. If you simply click on a keyword in the Keyword Tags panel, this action might instead filter the content area selection to display the images already associated with this keyword only. To prevent this from happening, you must click and hold

Figure 3.42 *Keywords can be used to categorize the images in ways that are meaningful to your business. In the Keywords panel view shown here you can see how I am able to select images based on the personnel who worked with me on commercial jobs.*

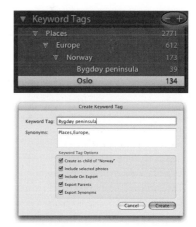

Figure 3.43 *If you click the plus icon, the Create Keyword dialog opens where you can enter a new keyword to be added to the Keyword Tags panel. Click the minus icon to delete keywords.*

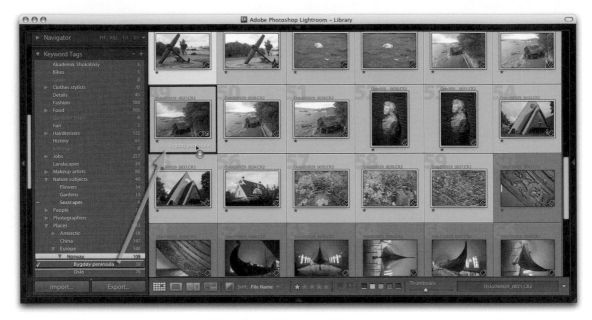

Figure 3.44 *You can apply keywords to an image or selection of images by highlighting the images you want to apply the keyword to and then dragging a keyword from the Keyword Tags panel to the image selection.*

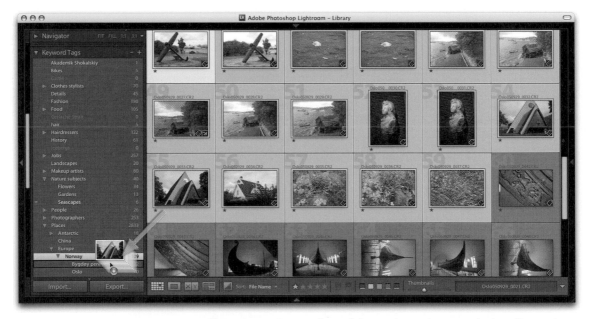

Figure 3.45 *You can also apply keywords to an image or selection of images by highlighting them in the content area and dragging the selection to the relevant keyword in the Keyword Tags panel.*

before dragging the keyword across to the content area. The other option is to make a selection in the content area and drag the selection to the keyword. In **Figure 3.45** I selected the same group of images and dragged the selection to the keyword *Bygdøy peninsula*.

In the right panel, the Keywording panel is located directly above the Metadata panel and provides an overview of all the keywords associated with an image or collection of images. When you click an image, you will see any keywords present listed in this panel, separated by a comma (there should be no spaces). As with the Import Photos dialog, you can add a new keyword by typing it in the Keywords field in the Keywording panel, and Lightroom will attempt to auto-complete entries as you type. If you have multiple images selected, the Keywording panel displays all the keywords that are active in the image selection. Those keywords that are common to all images in the selection are displayed as usual, but those keywords that apply only to a subselection of the images will be marked with an asterisk (**Figure 3.46**). If you have a multiple selection of images and want to unify a particular keyword across all of the images in that selection, simply delete the asterisk to make sure that all the selected images are assigned this keyword. If you want to change a particular keyword, you can highlight it and type in a new word. So if I want to delete the *Seascapes* keyword in Figure 3.46, I could highlight it and then press Delete.

Implied keywords and keyword sets

The Keywording panel lists keywords that have been applied explicitly to images in the Keyword Tags section. But as mentioned, some of the keywords that you enter will already have implicit keywords associated with them. So if I apply the keyword *Bygdøy peninsula*, it automatically includes the implicit keywords: *Places*, *Europe*, and they will appear listed below in the Implied Keywords section. The Keywording panel can also be used to contain sets of keywords. In the Figure 3.46 example, the Set section displays Recent Keywords. By having keyword items listed in a set, you are provided with a quick method of adding commonly used keywords to images in the content area. Select an image or a group of images and click a keyword to apply it to the selection. Or, you can create and edit custom keyword sets (**Figures 3.48**, **3.49**, and **3.50**).

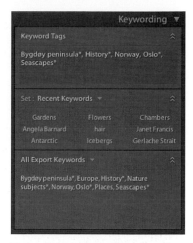

Figure 3.46 *Keywords associated with a single image or group of images are listed in the Library module Keywording panel. In the example shown here, I highlighted all the images from the Norway folder. The keywords marked with an asterisk apply to a subselection of images only.*

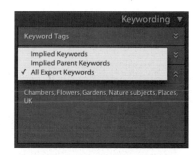

Figure 3.47 *The additional keyword display at the bottom of the Keywording panel can be used to display the implied keywords or used, as shown here, to display all exported keywords.*

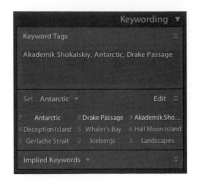

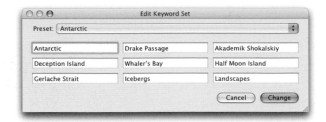

Figure 3.49 *Go to the Set section of the Keywording panel, choose "Custom keyword set," and then click the Edit button. The dialog shown here opens, and you can add existing keywords (or create new ones) that you would use for quick access when keyword editing a particular project. In this case, I created a keyword set that I would use when editing Jeff Schewe's Antarctic trip photographs.*

Figure 3.48 *The Keywording panel shown here displays the custom keyword set created in Figure 3.49. Hold down the* Alt *key to preview the keyboard shortcuts listed in Figure 3.50 for the Set shown here. Use the* Alt *key plus a number to quickly assign a keyword.*

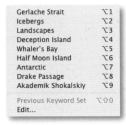

Figure 3.50 *After you create a new custom keyword set, go to the Metadata menu and check out the Keyword Set submenu to see the shortcuts listed for applying keywords (these shortcuts are toggled).*

TIP

All the keywords you currently utilize in Lightroom can be exported by selecting Metadata ➯ Export Keywords. The keywords used are saved as a text file using a tab-delimited format. Similarly, you can choose Metadata ➯ Import Keywords to import keywords into Lightroom from a tab-delimited keyword file.

A tab-delimited file is a plain text file with a tab between each indented level in the text. Tab-delimited files are one way to import and place data that is arranged in a hierarchical format.

Keyword hierarchy

It is important to plan not only your keyword list but also the hierarchy of keywords using a controlled vocabulary of keyword categories. The keyword list can be edited in the Keyword Tags panel by dragging and dropping the keywords in whichever way suits your needs best and at any time you want. It is possible to have several tiers of subcategories. For example, you could organize Place name keywords in the following order: *Places > Country > State > City*. When you are working in the Keywording panel, you can enter new keywords and assign a hierarchy by including a > character after the keyword, followed by a category. So if you wanted to add a new keyword called Elephants as a subcategory of Animals and Nature subjects, you would type *Elephants > Animals > Nature subjects*. When you press ⏎Enter, you will see the *Elephants* keyword appear as a new subset keyword in the Keyword Tags panel and be listed in the Keyword Tags section of the Keywording panel.

Keyword stamping

The Keyword Stamp lets you apply a keyword to one image at a time. You enter a single keyword in the empty field next to the Stamp tool icon, and then click the Keyword Stamp tool to make it active (**Figure 3.51**). It then becomes a floating tool, so you can click on any image to stamp it with the chosen keyword.

You can open the Set Keyword Shortcut dialog by double-clicking the Keyword Stamp tool or by selecting Metadata ⇨ Set Keyword Shortcut. You can also press ⌘ Alt K (Mac) or Ctrl Alt K (PC) to enable the Keyword Stamp tool.

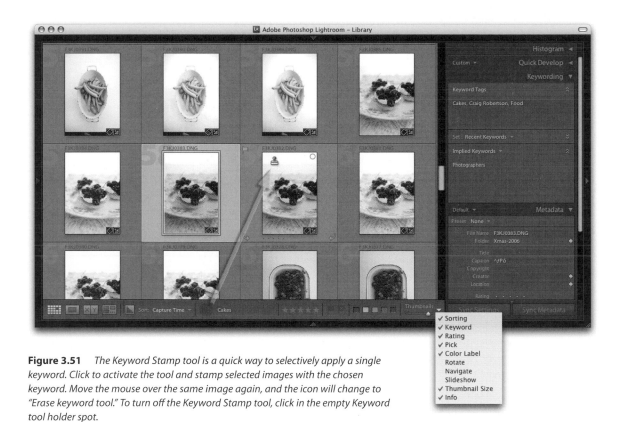

Figure 3.51 *The Keyword Stamp tool is a quick way to selectively apply a single keyword. Click to activate the tool and stamp selected images with the chosen keyword. Move the mouse over the same image again, and the icon will change to "Erase keyword tool." To turn off the Keyword Stamp tool, click in the empty Keyword tool holder spot.*

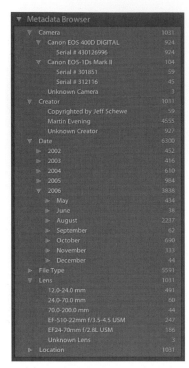

Figure 3.52 *The Metadata Browser panel.*

Metadata Browser Panel

The Metadata Browser panel lets you search by metadata using terms that are automatically embedded in the image files at the time of capture (**Figure 3.52**). Starting at the top of the panel, the Camera section lists photographs by both camera model and serial number. Suppose, for example, you suspected that a fault was developing with one of your camera bodies. Inspecting the images by camera type lets you filter out the images that were shot using that specific camera. The Creator section lists the photographs by the creator of the photograph (with some camera systems you can configure your camera to automatically embed your creator name at the capture stage). When the Date section is expanded, you can explore the library contents by folder date. The year folders expand to reveal months, and the month folders will expand to reveal individual dates (but note that the Find panel also offers more useful calendar date search functionality). The File Type section can be used to separates images, by file format to make it easy for you to quickly filter out images, such as the PSD masters only or just the raw DNG images. The Lens section is great for filtering the library by lens type, which can be really handy when you are searching for say, landscape shots that were taken with an ultra wide-angle lens. The Location section, which is the one section where you should definitely have added the metadata information manually, describes where a photograph was taken.

For some time now, I have been speculating about the possibility of using GPS coordinates to automatically calculate a location address. Global positioning devices are more commonly available these days and can be used to embed GPS coordinates in a capture file. I suspect that it will only be a matter of time before Lightroom has a plug-in to automatically update the Location metadata for you.

Find Panel

So far you have looked at how to catalog a library using folders to group images at the time they are imported. You then looked at how to rate images and separate the keepers from the rejects. And lastly you looked at how to add metadata information including keywords to describe the image content, adding context, meaning, and ultimately more value to the library pictures. Now you need to find your images.

Finding by metadata

You can use any of the panels mentioned so far to individually search for items by name or metadata, but the Find panel allows you to search by metadata and name everywhere at once. When you type in a term in the Find field, Lightroom searches the Folders, Collections, Keyword Tags, and Metadata Browser panels for any terms that match what is typed into the Search field. You can use the Find panel in this way to search the entire library, or just a subset of library images (**Figures 3.53** and **3.54**). Note that when you choose Library ⇨ Find or press ⌘F (Mac) or Ctrl F (PC), you are taken directly to the Search field in the Find panel. You can also choose Library ⇨ Enable Filter or press ⌘L (Mac) or Ctrl L (PC) to turn the enable filter on or off.

Finding by date range

You can also use the Find panel to search more effectively by date range. When the With Capture Date option is checked, you can search for images by date, such as within the last year, a specific year, or last month. Or, you can create a custom date range by clicking on either of the end dates and use the Enter Date Range dialog to set a date range, filtering to the nearest second even, should you need such accuracy (**Figures 3.55** and **3.56**).

Figure 3.53 *Find panel searches can be carried out by searching Any Text (as shown here) or by searching specific library criteria only, such as Filenames or Captions.*

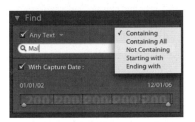

Figure 3.54 *Here is an example of the Find panel being used to search for a term that contains the letter sequence "Mal." You can select the search criteria containing those letters in any part, matching exactly, not containing those letters, or starting with or ending with those letters.*

Figure 3.55 *When the With Capture Date filter is turned on, you can use the date presets listed in Figure 3.56 to help narrow down the calendar date range for searches.*

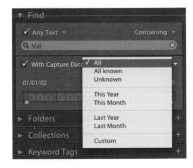

Figure 3.56 *When searching by Capture Date, you can use the Date Presets menu to quickly restrict the date range. This then allows you to use the date range sliders to accurately set the date range parameters.*

Advanced searches

Let's see a more complex search in progress (**Figures 3.57** and **3.58**). I first selected Show Entire Library and then went to the Find panel and typed in the letters *Mal* to initiate a library search for files with "Any Text" containing these three letters. As I started typing in the first few letters, the search started narrowing down the selection of images in the content area to show images where the folder name, collection name, keywords, captions, and so on contained the same letter sequence. In this instance, it short-listed the folders named *Mallorca 2006* and *Washington DC*, because as you will see below, the *Washington DC* folder contained images with the keyword *The Mall*. After an image selection is returned, click the check box next to the search preset (in this case, "Any Text") to toggle between the refined image selection and the original, unfiltered selection.

The Library Find panel in conjunctions with previously added metadata is incredibly useful to help you narrow down your image choices and locate specific pictures. As shown in Figure 3.54 on the previous page, the Find panel can be used to filter the contents of the library by searching for any text that matches or searching by specific criteria, such as matching by keywords only. Figure 3.58 shows how I was able to conduct a more targeted search by selecting the Washington DC folder first and then entering the search criteria *Mal* in the Find panel. Alternatively, I could have made a *Mal* search of the entire library first, and then clicked on the *Washington DC* folder or Keyword Tags item to narrow down a selection in this way.

You can conduct an inverse search by typing an exclamation mark (*!*) before the search term. For example, if I wanted to search for all images that were not shot on location, I would type *!Places* in the Library Filters search field. You can conduct a search for anything that begins with a specific search term by typing (+) at the beginning. So if I typed +*Mal* in the Search field, it would return the folders named *Mallorca 2006* and *Malta 2005* but not the *Washington DC* folder images, because *The Mall* keyword would not be included in this instance. You can also search for images by file extension. If you type in *.TIF*, you can search for TIFF images only. A search for two words separated by a space will return anything that matches those separate terms. Therefore, a search for *Mal Bygdøy* would return anything that included those two terms. In this case such a search would return files that shared the following folders and keywords: *Mallorca 2006*, *The Mall*, and *Bygdøy peninsula*.

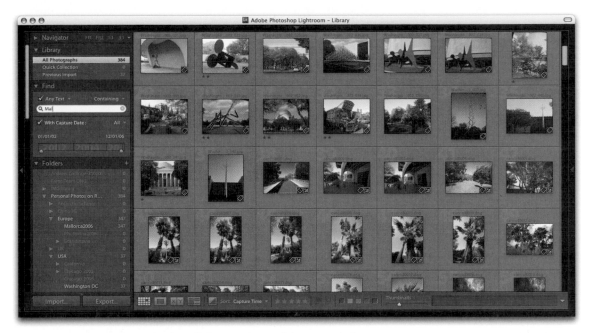

Figure 3.57 *Here are the results of an All Photographs search for images with two star ratings or higher using the term "Mal." This search result includes images shot in Mallorca, and The Mall, Washington DC.*

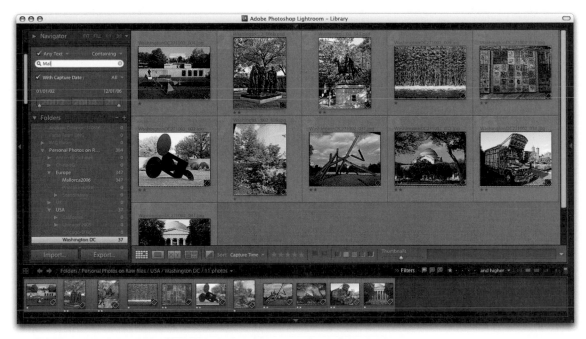

Figure 3.58 *Here are the results of a library search that focuses on the Washington DC folder for images with one star rating or higher where any metadata included the term "Mal."*

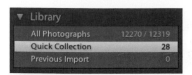

Figure 3.59 *To view a quick collection, click the Quick Collection item in the Photo Library panel.*

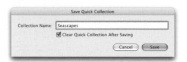

Figure 3.60 *Press ⌘ Alt B (Mac) or Ctrl Alt B (PC) to save a quick collection as a permanent collection to add to the Collections panel.*

Quick Collections

When it comes to combining search results, it is useful to familiarize yourself with Lightroom's collections features. A selection only offers a temporary way of linking images together in a group, and as soon as you deselect a selection or select a different folder in the library, the selection vanishes. Of course, you can still choose Edit �繼 Undo, or use the keyboard shortcut ⌘ Z (Mac) or Ctrl Z (PC) to recover a selection, but the main point is that selections offer only a temporary means of grouping images together. If you want to make a picture selection more lasting, you can convert a selection to a quick collection by choosing Photo ➳ Add to Quick Collection or by pressing the B key. Any images that have been added to a quick collection will be marked with a filled circle in the top-right corner in both the Library Grid and Filmstrip views. Note that you can have only one Quick Collection at a time but that you can make more selections and keep adding fresh images to it. A quick collection is remembered even after you quit Lightroom—no saving or naming necessary—and the images remain grouped until you decide to remove them from a quick collection. The quick collection can be accessed by clicking the Quick Collection item in the Library panel (**Figure 3.59**). You can also choose File ➳ Show Quick Collection or press ⌘ B (Mac) or Ctrl B (PC) to display the quick collection images only and choose File ➳ Return to Previous Content (press ⌘ B or Ctrl B again) to restore the previously selected image selection in the content area (**Figure 3.60**).

Quick collections let you view images from separate folders, group them as a selection, and save that selection while decisions are being made (**Figure 3.61**). Quick collections remain "sticky" for however long you find it useful to save them as such. However, after you have saved a quick collection as a permanent collection (see page 104), it is usually good housekeeping practice to clear the quick collection, which you can do by selecting File ➳ Clear Quick Collection or pressing ⌘ ⇧ Shift B (Mac) or Ctrl ⇧ Shift B (PC).

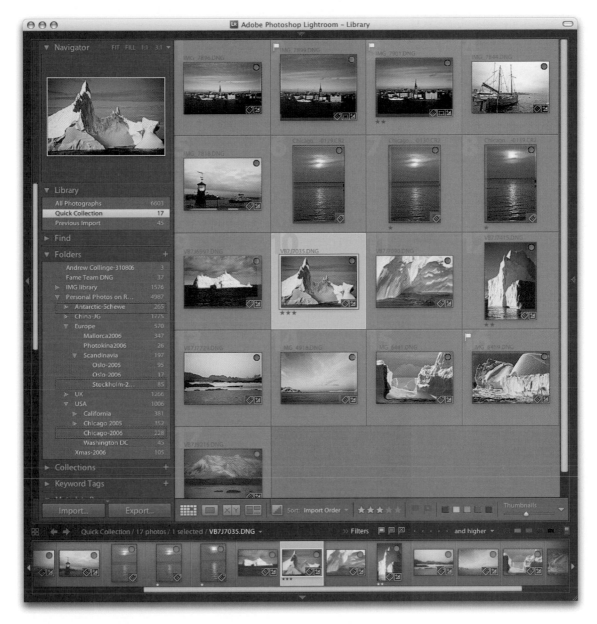

Figure 3.61 *One of the advantages of creating quick collections is that you can create one from images contained in separate folders and then select the quick collection to view an accumulation of all the selected images. In the example shown here, I marked images from the Antarctic, Oslo, Stockholm, and Chicago folders as photos to add to a quick collection. When I clicked on the Quick Collection item in the Library panel, I was able to view the images from these separate folders simultaneously.*

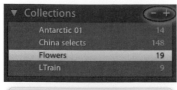

Figure 3.62 *To add a new collection, click the plus icon in the Collections panel. To delete a collection, click the minus icon.*

Collections

A quick collection can be converted into a collection, or you can convert any selection directly into a collection via the Collections panel. Whereas an image in the library can only be assigned to one folder at a time, you can use collections to create multiple instances of the master files. Collections are therefore useful for grouping images together from different folders in ways that are useful or meaningful (**Figure 3.62**). For example, **Figure 3.63** shows a collection I made from filtering images by keywords. Another collection I have is my Portfolio selection. This collection represents favorite master shots that I might want to include in my photography portfolio and contains images added from various shoots that may well change over time as I decide to add or remove certain images. As you conduct various library searches you can keep saving the results as a new collection. For example, in Chapter 5, "Printing," I describe how to use collections to save specific print jobs. Collections can be added to the Collections panel and managed in the same way as you manage the Folders and Keywords panels. Collections can also be placed into subsets by dragging and dropping or by creating a new subdirectory at the time of creation.

Figure 3.63 *To create the collection shown here, I first clicked the Mallorca keyword in the Keywording panel to select all Mallorca pictures. I then searched using Flowers to narrow down the selection to show images of flowers that were shot in Mallorca. I then clicked the Add Collection plus icon. This opened the Create Collection dialog shown in Figure 3.62, where I made a new collection called Mallorca Flowers as a child of the Flowers General collection.*

Sorting Images

You have the option of sorting images in Lightroom by Capture Time, Import Order, Edit Time, Edit Count (for sorting Edit versions of master images in the order they were created), Rating, Pick, Color Labels, File Name, File Extension, File Type, Aspect Ratio, or the User Order. You can always set the sort order by selecting the View menu and highlighting an item in the Sort submenu, but an easier method is to click the Sort menu on the toolbar. Next to the Sort menu is the Sort Direction button, which allows you to quickly toggle between ordering the images in ascending or descending sort order (**Figure 3.64**). For example, if you come back from a shoot with several cards full of images, there is a high probability that the order in which you import the photos may not match the order in which they were shot. If the files are renamed at the time of import, you may want to correct this later by re-sorting the capture files by Capture Time and then reapplying a batch rename by selecting Library ⇨ Rename Photos. The descending sort order can be particularly useful for when you are shooting in tethered mode and you want the most recent images to always appear at the top of the image selection in the content area.

NOTE

The User Order is a transient setting only. If you establish a User Order, the sort order will be remembered. If you switch sort orders and perform any kind of manual drag and drop, the previous manual User Order will be lost.

TIP

If you are viewing a folder, multiple folders, or a collection, you can manually sort the image order by dragging and dropping images either in the grid area or via the Filmstrip. Custom user orders created in this way will be remembered when you save a collection.

Figure 3.64 *The image sort order is by default set to photo Capture Time. This is probably the most useful sort order setting. In the View menu you can choose to sort the images by Import Order or by image Rating. You can also set the sort options directly from within the Lightroom Library module.*

Renaming the Library Images

Images can be renamed at any time after you have imported them into Lightroom. When in the Library module, you can make a selection of images via the grid or Filmstrip by selecting Library ➡ Rename Photos (alternatively, you can use the F2 keyboard shortcut). The Rename Photos dialog shown in **Figure 3.65** appears. You can use the File Naming menu to select (or create) a custom file renaming scheme (**Figures 3.65** and **3.66**).

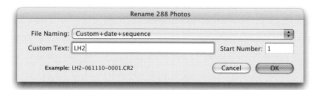

Figure 3.65 *In the Rename Photos dialog shown here, I selected a pre-created custom file renaming scheme from the File Renaming menu, entered custom text that would be utilized during the renaming, and set the Start Number to "1."*

Figure 3.66 *The Text Token Presets Editor dialog is used for creating custom File Naming settings.*

Convert to DNG

The Convert to DNG feature is useful for converting raw files to the DNG format. Although it is possible to convert other file formats such as JPEG to DNG, you will only really want to use this feature for converting actual raw files to DNG, so the Only Convert Raw files option is best left selected. Lightroom also lets you convert your raw files to DNG and Delete originals after successful conversion. Busy photographers will appreciate this feature because it allows you to import your raw files quickly immediately after shooting without having to convert them on import. On a busy studio shoot this can easily save you an hour or more of computer processing time, where time (as we all know) is money. You can then convert the raw files to DNG at a time when it is more convenient to do so, such as after the shoot has finished.

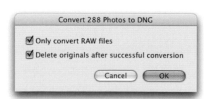

Figure 3.67 *The Convert Photos to DNG dialog.*

Exporting from Lightroom

The Export function lets you export images from Lightroom as finished files, allowing you to export copies of the master images as DNGs, TIFFs, PSDs, or JPEGs. To export files from Lightroom, make a selection and choose File ⇨ Export or press ⌘⇧Shift E (Mac) or Ctrl ⇧Shift E (PC). The Export dialog opens (**Figure 3.68**). Start by selecting a Destination Folder. This folder location will be remembered between exports, so you can easily set up some kind of hot folder on the desktop to regularly send your exports to. You can leave the File Naming section set to *Filename* if you want to retain the current naming, or add a text string such as *_web* if you need to differentiate these images from the original masters. In the File Settings section, images can be exported using the JPEG, PSD, TIFF, or DNG formats. Up to this point, all the library files will have been edited using the Lightroom internal RGB space, but you can now select an output Color Space for the exported files by choosing from sRGB, Adobe RGB (1998), or ProPhoto RGB. If you are choosing pictures to export for photo editing, your choices will boil down to Adobe RGB or ProPhoto RGB. Adobe RGB is a safer general choice, because it more closely preserves the appearance of the pictures as you have been used to seeing them on the screen (compared to sRGB, which may clip some of the colors) and is a widely adopted space for general photo editing work in a program

NOTE

The Export dialog has a Preset option that already contains a few preset export options to help you get started. For instance, To E-mail setting shown in Figure 3.68 puts the exported JPEGs in a folder called To E-mail on the desktop. Other presets include an Export to DNG and Burn Full-Size JPEGs. You can also use this dialog to create and save your own custom export preset settings.

NOTE

When checked, the Add Copyright Watermark option adds a small copyright notice to one of the bottom corners of the exported images (not available when exporting as DNG).

TIP

You can press ⌘ Alt ⇧Shift E (Mac) or Ctrl Alt ⇧Shift E (PC) to bypass the Export dialog by exporting based on the last used settings.

Figure 3.68 *The File ⇨ Export dialog, shown here indicating To E-mail preset.*

such as Photoshop. ProPhoto RGB is in many ways a better choice than Adobe RGB because the color gamut of ProPhoto RGB is a lot larger than Adobe RGB and more or less identical to the gamut of the native Lightroom RGB space. With ProPhoto RGB you can guarantee inclusion of all the colors that were captured in the original raw file, whether your display is able to show them or not. For this reason it is a favorite photo editing space for high-end print work where you want to maximize the color gamut to achieve the best print results. The downside of using ProPhoto RGB is that you must view the files in a color managed application in order to see the colors displayed correctly. If you view a ProPhoto RGB image in a program that does not recognize profiles (such as most Web browsers) or where the color management is switched off, the colors will look terrible. Adobe RGB files won't look so hot either if you don't color manage them, but ProPhoto RGB images will look even worse when they are not color managed! If you are familiar with the basic concepts of color management and are using Photoshop color management switched on, it will be safe for you to export using Adobe RGB or ProPhoto RGB. If any of the preceding information scares or confuses you, you should perhaps stick to using sRGB, and I would also advise choosing sRGB if you are exporting images as JPEGs for Web use, or for client approval, especially if you are unsure of how well the client's systems are color managed, or are preparing pictures to email friends. For the time being at least, sRGB is going to remain the most suitable lowest common denominator space for Web work and general use.

The Bit Depth can be set to 16-bit or 8-bit. One of the reasons so many professionals advocate working in 16-bit is because you can make full use of all the capture levels in an image when applying your basic tonal edits, rather than throw these away by converting to 8-bit and then making the edit adjustments. In Lightroom (and this is true for any raw processor) you are making all your basic edits in 16-bit regardless of how you export them. So at this stage you will already have taken full advantage of all the deep-bit levels data in the original capture. Therefore, choosing 8-bit at this stage is not necessarily such a damaging option to choose. If you think 16-bits will help you preserve more levels as you perform any subsequent editing work or you feel the extra levels are worth preserving, choose 16-bit. Also, when exporting as a JPEG, PSD, or TIFF, you can use the Constrain Size options to set the output size and set the number of pixels per inch or pixels per centimeter for the Resolution. In addition, the Post-processing options let you perform tasks like showing the exported images in the Finder or directly burning the exported files to a disk.

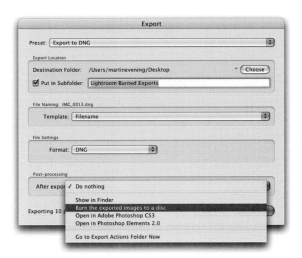

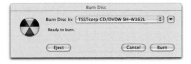

Figure 3.70 *When you choose the "Burn the exported images to disc" option, you can select the device unit that should be used to burn the disc. Then click "Burn."*

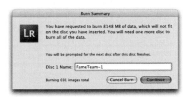

Figure 3.71 *In this Burn Summary dialog I entered the name of the disc to be burned. If there is more data than can fit on a single disc, Lightroom automatically alerts you and sets up the burn to be made to discs in sequence.*

Figure 3.69 *You can configure the Post-processing options in the Export dialog so that Lightroom will automatically burn the results of a normal file export to disc at the end of an export.*

Exporting Library Images to a CD or DVD

If you want to export images to a CD or DVD, you need to do so via the Export dialog. **Figure 3.69** shows the Export dialog configured to export selected images from the library using the Export to DNG preset. This option places the exported photos in a subfolder called "Lightroom Burned Exports." You could use any export setting here, but if you want to export the images and burn them to a disc, you should click the After export menu and choose the option "Burn the exported images to a disc." After you click Export, a folder export is created as before and then the Burn Disc dialog opens (**Figure 3.70**). If you have more than one CD/DVD burning device available, the dialog allows you to select the unit you want to use to burn the disc. Once you have done this, click Burn. You will then see the Burn Summary dialog, where you enter a name for the archive disc you are about to create (**Figure 3.71**). If there is not enough room on the disc to burn all the data, Lightroom informs you of this and enables a multi-disc burn session. In the example shown here, I wanted to archive a total of just over 8 GB of data to disc. But because a single recordable DVD disc can only hold a maximum of 4.3 GB of data, Lightroom will in these circumstances automatically divide the library export into batches of equal size (based on the space available on the first disc you insert to record with) and proceed to burn the data (and verify) to successive discs, appending each disc burn session and incrementing the count number.

4 | Image Processing

One of the most powerful features in Lightroom is the image processing engine and the way the image adjustment processing is deferred until the time you actually export an image from Lightroom. This method of image processing began in the early days of computer imaging. Deferred processing was adopted in the 1990s by programs such as Live Picture and xRes as a means to speed up image editing. Computers were a lot slower back then, yet it was possible to manipulate large image files in real time on relatively slow computers (with as little as 24 MB RAM memory) by deferring the image processing to the end.

These days, you can edit very large images in no time at all in Photoshop. But one of the key advantages provided by Lightroom is the way its deferred processing allows you greater freedom to retouch, adjust the tones, readjust them again, and crop without ever compromising the quality of the final exported image. In a conventional pixel-editing workflow, the pixels are always modified in a consecutive sequence of steps. When you work in Lightroom, you can apply a crop, spot the image to remove a mark, adjust the color, do some more retouching, readjust the crop again, and so on without comprimising the integrity of the master image. No restrictions are placed on the order in which you do things. And the changes you make only apply when you export the image from Lightroom as, say, a TIFF or a JPEG image.

Image Editing in Lightroom

Smarter Image Processing

The Lightroom image processing engine is notable for a number of reasons. Admittedly, there is no support for CMYK color in Lightroom and so for prepress work you always need to use Photoshop to handle the CMYK conversions. But the good news is that there are no color management settings to configure, nor color space issues or profile warnings to worry about. Adobe has made Lightroom simpler to use than Photoshop, and in my opinion, has done so without compromising the quality of color processing in any way. Lightroom uses a single RGB workspace to carry out all its image calculations. The space used is similar to the ProPhoto RGB space that was originally specified by Kodak. It uses the same coordinates as ProPhoto RGB, but has a gamma of 1.0 instead of 1.8. By using a 1.0 gamma, the Lightroom RGB workspace is able to match the native 1.0 gamma of raw camera files, and its wide gamut can therefore contain all the colors that any of today's digital cameras are capable of capturing. For these reasons, the Lightroom RGB workspace is ideally tailored to the task of handling the color processed data from the raw camera files. Concerns about banding in wide gamut color spaces have perhaps been a little overrated, since it is really quite difficult to pull apart an image in ProPhoto RGB to the point where you see gaps appearing between the levels. Suffice it to say, the Lightroom RGB space uses a native bit depth of 16-bits per channel, which means that Lightroom is able to process up to 32,000 levels of tonal information per color channel. Since a typical digital camera is capable of capturing up to 4,000 levels per color channel, it is probably true to say that the Lightroom RGB workspace can safely handle all of the tone and color information from any modern digital camera.

Lightroom does not use layers, but it does recognize and import layered images (providing the Backward compatibility option was switched on when saving the file in Photoshop). If you need to do any kind of layering work, it is quite easy to choose the Edit in External Editor command, carry on processing the image in another program, and save the results back to Lightroom in the form of an edited copy version of the original master image.

A digital image is made up of nothing more than a series of numbers, and during the image editing process those numbers are changed to new numbers. The Lightroom image processing engine ultimately reduces all of its pixel calculations into a single calculation by the most direct route possible to produce a mathematically purer, processed result, in which any image degradation is minimized. Another advantage of the Lightroom image processing engine is that you have the same full access to all of the image controls when working with JPEG, TIFF, and PSD images as you have when working with raw camera files. You can use all of the image controls available in the Lightroom Develop module such as the White Balance, Exposure, and Tone Curve controls to process any imported image. And the Develop controls in Lightroom also now match the controls shared by the Adobe Camera Raw engine in the new Photoshop CS3 program. The Develop settings applied to images using either of these two programs are now fully recognized by and compatible with each other.

Smarter Retouching

Actually, there are some retouching features in the Develop module, such as the Remove Spots tool and Remove Red Eye tools, that you won't find in Adobe Camera Raw. Or rather, you will have to wait until the final shipping version of Photoshop CS3 is released to see if this will be the case in Adobe Camera Raw 4 (ACR). The really unique thing about these tools is that you can apply them nondestructively to any image. You can therefore carry out basic spotting work on an image in Lightroom using the Remove Spots tool in Clone mode or Healing mode, and the retouching work will be saved and stored as editing instructions. This also applies to using the Remove Red Eye tool. Apart from the fact that all retouching work can be undone easily, you have complete freedom to make Develop adjustments in any order you like. It does not matter if you perform the spotting before you adjust the colors and tones, because Lightroom records these actions as editing instructions rather than editing the original pixels.

Steps for Getting Accurate Color

Calibrating the Display

You should make sure that the colors you see on the monitor show as accurately as possible what you are likely to see in print. The color management system in Lightroom requires no configuration. Lightroom automatically manages the colors without you having to worry about profile mismatches, which color space the image is in, or what the default workspace is. There may be problems with missing profiles, but this only applies to imported files where a conscious decision has been made to not color manage an image. Apart from these rare instances, you can rely on Lightroom to manage the colors perfectly from import through to export and print. However, you do need to give important consideration to the monitor display and ensure that it is properly calibrated and profiled before you can rely on using it for any kind of color work. Calibrating and profiling the display is essential, and it does not have to be complicated or expensive. So if you want to get the colors right and want to avoid disappointments, you should regard the following pages as essential reading.

Choosing a Display

The choice of display boils down to Cathode Ray Tube (CRT) or Liquid Crystal Display (LCD). The better CRT displays have mostly been discontinued and are hard to come by now, although there are a few good quality CRT displays such as the Sony Artisan that you may find in use. But apart from that your choices these days are restricted to LCD displays, of which the quality can vary greatly. There are different classes of LCD displays starting with budget-priced models and those on laptop computers, to large-screen professional LCD displays offering a high degree of color accuracy and wide color gamuts, such as the Eizo ColorEdge display. My personal favorites have been the Apple Cinema display series. These days I do most of my color work using an Apple 30-inch screen because I find the large screen area more comfortable to work with, and it is also easy to calibrate and profile. As with all things in life, you get what you pay for. Since the monitor is what you will spend all your time looking at when making critical image adjustments, it is as pointless to cut corners when choosing a display for the computer as it is to scrimp on buying anything but the best lenses for your camera.

Calibrating and Profiling the Display

The only truly effective way to calibrate and profile a display is to use a colorimeter or spectrophotometer. It is possible to buy a good colorimeter along with the necessary software package for under $250. When you consider how much you might be prepared to spend on camera lenses, it really is not worth spending any less than $1,000 on the combination of a good quality display plus calibration package. It is possible to spend a lot more on a professional calibration kit that also allows you to measure color samples and build print profiles. But if all you want to do is to calibrate and profile the display, these devices do not offer any significant advantages over what a basic colorimeter device can do, although some software packages can help you build better profiles using the same basic hardware profiling kit.

There are two stages to the profiling process. The first step is to calibrate the display to optimize the display output (**Figure 4.1**). The second is to measure various color patches on the screen with a calibrator. These calibrated patches are the source from which a profile can be built. On a CRT display there are often buttons or dials that allow you to adjust the brightness and contrast of the monitor and possibly some color controls that will allow you to set different white points and adjust the color output. These can be adjusted during the calibration process so as to optimize the performance and neutralize the display before making the profile measurements. Most LCD displays have only a brightness control that adjusts the luminance of the backlight on the screen and that's it. So when running through the preliminary calibration steps, there is nothing you can adjust, other than the brightness, and you simply skip the steps where you are unable to make any adjustments to the display output.

White Point and Gamma

Apart from asking you to adjust the hardware settings, the calibration software will ask you to choose white point and gamma settings before you proceed to build a profile. If you are using a CRT display, I recommend you always choose a white point of 6500 K. If you are using an LCD display, it is not possible to manually adjust the white point the way you can on a CRT. Although you can set a specific white point for an LCD display, doing so will only compromise the display's performance, so it is usually best to select the native white point for the LCD. Whether you are using a Mac or PC computer, the gamma should ideally be set to 2.2. On the Macintosh, the 1.8 gamma option is only there for quaint historical reasons.

TIP

The performance of your monitor display will fluctuate over time, and therefore it is advisable to update the monitor profile from time to time. CRT monitors should be reprofiled once a week. LCD displays fluctuate a lot less, so you probably only need to re-profile just once every four weeks.

Figure 4.1 *I prefer to use the Gretag Macbeth Eye-One Photo to calibrate the display I use at work.*

Macintosh 1.8 gamma

The Macintosh 1.8 gamma dates back to the very early days of Macintosh computers, long before color displays and ICC color management was universally adopted. Back then, people found that the best way to get an image viewed on a Macintosh screen to match the output of an Apple black-and-white laser printer was to adjust the gamma of the monitor to 1.8. These days, Adobe programs like Photoshop and Lightroom always compensate for whatever monitor gamma is used by the system to ensure that all images are displayed at the correct brightness regardless of the gamma that was selected when calibrating the display. Setting the gamma to 1.8 instead of 2.2 lightens the interface but has absolutely no impact on the lightness of the images displayed in Lightroom. These will always be perceived as being displayed at the same brightness regardless of the monitor gamma. If you are mainly using your computer for image editing work, it is best to use a gamma setting of 2.2, because it means that the image tones you preview in Lightroom are rendered on the screen with a more even distribution.

Matching white balances

People often assume that the goal is to match the white balance between different displays and viewing light sources. For side-by-side comparison this can help, but what people tend to forget is that their eyes are constantly compensating and can accommodate changes in white balance from one light source to another. You can edit an image on a display using a white point of 7000 K and check the results with a viewing box that has a white balance of 5500 K, as long as the two are a short distance apart. In these situations your eyes will adjust to analyze the colors relative to what they perceive to be the whitest white.

Steps to Successful Calibration and Profiling

For accurate calibration you first need to decide whether you want to buy a basic device for calibrating the monitor display only or a more advanced device that allows you to create your own custom print profiles. I use the Gretag Macbeth Eye-One Photo. The following steps show you how the Eye-One Match 3.4 software guides you through the calibration and profiling process with either the Eye-One Photo or the more affordable Eye-One Display2 calibrator. Prior to doing a calibration, make sure the calibrator head and white tile are clean before making any measurements. Also, ensure that the screen surface is clean and free of dust. The following steps walk you through the process.

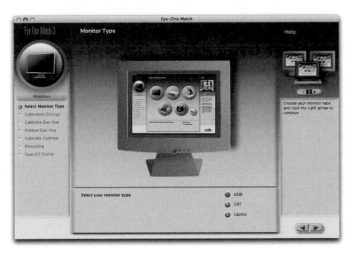

1. This first screen asks you to identify the type of display you want to calibrate and build a profile for. The decision made here affects the recommended settings shown in the next dialog.

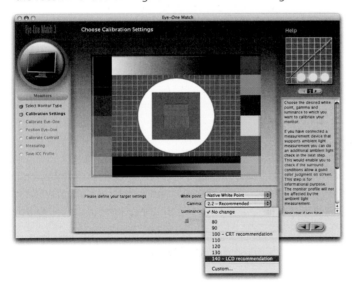

2. In the previous dialog I identified the monitor as an LCD type display and the settings shown here are those recommended for a desktop LCD display. Since you cannot actually adjust the white point of an LCD display, it is best to select the Native White Point option. Although the software recommends that a luminance of 140 candelas m^2 is ideal for calibrating and building profiles with a desktop LCD display, this is not an absolute figure. Ideally, you should use a luminance between 110–140 for a desktop LCD display and a luminance of around 85–100 for a CRT-type display.

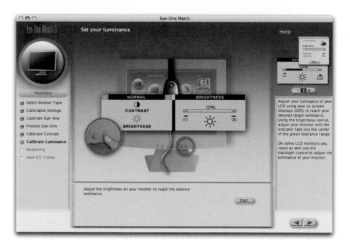

3. Now you are ready to place the calibrator on the screen and start the calibration process. To measure a CRT monitor, a suction cup-type device attaches the calibrator to the screen. To measure an LCD display, you must use a counterweight attachment to carefully hang the calibration device over the screen. The Eye-One Match software auto-detects the location of the calibrator so it knows which section of the screen the calibrator should take its measurements from.

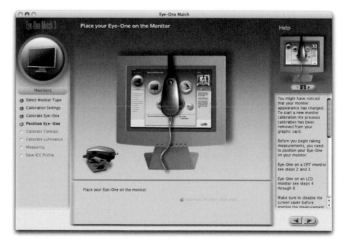

4. If you have a CRT monitor, you should be able to adjust the contrast, in which case you should set this to maximum. Next you need to adjust the brightness controls on the screen so that the measured brightness matches the desired setting. If you have a CRT display with adjustable color controls, there will be a step that allows you to manually adjust the color guns on your monitor to produce a neutral gray display.

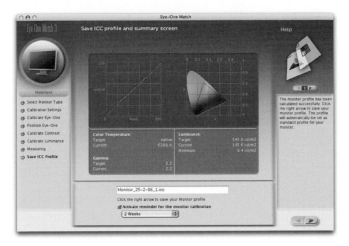

5. If you are calibrating an LCD display, then simply skip this, and
proceed to the next step in which a series of color patches flash on
the screen. The calibration device measures these patches and uses
them to build the monitor profile. The profile measurement process
takes a few minutes to complete. You need to make sure that your
screen saver doesn't kick in while the calibration is underway. For
example, the settings on an LCD laptop in battery-power mode
may auto-dim the display half way through the profiling process
and contaminate the results. One way to ensure this does not hap-
pen is to keep the mouse cursor moving every 30 seconds or so
(outside of the area being measured of course!) until the process
is complete. At this stage you can click to save the monitor profile
that has been generated, and it will automatically be configured as
the new monitor display profile.

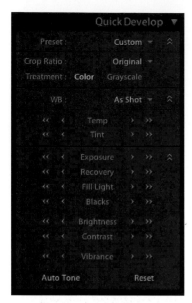

Figure 4.2 *The Quick Develop buttons are laid out with arrows indicating how you can increase or decrease an adjustment. To restore an adjustment to its default setting, click the name in the middle. The Auto Tone button applies an auto adjustment to the Exposure, Recovery, Blacks, Brightness, and Contrast, whereas the Reset button resets everything back to the Lightroom defaults.*

Quick Develop Controls

The Quick Develop panel in the Library module contains a set of basic controls that allow you to apply quick tone and color adjustments to single or multiple images that have been selected in the grid or Filmstrip. These provide an easy way to make quick adjustments to the White Balance, Exposure, Recovery, Fill Light, Blacks, Brightness, Contrast, and Vibrance (**Figure 4.2**). The panel may say Quick Develop, but these adjustments are the same as those found in the full-featured Develop module. The main difference here is that the Quick Develop adjustments are applied relative to the current Develop settings.

Quick Develop Color and Tone Controls

To use Quick Develop, go to the Library module and select an image (or selection of images). To apply a preset adjustment, click the Preset menu shown in **Figure 4.3** and choose from one of the custom Develop module presets listed. The Crop Ratio menu options will let you apply a preset crop setting, and the Treatment section lets you decide whether to process an image in color or as grayscale (the term "grayscale" could be considered a little misleading, because images in Lightroom are not actually converted into Grayscale mode). Next, we come to the WB (White Balance) options, which include the Temp and Tint controls. If you are shooting with a camera set to Auto White Balance mode, or you were using a white balance that was correct for the lighting conditions at the time of shooting, you will probably want to leave this set to "As Shot." But otherwise, you can click the White Balance menu (also shown in Figure 4.3) and choose one of the preset settings listed there, or select the "Auto" setting and Lightroom will try to calculate an optimized White Balance setting for you.

The Tone controls allow you to increase or decrease the tone adjustments by clicking the arrow buttons. The single chevron icons increase or decrease a setting by small amounts and the double-chevron icon by larger amounts (click the setting name in the middle to reset it to its default setting). I advise you to always start by adjusting the Exposure amount first, because the Exposure is critical for determining the clipping point for the highlights, and an Exposure adjustment always affects the highlight clipping point and the overall brightness. Once you have set the Exposure you can if necessary adjust the Recovery, which moderates the effect of an Exposure adjustment to preserve critical highlight detail. Fill Light is a shadow lightening adjustment that lets you brighten the shadows more should you need to do so. The Blacks slider controls the

shadow clipping. Brightness and Contrast are fairly self-explanatory but are applied *after* the tone adjustments, whereas Vibrance can be used to increase or decrease the saturation. This adjustment is similar to the Saturation control in the Develop module, but it works by applying a nonlinear adjustment that brightens the duller colors without oversaturating the already saturated colors. That's it for the controls in Quick Develop. If you want to apply more advanced tone and color adjustments, you need to use the Develop module. The Auto Tone button at the bottom applies an automatic correction to the following Develop module settings: Exposure, Recovery, Blacks, Brightness, and Contrast (this action is undoable by clicking the Reset button next to it). An Auto adjustment can sometimes make an instant improvement. Sometimes it will not do much because the tone adjustments were correct anyway, and other times it may make the image unexpectedly darker. It is ridiculous to expect an automatic function such as this to perform flawlessly every time, but for the most part, I find that Auto Tone works well for the majority of times that I use it, and that is good enough for me. The Auto Tone settings can often be a useful starting point for further Quick Develop edits (**Figure 4.4**). The following steps show the results obtained with Quick Develop.

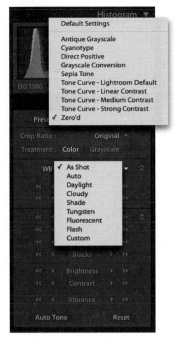

Figure 4.3 *The Quick Develop panel showing the Preset and White Balance menu lists.*

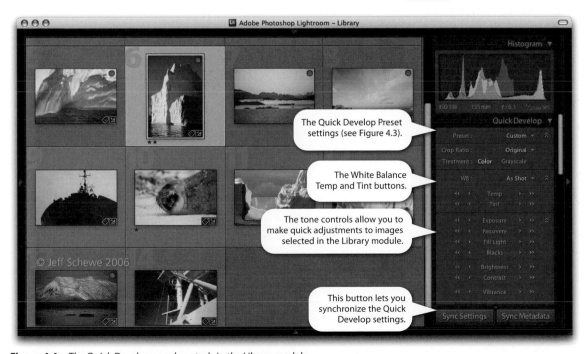

Figure 4.4 *The Quick Develop panel controls in the Library module.*

1. This daylight photograph was shot with a digital camera in raw mode where the camera had wrongly used a fixed tungsten lighting White Balance setting. When the image was previewed in Lightroom using the "As Shot" White Balance and Exposure settings, it had a noticeable blue cast and blown out highlights.

2. I then clicked the White Balance menu to set the white balance to Auto. I could also have pressed ⌘ Shift U (Mac) or Ctrl Shift U (PC). This got rid of the blue cast.

3. The picture still looked a little overexposed, so I clicked the Auto Tone button. Or I could have used the ⌘U (Mac) or Ctrl U (PC). This automatically adjusted the Exposure setting so that the highlights were no longer clipped as well as adjusting the other tone settings. I also clicked the Add Fill Light button a few times, because the shadows were too dark.

4. I then clicked the Grayscale button to see what a black-and-white version would look like (if you want to undo the grayscale conversion, click the Color button).

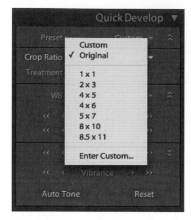

Figure 4.5 *The Quick Develop crop menu options contain a list of presets. You can add to this list by clicking on Enter Custom to add a new custom crop proportion to the list.*

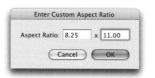

Figure 4.6 *The Enter Custom Aspect Ratio dialog.*

Quick Develop and Develop Settings

Clicking the arrow buttons in the Quick Develop panel will simultaneously update the settings in the Basic panel of the Develop module. The correlation between the two locations is as follows: An image will become incrementally cooler as you click the arrow buttons to the left and warmer as you click the arrow buttons to the right. The single arrow buttons produce small shifts in color and clicking the double arrow buttons produces more pronounced color shifts. Each click of an Exposure single arrow button is equivalent to a 0.33 unit shift in the Develop module, whereas each click of a double arrow button is equivalent to a 1.00 shift. With the Recovery, Fill Light, Brightness, Contrast, and Vibrance, a single arrow click is equivalent to a 5 unit shift in the Develop module, and a double arrow click is equivalent to a 20 unit shift (except Fill Light, which jumps 15 units at a time). With the Blacks button, a single arrow click makes 1 unit shifts and double arrow clicks 5 units.

Quick Develop Cropping

The Quick Develop Crop Ratio menu lets you apply a crop that evenly trims the image at either end (**Figure 4.5**). You can also create your own Custom Aspect Ratio crop settings for use in Quick Develop (**Figure 4.6**). In **Figure 4.7** I selected an 8 x 10 proportional crop and applied it to the selected photograph.

Figure 4.7 *Shown here is a photograph to which I applied a 8 x 10 proportional crop to a landscape image with a 2:3 aspect ratio.*

Synchronizing Develop Settings

The Sync Settings button at the bottom of the right panel lets you synchronize all the Develop image settings, not just those that have been applied via the Quick Develop panel (**Figure 4.8**). If you have a group of images selected and want the settings to match the most selected image, just click the Sync Settings button, which calls up the Synchronize Settings dialog (**Figure 4.9**). By the way, the most selected image will be the image that is currently the most highlighted in the grid and also is the one displayed in the Navigator. Notice that the Synchronize Settings dialog contains several selectable options for all the different Develop settings. If you have just imported a collection of images and this is the first time you are editing the pictures, select Check All so that all the image setting attributes will be synchronized. This is best in the early stages of a Library photo edit, because you won't disrupt any preconfigured settings in all the other images. The Check All option is therefore quicker to use in those situations where not much has been done to any of the pictures yet. If you are synchronizing photographs and it is likely that some of the images may have been individually adjusted, you probably won't want to override these settings when you carry out a synchronization. In these instances, it is better to make a careful selection of only the settings attributes you want to see synchronized and leave all the other settings as they are. When you are done, click the Synchronize button at the bottom to synchronize the image settings so that they will all match the most selected image.

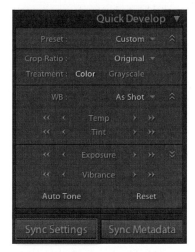

Figure 4.8 *The Sync Settings button can be used to synchronize all Develop module settings, not just those that have been applied via the Quick Develop panel.*

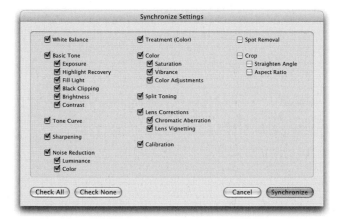

Figure 4.9 *When you click the Synchronize button in the Quick Develop panel, the Synchronize Settings dialog opens.*

TIP

Notice that the Spot Removal and Crop settings are deselected by default. This is because you may not always want to synchronize these specific settings. For example, synchronizing the Spot Removal settings can be beneficial if you are synching a selection of matching shots in which you want to remove sensor dust marks that always appear in the same spot and the individual pictures don't vary too much. But if all the pictures are shots of different subjects, sharing the Spot Removal settings would just create a big mess (as well as overwriting any spot removal work you had done already).

JPEG capture has the advantage of offering faster capture burst rates and smaller file sizes. JPEG capture does make sense for people like busy news photographers, where speed and the compactness of the file size is essential for wireless shooting. JPEG is also perfectly fine for shooting fun photos on a digital compact camera. But for everything else I recommend that you shoot in raw mode when possible. Raw files are often not that much larger than a high-quality JPEG, and the raw mode burst rates on a typical digital SLR are usually adequate for all but the fastest sports shooters. Apart from that, it just doesn't make sense these days to not shoot in raw mode. Above all, Lightroom is designed to help you make the best possible photographs from the raw data captured by your camera sensor. Only by shooting in raw mode can you ever hope to achieve the highest quality results.

Raw or JPEG?

At first glance, Lightroom appears to handle the processing of raw capture images and non-raw images as if they were the same. The fact that you now have more controls at your disposal to edit the color and tone in a JPEG capture is in one way a good thing, but it would be dangerous to conclude from this that JPEG is now equal to the quality of a raw capture. A brief summary of the differences between shooting in raw and JPEG mode follows. See the images on the next page for more.

Why a Raw File Is Like a Digital Negative

A typical good-quality digital camera is capable of capturing up to 4,096 levels of information per color channel. This does not mean that every image capture contains 4,096 levels in every channel. For example, an incorrect camera exposure certainly causes some levels to be lost. But even though you may well capture fewer than 4,096 levels per channel, that's still plenty of levels to work with in Lightroom. A raw capture file contains the direct raw data as captured by the sensor, without any pre-image processing applied to it. The only factor that limits the potential of a raw capture file is the camera exposure and camera ISO setting. But that is the major advantage of raw capture: When you shoot using raw mode, apart from the exposure and ISO setting, nothing else about the image processing will have been decided yet. A raw camera capture file is really like a digital negative that has yet to be processed, and as such is a master file with the potential to be processed in many different ways. Some photographers have found their initial encounters with raw images to be off-putting because some raw images will appear dull and lifeless at first. But this in a way is a good thing because you want there to be room to expand the tones and add more contrast as you see fit. The controls in Lightroom's Develop module can work wonders on any image, but they work best with raw images.

The JPEG Alternative

The alternative option is to shoot using the JPEG mode where the camera automatically applies the image processing. This can include things like setting the white balance, adjusting shadow and highlight clipping, applying a tone curve, removing noise, sharpening the image, converting the raw data to an 8-bit RGB output space, and compressing the color data (while trying to preserve the luminance) to produce a JPEG capture file. All the image processing is managed by an onboard image processor inside the camera and the user has limited control over the JPEG processing beyond adjusting the White Balance settings, sharpness, noise handling, and RGB output space.

1. If you shoot a scene such as this using JPEG mode, the clipping you see in the histogram and also in the clipping gamut warning seen in the clouds indicates that there is nothing that can be done to reveal more information highlights. The tonal range in the JPEG image has already been fixed.

2. If the same image is captured in raw mode, a negative Exposure combined with a positive Recovery adjustment quickly reveals the highlight detail that the JPEG capture version was unable to preserve. When you process a raw file, you will have more tones to play with and therefore more flexibility when it comes to making tone decisions in the Develop module.

NOTE

The panels in the right section of the Develop module can be expanded by clicking the panel bar disclosure button. If you [Alt]–click an individual panel bar disclosure button, you put the panel bars into "solo" mode which means that as you click you expand a panel. The action simultaneously closes all the other panels.

TIP

You can reset the individual Develop settings at any time by double-click-ing the slider names.

NOTE

All the Lightroom shortcuts can be learned by going to the Help menu and choosing the module help option at the bottom of the menu (or press [⌘][?]). In addition to these there are shortcuts that will enable you to switch between individual modules (these are the Mac shortcuts. PC users should use [Ctrl][Alt] plus the number).

[⌘][Alt][1] to select Library

[⌘][Alt][2] to select Develop

[⌘][Alt][3] to select Slideshow

[⌘][Alt][4] to select Print

[⌘][Alt][5] to select Web

[⌘][Alt][↑] to go back to the previous module.

Also, G selects the Library module in Grid mode, E selects the Library module in Loupe mode. D selects the Develop module and R selects the Crop tool in the Develop module.

The Develop Module Interface

The Develop module provides all the controls that beginners and advanced users need for making adjustments and corrections to an image (**Figure 4.10**). The main controls are located in the right panel section. At the top is the Basic panel, which is an essential starting point for all image adjustments. This is followed by the Tone Curve panel, which provides you with a more advanced degree of control over the image tones, allowing you to further fine-tune the Tone settings that have been set via the Basic panel. In the example shown here, the Tone Curve controls have been adjusted to apply the optimum contrast and brightness in both the sky and the rock (note the unusual tone curve shape). The Tone Curve has a Target Adjustment tool, which when you click it allows you to move the cursor over the image, click on an area of interest, and drag with the mouse to lighten or darken those tones rather than having to drag the sliders. Similar Target mode controls are available when making HSL and Grayscale panel adjustments. Below that is the HSL/Color/Grayscale panel. The HSL section provides similar controls to the Hue/Saturation adjustment in Photoshop. These settings allow you to adjust separately the hue, saturation, and luminance components of an image. The Color section is similar to HSL, but with simpler controls (but no Target mode option). Clicking the Grayscale section (V) converts an image to black and white and lets you make custom monochrome conversions, creatively blend-ing the RGB color channels to produce different types of monochrome output. The Split Toning controls can be used to colorize the shadows and highlights separately (the Split Toning controls actually work nicely on color images as well as black and white). The Detail panel lets you to add sharpness to imported images and also has controls for suppressing the color noise and luminance noise in an image. The Lens Correction panel controls can correct common lens defects such as the chromatic aberration responsible for color fringing as well as lens vignetting. The Camera Calibration panel allows advanced users to apply custom camera calibration settings that can compensate for variations in the color response of an individual camera sensor. All the Develop settings can be saved as custom presets. The left panel con-tains a selection of default presets to get you started, but it is easy to create your own presets using all or partial combinations of the Develop module settings. Notice that as you roll over the list in the Presets panel you see an instant preview in the Navigator area above, without having to click to apply an effect to the main image.

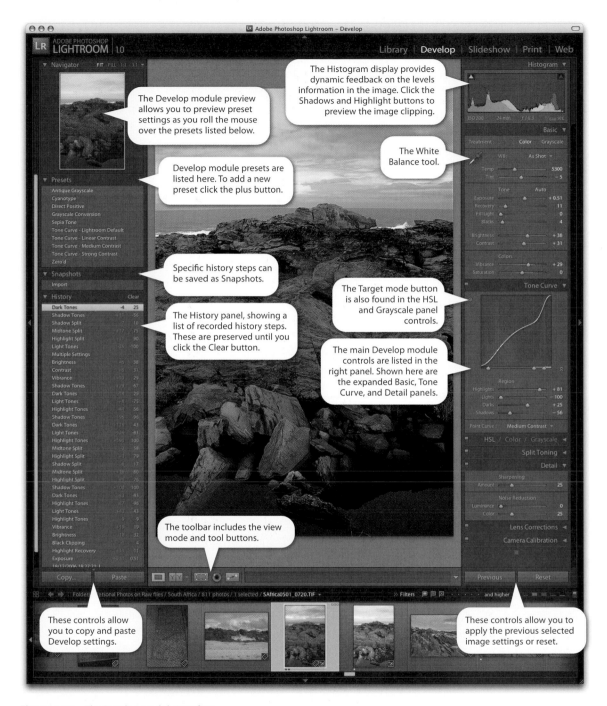

The Histogram display provides dynamic feedback on the levels information in the image. Click the Shadows and Highlight buttons to preview the image clipping.

The Develop module preview allows you to preview preset settings as you roll the mouse over the presets listed below.

The White Balance tool.

Develop module presets are listed here. To add a new preset click the plus button.

Specific history steps can be saved as Snapshots.

The Target mode button is also found in the HSL and Grayscale panel controls.

The History panel, showing a list of recorded history steps. These are preserved until you click the Clear button.

The main Develop module controls are listed in the right panel. Shown here are the expanded Basic, Tone Curve, and Detail panels.

The toolbar includes the view mode and tool buttons.

These controls allow you to copy and paste Develop settings.

These controls allow you to apply the previous selected image settings or reset.

Figure 4.10 *The Develop module interface.*

Develop Module Cropping

Wherever you are in Lightroom, you can switch to Crop Overlay mode by pressing R, which always takes you directly to the Develop module. If you are already in the Develop module, you can click the Crop Overlay mode button on the toolbar. Once you are in Crop Overlay mode, a crop bounding box appears, initially selecting the whole image. You can at this stage click the Crop Frame tool to activate it and move the Crop Frame cursor over the photograph to then click and drag to make a freeform crop (as you would with the Crop tool in Photoshop). When you have finished defining the crop, the Crop Frame tool reappears on the toolbar below. You can then proceed to modify the crop in various ways. As you drag a corner or side handle of the crop bounding box, a crop is applied to the photograph, shading the areas that fall outside the crop. To reset the crop, click the Clear button or press ⌘ Shift R (Mac) or Ctrl Shift R (PC). As you drag the crop handles, the image and crop edges will move relative to the center of the crop (**Figure 4.12**), while dragging the cursor inside the crop bounding box will scroll the image relative to the crop. Hold down the Alt key, and the crop box adjustments will be relative to the crop box center. To rotate and crop an image at the same time, move the cursor outside of the crop bounding box and click. Then use the Straighten slider on the toolbar, or use the Straighten tool to straighten the photograph. In either case the image will rotate relative to the crop, which will always remain level. The crop overlay grid shown in Figure 4.11 is by default shown only in Auto mode whenever you click in the image area. You can manually set the Crop Grid Overlay modes by selecting View ⇨ Crop Grid Overlay and selecting from the submenu, or by pressing O to cycle through the Crop Grid Overlay options.

Crop aspect ratios

When the Constrain Aspect Ratio button is checked, any adjustments to the crop bounding box preserves the current crop aspect ratio. If no crop setting has been applied yet, the aspect ratio is locked to the current image proportions. So if you check this box and drag any of the handles, such as the corner or side handles, the crop area will match the exact proportions of the image. If you go to the Crop Presets list, you can then select one of the aspect ratio presets in the list or choose Enter Custom, which opens the Enter Custom Aspect dialog shown in Figure 4.12. Here you can enter settings for a new custom aspect ratio setting. Click OK to add a new crop aspect ratio to the preset list.

Crop Frame tool.

Crop tool Presets list.

Clear Crop settings.

Crop Overlay mode button.

Constrain Aspect Ratio lock (A).

Straighten tool and slider control.

Figure 4.11 *The toolbar in Crop Overlay mode, showing the cropping controls.*

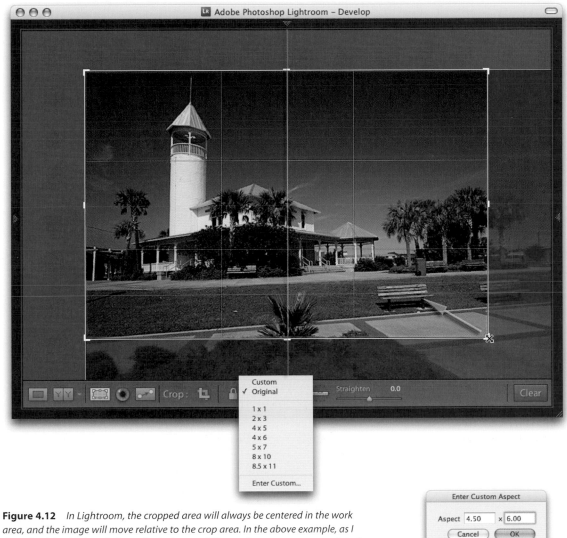

Figure 4.12 *In Lightroom, the cropped area will always be centered in the work area, and the image will move relative to the crop area. In the above example, as I drag the right side handle inwards, the image shifts out the way to accommodate the change made to the crop area.*

1. If you click the Crop Frame tool to select it, you can simply drag to apply a freeform crop to a photograph. Release the mouse and the Crop Frame tool returns to its usual location on the toolbar.

2. In this next step, I clicked the Crop Lock button to unlock the fixed crop aspect ratio. This allowed me to then click a corner or side handle of the crop bounding box and drag to reposition the crop relative to the photograph.

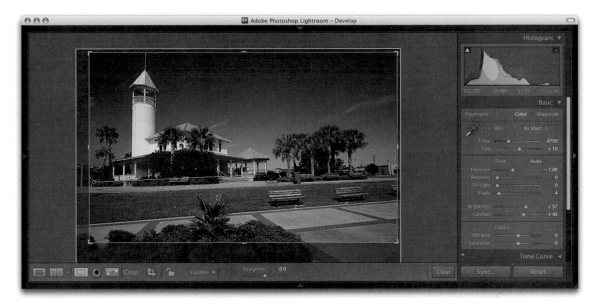

3. If you now click the Straighten tool, you can drag it across the image to define a straighten angle. But you can also adjust the straighten angle by adjusting the Straighten slider on the toolbar.

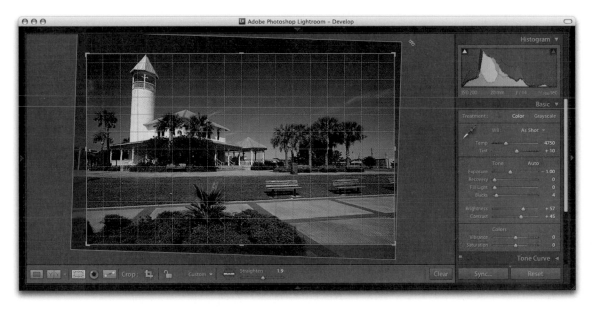

4. You can also straighten a photograph by clicking anywhere outside of the crop bounding box and dragging. As you do this a fine grid appears to help guide you. You can use the grid lines to help align the rotation to elements in the picture.

Repositioning a crop

The Crop tool in Lightroom always restricts the cropping to within the boundary of the document. Unlike Photoshop, you cannot drag the Crop tool outside the image document area to increase the canvas area. You can only crop an image within the confines of the photograph. So however you drag or rotate the crop, you will always be applying the crop to the inside of the picture. When you click inside the crop bounding box, the cursor changes to show the Hand tool, which enables you to scroll the image relative to the crop. As you drag with the mouse, the crop box remains static and the image moves behind the crop (**Figure 4.13**).

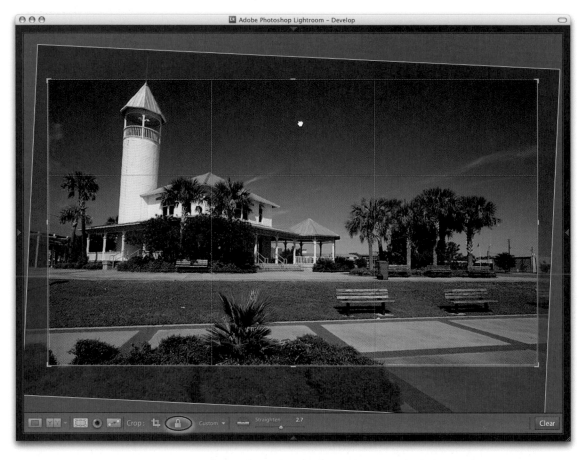

Figure 4.13 *When the Crop Lock button is checked again, the crop bounding box is locked to the current aspect ratio. When you drag any of the bounding box handles, the current aspect ratio is the one that is applied. As you click on the photograph in the content area, you can reposition the image relative to the crop.*

Histogram Panel

When you are in the Develop module, the Histogram panel is always displayed in the top-right corner (there is a duplicate Histogram panel in the Library module, but the Develop module histogram has more direct relevance when making Develop adjustments). Histogram information is only useful if you know how to interpret it correctly. For example, if you shoot using raw mode, the histogram display on a digital camera can be misleading because it is based on what a JPEG capture would record, and the dynamic range of a JPEG capture will always be less than that available from a raw file. If you are shooting raw, the only way to tell if there is any clipping is to inspect the raw image in a program like Lightroom, or via the Photoshop Camera Raw plug-in. In other words, don't let the camera histogram unduly sway your judgement if you have good reason to believe you are shooting with a correct camera exposure. If you are editing an imported JPEG, PSD, or TIFF image, the Lightroom histogram represents the tone range based on the file's native color space. If you are editing a raw capture, there are no gamut constraints until you export the image as a JPEG, TIFF, or PSD file, at which point the gamut space limits will be determined by the choice of RGB output space. sRGB has a small gamut and many of the colors will be clipped when you export (**Figure 4.14**). Adobe RGB is a popular, commonly used color space, and ProPhoto RGB has the widest gamut of all. Incidentally, Lightroom uses a wide gamut RGB space similar to Pro Photo RGB to do all the image calculations, and the histogram and RGB percentage readouts are based on the native Lightroom RGB space. To find out more about the Lightroom RGB space, refer to the Appendix.

NOTE

For those working on a computer with a small pixel size display, you will be pleased to know that you can collapse both the Navigator and the Histogram displays. This can make quite a big difference when working with the right panel displays because it allows you to observe both the Basic and Tone Curve panels simultaneously. Note also that the other panels slide beneath the Histogram panel as you scroll down the panel list. This too can be helpful for those who have limited screen real estate, because it allows you to see the Histogram and Tone Curve panels at the same time.

TIP

Press ⌘ 0 (Mac) or Ctrl 0 (PC) to toggle between collapsing and expanding the Histogram panel.

© George Jardine 2006

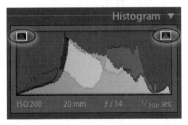

Figure 4.14 *One way to preview the image with a clipping warning is to roll over or click the buttons circled here. Clicking these buttons toggles displaying the color overlays shown here. Blue indicates the shadow clipping and red indicates the highlight clipping. The clipping warning triangles indicate initial clipping by the colors that are being clipped most and then change to white as all channels are clipped.*

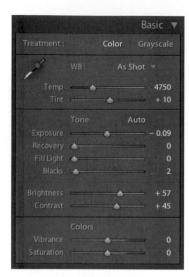

Figure 4.15 *The Basic panel.*

Basic Panel Controls

If you have ever used the Adobe Camera Raw plug-in with Photoshop and Bridge, you are already familiar with some of the Basic panel controls. And if you are using Photoshop CS3, you will find that all the panel adjustments in the Develop module will be the same as those in the latest version of Adobe Camera Raw. The Color controls include the White Balance tool, Temp, and Tint sliders which can be used to precisely adjust the white balance of a photograph. With these controls, you can color correct most images, or apply different white balances. The Exposure slider sets the highlight point and determines where the image highlights are clipped. You may be aware that the Exposure slider is often used as a negative exposure adjustment to rescue highlight detail. The problem here is that you can often end up setting the exposure a lot lower than is ideal, and end up making the image darker than necessary. The Recovery slider is a highlight recovery control. It is not a tool for darkening highlights in the same way or to the same extent that the Fill Light can compensate for dark shadows. Rather, the Recovery slider can be used to let you bring back highlight detail without having to drag the Exposure slider too much to the left. My advice is to start with the Recovery set to zero, adjust the Exposure first but without dragging the Exposure too far to the left, and use Recovery only when necessary to bring back important highlight detail. Note that if you hold down the [Alt] key as you drag the Recovery slider, you see a Threshold mode view of the highlight clipping. The Blacks slider controls the shadow clipping, and although setting the shadows is not as critical as setting the highlights, you still need to be aware of how much is safe to clip when adjusting the Blacks slider. The Fill Light is used to dramatically lighten the shadow areas. As with Recovery adjustments, I recommend that you always adjust the Blacks first before you add a Fill Light adjustment. The Brightness and Contrast controls allow you to make basic adjustments to all the tones between the shadow and highlight clipping points. At first, the Vibrance slider appears to be very similar to the Saturation slider. And it is, except that the Vibrance slider applies a nonlinear saturation adjustment. This means that lower saturated pixels get more of a saturation boost than the higher saturated pixels. The advantage is that colors can be given a saturation boost, but with less risk of clipping. Vibrance also contains a skin tone protector that prevents skin tone colors from being boosted. Vibrance is a very useful alternative to the basic (and by comparison, cruder) Saturation slider.

Camera Exposures

A typical CCD or CMOS sensor in a digital camera is capable of recording up to 4,000 levels of information. If you are shooting in raw mode, the ability to record all these levels very much depends on a careful choice of exposure. The ideal camera exposure should be bright enough to record all the tonal information without clipping important highlight detail. This is because half the levels information is recorded in the brightest stop range. As is shown in **Figure 4.16**, for each stop decrease in exposure, the number of levels that can be recorded are potentially halved. The upshot of this is that you do not want to deliberately underexpose an image unless to do otherwise would result in the loss of important highlight detail. Deliberate underexposure will have a dramatic impact on the deep shadow detail, since relatively fewer levels are left to record the shadow information. **Figure 4.17** shows how you can easily lose detail in the shadow areas due to an underexposure at the capture stage.

If you are shooting raw, it is unwise to place too much emphasis on the camera histogram. It is best to either trust the exposure system in the camera to get it right or rely on the histogram in Lightroom.

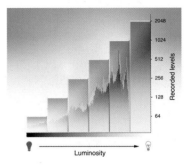

Figure 4.16 *If you don't optimize the camera exposure, you may be missing the opportunity to record a greater number of levels via the sensor. The top diagram shows how a correctly optimized exposure makes maximum use of the sensor's ability to record the fullest amount of levels information possible. In the lower diagram you can see how recording the exposure just one stop darker than the ideal exposure results in only half as many levels being recorded by the sensor.*

Figure 4.17 *This image is divided diagonally. The top section shows the enhanced shadow detail using an optimum camera exposure setting, and the bottom section shows the same scene captured at minus two stops camera exposure and then processed to match the luminance of the normal exposure. Notice that there is more noise and less tonal information in the underexposed version.*

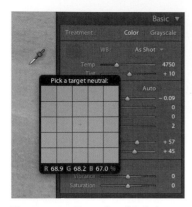

Figure 4.19 *To set the white balance, click the White Balance tool to activate it and mouse over the image to locate an area that should be neutral. Click with the tool to set the white balance.*

Basic Image Adjustment Procedure

The main purpose of the Basic Develop controls is to make a first pass tonal adjustment to optimize the tonal levels in the source image. The goal is usually to set the white balance first, adjust the shadow and highlight points to maximize the full tonal range, and then make further basic adjustments to balance the distribution of tones that lie in between so that the overall brightness and contrast are optimized. This has pretty much been the standard Develop workflow that Adobe Camera Raw users have worked with in the past, and the Basic panel controls in Lightroom now all match the equivalent sliders in the latest version of Camera Raw that comes with Photoshop CS3.

The White Balance tool is located near the top of the Basic panel (**Figure 4.18**). You can activate the tool by clicking it (or press W), which unlocks it from its location and allows you to click anywhere in the image to set the white balance (**Figure 4.19**). The floating pixel magnifier provides an extreme close-up of the pixels you are measuring, which can really help you select the right pixel reading. As you mouse over an image, you see the RGB readout values for the point in the picture beneath the cursor (**Figure 4.20**). The RGB readings are shown as percentage values and they can help you locate and check the color readings. If the RGB values are all close enough to the same value, a color is neutral. If the Auto Dismiss option is disabled (see page 146), you can hold down the W key and continue clicking with the tool until you get the right balance setting, while the [Esc] key can be used to cancel and return the tool to its normal docked position.

Figure 4.20 *Instead of using the customary 0-255 scale, the RGB readouts are given as percentages. You can determine the neutrality of a color by how close the readout numbers are to each other.*

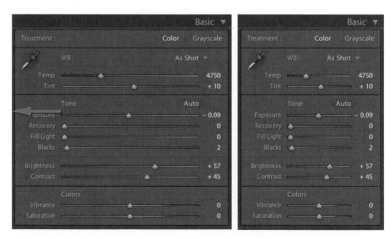

Figure 4.18 *The Develop panels can be expanded by dragging on the side edge. If there is enough space on your screen, an expanded Develop panel allows greater precision when making adjustments such as in the Basic panel shown here.*

White Balance Adjustments

In most shoot situations, once you have found the right white balance, all the other colors will tend to fit into place. The As Shot camera Auto White Balance setting may do a good job, but it really depends on the camera you are using (**Figure 4.21**). Even the best camera won't know how to handle every lighting situation it meets. In **Figure 4.22**, we see a scene where there were mixed lighting conditions. This photograph could be processed for either the daylight lighting or the tungsten lighting indoors, and each could be said to be correct. In situations like this you can't always rely on the camera auto white balance; you have to decide for yourself which setting looks the best. This is where the White Balance tool can come in handy. The trick is to analyze the picture and look for colors in the scene that should be a neutral, nonspecular, textural highlight. You should try to select a neutral light gray, because if you select a white that is too bright, there may be some clipping in one or more of the color channels, and that can result in a false white balance measurement and adjustment.

Figure 4.21 *Among other things, the Gretag Macbeth ColorChecker chart is useful for taking white balance readings under the same lighting conditions as those you are about to shoot with. To take a white balance reading in Lightroom, click on the light gray patch next to the white patch.*

NOTE

It is tempting to assume that the grayscale patches in the Gretag Macbeth ColorChecker chart shown in Figure 4.21 correspond to the full tonal range that you are trying to optimize using the Basic and Tone Curve panel controls. This is a dangerous assumption to make because in a properly optimized image, the white and black patches rarely ever equate to the respective highlight and shadow points in the image. For example, the black patch in the ColorChecker is really a dark gray, and if you were to clip the shadows using this patch as your guide you could end up clipping a lot of important shadow information.

TIP

To apply an auto white balance, you can also press ⌘ Shift U (Mac) or Ctrl Shift U (PC).

Figure 4.22 *The white balance can be measured manually by selecting the White Balance tool () and clicking a color in the image that should be near white in color. This image shows two possible white balances: one measured for the outside daylight (left) and one measured for the indoor lighting (right).*

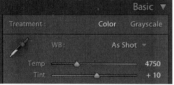

Figure 4.23 *The White Balance slider controls in the Basic panel allows you to manually adjust the white point in an image. The Temperature slider adjusts the white point from warm artificial lighting conditions to cool daylight and beyond. The Lightroom slider represents this as a progression going from blue to yellow. The Tint slider allows you to fine-tune the white point for any green/magenta bias in the white point.*

Understanding White Point

The White Balance slider controls in the Basic panel have the greatest impact on the color appearance of an image (**Figure 4.23**). The numbers used in the Temp slider refer to the temperature scale measured in degrees Kelvin, which in photography is commonly used when describing the color temperature of a light source.

Artificial lighting, such as a tungsten lamp light source, has a color temperature of around 2800–3200 K, whereas average daylight is notionally rated as being 5000 K and overcast daylight is somewhere around 10000 K. Photographers often describe higher color temperature lighting conditions as being cooler and the lower color temperature lighting conditions as being warmer, because most people equate blue colors with coldness and reddish colors with warmth (although strictly speaking, a bluer color temperature is actually hotter). The Temperature slider scale allows you to set what should be the white point of the image based on the Kelvin scale. The key point to emphasize here is that the White Balance controls are used to "assign" the white point as opposed to "creating" a white balance. Some people get confused on this point because they assume that if 3200 K equates to tungsten-balanced film and 5500 K equates to daylight-balanced film, they wrongly expect that dragging the Temperature slider to the right makes the image cooler and dragging to the left makes it warmer. The opposite is true, because you are using the Temperature slider to assign a color temperature to the image. Dragging the slider to the right will make the image warmer and dragging to the left will make it cooler. Try thinking of it this way: If you have a photograph shot under average daylight conditions and assign the image a lower color temperature more suited for tungsten lighting conditions, such as 3200 K, then naturally enough, the colors in the image will appear blue. This is the same as using a tungsten-balanced film emulsion to record a daylight scene.

Tint Adjustments

The Tint slider adjustments that are required can usually be quite minor, except for those situations where the light source emits uneven spectral wavelengths of light, such as when shooting under fluorescent lighting. It is hard to set an accurate white point for these types of lighting conditions, but fluorescent lighting conditions will usually require a heavy magenta tint bias to the white point to remove a green cast.

Creative white balance adjustments

Who is to say if a correct white balance is any better than an incorrect one? Before digital capture came along, photographers could only choose between shooting with daylight-balanced or tungsten-balanced film emulsions. A lot of photographers would simply accept whatever colors the film produced, although some professionals had the know-how to measure the color temperature and would place filters over the camera lens to correct for color shifts in the lighting. With a digital camera it is easy to set the white balance precisely. There may be times, such as when shooting catalog work when it is critical to get the color exactly right from camera to screen. But you don't always have to obsess over the color management at the capture stage on every type of shoot. You now have the freedom to interpret a master raw file any way you like, and you can change the mood in a photograph completely by setting the white balance to an incorrect setting (**Figure 4.24**).

TIP

If you do a shoot using a studio flash system (not the built-in flash) and have the camera set to auto white balance, there is a high probability that the white balance reading will be influenced by the tungsten modelling lights instead of the strobe flash.

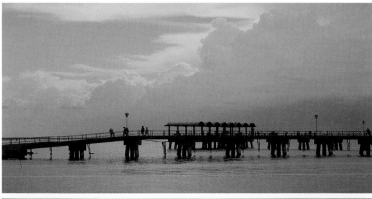

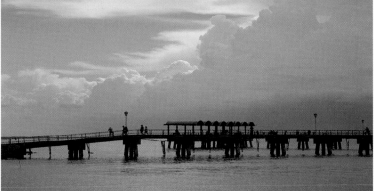

Figure 4.24 *Here is an image processed using two different white balance settings. It is often largely a matter of personal judgement when deciding which version you prefer, since neither of these uses what could be called a "correct" white balance.*

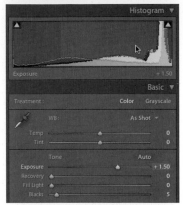

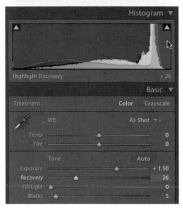

Figure 4.25 *In the top histogram, the highlights need to be expanded to fill the width of the histogram. In the middle example, I adjusted the Exposure slider to make the image brighter, while keeping an eye on the clipping indicator so as not to go beyond the clipping limits for the highlights. In the bottom example, I compensated with the Recovery slider to reduce the extreme highlight clipping, preserving more highlight detail but without compromising on the exposure brightness.*

Basic adjustments and the Histogram panel

I normally use the Exposure slider to set the highlight clipping and the Blacks slider to adjust for the shadow clipping. These two Basic tone adjustments can make the biggest difference to the appearance of an image. Get the highlights and shadows right and you will often find that all the inbetween tones will look right too. But while the Exposure slider is seen as the key tool for controlling the highlight clipping, it acts as a brightness control as well. This is where the Histogram panel is useful, because as you make an exposure adjustment you can observe the image levels expand to the right, just to the point where the highlights should begin to clip. **Figure 4.25** shows how the levels were expanded as the Exposure was increased. But notice also how the highlight clipping indicator lit up as I came within range of where the highlights were about to clip (the color indicates which colors are clipping). You can use the highlight indicator as a guide to the range of exposure settings that are suitable to use on a particular image. You can then use the Recovery slider to compensate for any unwanted highlight clipping. As you drag the Recovery slider to the right the highlight end of the histogram compresses to recover the clipped highlight detail, and the highlight clipping indicator will turn off at the optimum point where there is no more clipping. As you experiment with these slider controls, you soon discover how it is possible to use Exposure to set what looks like the best exposure setting for the image brightness (but within the range of clipping tolerance), and then compensate separately for the precise clipping by using the Recovery slider.

The Blacks and Fill Light sliders appear to do the same thing in reverse, but their behavior is in fact different. For raw camera files, the default Blacks setting is "5." This should be about right for most images. You can set this lower, but even with an underexposed image it is unlikely you will want to set the Blacks to a value as low as zero. The shadows clipping indicator also lights up to indicate the range of appropriate Blacks settings to use as you try to determine where best to clip the shadows. The Fill Light slider is not a shadow recovery control in the same way as the Recovery slider is used to rescue the highlights. The Fill Light is ideal for lightening the shadow in dark tone areas, and it can certainly make quite a dramatic difference on a photograph that has heavy shadows. As you adjust the Fill Light, the clipping indicator will again hint at the ideal range of settings to use. You can extend a Fill Light adjustment beyond this range, but overdoing the Fill Light won't always produce the most natural-looking results.

But what's really cool is that the Histogram is more than just an information display. You can also use it to actively adjust the four main Basic panel tone slider controls: Exposure, Highlight Recovery, Fill Light, and Blacks (**Figure 4.26**). As you roll the mouse over the histogram, you will see each of these four sections highlighted in the histogram. And if you click and drag, you can actively mold the shape of the histogram and levels output by dragging with the mouse inside the Histogram panel.

The Brightness and Contrast appear only once in the Basic panel. These controls are partly there for legacy reasons, because customers have grown accustomed to working with them in the Adobe Camera Raw plug-in and are familiar with and like the control that they give. In practice I find that Brightness is the more useful of the two, because an Exposure adjustment won't always do enough to lighten or darken every image I encounter. As for the Contrast slider, it can be useful, particularly if you are familiar with the legacy Camera Raw method for processing raw files and want to carry on using these same adjustment methods. But in my opinion, the four tone slider controls in the Tone Curve panel offer a much better and more precise way of adjusting the contrast.

The overall objective of using the Basic panel for editing is to adjust the raw (or pixel image) data to produce an image that is more or less correct for tone and color. The separation between the Basic and Tone Curve panels is there because the Tone Curve controls are designed to pick up from where the Basic panel adjustments left off. It is important to understand this distinction, because the image data is processed through the Basic panel first before being fed through the Tone Curve panel, where you can make fine-edit adjustments to the tones in the image. For example, if you look carefully in the Tone Curve panel you will notice how the histogram from the Histogram panel is mirrored in the background of the Tone Curve edit box. The Tone Curve panel will be discussed shortly. We'll also take a look at a step-by-step example of how to work with the Basic panel.

Auto Tone setting

The Auto Tone check box works really well on a great many images as a quick fix tone adjustment. It can automatically set the Recovery, Blacks, Brightness, and Contrast (always resetting Exposure and Fill Light to zero). From there you can adjust the Exposure and Fill Light manually to fine-tune an adjustment. Auto Tone can also be checked in a preset, allowing you to import images with Auto Tone enabled from the very start.

Figure 4.26 *The Basic panel adjustments shown here were all achieved by clicking on different sections of the histogram and dragging right or left to increase or decrease the setting represented by that particular section of the histogram.*

TIP

To apply auto tone to an image, press ⌘U (Mac) or Ctrl U (PC).

Figure 4.27 *In the top image the highlights are all reflective. They contain no information, and you would normally want to clip these highlights to achieve the optimum image contrast. In the lower image you also have reflective highlights in the hub cap, but it is essential to ensure that the nonreflective highlights of the white tire wall do not get clipped.*

Highlight Clipping and Exposure Settings

The main objective when optimizing an image is usually to ensure that the fullest tonal range is able to reproduce in print. With this in mind, it is vitally important that you set the highlights correctly. If the highlights are clipped too much, you risk losing important highlight detail in the finished print. And if you don't clip them enough, you end up with a flat print that is lacking in sparkle.

The important thing to appreciate here is the difference between reflective and nonreflective highlights. The two examples shown in **Figure 4.27** help explain these differences. A reflective highlight (also referred to as a specular highlight) is a shiny highlight, such as the light reflecting off a glass or metal surface. A reflective highlight contains no highlight detail, and therefore it is advisable to clip the highlights so that these highlights are the brightest part of the picture and will print using the maximum white value.

Nonreflective highlights (also known as nonspecular highlights) need to be treated more carefully, because they mostly contain important detail that needs to be preserved. Each print process varies, but in general, whether you are printing to a CMYK press or printing via a desktop inkjet printer, if the nonreflective highlights are set too close to the point where the highlights clip, there is a real risk that the detail in these highlights may print to the same paper white as the clipped highlights.

It is not too difficult to learn how to correctly set the Exposure slider to clip the highlights, especially when you are aware of the difference between a reflective and nonreflective highlight, and the clipping issues involved. Most images will contain at least a few reflective highlights, and in practice I usually use the Threshold mode (see page 147) to analyze where the highlight clipping takes place and toggle between the Threshold mode and Normal image view to determine if these highlights contain important detail or not. Alternatively, you can use the clipping gamut warning in the Histogram panel. I usually try to set the Exposure to clip the reflective highlights, but I do carefully check the nonreflective highlights as well and ensure that I nudge back a little on the Exposure slider so that they have a lightness value that is a little less than the brightest white.

Setting the Blacks

Setting the Blacks is not nearly as critical as when you are adjusting for the highlights. It really all boils down to a simple question of how much you want to clip the shadows. Do you want to clip them a little or do you want to clip them a lot?

I know there are Photoshop books and tutorials that instruct you to set the shadow point to some specific black value that is lighter than a zero black, but this advice is only useful if you are working toward a specific, known print output. And even then this should not really be necessary, since both Lightroom and Photoshop are able to automatically compensate the shadow point every time you send a file to a desktop printer, or each time you convert an image to CMYK. The internal workings of Lightroom ensure that the blackest blacks you set in the Basic panel will faithfully print as black and preserve all the shadow detail.

On page 148 I show an example of how to use the Threshold mode to analyze the shadows and determine where to set the clipping point with the Blacks slider. In that example, the objective is to clip the blacks just a little so as to maximize the tonal range between the shadows and the highlights. Some photographs may contain important information in the shadows; the photograph of the car tire and black bodywork in Figure 4.27 is a good case in point, because there is a lot of information in the shadow region that needs to be preserved. This is where the Brightness and Contrast sliders come in handy, and more important, the Tone Curve controls, which I will discuss shortly. The Tone Curve controls provide you with really precise control over tonal detail in the shadows and highlight areas.

It is rarely a good idea to clip the highlights unnecessarily, but clipping the shadows can greatly enhance the contrast. **Figure 4.28** shows a classic example of an image where the shadows have been deliberately clipped. A great many photographers have built their style of photography around the use of deep blacks in their pictures. For example, Photographer Greg Gorman (whose work appears on pages 190–193), regularly processes his black and white portraits so that photographs shot with a black background print with a solid black.

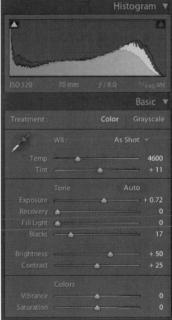

Figure 4.28 *In this example, I dragged the Blacks slider to 17 because I deliberately wanted to clip the shadows to a solid black.*

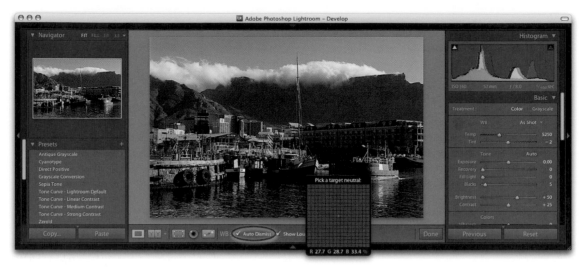

1. Here is a before image in which the Lightroom Basic adjustments have been set to the Lightroom defaults and the White Balance setting is As Shot White Balance (as recorded by the camera). I began by selecting the White Balance tool and clicked on the white paint work of one of the boats to select what should have been a nonreflective neutral color. Note that if you uncheck the Auto Dismiss option on the toolbar, you can hold down the W key and keep clicking with the White Balance tool to produce a new White Balance setting (release the mouse to cancel).

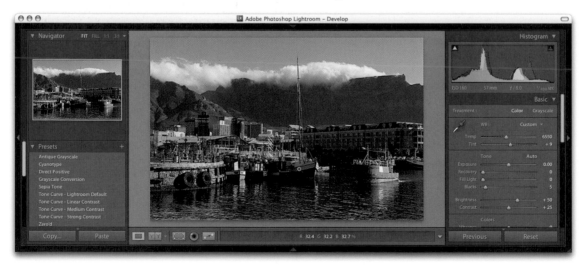

2. Here is the same photograph after I had applied a white balance correction. The RGB percentage readouts where I had clicked with the White Balance tool now show a more neutral balance.

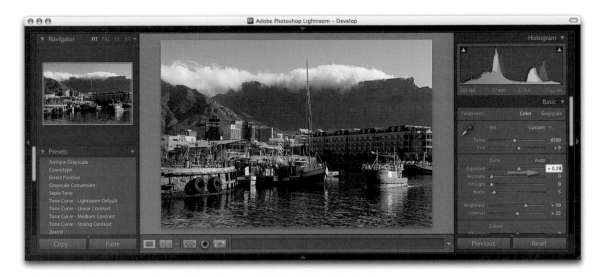

3. The Exposure slider was then used to expand the tonal range. This optimizes the highlights and lightens the image.

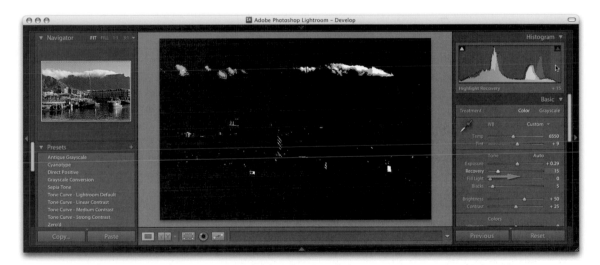

4. The Recovery slider helps prevent any highlight clipping. If you hold down the [Alt] key as you drag the Recovery slider, the image is displayed in Threshold mode. If there is highlight clipping, you will see a posterized image that shows where the highlights start to get clipped. If the highlights you see being clipped are specular (reflective) highlights, it is okay to clip them. But if the highlights contain nonreflective highlight detail, it's be best to nudge the Recovery slider more to the right to reduce the clipping.

5. Similarly, when you use the Blacks slider to set the shadow point in an image, you can hold down the [Alt] key again to see the image displayed in the Threshold mode. If there is no clipping, the image displays as white. As you gradually move the Blacks slider to the right, a posterized image starts to appear. It is usually best to set the Blacks slider so that there is just a small amount of clipping in the shadows.

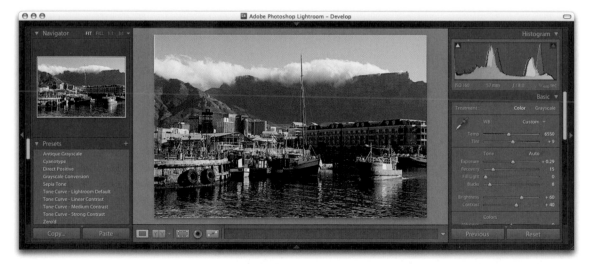

6. The Basic Develop controls generally allow you to make big enough improvements to the appearance of an image such that you won't always need to do anything else to a photograph. In this example, I added a little more overall Brightness and Contrast. Normally, I prefer to set the contrast via the Tone Curve panel.

Vibrance and Saturation

Both the Vibrance and Saturation sliders can be used to boost the saturation in an image. The difference between the two is that the Saturation slider applies a linear adjustment to the color saturation, whereas a Vibrance adjustment uses a nonlinear approach. In plain English, this means that when you apply a Vibrance adjustment, the less saturated colors will get more of a saturation boost than those colors that are already saturated (**Figure 4.29**). This can be of real practical benefit when applying a saturation adjustment to a picture where you want to make the softer colors look brighter, but don't want to brighten them at the expense of losing important detail in the already bright colors. In **Figure 4.30**, I demonstrate how a saturation boost can easily damage the color information in an image. The other benefit of working with Vibrance is that it has a built-in skin color protector that should filter out colors that fall within the skin color range. This can be useful if you are editing a portrait and you want to boost the color of someone's clothing, but at the same time, you don't want to oversaturate the subject's skin tones. Vibrance is the only saturation control you ever really need. However, the Saturation control remains useful. A Saturation adjustment is useful for making big shifts to the saturation, such as when you want to dramatically subdue the colors in a photograph (**Figure 4.31**).

Figure 4.29 *In this example, the left half of the photograph shows the normally corrected version and the right half shows a version in which I applied a +60% Vibrance adjustment, which boosted the subtle colors in this scene.*

Figure 4.30 *In the top screen shot I increased the Vibrance to 60%. This resulted in the flowers appearing more saturated than they were originally, but without over-saturating to the point where detail was lost. In the lower screen shot I increased the Saturation slider by the same amount. The Saturation boosts all colors equally, and as you can see here, there is a lot of clipping in the saturated red colors.*

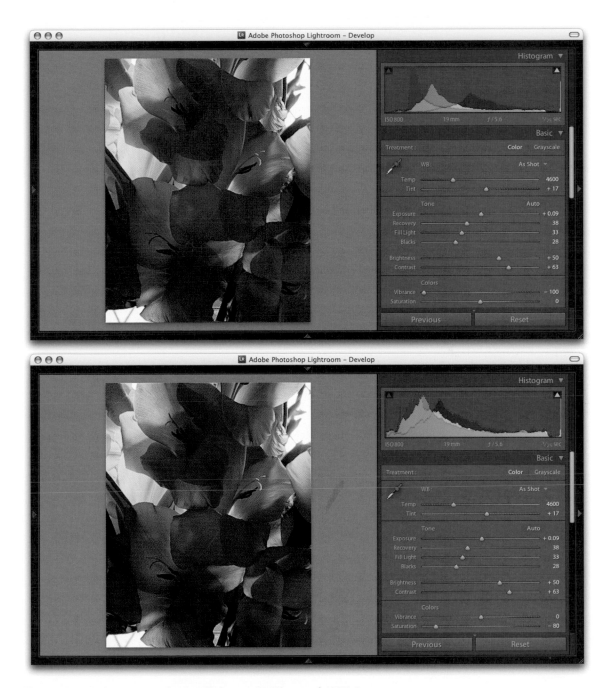

Figure 4.31 *In the top screen shot I applied a negative Vibrance of -100%. As you can see, the effect is quite subtle. This is an effective tool for making gentle reductions in the color saturation. If you move the Saturation slider all the way to -100%, you will end up with a monochrome image. In the bottom screen shot, I reduced the Saturation to -80%, which produced a pastel color version of the image.*

Correcting an Overexposed Image

Lightroom has the ability to reveal highlight detail that might otherwise have remained hidden. You can often recover seemingly lost highlight information by combining a negative Exposure adjustment with the use of the Recovery slider. It may be possible to use this technique on a JPEG image to darken the highlights a little, but this method really only works best with raw images. Lightroom is able to use all of the luminosity information contained in a raw file that is simply waiting to be discovered. In the accompanying images, I was able to recover three quarter stops of exposure, but in some cases it is possible to recover up to two stops of exposure. As mentioned on page 137, it is often better to optimize the camera exposure to capture as much of the shadow detail as possible, but without overexposing to the point where you are unable to process important highlight information. I will often ignore the camera or light meter readings and deliberately overexpose at the time of capture to record the maximum amount of levels information, and use the combination of a negative Exposure and a positive Recovery shift when processing the image.

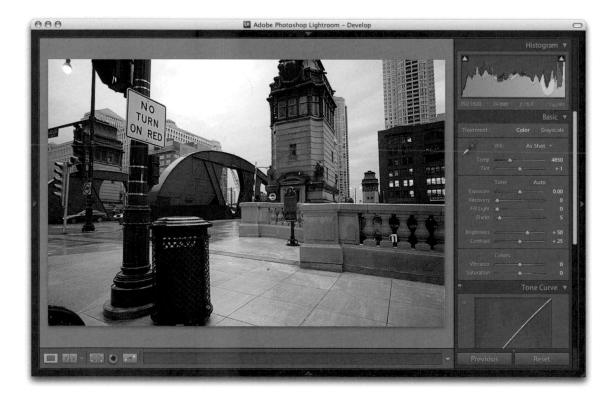

1. The photograph on the facing page was first processed using the default Basic panel settings in the Develop module. The histogram shows clipping in the highlights, and you can see how there is very little detail in the sky. A histogram like this can appear disconcerting until you realize that there is a lot more information contained in the image. Although Lightroom can work its magic on all images, it has a limited effect on pixel-based images such as JPEGs or TIFFs. For best results, you should use this technique when processing raw master files.

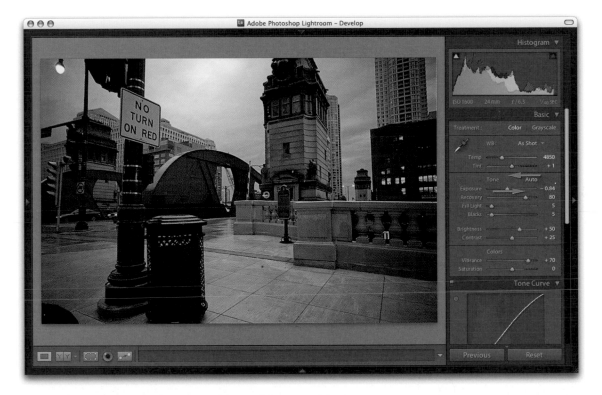

2. Highlight recovery can be achieved by applying a combination of a negative Exposure value combined with a positive Recovery adjustment. If you drag the Exposure slider to the left, you can effectively recover at least a stop worth of information, and maybe even as much as two stops. The downside is that you usually end up making the overall image darker. But when you combine this with a positive move with the Recovery slider, you see highlight information that would otherwise be clipped.

Correcting an Underexposed Image

Underexposed images represent a bigger problem because there are fewer levels available to manipulate, particularly in the shadows. The Basic panel controls in Lightroom can be used to brighten an image and lift out the shadow detail. But it is important that you work through the Basic image adjustments in the right order, as described in the following images. When adjusting the tones in an underexposed photograph, you will notice that the Blacks adjustment can be very sensitive. A small shift of the Blacks slider can make a very big difference. In the example shown here I could have opened the shadows more by setting the Blacks slider to 1 or 2. But by choosing 4, I was able to preserve more of the overall contrast.

1. As with the highlight recovery method earlier, corrections for underexposure should mainly be done by adjusting the Exposure slider first to set the highlight clipping. This should be followed by an adjustment to the Blacks, and then an adjustment to the Brightness and Contrast.

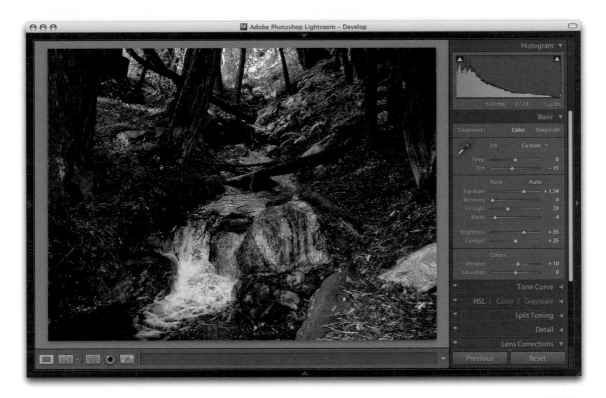

2. In this example I dragged the Exposure slider to the right, which enabled me to preserve all the information in the highlights. The Blacks were then adjusted so that the shadows were just clipped. The Fill Light adjustment was then used to radically lighten the dark shadow areas. I used the Brightness and Contrast sliders to lighten the midtones further and add more contrast depth. What you don't want to do here is to adjust the Brightness slider before you adjust the Exposure slider. Although similar results can be achieved in this way, you will end up stretching the shadow tones far more than is good for the image. For best results, approach the Basic controls in the order just described.

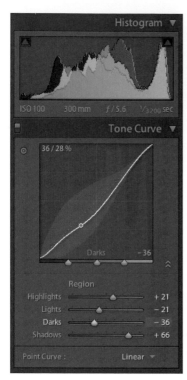

Figure 4.32 *The Tone Curve panel controls are shown here with an adjustment in progress being made to the Darks. Notice how the histogram in the Histogram panel is mirrored in the curve graph and both are updated as you edit the Tone Curve controls.*

NOTE

In Target Adjustment mode you can use the up and down arrow keys to increase or decrease the settings. Holding down the Alt key as you adjust the values applies smaller incremental adjustments. Holding down the ⇧Shift key as you adjust the values applies larger incremental adjustments.

Tone Curve Controls

The Tone Curve controls offer a new approach to tone curve mapping (using a term called "parametetric curves" in Lightroom and Camera Raw 4.0), where the tone curve is modified by making slider control adjustments. The reason the Tone Curve controls are presented in this way is to encourage people to make tone curve adjustments based on descriptive criteria. If you are used to working with curves in Photoshop, the Lightroom method may appear restrictive at first, but the Tone Curve slider controls in Lightroom can often inspire you to create tone curve shapes that are quite unlike the curve shapes you might have applied when adjusting them manually. The new slider controls also recognize that a lot of photographers just didn't get how to work the curves adjustment in Photoshop. The Tone Curve sliders will hopefully make curves adjustments accessible to everyone now. But the good news is that you can still manipulate the curve graph directly by clicking on a point on the curve and dragging up or down to modify that particular section of the curve. Best of all, you can also edit the curve by targeting an area of interest in the actual picture. If you click the Target Adjustment tool button you can then click over any part of the image and drag the mouse up or down to make the tones there lighter or darker. When you start using this method of tone editing to refine the tones in an image, you won't even need to look at the Tone Curve panel. You can also use the keyboard arrow keys: The up and down arrows adjust the tone values (note, the left and right arrow keys are reserved for navigating images in the Filmstrip). You can turn off the Target Adjustment tool by clicking the button again or by pressing ⌘ Alt Shift N (Mac) or Ctrl Alt Shift N (PC).

The four main slider controls for controlling the tone curve are Highlights, Lights, Darks, and Shadows. The slider controls also provide a shaded preview of the range of shapes an individual Tone Curve slider adjustment will make. In **Figure 4.32**, I was in the process of adjusting the Darks slider. The gray shaded area represents the limits of all possible tone curve shapes I can create with this particular slider in conjunction with the other current slider settings. For those who understand curves, this provides a useful visual reference of how the curve looks. Plus, you can edit it by clicking anywhere on the curve and moving the mouse up or down to make that section of the tone curve lighter or darker.

As mentioned earlier, the Basic panel is used to apply the main tone adjustments, and it is important to understand that these are all applied upstream of the tone curve, so the Tone Curve is an image adjustment control that you always apply after making the initial Basic panel adjustments. The layout of the tools in both the Basic and Tone Curve panels are also influenced to some degree by the legacy constraints of the Adobe Camera Raw plug-in. For example, recall that the Contrast control in the Basic panel is mainly there to provide an equivalent slider control to the one found in the Camera Raw plug-in. So those people who prefer using the simpler Camera Raw method of adjusting contrast can continue to do so. But more important, it has been necessary to ensure that settings applied to an image via Camera Raw in Photoshop will also be recognized (and made accessible) when the same image is opened via the Develop module in Lightroom. I mention all this as an explanation for the presence of the Point Curve menu at the bottom of the Tone Curve panel (**Figure 4.33**). In the early days of Camera Raw, some purists argued that the tone curve should always default to Linear, and if you wanted to add contrast, it was up to the user to edit the curve. Meanwhile, almost every other raw converter program was applying a moderate amount of contrast to the curve by default. The reason for the default application was that photographers liked their pictures to have a more contrasty and film-like look as the standard setting. Consequently, the Adobe Camera Raw plug-in has evolved to offer three choices of curve contrast; Medium Contrast is the default setting. So the Point Curve menu in the Tone Curve panel is mainly there to match up raw files that have been imported with legacy Camera Raw settings. The Medium Contrast curve applies more of a kick to the shadows to make them slightly darker and lightens the highlights slightly (which you can see by looking at the shape of the curve). The Point Curve is therefore nothing more than a curve shape setting that can be used as a starting point for making further edits to the tone curve, and is mainly there for legacy and compatibility reasons.

The Tone Range Split Points at the bottom of the tone curve allow you to restrict or broaden the range of tones that are affected by the four Tone Curve sliders (**Figure 4.34**). For example, moving the Dark Tone Range Split Point to the right offsets the midpoint between the Shadows and Darks adjustments. Adjusting each of the three Tone Range Split Points enables you to fine-tune further still the shape of the curve. These adjustment sliders are particularly useful for those instances where you are unable to achieve the exact localized contrast adjustment you are after when using just the Tone Curve sliders.

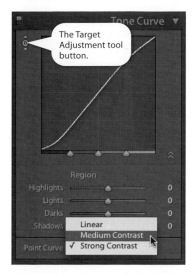

Figure 4.33 *The Point Curve menu offers a choice of three curve presets.*

TIP

If you like using the on-image tone curve editing and screen real estate is of a premium, you can collapse the Tone Curve sliders by clicking the chevron icon next to the Tone Curve graph.

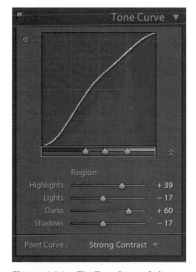

Figure 4.34 *The Tone Range Split Point controls.*

The Tone Curve Zones

The Tone Curve zones are evenly split between the four quadrants of the tone curve. In the following step-by-step example, my goal is to show a series of tone curve adjustments in which each of these zones is adjusted. To emphasize how the Tone Curve Zone sliders operate, I have highlighted the active quadrants in green to accentuate the zone regions, and to show which areas of the curve are being adjusted.

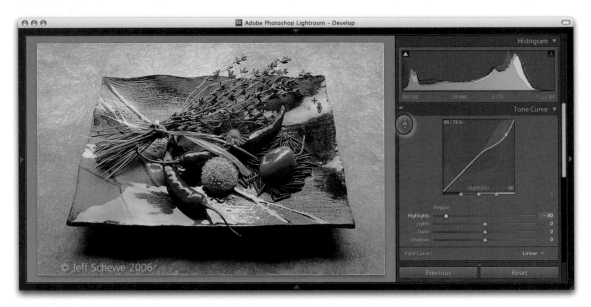

1. I began by adjusting the Highlights slider to make the brightest portion of the image darker and set the Highlights to -80. This could have been done in several ways: dragging the Highlights slider in the Tone Curve panel to the left, clicking anywhere on the green shaded section of the curve and dragging the curve to move it downwards, or clicking this portion of the curve and using the down arrow key on the keyboard to darken the Highlights. But I actually used a Target Mode adjustment. I clicked the Target Adjustment tool button (circled) to make it active and moved the cursor over the image. I then clicked and dragged downwards to darken the tones in the selected portion of the curve. Note that you need to use up and down mouse movements here, and similarly, you can also use the keyboard arrow keys to make the same kind of adjustments.

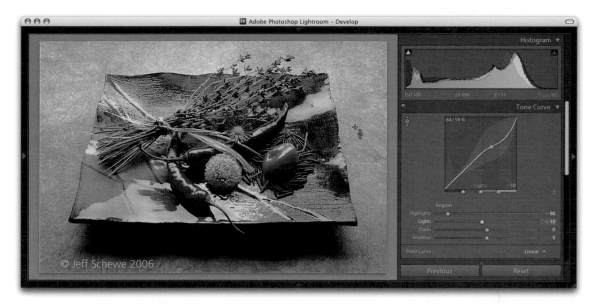

2. Next I wanted to concentrate on darkening the tones within the Lights zone of the curve. I placed the cursor over the table area and again dragged downwards with the mouse.

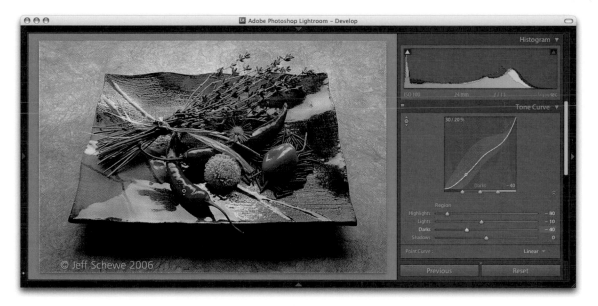

3. I then darkened the Darks zone by moving the mouse over one of the chili peppers and dragged the mouse downwards. If you are using the arrow keys, you can use the [Alt] key to apply small incremental shifts and the [Shift] key to apply bigger shifts.

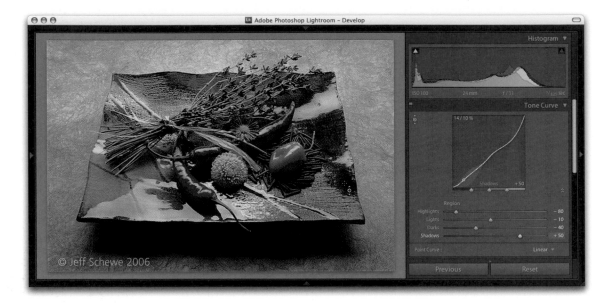

4. I adjusted the Shadows, which again could be done by dragging the Shadows slider, and clicking on the curve to directly edit the shape of the tone curve. But in this case, I placed the mouse over a shadow area in the image and dragged the mouse upward to lighten the shadows.

Combining Basic and Tone Curve Adjustments

So far, Tone Curve adjustments have been made in isolation. But in a typical develop session, you will normally work using a combination of both the Basic and Tone Curve adjustments. Over the next few pages, I provide a step-by-step example in which the Basic panel adjustments are applied first in order to correct the white balance, recover lost highlight detail, and improve the overall contrast in the photograph. Tone Curve adjustments follow to fine-tune the tonal balance and bring out more detail in the highlights and shadows. You can do a lot to improve the appearance of a photograph by making just a few Basic and Tone Curve adjustments. With careful use of the controls, it is possible to edit the tones in a picture such that there will be no need to apply any localized dodging and burning to get the look you are after.

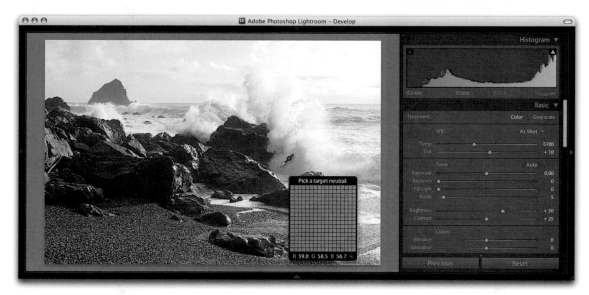

1. Here is a raw image where just the default Lightroom Develop settings have been applied. I first corrected the "As Shot" white balance. I then selected the White Balance tool and rolled the cursor over an area that I wanted to make neutral.

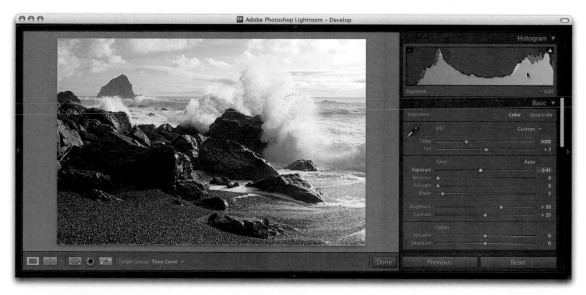

2. I clicked with the White Balance tool and was pleased with the cooler color temperature setting this gave me. I then proceeded to darken the Exposure setting, which I did by clicking on the mid-section of the histogram, holding the mouse button down, and dragging it to the left.

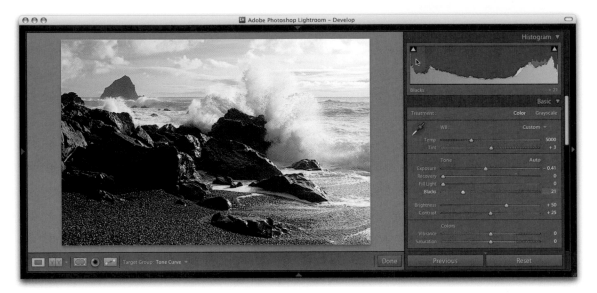

3. The Exposure slider can mainly be used to make the image brightness look right without worrying too much about the highlights. Next, I adjusted the Blacks slider to set the shadow clipping point. I clicked on the shadow end of the histogram graph and again held the mouse button down, and dragged to the left. Note: Dragging to the left in the histogram increases the amount of clipping in the Blacks.

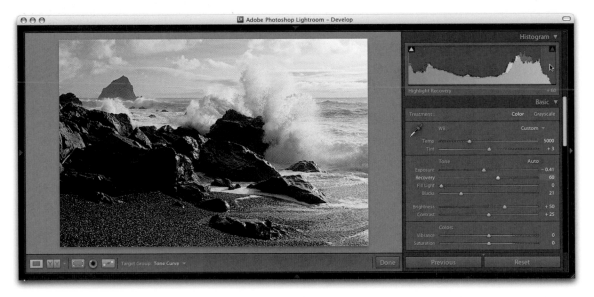

4. In this step, I applied a Recovery setting of +60, which helped prevent the highlights from becoming too clipped.

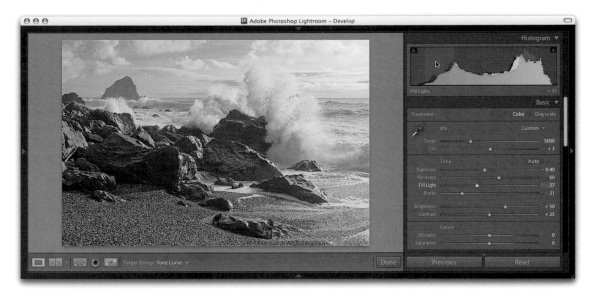

5. I wanted to preserve as much shadow detail as possible, so I clicked on the Fill Light zone of the histogram and while holding down the mouse button, dragged the mouse to the right to add more Fill Light in the shadows.

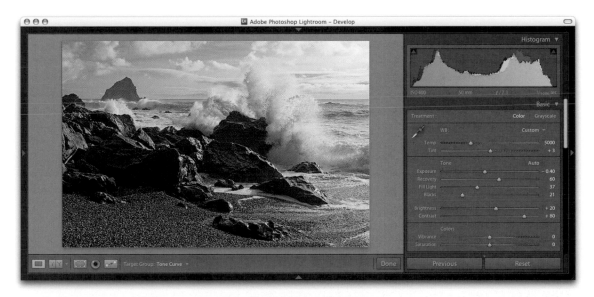

6. At this point I could have completed the Basic panel tone editing by applying a reduction to the Brightness and a major boost to the Contrast to achieve what could be considered an acceptable finished result.

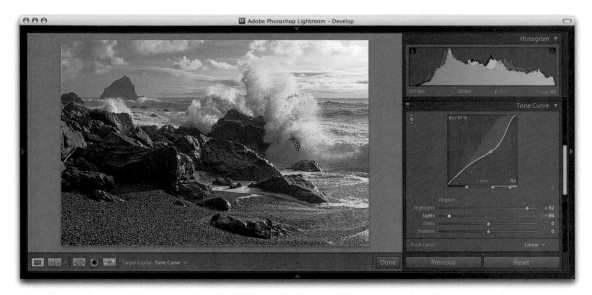

7. Instead of using Brightness and Contrast, I reverted back to the settings in step 5. I opened the Tone Curve panel and used the Tone sliders to improve the brightness and contrast. With the Tone Curve panel in Target mode, I clicked on the clouds, held down the mouse button, and dragged the Highlights to +72. I then clicked on the shaded spray and dragged the Lights down to -84. Notice how the steep curve increased the contrast in the Lights and Highlights zones.

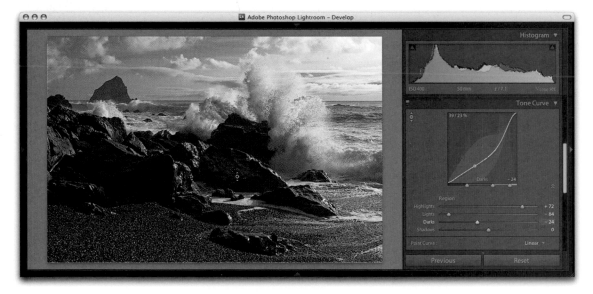

8. I then clicked on the rocks and dragged downwards to take the Darks zone down to -24%.

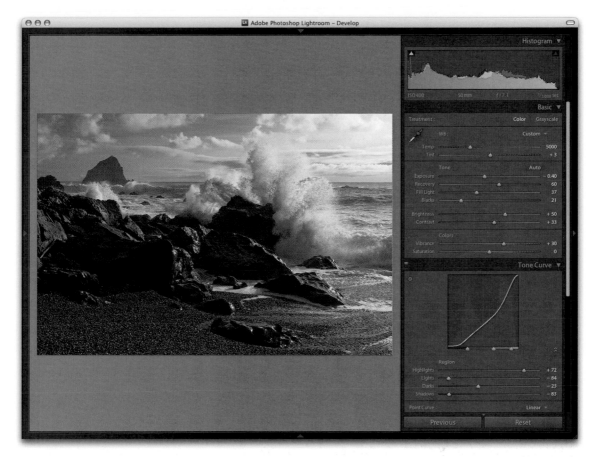

9. In this final version, I rolled the mouse over the shadows on the rocks and clicked, dragging downwards to darken them to -83%. At this stage, I had completed all the main Tone Curve adjustments and the image was looking more interesting than in step 6. But the Tone Curve editing didn't end there: I clicked on the Split Point sliders and dragged them to fine-tune the curve shape and achieve the exact tone mapping I was after. If you compare the version shown here with the one in step 6, the earlier version is perfectly acceptable, but the Tone Curve panel provides you with a more versatile version of the Brightness and Contrast controls. With those controls you have almost complete control to shape the curve any way you like using just the four Tone Range controls plus the Split Point adjustment sliders.

Tone Range Split Point adjustments

The Tone Range Split Points are located at the bottom of the tone curve. Note that I have added emphasis to the figure diagrams shown below to underscore this feature (**Figures 4.35**, **4.36**, and **4.37**).

Figure 4.35 *The screen shot on the left shows a tone curve with the Tone Range Split Points in their normal positions with equal spacing for the Shadows, Darks, Lights, and Highlights zones. The middle example shows the Shadows zone set to its widest extent, compressing the other three zones. The example on the right shows the Highlights zone set to the widest point allowed.*

TIP

You can always double-click the Tone Range Split Points if you need to reset them to their default settings.

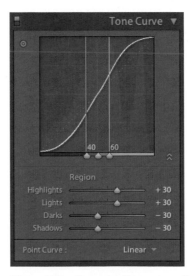 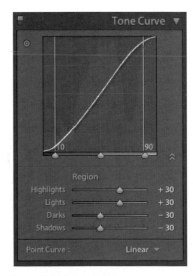

Figure 4.36 *By moving the two outer Tone Range Split Points in closer you can increase the midtone contrast, and you can reduce the contrast by moving them farther apart.*

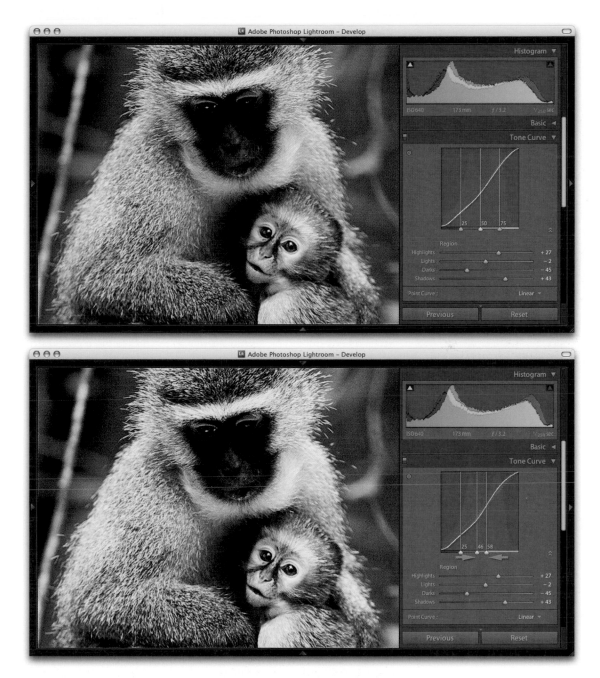

Figure 4.37 *These screen shots show a photograph where all the Tone Curve zone settings have been altered. In the top screen shot, the Tone Range Split Points are in their default positions and the Tone Curve zones are evenly divided. In the lower screen shot I moved the sliders to compress the width of the Lights zone and thereby increased the contrast in the Lights tone area.*

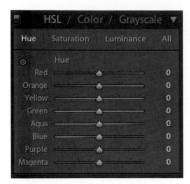

Figure 4.38 *The HSL / Color / Grayscale panel with the HSL mode selected.*

Figure 4.39 *The HSL / Color / Grayscale panel with the Color mode selected.*

NOTE

Mark Hamburg and Thomas Knoll are pretty pleased with the way the color sliders break with the traditional additive and subtractive primary color slider controls. The colors chosen here provide a more practical range of color hues to work with. They are the ones that more usefully match the colors that people most often want to adjust.

NOTE

The Saturation slider controls apply a nonlinear saturation type adjustment (similar to what the Vibrance slider does). This means that as you increase the saturation, lower saturated pixel values are increased more relative to the already higher saturated pixel values in an image.

HSL / Color / Grayscale Panel

The HSL / Color / Grayscale panel is an all-in-one panel for fine-tuning targeted color adjustments and grayscale conversions. The HSL component is kind of equivalent to the Hue/Saturation dialog found in Photoshop except in Lightroom you can now apply these types of adjustments to raw images, not just pixel images (although you can do this now in Photoshop CS3). Essentially, you have three color adjustment sections for controlling the Hue, Saturation, and Luminance over eight color band ranges with Target Adjustment tools available for each. The Color section of this panel provides a more simplified version of the HSL controls, with button selectors to choose the colors and Hue, Saturation, and Luminance sliders. In addition is the Grayscale section, which I discuss later on in this chapter.

The sliders in the Hue section control the hue color balance and allow you to make subtle (or not so subtle) hue color shifts in each of the eight color band ranges. For example, if you start with the Green Hue slider, dragging the slider to the right makes the greens more cyan, while dragging the slider to the left makes the greens more yellow. The sliders in the Saturation section control the color saturation. Dragging a slider to the right increases the saturation, while dragging to the left decreases the saturation to the point where if all the Saturation sliders were dragged to the left, you could convert the whole of the image to monochrome. The sliders in the Luminance section darken or lighten the colors in the selected color ranges. If you click on the All button, the panel expands to reveal a complete list of all the sliders. As with the Tone Curve panel, the HSL controls can be applied in a Target Adjustment mode. Just click to select an HSL section such as "Hue," "Saturation," or "Luminance," and then click the Target Adjustment tool button to switch to Target Adjustment mode. Click and drag up or down with the mouse to adjust the tones that match where you are dragging. The HSL / Color / Grayscale panel should be considered a color adjustment tool for use in those situations where you need to target specific colors and fine-tune color adjustments. The Target Adjustment controls are specific to each section of the HSL panel, so do be careful when switching between Hue, Saturation, and Luminance to activate the Target mode in whichever section you are editing with. You can turn off the Target Adjustment tool by clicking the button again, or pressing ⌘ Alt Shift N (Mac) or Ctrl Alt Shift N (PC).

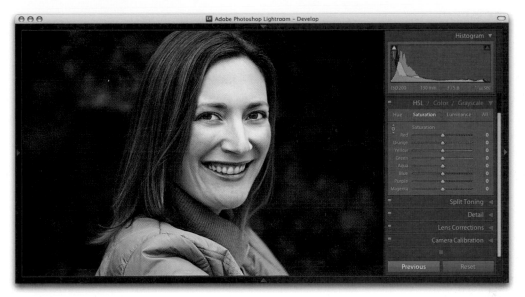

1. If you shoot a lot of skin tones, you might consider creating a custom camera calibration (see page 180). But if you are shooting a mixture of subjects with the same calibration, you can also use the HSL Color Tuning panel to compensate for reddish skin tone colors.

2. In this example, I went to the Hue section and clicked to activate the Target Adjustment tool. I then clicked on a skin tone area in the picture and dragged the mouse upwards to make the skin tones less red and more yellow.

The Target Adjustment tool can also be activated using the following shortcuts: Press ⌘ Alt Shift H (Mac) or Ctrl Alt Shift H (PC) to turn on the Hue Target Adjustment tool. Press ⌘ Alt Shift S (Mac) or Ctrl Alt Shift S (PC) to turn on the Saturation Target Adjustment tool. Press ⌘ Alt Shift L (Mac) or Ctrl Alt Shift L (PC) to turn on the Luminance Target Adjustment tool. And press ⌘ Alt Shift N (Mac) or Ctrl Alt Shift N (PC) to turn off the Target Adjustment tool.

Selective color darkening

At first glance, the HSL controls in Lightroom appear to be the same as those in Photoshop's Hue/Saturation dialog, but if you experiment a little further with the HSL controls, you will notice some distinct differences. Although the hue shift increments are the same as those in the Photoshop Hue/Saturation dialog, the Lightroom Hue slider adjustments are somewhat tamer than their Photoshop cousins. In Lightroom you are limited to a hue shift of just 30 degrees in either direction. Looking back at the example on the previous page, if I were to drag the Red hue slider fully to the left, I could make the skin tones more magenta, and if I dragged it to the right, I could make them more yellow. But I can't make the skin tones go green (as I can with Photoshop)! There is still some room to go crazy and do things like turn blue skies purple or upset the white balance, but the hue adjustments in Lightroom are definitely more constrained. The Saturation sliders respond more or less the same as they do in Photoshop, but the most marked differences are revealed when working with the Luminance controls. When you adjust the Lightness in the Photoshop Hue/Saturation dialog, the colors mostly tend to lose their saturation, and to selectively darken a color in Photoshop, you often have to search for a magic combination of saturation and lightness that will achieve the desired result. But the Lightroom sliders really do respond the way you would expect them to. The Luminance sliders can provide you with complete control over the luminance of any color range as shown in the accompanying screenshots.

1. In the image at the top of the facing page, the challenge is to simulate the effect of a polarizing lens filter and darken the blue sky without affecting the tonal balance of any of the other colors. If I was working on this image with the Hue/Saturation adjustment in Photoshop, it would be tricky to find the exact Saturation and Lightness values that would make the blue sky go darker.

2. If I want to darken the sky in Lightroom, all I have to do is switch to the Target Adjustment mode in the Luminance section, and click on an area of sky and drag downwards. As you can see in the image at the bottom of the facing page, this mainly reduces the Blue slider luminance. A word of caution though: You may need to adjust the Detail panel controls to reduce unwanted halos. Here, I set the Color noise to zero.

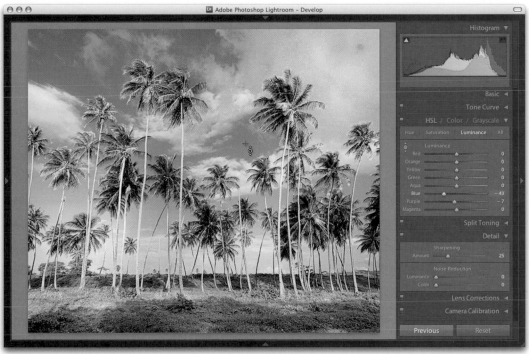

Figure 4.40 *The Detail panel controls.*

Fine-tuning Images

Detail Panel

With the Detail panel you can improve the sharpness and reduce noise that is present in an image (**Figure 4.40**). The Amount slider lets you adjust the amount of sharpening that is applied to the image. In Lightroom, the default behavior is to apply no Detail panel adjustments to an image unless it is recognized as a raw capture. Raw capture images should always require some degree of sharpening and noise filtering, whereas JPEG captures already have had some level of sharpening and noise processing applied in-camera (see "Raw or JPEG?" on page 126). Other pixel images such as TIFFs and PSDs should not require any Detail processing unless you are working on an unsharpened scanned image. If a pixel image has already been sharpened, the last thing you want is for more sharpening to be applied after it has been imported into Lightroom.

There are many reasons sharpening might be necessary. Perhaps the lens optics on your camera are not as sharp as they could be, and a little extra sharpening will make the picture look more detailed. But it is more common that the process of converting the light information that hits the photo sites on the sensor and subsequent digital data processing will result in an image with softer edge detail than would normally be considered desirable. A little sharpening at the post-capture stage is often necessary to produce an image that is sharp enough to look good on the screen, but without being overly sharpened. If an image is sharpened too much at this stage, you may end up with artifacts that will only be compounded as additional adjustments are made to the photograph. Therefore, presharpening should be applied to raw capture images in moderation. Some raw image processing programs apply sharpening in a clandestine way, giving the impression that their raw processing is by default somehow sharper than everyone else's. Other programs such as Lightroom don't hide the fact that there is a certain level of sharpening being applied and give you the option to turn sharpening off completely by setting the Amount slider to zero.

Presharpening is about striking the right balance between compensating for the image softness in a raw file while avoiding the problems that can be caused by oversharpening at this preliminary stage. At this point I should mention that to produce crisp print output, further sharpening is necessary. The amount of sharpening required varies

according to many factors, such as the print process, print size, print resolution, and the type of paper used. But all you are doing with the Detail panel settings in the Develop module is applying a small amount of presharpening to the raw capture images only.

The Sharpening applied at the Develop module stage uses an edge detection method to achieve a sharper image without generating visible halos around the sharp edges. A Threshold setting is calculated automatically behind the scenes, based on the metadata in the raw camera file. So although there is only a single sharpening control, the Amount slider actually offers a more sophisticated approach to sharpening compared with the Unsharp Mask filter controls in Photoshop. But be careful not to apply too much sharpening. The 25% default setting provides a useful starting point, and you should probably use this setting for all your raw image processing unless you intend to use a third-party sharpening product. In which case, you should make sure that the image is exported or sent to Photoshop as a pixel-edit file with absolutely no sharpening applied to the image. On the whole I find the sharpening in Lightroom more than serviceable for most images, but for precision sharpening, I would still recommend using a third-party sharpening method such as PhotoKit Sharpener.

The other controls in the Detail panel can be used to suppress image noise, which will always be present to a greater or lesser extent. If you are shooting with a good quality digital camera at the standard ISO setting, you will be hard-pressed to see any noise in an image. But not all cameras are the same, and some camera sensors are particularly prone to showing noise, especially at the higher ISO capture settings. Image noise can be characterized in two ways. Color noise is usually the most noticeable and most ugly aspect of a noisy image. The Color slider will mostly get rid of the noise by tackling the color noise. If necessary, you can move the slider all the way up to 100% to remove the color noise artifacts. But be aware that some images can look a lot worse if you try to remove all the color noise with a high Color setting. Figure 4.55 on page 206 shows how setting the Color slider too high can soften detail in the blue channel. With very noisy images, an electronic grain can remain that is more like a fine speckled noise pattern. The Luminance slider in the Detail panel can help you smooth out the luminance noise. As with the Sharpening slider, you want to exercise caution here. The default Luminance setting is 0%. You could try raising this to around 5–20%, but it shouldn't be necessary to go beyond 40% except in extreme circumstances.

TIP

It is wonderful having tonal adjustment controls that allow you to pull more information out of the shadows, but one of the incidental results is that Lightroom is more capable of highlighting shadow noise problems. Many camera manufacturers are only too painfully aware of the problems of shadow noise and do their best to hide it by deliberately making the shadows darker to help hide any shadow noise. Some raw processor programs from camera manufacturers apply a shadow contrast tone curve by default. If you use the Tone Curve controls in Lightroom to bring out more shadow information, just be aware that they will emphasize any shadow noise in the image. It is therefore always worth inspecting the shadows close-up after making such adjustments and checking to see if the Luminance and Color sliders are needed to hide any noise.

NOTE

The Photokit Sharpener plug-in mentioned is a third-party sharpening plug-in for Photoshop that was created by Bruce Fraser of PixelGenius LLC, of which I am also a partner. To find out more about this product, go to www.pixelgenius.com/sharpener.

Sharpening an image

Lightroom sharpening is applied mostly to the edges and minimizes the generation of halos that can lead to problems further down the line as you start editing the image. Lightroom sharpening should work well on most subjects. If you feel the need to increase the sharpening above the default 25% level, check the whole image carefully at the 1:1 pixel view to ensure that the sharpening is not generating any unwanted artifacts (**Figure 4.41**). If you prefer to sharpen your images outside Lightroom, this can be done after you have made all your image edits and basic retouching. Choose Photo ⇨ Edit in Photoshop to apply the sharpening, and then save and close the file in Photoshop to bring the image back into Lightroom as a pixel edited image.

Figure 4.41 *In Lightroom, imported raw images use a default 25% Amount setting, because all raw images require some level of sharpening at the post-capture stage. If you are confident with the way Lightroom sharpens your pictures, you can leave the defaults as they are, or carefully inspect the image at an actual pixels view to see if a higher amount would improve the image without creating any artifacts. A small amount of luminance noise reduction can help suppress such artifacts as well as any luminance image noise.*

Removing noise

Get to know your camera and how the sensor responds to different lighting conditions. Some cameras fare better than others in low-light conditions: there will always be a trade-off between shooting at a medium ISO setting with a slower shutter exposure and shooting at a high ISO setting with a faster shutter exposure. Consider using a tripod or image stabilizing lenses as an alternative to shooting at the highest ISO setting. Where noise is a problem, I recommend using the Color slider first to remove the color noise followed by the Luminance slider to remove the fine luminance noise artifacts (**Figure 4.42**). Note that increasing the smoothness will compromise the sharpness. But don't be too paranoid about noise. There is no point in trying to remove every bit of noise, because the print process can be very forgiving!

TIP

Avoid turning the Color slider up to 100% every time you encounter a high ISO, noisy image. The noise reduction works by blurring the blue channel. If you have important information in the blue channel, you can end up softening the image detail.

Figure 4.42 *This close-up view of an interior was shot at the highest ISO setting on a Canon EOS 1Ds Mark II camera. The image is shown in halves. On the left is the Before view with no Detail adjustments and on the right the After version where I applied a 21% Luminance and a 100% Color setting. The Color noise reduction removed nearly all of the color noise, and the Luminance setting removed most of the luminance noise. A higher Luminance setting would have smoothed out even more of the noise, but this might have resulted in a softer-looking image.*

Figure 4.43 *The Lens Corrections panel controls.*

Lens Corrections Panel

The sensors in the latest digital SLRs and medium format camera backs are able to resolve a much finer level of detail than was possible with film. As a consequence, any deficiencies in the lens optics are even more apparent. To address these problems, some camera companies have designed "digital" lenses that are specially optimized to provide finer image resolution or in the case of non-full frame sensor cameras, lenses that are optimized for a smaller sized sensor chip.

Where lens aberrations are a problem, the controls in the Lens Corrections panel are able to address and correct such optical lens deficiencies (**Figure 4.43**). The Chromatic Aberration sliders include the Red/Cyan and Blue/Yellow controls. Chromatic aberrations are caused by the inability to focus the red, green, and blue light wavelengths at the same distance along the optical axis. As a result, in an image where some color wavelengths are focussed at different points, you may see color fringes around edges of high contrast. This can be particularly noticeable when shooting with some wide angle lenses (especially when they are being used at wider apertures). You may well see color fringing occur in areas of high contrast towards the edges of the frame. The Chromatic Aberration sliders are able to correct such lens problems by very slightly expanding or shrinking one of the RGB channels relative to the other two. So if you adjust the Red/Cyan slider, the red channel expands or shrinks relative to the green and blue channels. If you adjust the Blue/Yellow slider, the blue channel expands or shrinks relative to the red and green channels. If you hold down the Alt key as you drag on the Chromatic Aberration sliders, you will see a more neutral color image in which the color fringe edges are easier to detect. As with the Detail panel controls, you must really inspect the image at the actual pixels view size to gauge these adjustments correctly. In particular, you will need to scroll the image to carefully examine the corner edges where fringing will more likely be at its worst. As just mentioned, these problems are more common with wider angle lenses, so you may find you need to share the lens correction settings made for one image across several others in a series (providing that they were all shot with the same lens at the same zoom setting and same aperture). In the previous chapter I explained how the Metadata Browser panel lets you quickly view all images that were shot with the same camera lens. This ability to quickly filter and group images can be useful if you want to synchronize a subset of Lens Corrections settings. The following images illustrate the problem.

1. This photograph of a cinema sign is shown at a 200% close-up view. If you look carefully, you can see some color fringing around the sharp edges of the sign, which indicates a problem caused by the lens. This can be resolved by adjusting the Chromatic Aberration sliders in the Lens Corrections panel.

2. I first adjusted the Red/Cyan slider to remove the more noticeable red fringe along the lower side of the edges in the picture and then made a more minor Blue/Yellow adjustment.

Removing a vignette

Lens vignetting is also more common with wider angle lenses and is particularly noticeable if the subject you are photographing contains what should be an even shade of tone or color. For example, if you are photographing a landscape with a large expanse of sky or viewing a photograph taken against a plain wall, it is in these types of situations that you may become more aware of any lens vignetting problems that are noticeable as a darkening of the image toward the corner edges. The Amount slider can be used to lighten the outer corners relative to the center, and the Midpoint slider will adjust the midpoint of the vignetting adjustment from the center toward the edges.

The images on the opposite page are good examples of how to remove a vignette from a landscape photograph. Most of the correction is done by first adjusting the Amount slider, followed by fine-tuning the Midpoint slider to balance the vignette from the center to the edge. The correction now precisely matches the vignette in the photograph. And just as you can use the Lens Vignetting sliders to remove a vignette, you can also use them to apply a vignette as well. I quite often like to deliberately darken or lighten the edges of a photograph and use the Lens Vignetting sliders as basic dodge or burn tools for the corners of a photograph.

1. Vignetting is always more noticeable in photographs where there is a large area of flat continuous color or tone. When you photograph a scene with a deep blue sky, such as the one in the topmost image on the opposite page, the sky will always be a light blue at the horizon falling off to a darker, deeper blue at the top of the frame. But even so, the increase in density towards the corners is still noticeable.

2. Now compare the bottom version with the top image. In the bottom image, I applied some lens vignetting adjustments via the Lens Corrections panel. I entered a positive value for the amount to lighten the corners and then fine-tuned this anti-vignetting adjustment by tweaking the Midpoint slider.

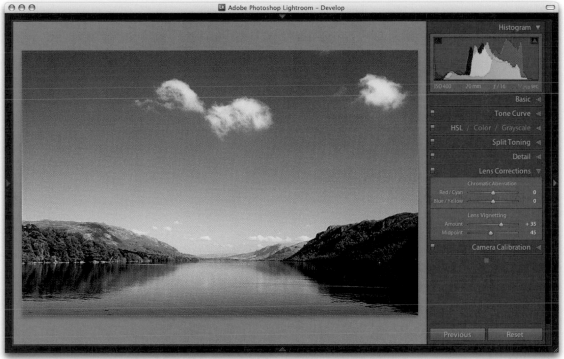

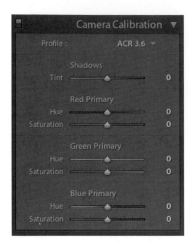

Figure 4.44 *The Camera Calibration panel controls.*

Camera Calibration Panel

The camera raw conversions in Lightroom are the result of many years of painstaking work, in which Thomas Knoll (who with his brother John created the original Photoshop program) evaluated the color response of lots of different cameras. Basically, for each camera raw format that is supported, Thomas made two profiles that measure the camera sensor's color response under controlled daylight and tungsten lighting conditions. Using this data, it has been possible to extrapolate what the color response will be for all white balance lighting conditions that fall between these two setups and beyond.

About 150 different cameras are supported by Adobe Camera Raw (ACR) and Lightroom, and in some instances several camera samples were tested to obtain a representative average set of measurements. Other times only one camera model was actually used. But in all cases it is clear that the measurements made by Thomas can only ever be as good as the camera or cameras from which the measurements were made (and how representative these were of other cameras of the same make). As you know, the sensors in some cameras can vary a lot in color response from camera to camera. This variance means that although a raw file from your camera may be supported by Lightroom, there is no guarantee it will be exactly similar in color response to the raw files from the cameras Thomas evaluated. This is where the Camera Calibration panel comes in. The Camera Calibration panel sliders can be used to make fine-tuned adjustments to the color response (**Figure 4.44**). See also "Color Calibration panel color effects" and Figures 4.46, 4.47, and 4.48.

Creating a custom calibration via Photoshop

If you have Photoshop CS or later, you can automatically create a custom calibration for your camera that involves the use of Thomas Fors ACR Calibrator script. This script works for Mac or PC and can be downloaded from http://fors.net/chromoholics. Install the script in the Photoshop application/Presets/Scripts folder, then restart Photoshop and follow the step-by-step instructions in the following steps. The script will open a new ACR Calibrator Status Window (**Figure 4.45**) and run through a series of procedures, in which the raw image containing the Color Checker chart is opened many times using different settings to measure the results. This process can take a very long time to complete, which is why it is important to keep the bit depth at 8-bits per channel and the image size small. It will also help if you hide all the palettes before you run the script.

1. To use the Adobe Camera Raw Calibrator script, you will need to photograph a Gretag Macbeth ColorChecker chart and open the raw file via the Adobe Camera Raw dialog in Photoshop. Use the White Balance tool to measure the circled patch (next to the white patch). Next, crop the image tightly around the ColorChecker chart, set the crop size to the smallest resolution possible and set the bit depth to 8-bits per channel. Click Open to open the image in Photoshop.

2. With the image open in Photoshop, select the Pen tool with the Paths mode option selected in the Tool Options bar. Click with the Pen tool on the brown patch, followed by the white patch, the black patch, and lastly the blue-green patch. Now go to the File ⇨ Scripts and select the ACR Calibrator script. The script will automatically open the raw file many times over and gradually build a Calibrator status report in a new Photoshop document.

Figure 4.45 *Here is the ACR Calibrator Status Window after the script has run its full course. I have highlighted the calibration settings in yellow. You need to write these figures down, enter them in the Calibration panel in Lightroom and save them as a custom calibration setting for your camera. You may also want to make a note of the Color Temp (temperature) white balance and Tint settings, and save them as part of your custom calibration setting.*

Camera Calibration panel color effects

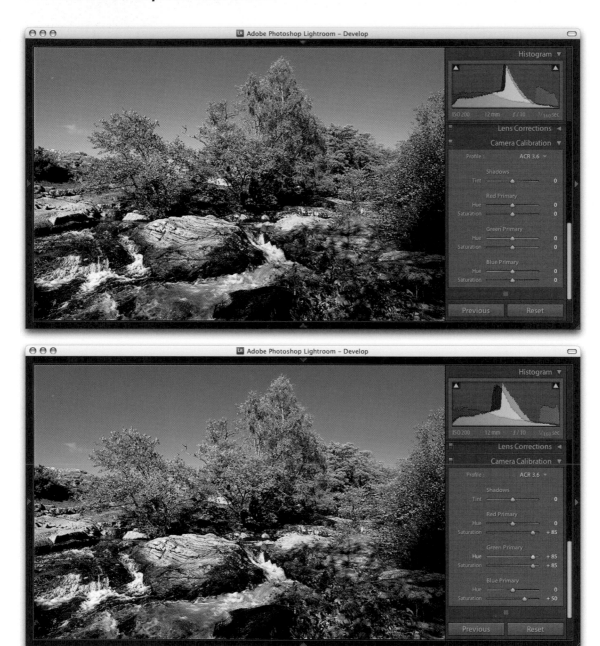

Figure 4.46 *The top screen shot is a standard version of an image with zeroed Camera Calibrate settings. The lower screen shot is a vivid color setting that was created using the Camera Calibration settings shown here.*

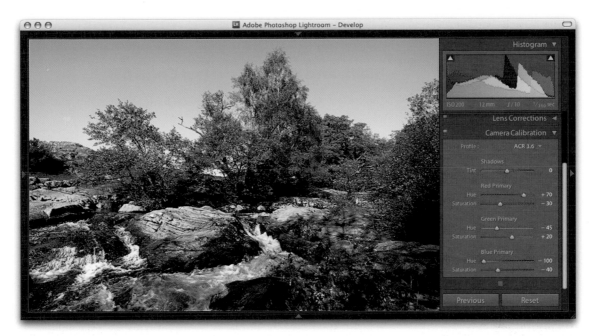

Figure 4.47 *To create this color infrared effect, I used the Camera Calibration settings shown here. In addition, I set the Shadows in the Split Toning panel to Hue 180 and Saturation 25.*

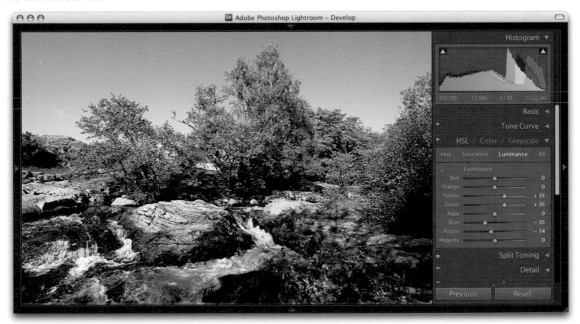

Figure 4.48 *To create this magenta sky effect, I used the Camera Calibration settings shown here. In addition, I set the Yellow luminance in the Color Settings panel to +35 and the Greens luminance to +35.*

Black and White Conversions

Black and White Develop Controls

The easiest way to convert a color image to monochrome is to click the Grayscale button (V) in the Basic panel, or click Grayscale in the HSL / Color / Grayscale panel. Either method immediately activates the Grayscale Mix controls and converts the photograph to black and white (**Figure 4.49**). The term "Grayscale Mix" is a little misleading, since Lightroom is not actually converting a color image to grayscale mode, but rather it is creating a desaturated version of the color original that remains in RGB mode. What Lightroom is doing here is blending the grayscale information contained in the individual red, green, and blue channels that make up a composite RGB image. If you have ever played with the Channel Mixer controls in Photoshop, the Grayscale Mix controls will appear familiar. In Lightroom, however, there are eight color slider controls to play with instead of three. This provides you with more subtle control over the channel mixing than you had in Photoshop. But more subtle can also mean more complex. To make things a little easier, the Grayscale Mix panel offers an Auto-Adjust button that, when you click on it, applies an automatic monochrome conversion that is determined by the White Balance set in the Basic panel. You can then vary a grayscale mix effect by adjusting the Temperature and Tint sliders up in the Basic panel.

If you deselect the Auto-Adjust box in the Grayscale Mix section, you will have full control over the individual sliders; and these can be adjusted any way you like to create custom black and white conversions like those shown in **Figure 4.51**. The great thing about the Lightroom Grayscale Mix is how the tonal balance of the image automatically compensates for any adjustments you make. Even so, it may still be necessary to revisit the Basic panel and readjust the Tone controls such as the Exposure, Brightness, and Contrast after you have made a major Grayscale Mixer adjustment. The Split Toning section can be used to add split tone color effects to a black and white image, but can also be used on color originals to produce cross-processing effects. As always, favorite Develop settings can be saved as presets in the Presets panel, and a couple of black and white presets are there for you to play with, such as the Antique Grayscale.

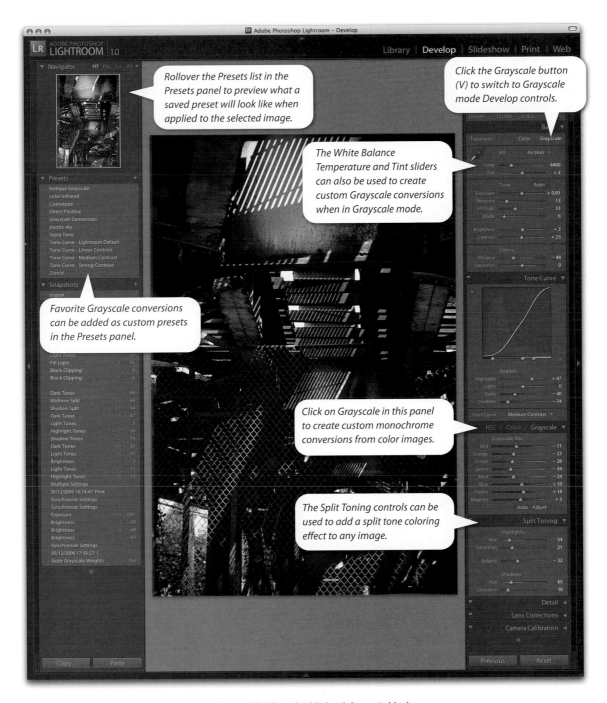

Figure 4.49 *In this screen shot of the Develop module, I have highlighted the main black and white adjustment controls.*

Figure 4.50 *An RGB image consists of three grayscale channels that describe the red, green, and blue color information at the time of capture. The red, green, and blue information is then combined together to describe the RGB component image. Here already you can see three quite different black and white interpretations of the original color photograph.*

Black and White Conversion Options

In the early days of black and white photography, film emulsions were limited in their color response. Most of these film emulsions were mainly sensitive to blue light only, which is why the skies in old photographs often appear white, and the photographer could process his or her films in the darkroom using a red safe light. As film emulsion technology improved, panchromatic black and white films began to emerge, and film photographers were able to creatively exploit the improved color sensitivity in these modern film emulsions. This next section shows you how to continue that tradition when working with digital captures.

An RGB color image such as a raw-processed digital capture is made up of three grayscale images that recorded the luminance information in the original scene as it passed through red, green, and blue filters over-laying the photosites on the camera sensor. The RGB color image you preview on the computer screen is a composite of those three grayscale channels as displayed through the tiny red, green, and blue filters in the LCD screen. **Figure 4.50** shows the individual color channels that make up the RGB full-color image shown in **Figure 4.51**. Before I explain how to use the Grayscale Mix controls, I just want to convey the general principle of how the three RGB color channels can be blended together to produce different types of black and white conversions.

I often hear of photographers who unnecessarily limit their black and white options, because they are simply unaware of the grayscale conversion techniques that use all the color channels in a color image. For example, some people set their cameras to shoot in a black and white JPEG mode. This not only restricts the tone adjustment options, but also the black and white conversion options. The camera's onboard image processor decides on the fly how to blend the color channel information and produce a fixed color to black and white conversion. You are consequently left with no room to maneuver, because all the color data is thrown away during the in-camera JPEG conversion process. Then there is the RGB to Lab mode method in which you delete the a and b channels and convert the remaining Lightness channel to Grayscale mode. But I better be careful of what I say about Lab mode editing because of late there has been a resurgence of interest in the Lab color space. But I would say that there is nothing to be gained from this approach, because yet again, you are throwing away all the color data before you make the conversion.

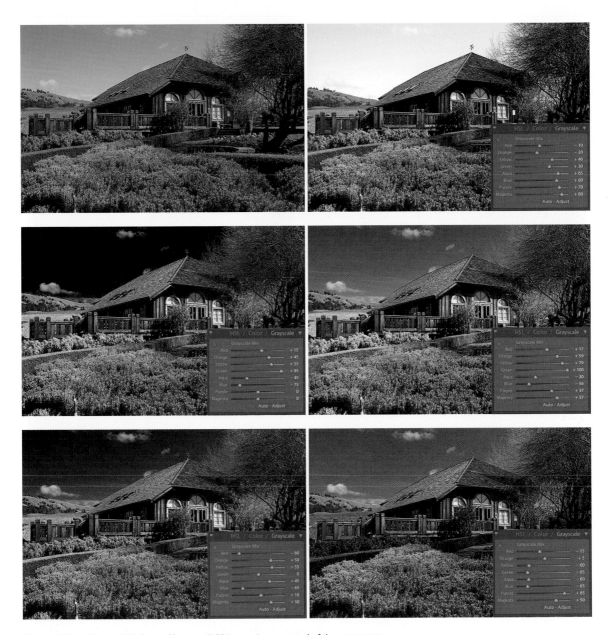

Figure 4.51 *Figure 4.50 showed how an RGB image is composed of three separate grayscale channels representing the red, green, and blue colors in the final composite. The Grayscale Mix enables you to blend the color channel information in many different ways to produce very different monochrome conversions from a color original.*

Temperature Slider Conversions

Let's now look at how to use the Grayscale Mix in Lightroom to convert a color image to black and white (**Figure 4.52**). As just mentioned, one method is to click the Grayscale button in the Basic panel and adjust the White Balance settings. **Figure 4.53** shows two possible black and white outcomes that can be achieved by first dragging the temperature (Temp) slider in the Basic panel and then clicking the Auto-Adjust button in the Grayscale Mix section of the HSL / Color / Grayscale panel. The top version in Figure 4.53 shows a white balance with a warm bias. Notice that the blue sky tones appear darker and the terra-cotta pots appear lighter when they are converted to black and white. When the Temp slider is dragged in the opposite direction as seen in the bottom picture, the blue sky tones appear lighter and the pots darker. You can adjust the Tint slider too. For example, dragging the Tint slider to the left makes the cactus plants appear lighter relative to the other tones.

The optimum settings very much depend on the subject matter. The following step-by-step exercise shows you how to optimize the black and white conversion of a color portrait using the Grayscale Mix and White Balance Temp slider.

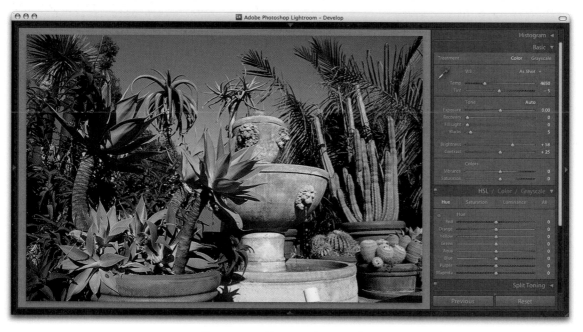

Figure 4.52 *Here is a color original. Compare the monochrome conversions on the next page with the red, green, and blue colors in this photograph.*

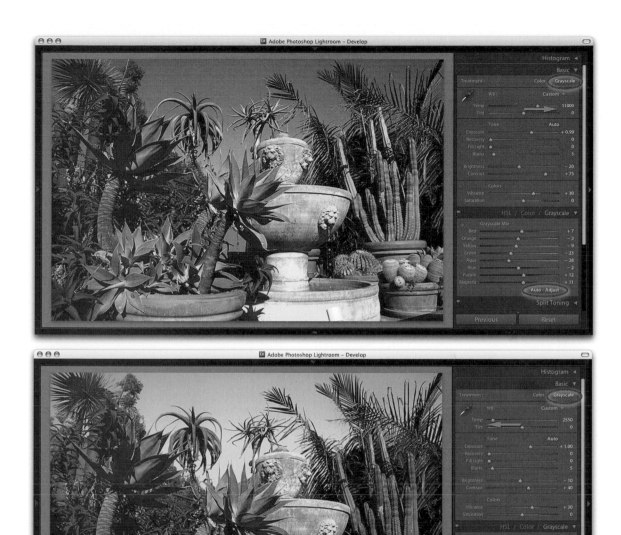

Figure 4.53 *Here are two grayscale versions of the color image shown in Figure 4.52. Note that the Grayscale button is selected in the Basic panel, which switches the controls in the HSL / Color / Grayscale panel to Grayscale mode. After making a change to the White Balance settings, you need to click the Auto-Adjust button to update the auto settings in the Grayscale section. The top version shows a warm white balance temperature conversion, and the bottom version shows a cool white balance temperature conversion.*

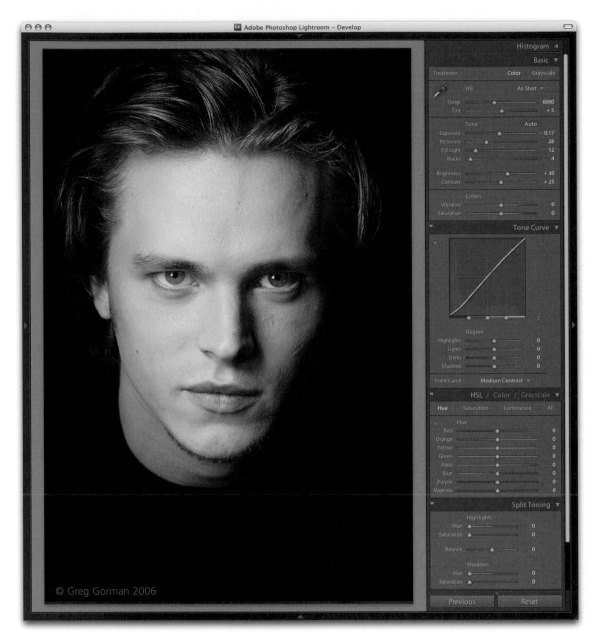

© Greg Gorman 2006

1. Let's look at how the Grayscale Mix controls in union with the White Balance Temp Slider can affect grayscale conversions. Here is an original color photograph of the actor Jonathan Jackson, photographed by Greg Gorman. This photograph uses the default Develop settings in Lightroom.

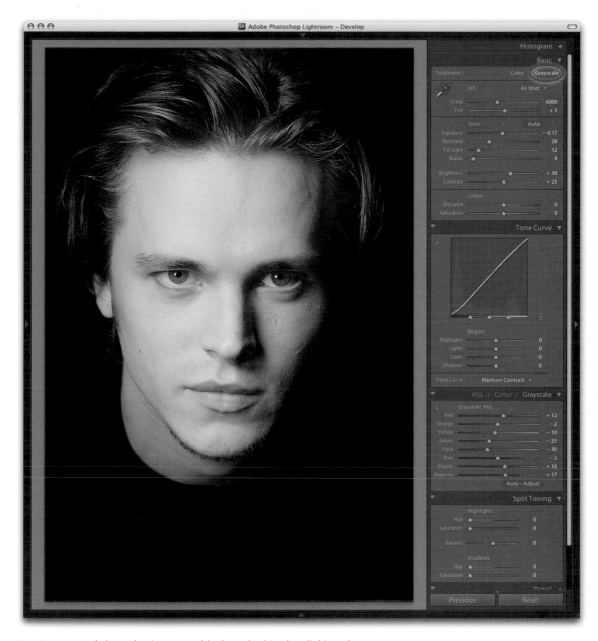

2. I converted the color image to black and white by clicking the Grayscale button in the Basic panel (circled). The default Grayscale Mix in the HSL / Color / Grayscale panel applied an auto adjustment that was based on the current White Balance Temperature and Tint settings. As default conversions go, this is not a bad starting point to work from.

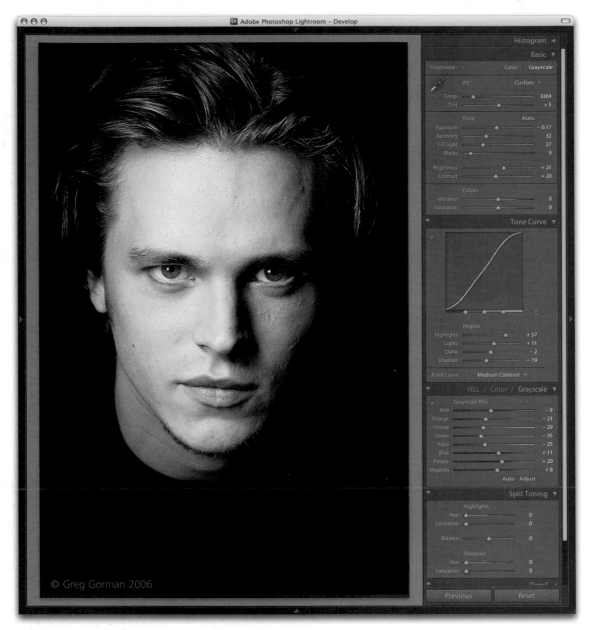

© Greg Gorman 2006

3. I then adjusted the White Balance Temp slider to find an optimum setting that would yield the best skin tone contrast and kept clicking the Auto-Adjust button to update the Grayscale Mix settings. I also adjusted the Tone Curve settings. The goal here was to increase the tonal contrast that produces deeper shadows while preserving all the information in the skin tones.

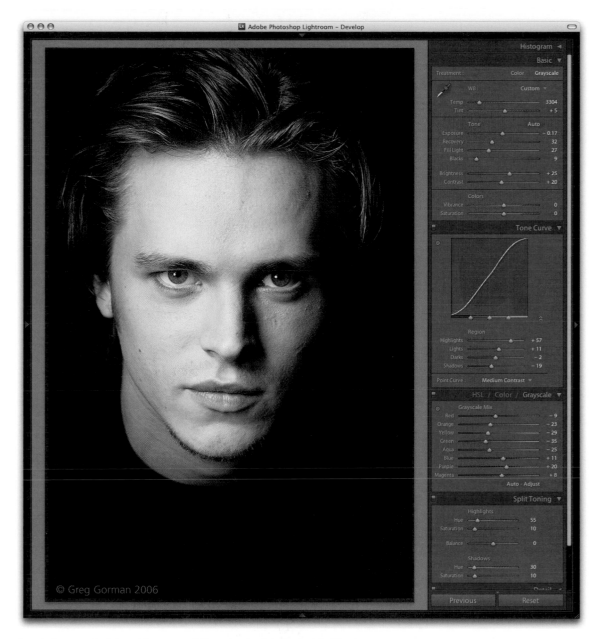

© Greg Gorman 2006

4. I also wanted to add some subtle color toning to the finished photograph. So I used the Split Toning panel to add a red highlight and yellow shadow split tone (black and white split tones are covered in the next section).

Figure 4.54 *The Split Toning panel.*

Fine-tuning Black and White Images

Split Toning Panel

It should be fairly easy to produce a neutral gray print, as long as you have a good profile for your printer or are using a printer and ink combination that are specifically designed for black and white work. It should not even matter how well your monitor is calibrated. If an image is in black and white, you should be able to produce a perfectly neutral gray print regardless of how the photograph looks on the screen. If you do not see perfectly neutral black and white prints, there may be something wrong with your printer profiles, or if using an inkjet printer, the print heads may need a cleaning.

The Split Toning controls are mainly intended for use on images after they have been converted to monochrome, when you want to deliberately add some color to the monochrome tones in a photograph (**Figure 4.54**). The Hue sliders can be used to adjust the hue color in either the highlights or the shadows and the Saturation sliders can be used in conjunction with the Hue sliders to apply varying strengths of color tone. Note that if you hold down the Alt key as you drag a Hue slider, you get a saturation boosted preview that can help you tell more clearly which hue color you are selecting without having to change the Saturation slider setting. The Balance slider lets you offset the balance between the shadow and highlight color toning. This extra slider control provides you with a really nice fine-tuning control to your split tone effects.

Split toning is a popular technique that has long been favored by photographers who were used to working in a black and white darkroom. In the old days, photographers used chemicals to first bleach a print and then used a bath of color toner solution to redevelop the image with a color dye. The trick was to get the timing right with the bleach bath, so that you did not etch away all of the original image and therefore obtain a print where the shadow tones were only partially colored. You could use different combinations of chemical processes to obtain prints with one color applied to the shadows and another color applied to the highlight tones. With the Split Toning Controls in Lightroom, there are no hard and fast rules as to which color combinations to use. It can sometimes be useful to pick contrasting colors such as a blue color for the shadows and a warm color for the highlight tones. Or, if you want a more uniform-looking color, apply identical (or nearly identical) settings to the highlights and the shadows. The following images give you an idea of what's possible.

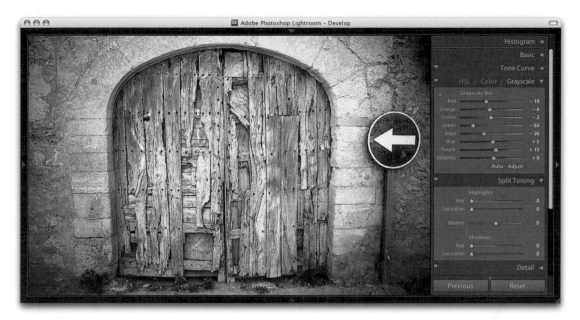

1. This photograph has been converted to black and white in Lightroom using the Grayscale Mix controls.

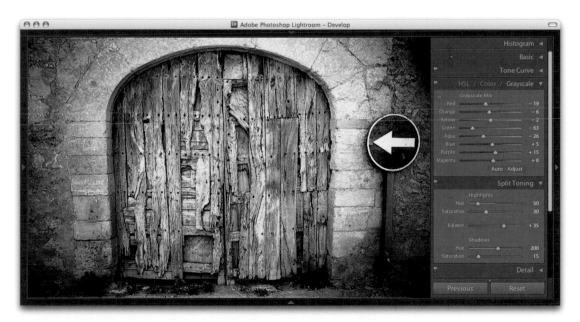

2. I used the Split Toning controls to apply a warm sepia color to the highlights and a cool color to the shadows. Then I adjusted the intensity of the color with the Saturation sliders and offset the split tone midpoint by adjusting the Balance slider.

Split toning a color image

The Split Toning controls work great on color photographs too. If you want to give your photographs that distorted color look so favored by filmmakers and "trying so hard to be arty" TV commercial directors, here's how you can go about replicating those coloring effects in Lightroom. It is really easy to vary the effects shown here and save successful color split tone effects as preset.

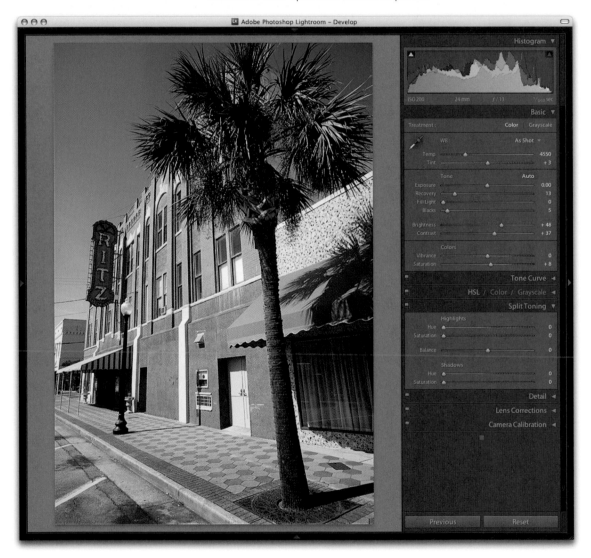

1. Here is a standard version of a color original. No special effects have been applied just yet. This is a normal exposure photograph, processed using the default Lightroom Develop settings.

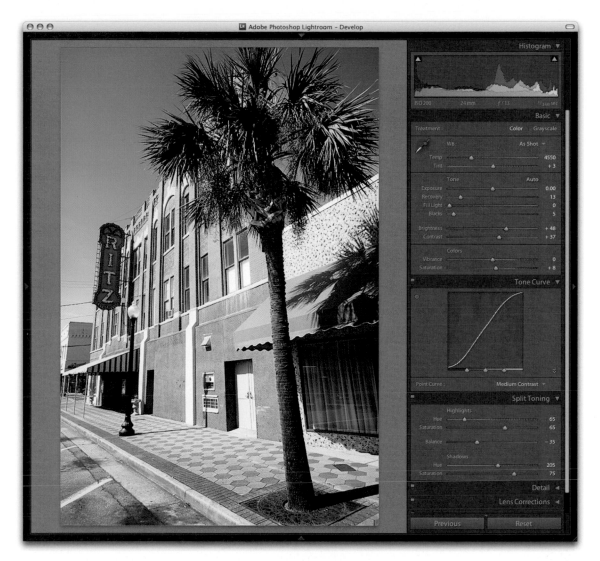

2. I made a few adjustments to the Tone Curve settings to add a little more contrast, particularly in the deep shadow areas. The White Balance and Saturation settings have remained the same, but the color effect you see here has mostly been achieved by adjusting the Split Toning controls. In this example I tried to simulate a typical cross-processed film look. This was achieved by setting the highlight hue to yellow and the shadow hue to cyan/blue. I could have achieved a more subtle effect than the one shown here by reducing the Saturation amount for the Highlights and the Shadows. I also offset the Balance slightly to add more weight to the blue coloring in the shadows.

Full Grayscale Mix Conversions

After you deselect the Auto-Adjust button in the Grayscale Mix panel, you will have almost unlimited freedom to create custom blends that suit the image you are working on. This is where the real fun begins, because custom Grayscale Mix blends give you complete control over how light or dark certain colors will be rendered in the black and white converted version. The following steps show how I was able to maximize the contrast in the sky and the clouds. Notice that I gave the Aqua and Blue sliders negative values because I wanted these colors to render darker. Also notice how the temperature adjustment made the image cooler, which when combined with the Grayscale Mix adjustments further enhanced the sky contrast. Remember, the Grayscale Mix outcome is always influenced by the White Balance setting, so it is always useful to try out different white balance adjustments as you search for the best combination, as shown in the following images.

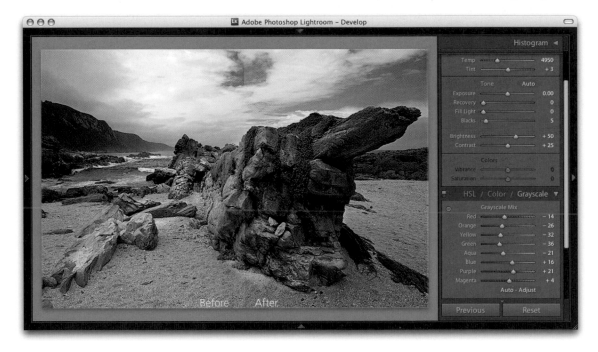

1. The colors and tones were optimized using the Basic and Tone Curve panels. This screen shot shows the color original alongside a black and white version that used the default Auto-Adjust Grayscale Mix setting. The black and white conversion was nowhere near as dramatic as I would like.

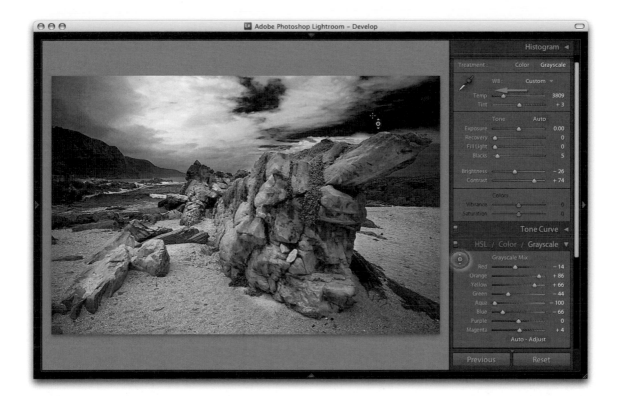

2. This second version shows the same image after I made some custom edits using the Grayscale Mix controls. I clicked the Target Adjustment tool button (circled), moved the mouse over the rocks, and dragged upward to lighten them. I then moved the mouse over the sky and dragged downward to darken it and add more contrast to the clouds. Notice that I also tweaked the White Balance Temp slider to make the Grayscale Mix adjusted version look even more contrasty.

TIP

You can also press ⌘ Alt Shift G (Mac) or Ctrl Alt Shift G (PC) to turn on the Tone Curve Target Adjustment tool in the Grayscale Mix and press ⌘ Alt Shift N (Mac) or Ctrl Alt Shift N (PC) to turn off the Target Adjustment tool.

Color Slider Controls

The Grayscale Mix contains eight color slider controls. If you want to create dramatic black and white conversions, move the sliders farther apart and try moving two or more sliders in unison. In the example in the preceding steps, I moved the Aqua and Blues sliders to the left. This created the most dramatic tonal contrast based on the opposing colors of the warm driftwood against a cloudy blue sky. The following section shows how to push Lightroom black and white conversions to even greater extremes.

Extreme Grayscale Mixing

Now watch what happens when you take the White Balance settings to extremes before applying a Grayscale Mixer conversion. The following steps illustrate just one of the many ways that you can explore making creative black and white conversions in Lightroom.

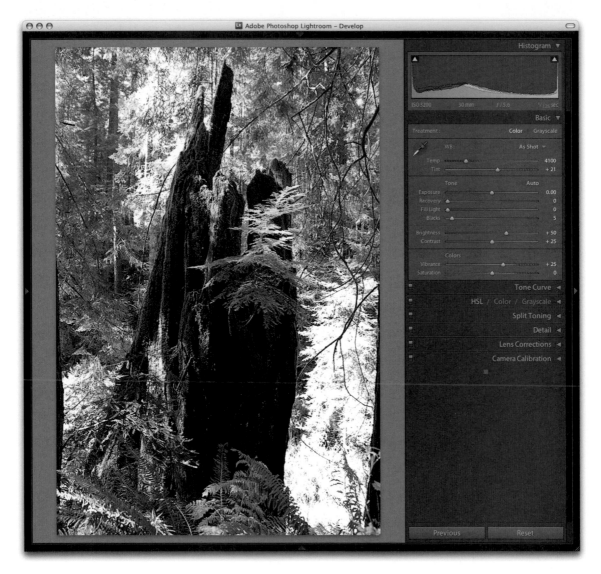

1. Here is the before version in which I optimized the tones to bring out the most detail in the midtone areas, letting some of the background burn out to white

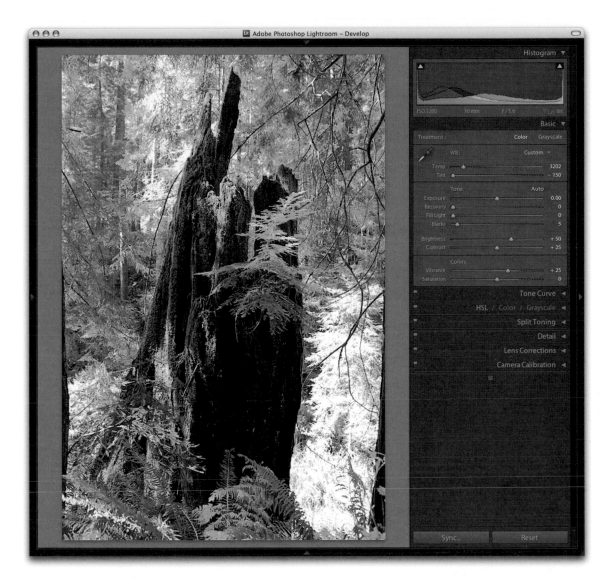

2. To begin creating the fake black and white infrared look, I
started with the image in Color mode, made the White Balance
Temperature slightly cooler, and applied a full negative Tint adjust-
ment to the white balance to make the green colors, such as the
leaf foliage, as bright as possible, but without actually clipping any
of the important areas of color detail. I also increased the Vibrance
slightly to make the green colors even richer.

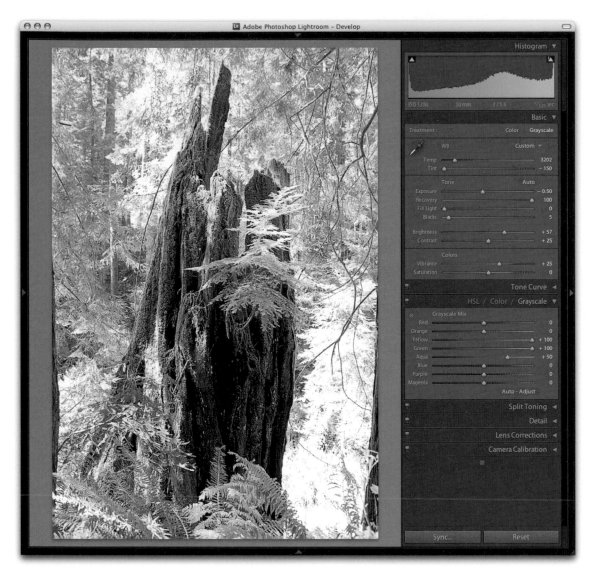

3. I then clicked the Grayscale button in the HSL / Color / Grayscale panel to turn the photograph to black and white. To get the full infrared look you see here, it is important to note that I set the Yellow and Green sliders in the Grayscale Mix section to maximum and the Aqua slider to 50%. I also adjusted some of the Basic panel settings. In particular, I set the Recovery slider to 100%, which helped me preserve some of the delicate tone information in the leaves.

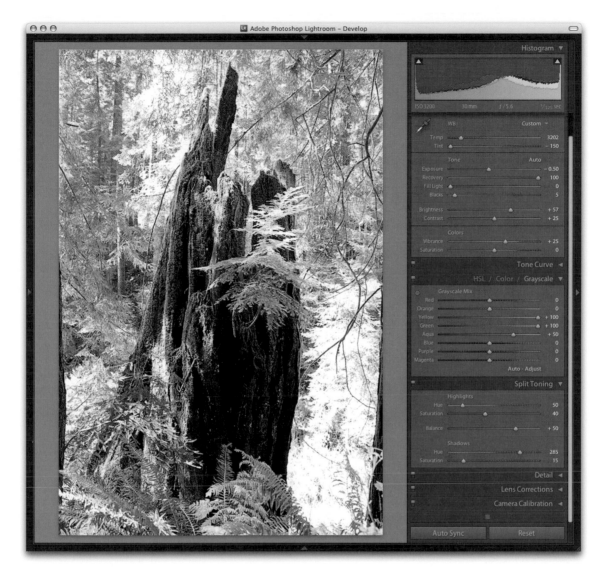

4. I went to the Split Tone panel to add a split tone coloring effect which added some warmth to the highlights and a slight magenta cast to the shadows. The settings shown here worked well for this particular image. If I wanted to apply this infrared effect to other images, I would save these settings as a custom preset. The main thing to remember is to lighten the greens by applying an extreme Tint slider adjustment in combination with the Grayscale Mix settings shown here. The Basic panel and other tone settings will most likely need to be fine-tuned on an image-by-image basis.

Desaturated Color Adjustments

This last method offers a rather sneaky and perhaps less obvious approach to making a monochrome conversion from a color image. Although you can convert an image to black and white by moving the Saturation slider down to its minimum, there is no advantage to doing so, since clicking the Grayscale button offers you more options via the Grayscale Mix controls. However, if you instead reduce the individual Saturation sliders in the HSL / Color / Grayscale panel, you can adjust the Luminance sliders (and to some extent, the Hue sliders as well) to achieve rather nice-looking monochrome adjustments that are similar in style to the conventional Grayscale Mixer method. The main reason I sometimes prefer using this particular method of grayscale conversion is that I find I can get smoother tones in the blue areas of a photograph. This conversion method is therefore more suitable for red contrast-type conversions where I want to significantly darken a blue sky.

1. In this photograph a few minor adjustments were made to the default settings in the Basic panel and other panels.

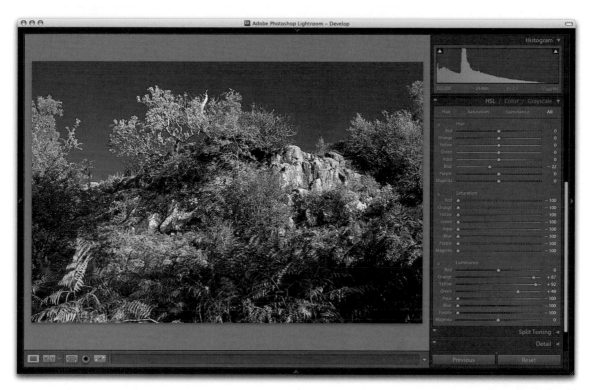

2. To create the result shown here, I clicked the All button in the HSL / Color / Grayscale panel to reveal all the sliders and set all of the Saturation sliders in the Saturation section to zero. Since this is a useful starting point for making other monochrome adjustments that used this same method, I clicked the Add button in the Presets panel to save this as a subset to just desaturate all the Saturation sliders. I then proceeded to adjust the sliders in the Hue and Luminance sections. Notice that in the Luminance section I set the Aqua, Blue and Purple sliders to -100 and raised the luminance with Green (+49), Yellow (+92), and Orange (+87) sliders. Although not shown in this screen shot, I also fine-tuned the conversion by setting the white balance to a higher value and reducing the brightness slightly.

When trying out this method of black and white conversion, you might also want to look at the effect the Basic panel Vibrance and Saturation sliders have on the image. Interestingly, a negative Vibrance adjustment also made the sky appear darker in the photograph.

Assessing Your Images

Comparing Before and After Versions

While you are working in the Develop module, you can simultaneously compare the before and after versions of any photograph you are working on. This allows you to compare the effect of the Develop settings adjustments, as they are applied to the image. To view the before and after adjustments, click the Before/After view mode button, and then click on the disclosure triangle, circled in **Figure 4.55**, to select one of the Before/After viewing modes from the fly-out menu. These viewing modes let you display two identical views of the currently selected image, splitting the screen vertically, when using the

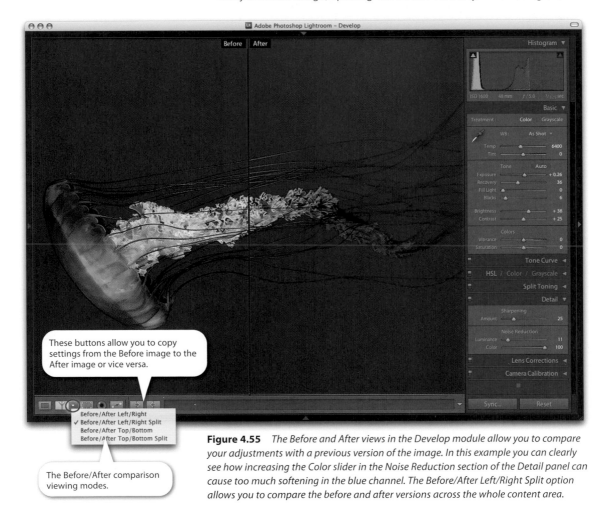

These buttons allow you to copy settings from the Before image to the After image or vice versa.

Before/After Left/Right
✓ Before/After Left/Right Split
Before/After Top/Bottom
Before/After Top/Bottom Split

The Before/After comparison viewing modes.

Figure 4.55 *The Before and After views in the Develop module allow you to compare your adjustments with a previous version of the image. In this example you can clearly see how increasing the Color slider in the Noise Reduction section of the Detail panel can cause too much softening in the blue channel. The Before/After Left/Right Split option allows you to compare the before and after versions across the whole content area.*

Left/Right view. The image views can also be viewed horizontally, using a Top/Bottom view. The Split views divide the image in half, displaying a Before view on the left and an After view on the right or a Before view on top and an After view below (**Figure 4.56**). Alternatively, you can repeat click the Before/After button to cycle through all the available views. You can also use the Y key to toggle the standard Left/Right view mode, press ⌥Y to toggle the standard Top/Bottom view mode, and press ⇧Y to then go to a Split screen version of either of the above (pressing D returns to the default Loupe mode view). While you are in any of the Before/After view modes, you can also zoom in to scroll the image and compare the results of your adjustments up close.

TIP

You can switch between the before and after versions in the Develop module by going to the View menu and choosing Before / After ⇨ Before Only. Or, use the backslash key (\) shortcut to quickly toggle between these two viewing modes.

Figure 4.56 *These two screen shots show you the two main viewing modes for comparing before and after versions of an image. The top image shows a photograph in the Before/After Left/Right view mode and the bottom image in the Before/After Top/Bottom Split view mode.*

Copy settings from
the after photo to
the before photo.

Copy settings from
the before photo to
the after photo.

Figure 4.57 *The Copy settings buttons only appears at the bottom of the Develop module when either the Left/Right or Top/Bottom view modes have been selected. The buttons shown here when the Left/Right view mode is selected.*

Managing the Before and After previews

When you edit an image in one of the Before/After viewing modes, you can make umpteen adjustments via the Develop module and at all times be able to compare the revised After version with the Before version. But suppose that you want to make the current After version the new Before. You can do this by clicking the Copy settings from the After photo to the Before photo button. This updates the Before image with the After image settings. What you are effectively doing here is making a snapshot of the settings at a certain point in the Develop adjustment process and therefore able to make further new adjustments and compare these with the Before version. Let's say at this point that you continue making more tweaks to the Develop panel settings, but decide that these corrections have not actually improved the image and the interim Before version was actually better. You can reverse the process by clicking the Copy settings from the Before photo to the After photo button. Basically, the Before and After compare mode controls let you take a snapshot of an image mid-correction. The following steps illustrate one such workflow, as well as how to restore the original Before version as a Before preview.

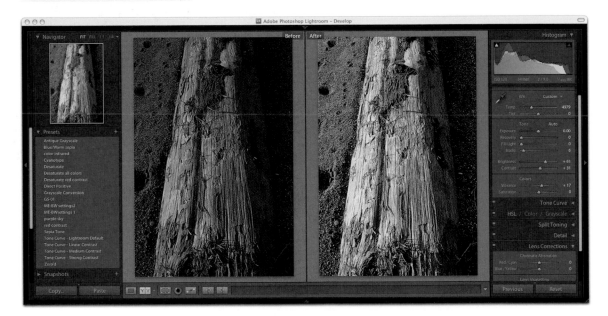

1. This screen shot shows a Before version of the image which was as shot, and on the right an After version that has been modified using the Develop module adjustments.

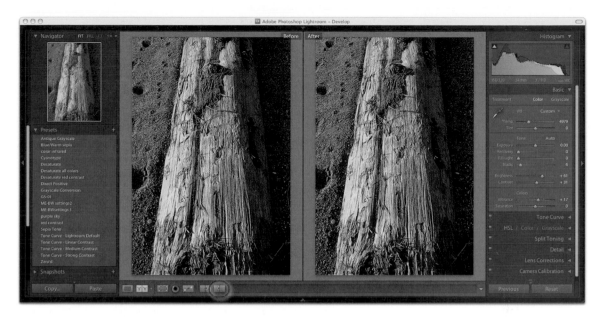

2. I clicked the Copy settings from the After photo to the Before photo button to create two identical versions of the image displayed in the Before/After previews.

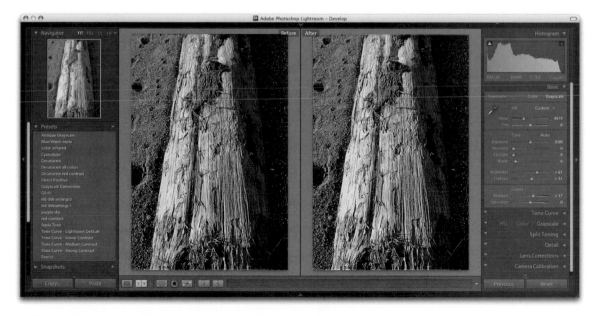

3. The result is a new Before image against which I can compare further Develop adjustments. In this example the After preview shows a grayscale conversion.

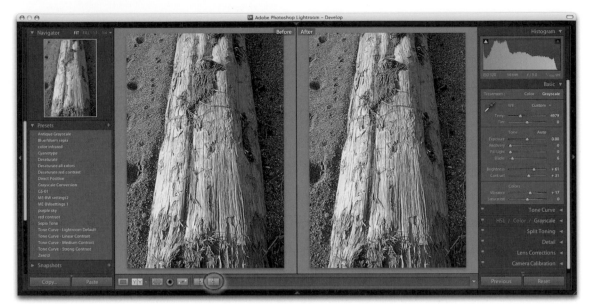

4. Once again, I was able to update the Before preview by clicking the Copy settings from the After photo to the Before photo button.

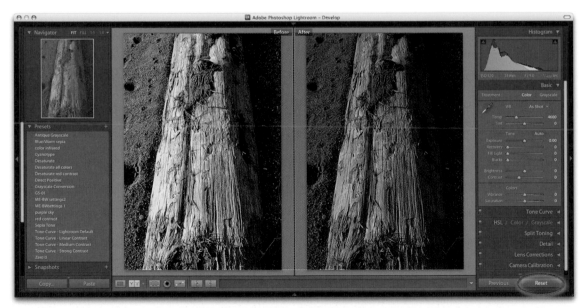

5. But what if I wanted to make the Before preview revert back to the original Before state? To do this I clicked the Reset button in the bottom-right corner of the Develop module. The After preview now shows the original Before version.

6. Now I want the Reset version to be the new Before preview. To do this, I clicked on the Copy settings from the After photo to the Before photo button again. Both halves now display the Reset version.

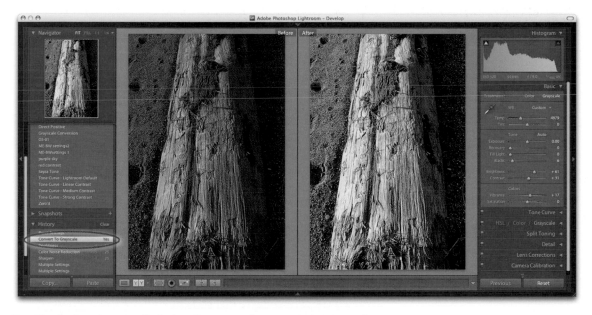

7. Finally, to return to displaying the grayscale converted state as the After version, I went to the History panel and clicked on the one before last, Convert to Grayscale history state.

Dust marks are the bane of digital photography, and ideally you want to do as much as you can to avoid dust or dirt getting onto the camera sensor. I have experimented with various products and found that the Sensor Swabs used with the Eclipse cleaning solution from Photographic Solutions Inc. (www.photosol.com) are reliable products. I use these from time to time to keep the sensors in my cameras free from marks. It is a bit scary when you first try to clean a sensor. Just remember to follow the directions and don't use too much solution on the sensor swabs, because you don't want to drench the sensor surface with cleaning solution.

Image Retouching Tools

The retouching tools on the Develop module toolbar can be used to retouch a photograph in Lightroom without actually editing the pixel data. When the two tools described are used, their actions are recorded as sets of instructions. The pixel image data in the original master file always remains untouched. It is only when you choose to export a file as a TIFF, JPEG, or PSD, or carry out an Edit in external editor command that the retouching work is physically applied to the exported image.

Remove Spots Tool

The Remove Spots tool (N) has a Clone mode and a Heal mode. In Clone mode, the Remove Spots tool copies and repairs from a sampled area without trying to blend the results of the retouching. In Clone mode a soft-edged selection is used, and it is the most appropriate mode to work with when removing spots that are very close to an edge. For all other retouching work, I suggest using the Heal mode, which blends the results of the retouching with the image information that is just outside of the area you are trying to repair. The Heal mode usually is successful in hiding the blemish removal areas with an invisible blend.

To work with the Remove Spots tool, start by setting the Spot Size so that it matches the size of the areas you intend to repair. Perhaps the quicker method is to use the square bracket keys on the keyboard. Click or hold down the] key to make the spot size bigger and use the [key to make the spot size smaller. Next, locate the spot or blemish you wish to remove and click on it with the Remove Spot tool. Initially, you see a small crosshair in the center of the cursor circle. You can use this to help you target the dust spot you want to remove by centering the cursor precisely. Then drag outwards to select an image area that you'll use to "cover" the spot. At this stage notice that the original (destination) circle cursor turns pink and the sample cursor edge will be green. A linking arrow appears to remind you that image information is being sampled from inside the green cursor circle area and is repairing the image inside the pink cursor circle (**Figure 4.58**). You won't see anything happen until you release the mouse, after which the clone or heal will take place, and the destination cursor circle will remain as a white Remove Spot circle on the screen for as long as the Remove Spots tool is active in the Develop module. Because Lightroom is recording all these actions as an edit instruction, you have the freedom to fine-tune

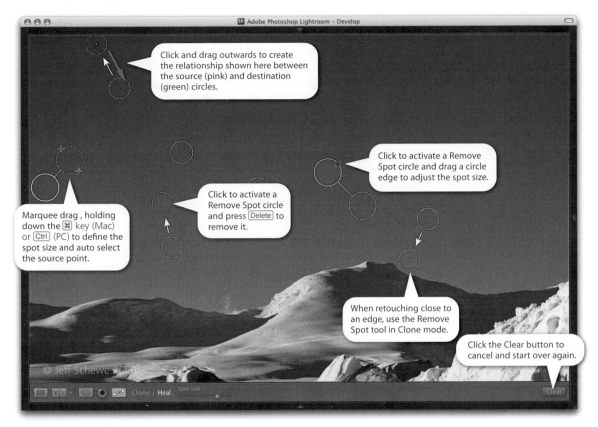

Figure 4.58 *This figure shows a combined series of a snapshot of the Remove Spots tool in action to illustrate the different ways you can use this tool.*

any clone and heal step. Do this by clicking inside a Remove Spot circle (to reactivate it) and repositioning either the source or destination circles. Carefully place the mouse over either of the cursor circle edges (a bar with a bidirectional arrow will appear), and click and drag to dynamically adjust the spot size of both the source and destination circles. Another way to work with the Remove Spots tool is to click and drag with the ⌘ key (Mac) or Ctrl key (PC) held down. This allows you to define a different spot size each time you drag with the tool, but the sample cursor will pick anywhere that surrounds the area you define for spot removal. When using this method of spotting, the source selection may appear quite random, but Lightroom is using the same logic as is used by the Photoshop Spot Healing brush, which intelligently seeks an ideal area to sample from.

NOTE

One of the best things about the Remove Spots feature is that you can continue to edit the tones and colors in the photograph afterwards and the spotting adjustments will always update accordingly. As you will read later, you can also synchronize the settings in one image with others from the same sequence. This includes synchronizing the spot removal. So if you get the spotting work right for one image, you can use a synchronization to copy the spot removal work to all the other pictures.

Remove Red Eye Tool

The Remove Red Eye tool corrects photographs in which the direct camera flash has caused the pupils in people's eyes to appear bright red. To use this tool, open an image that needs to be retouched, select the Remove Red Eye tool, and click over the eyes that need to be adjusted as I did in **Figure 4.59**. Lightroom detected the red eye areas that needed to be retouched and automatically adjusted the marquee size to fit. It's really quite neat the way Lightroom does this! After defining an area that needed to be treated, the Red Eye options appeared on the toolbar. These options allowed me to adjust the sliders to fine-tune the Pupil Size area I wanted to correct and decide on the amount I wanted to Darken the pupil. You can revise the Red Eye removal settings by clicking on a rectangle to reactivate it and use the Delete key to remove individual red eye corrections. If you don't like the results you can always click the Clear button to delete any Remove Red Eye retouching and start over again.

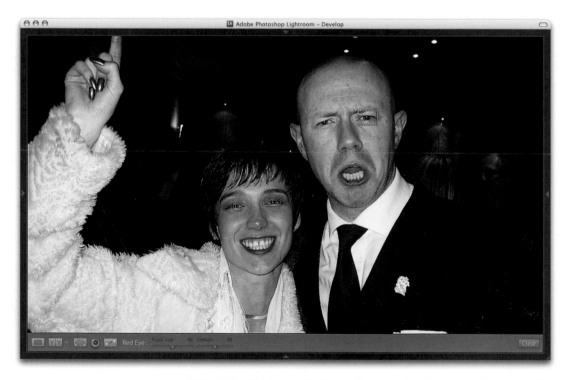

Figure 4.59 *The Remove Red Eye tool in action. Select the Remove Red Eye tool from the toolbar and drag to define the areas you wish to correct.*

History Panel

Every step that is applied in the Develop module is recorded as a separate history state in the History panel (**Figure 4.60**), which is located just below Presets and Snapshots. **Figure 4.61** shows an example of how the history states display after having made a series of basic adjustments to an image. The History feature in Lightroom has the unique advantage over Photoshop in that all the history steps are preserved after you quit Lightroom. When you relaunch the program, the last selected history step is applied to the image, and all other history states are preserved. There are several ways you can navigate through a file's history. You can go to the History panel and click to select a history step, which will allow you to jump quickly to a specific state. You can also roll the cursor over the list in the History panel to preview the history states in the Navigator panel before applying them. History is useful because it allows you to revert to any previous Develop module setting (even after you have quit), and you can access an unlimited number of history states via the History panel, without incurring the efficiency overhead that is normally associated with Photoshop image editing and History. Alternatively, you can select Edit ⇨ Undo or press (⌘Z) (Mac)

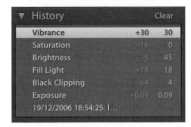

Figure 4.60 *In this close-up view of the History panel in Figure 4.61, you can see the original history state that was date stamped at the time of import. The subsequent history states are listed in ascending order. The numbers in the middle column show the number of units up or down that the settings were shifted, and the right column lists all the new setting values.*

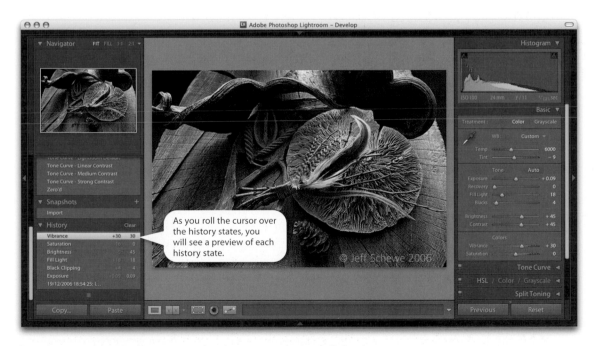

Figure 4.61 *In this example you can see that the sequence of steps applied to the image are recorded in the History panel in the order they were applied.*

or ⌃Ctrl Z (PC) to undo the last step and as you repeatedly apply ⌘Z, the history steps will be removed from the top of the list one by one. You can restore these steps by selecting Edit ⇨ Redo or pressing (⌘⇧Shift Z) (Mac) or (Ctrl ⇧Shift Z) (PC), but if you carry out a series of undos and then quit Lightroom, you will be unable to recover those later history steps. If you click the Clear button in the History panel, you can delete the history steps associated with that image. Clearing the list of history steps is useful if the number of history steps is getting out of control and you want to better manage the history list. One way to do this is to use the Snapshots feature to store your favorite history states as a saved setting.

Snapshots Panel

The Snapshots panel is designed to work in conjunction with the History panel and can be used for saving snapshot variations of an image (**Figure 4.62**). Rather than use the History panel to wade through a long list of history states, it is far more convenient to use Snapshots to save specific history states in a separate panel. This makes it easier for you to retrieve history states that are of particular importance and usefulness. For example, there is no need to force Lightroom to save an Edit TIFF version of a master image to preserve a favorite image state. You can use the Snapshots panel to save multiple variations, such as a color and a black and white version of the same picture (**Figure 4.63**).

To use the Snapshots feature, select a state from the History panel that you want to record as a snapshot (or keep the image in its current state), and click the plus button at the top of the Snapshots panel to create a new untitled snapshot. Give the new snapshot a name and press Enter. Snapshots are arranged alphabetically in the Snapshots panel, and the preview in the Navigator panel updates as you roll the mouse over the snapshots in the list. You simply click a snapshot to select it. If you want to delete a snapshot, click the minus button. You can also synchronize settings within snapshots by choosing Develop ⇨ Sync Snapshots. The Synchronize with Snapshots dialog opens and is identical to the Synchronize settings dialog shown in Figure 4.69 on page 221.

Figure 4.62 *The Snapshots panel is used to store saved history steps as variations.*

NOTE

The Sync Snapshots feature is particularly useful for updating previously created snapshots with new settings updates. For example, if you just spent time doing some spot removal or carefully cropping an image, it is handy to use the Sync Snapshots command to update just the Spot Removal and Crop settings in all the previously created snapshots.

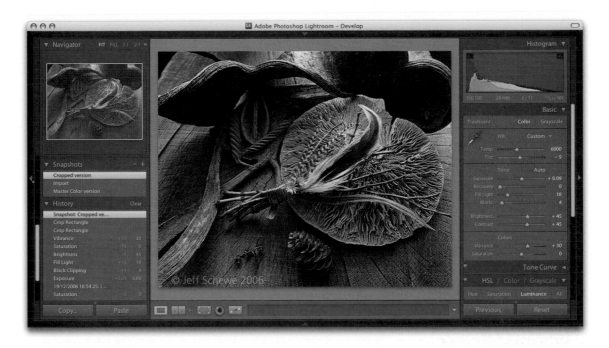

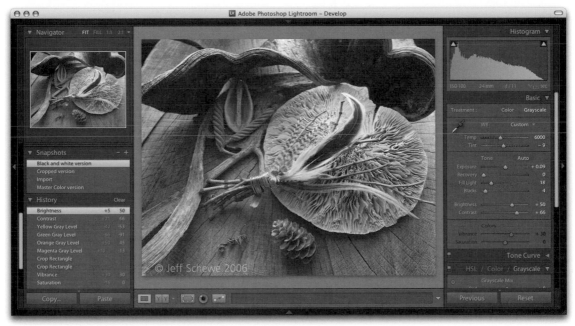

Figure 4.63 *In the top screen shot I saved a cropped version of the master shot that was edited in Figure 4.61 as a new snapshot titled "Cropped version." I then made a few adjustments using the Grayscale Mix settings and titled this "Black and white version."*

Figure 4.64 *Virtual copy images will automatically be stacked with the master file and are viewed in the Library Grid. You can tell which images are virtual copies by the turned page badge in the bottom-left corner.*

Easing the Workflow

Making Virtual Copies

As well as making snapshot versions, you can also create virtual copies of the master images by going to the Library module and choosing Photo ⇨ Create Virtual Copy. This creates a virtual copy version of a master image that will automatically be grouped in a stack with the master image (**Figure 4.65**). As the name suggests, you are making a proxy version of the master. It looks and behaves like a separate copy image but is in fact a virtual representation of the master that you can edit in Lightroom as if it were a normal image.

So what is the difference between a virtual copy and a snapshot? A snapshot is a saved history state that's a variation of the master. You have the advantage of synchronizing specific edit adjustments across all the snapshot versions but lack the potential to create multiple versions as distinct entities that behave as if they were real copies of the master image. A virtual copy is like an independent version of a snapshot, because when you create a virtual copy, you have more freedom to apply different types of edits and preview these edits as different image versions. You could, for example, create various kinds of black and white renderings and also experiment with different crops on each virtual copy version. **Figure 4.66** shows how you might use the Compare view mode to compare various virtual copy versions of an image alongside the master version. Virtual copies also make it possible for you to create collections that use different renderings. For example, you could use the Create Virtual Copy command to create black and white versions as well as color versions from a master image, and then segregate them into separate collections.

You also have the freedom to modify the metadata in individual copies. For example, you may want to modify and remove certain metadata from a virtual copy version so that when you create an export from the virtual copy, you can control which metadata items are visible in the exported file. Let's say you are running a location scouting service and send out images to clients that show the properties you recommend as photographic locations. You would store all the relevant metadata about the location details such as the zip code, but you would legitimately be within your rights to remove such commercially sensitive information when distributing these images to prospective clients.

Figure 4.65 *As you make virtual copies of a master file, they will automatically be stacked with the original master image.*

Figure 4.66 *One of the advantages of having stacked versions of a master file is that you can experiment with different treatments and use the Compare view to check these against the original master.*

Figure 4.67 *When more than one image is selected via the Filmstrip, the Sync... button lets you synchronize images in that selection through the Synchronize Settings dialog. When you hold down the* Alt *key, the button changes to Sync, and bypasses the Synchronize settings dialog. Or you can hold down the* ⌘ *key (Mac) or* Ctrl *key (PC) to access the Auto Sync button (bottom).*

Synchronizing Settings

After discussing all the main Develop controls, let's look at ways they can be applied efficiently. Whenever you have a selection of images active, the Previous button will change to show Sync, which allows you to synchronize the Develop settings across a group of images that have been selected via the Filmstrip, with the settings synchronized to the primary (most selected) image (**Figure 4.67**). In **Figure 4.68**, the selected images are those with a gray surround, and the most selected image would be the one with the lightest gray color. When you click the Sync button, the dialog shown in **Figure 4.69** appears and lets you decide which settings you want to synchronize. If you click the Check All button, everything will be checked, which in most cases is the easiest and most practical option. If you click Check None, you can then pick and choose a subset of synchronization settings. Whether you choose to save everything or just a subset of settings, there will be important consequences that will affect the synchronization. If you choose Check All, everything in the selected image will be copied and pasted. This might include the White Balance or Crop settings that were specific to just that image. If you choose to synchronize only a small subset of settings, you may omit synchronizing important settings such as the Detail sharpening. On the other hand, you may overwrite edits you didn't mean to change, such as the spot removal work done on a particular photograph in a selection

If you hold down the Alt key, the Sync... button changes to just Sync, and when you click the Sync button, it bypasses the Synchronize Settings dialog and applies a synchronization based on the last used Synchronize settings. When you hold down the ⌘ key (Mac) or Ctrl key (PC), you can access the Auto Sync button, which automatically synchronizes selected images. To use Auto Sync, you must make a selection of images first, ⌘– (Mac) or Ctrl– (PC) click the Sync... button to select Auto Sync, and then you can start making develop adjustments to the most selected image. As you make adjustments to the most selected image, you will see these same adjustments being propagated across all of the images in the selection. To exit this mode, just click the Auto Sync button again to return to Sync. There is also the Reset button that simply resets the image back to the standard Lightroom default settings.

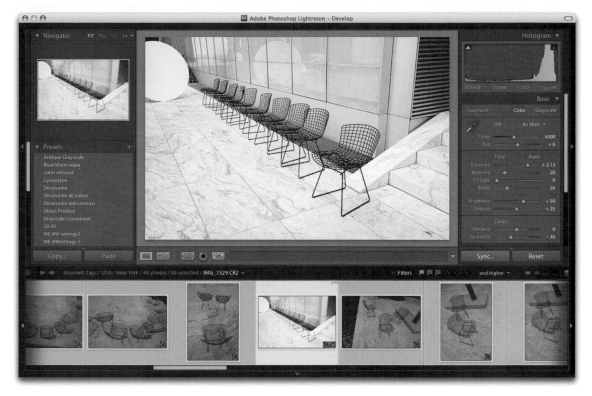

Figure 4.68 *The Develop settings in the most selected image can be synchronized with all the other images in a selection by clicking the Sync... button. The selected images in the Filmstrip are indicated with a gray surround, and the most selected image is the one with the lightest gray color.*

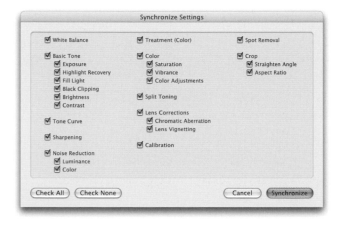

Figure 4.69 *The Synchronize Settings dialog. As explained in the Note on the previous page, you need to use the Check All settings with caution since synchronizing everything will overwrite all the settings in the selected images.*

TIP

You can also press ⌘ Shift S (Mac) or Ctrl Shift S (PC) to access the Synchronize settings.

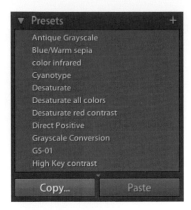

Figure 4.70 *The Copy and Paste buttons are located at the bottom of the left panel in the Develop module.*

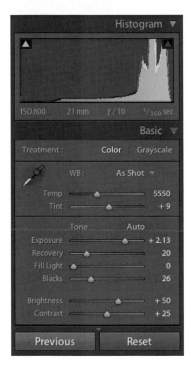

Figure 4.72 *The Previous button is at the bottom of the right panel. If you have an image selection active, this button will display Sync. If you hold down the* Shift *key, the Sync button changes back to Previous.*

Copying and pasting settings

Another way to synchronize images is to copy and paste the Develop settings from one image to another (**Figure 4.70**). If you are in the Develop module, you can select an image from the Filmstrip and click the Copy button. The Copy Settings dialog shown in **Figure 4.71** opens. Here you can specify which settings you want to copy. If you Alt–click the Copy button, you can bypass the Copy Settings dialog. So if previously you configured the Copy Settings to Check All, Alt–clicking the Copy button will copy all settings. You can then select an image or a selection of images and click the Paste button to apply the current copied settings. But while you are in the Develop module, you can also press ⌘C (Mac) or Ctrl C (PC) to copy the settings (combine this with the Alt key to bypass the Copy Settings dialog), and press ⌘V (Mac) or Ctrl V (PC) to paste the settings. You can also select an image and click the Previous button (**Figure 4.72**), which is a quick mechanism for copying the settings from the last image you selected in the Filmstrip and pasting these settings to the current image. If you want to apply a Previous setting to a selection of images, hold down the Shift key and the Sync button will change back to Previous again, allowing you to click to apply a complete paste of the settings from the previously selected image.

When working in the Library module you need to rely on the following shortcuts: press ⌘⇧Shift C (Mac) or Ctrl ⇧Shift C (PC) to copy the settings, ⌘⇧Shift V (Mac) or Ctrl ⇧Shift V (PC) to paste, and use ⌘Alt V (Mac) or Ctrl Alt V (PC) to apply Previous settings.

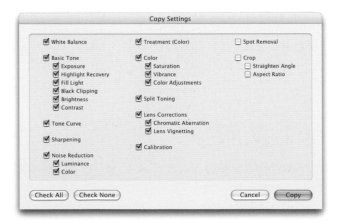

Figure 4.71 *The Copy Settings dialog shown here, copies all the settings except the Spot Removal and Crop.*

Saving Develop settings as presets

Copying and applying settings is useful for short-term requirements, but if you need to save settings more permanently, you should save the settings as a preset. **Figure 4.73** shows a view of the Develop module displaying the Presets panel with a list of saved Develop preset settings. You can add your own Develop presets by clicking the plus button in the Presets panel. The New Develop Preset dialog shown in **Figure 4.74** opens. As with the Synchronize Settings dialog, you can make a custom selection of settings that you want to save as part of the preset. It is worth giving some thought to exactly which settings you would like to save. For example, you may want to create a preset that applies only the White Balance and Calibration settings. This could be useful

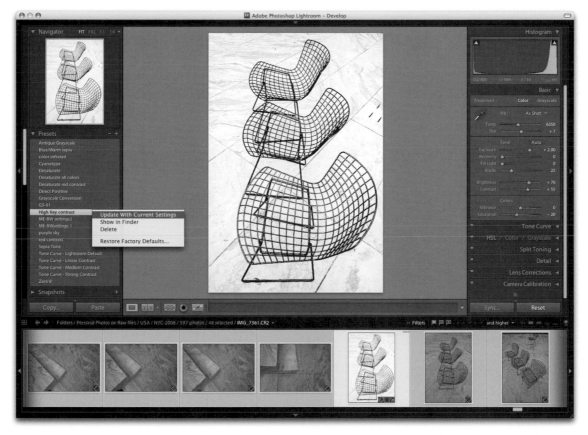

Figure 4.73 *Note that as you roll the cursor over the Presets list, the Navigator updates to show you a quick preview of how the Preset settings will affect the image. You can update existing settings by holding down the* Ctrl *key (Mac) or right-clicking (PC) to reveal a contextual menu for the presets. Click the minus button to remove a selected preset from the list.*

whenever you want to selectively apply these changes and leave all the other settings untouched. When you have decided which Develop settings to include, name the preset, and click the Create button (**Figure 4.74**). The Auto Tone option is potentially useful for those times when you want to include an Auto Tone adjustment as part of a preset. When Auto Tone is included, it makes an Auto Tone adjustment based on the individual image contents.

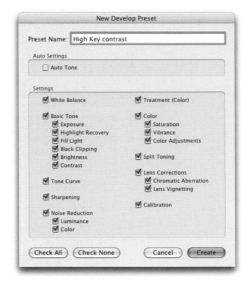

Figure 4.74 *The New Develop Preset dialog asks you to type in a name for the preset you are about to add.*

Editing an Image in Photoshop

So far I have covered all of the image processing that can be done exclusively in Lightroom using the Develop module controls. Remember, Lightroom's edits are nondestructive. The library contains master images that are always preserved in their original state, and there can only be one master of each library image. Variations of the master files can be created by saving snapshots. But if you want to edit an image outside Lightroom in an image editing program such as Photoshop, pixel image copies must be created, and these will be distinguished as being *-Edit* versions of the master. This applies to all master library images you choose to edit in an external editing program, raw files and pixel images alike.

To edit a Lightroom library photograph in Photoshop, select Photo ⇨ Edit in Adobe Photoshop, or press ⌘ E (Mac) or Ctrl E (PC). If you have an additional external editor application configured in the Lightroom Preferences (**Figure 4.75**) this will also appear in the same menu and can also be accessed by pressing ⌘ Alt E (Mac) or Ctrl Alt E (PC). By selecting an alternative external editor program, you are not solely restricted to using Adobe Photoshop. For example, if you want the option of opening your Lightroom images in Adobe Photoshop Elements or Corel PaintShop Pro, you can configure one of these programs as an alternative external image editing application.

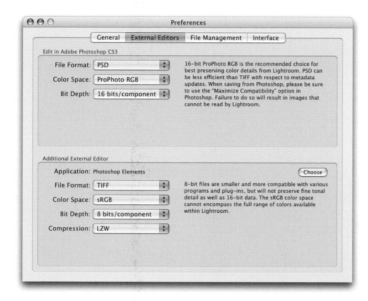

Figure 4.75 *To change the external editing application, select Lightroom ⇨ Preferences. Go to the Additional External Editor section and choose the File Format, Color Space, and Bit Depth options you want to use when creating an edit version of a master image in either Photoshop or an additional external editor program.*

Whenever you select a raw image and you choose Edit in Photoshop (or other program), the dialog shown in **Figure 4.76** appears. In this situation only one option is available and that is to "Edit a Copy with Lightroom Adjustments." This will render a flattened pixel image and open it in Photoshop (or other external editor program). The opened image will have *-Edit* appended to the original filename and open as a TIFF or PSD image. At the same time, this *-Edit* version is added to the Filmstrip (or Grid view if you are working in the Library module).

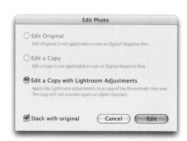

Figure 4.76 *This dialog appears when a raw image is selected and you choose Edit in Photoshop. The only available Edit option is to edit a pixel-rendered copy of the raw file and apply Lightroom adjustments. The Stack with original option will auto stack the version images with the master.*

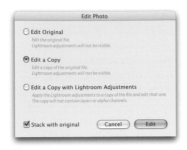

Figure 4.77 *If a non-raw image is selected in Lightroom and you choose Edit in Adobe Photoshop, all the edit options will be available. You can edit the original file (without Lightroom adjustments), edit a copy (also without Lightroom adjustments), or create an edit copy of the original image with Lightroom adjustments applied.*

From there you can edit the photograph however you like. When you are finished, save and close the image. The Lightroom previews will update to reflect the changes made to the edited version of the image.

Whenever you select a non-raw image, such as a JPEG or an existing Edit copy image, the dialog shown in **Figure 4.77** appears with all options available. As before, you can choose Edit a Copy with Lightroom Adjustments, but you can also choose Edit a Copy to edit the file in its original state, ignoring any Lightroom adjustments. (See the steps that follow for more on Edit a Copy.) Both options create an additional edit version (*-Edit*, *-Edit-2*, *-Edit-3* etc.). If the images in your library are not raws but TIFF or JPEG masters, either of these options can be used to create editable versions that always preserve the masters in their original state. The Edit Original option is useful for editing layered masters or editing derivative versions of a master. In other words, once you have made an *-Edit* copy of the master image, you will most likely want to always choose the Edit Original option whenever you choose Edit in Photoshop. This allows you to open the copy image, edit it in Photoshop, and close it again without creating a new copy each time.

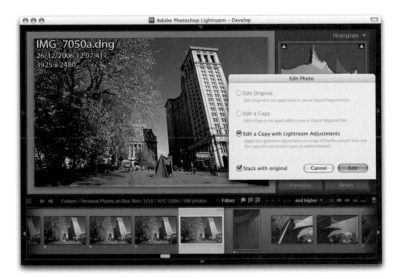

1. I selected a master DNG image from the Filmstrip and used the Edit in External Editor command (⌘E [Mac] or Ctrl E [PC]) to create an edit copy that could be edited in Photoshop. Notice that I checked the "Stack with original" option in the Edit Photos dialog. This groups the edited version as part of a stack with the original master image.

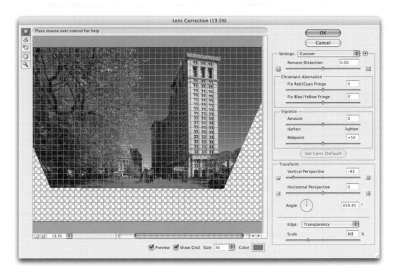

2. The edit copy of the original photograph opened directly in Photoshop and allowed me to use the Lens Correction filter to remove some of the perspective distortion in the picture. After applying the filter, I chose File ⇨ Save and closed the image.

2. Back in Lightroom you can see how the modifications made in Photoshop to the edit copy are reflected in the Filmstrip and main preview. The Edit Copy photo has now been added to the same folder as the original and is currently highlighted in the Filmstrip, where you can see the selected image identified as number 2 of 2 images in the stack just created.

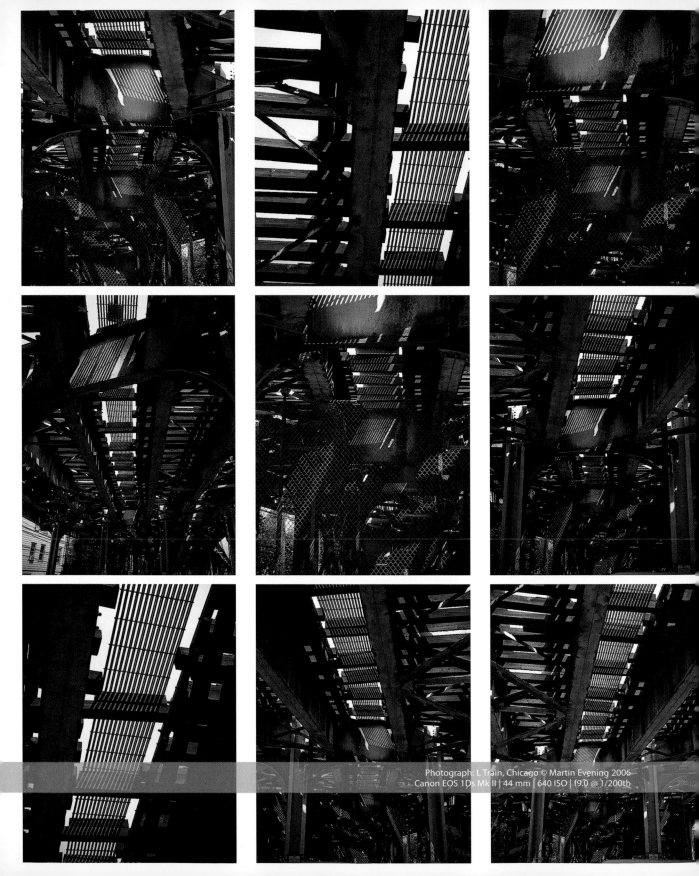

5 | Printing

Digital printing has come a long way from the early days of Photoshop when few photographers were convinced that you could really produce a digital print from a computer to rival the quality of a photographic print. Graham Nash and Mac Holbert of Nash Editions were early pioneers of digital printing and the first to demonstrate how inkjet technology could be used to produce print output from the computer onto high-quality art paper.

In the intervening years photographers have seen amazing breakthroughs in technology and pricing, such that these days you can buy a photographic quality printer for just a few hundred dollars. But alas, many people still get beaten by the complexities of the operating system Print dialogs and the inability to make print color management work for them. Fortunately, the Print module in Lightroom can make your life easier. To start with, you are able to see previews of how your photographs will be laid out on the page. In the Lightroom Print module, you can set up batches of images in a print queue to produce high-quality prints or work in fast print mode to generate quick sets of contact sheets. And best of all, once you master how to configure your print settings, they can be saved as part of a template for more reliable and consistent printing results.

Preparing for Print

The Print Module

The Print module gives you complete control over the print page layout and provides proper sized previews of the images that have been selected for printing. Starting from the top, the Image Settings can be used to apply some basic rules as to how the selected image or images fill the cell areas, such as whether to rotate the images for the best fit, or zoom and crop the photos to fit a cell, or add a Stroke Border. The Layout panel can be used to define the margins, grid layout, and cell size for the images. To help you get started, several templates are ready for you to choose from in the Template Browser panel, and you can preview the layout format as you roll over the items in the Template Browser list. In **Figure 5.1**, notice that a fine-art custom template's selected with the rulers showing the measurements in inches.

The Overlays panel lets you add information to the print. You can place your Identity Plate as a logo or as custom text and add things like borders and page numbers. If you are using the Print module to print contact sheets, you can include additional file information below the print cells. The Print Job panel lets you decide how the page or pages should be printed. There is no need for an Image Resize dialog in the Print module, because the Page Setup options and Print Resolution in the Print Job panel are all you need to size an image correctly for print. The Draft Mode Printing option is great for speedy print jobs, because it makes full use of the large JPEG previews (that Lightroom has already rendered). Providing the previews have all been built, the print processing is virtually instantaneous. When Draft Mode Printing is disabled, Lightroom processes the image data from the original master file, and you can then decide which level of output sharpening to apply. For easy printing you can use the Managed by Printer setting, or if you feel confident, you can select a custom print profile and rendering intent.

You can click the Page Setup button on the toolbar to specify the page setup size and paper orientation, and then click Print Settings to specify the print output settings such as the paper media type and print quality. Both the Page Setup and Print Settings configurations can be saved as part of a print template, which helps reduce the number of opportunities for a print error at the operating system level. Click the Print button to OK all the settings and make a print.

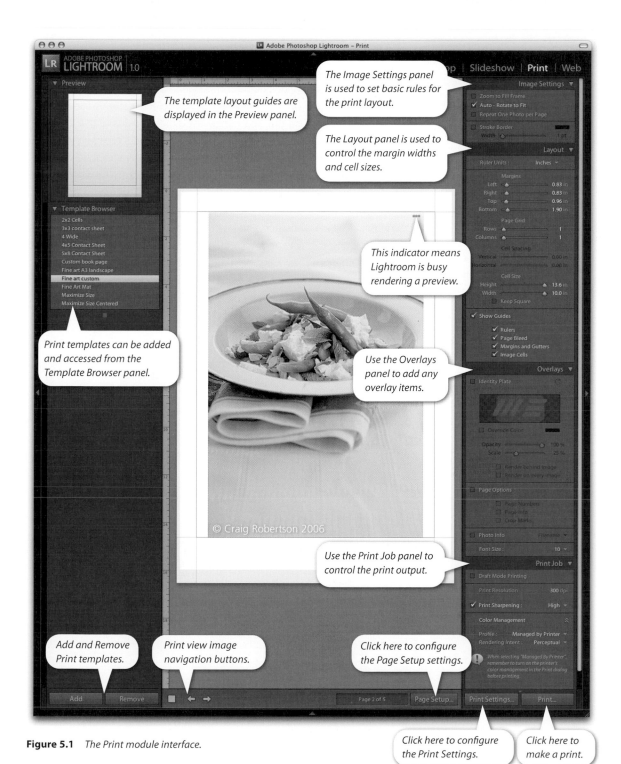

The template layout guides are displayed in the Preview panel.

Print templates can be added and accessed from the Template Browser panel.

The Image Settings panel is used to set basic rules for the print layout.

The Layout panel is used to control the margin widths and cell sizes.

This indicator means Lightroom is busy rendering a preview.

Use the Overlays panel to add any overlay items.

Use the Print Job panel to control the print output.

Add and Remove Print templates.

Print view image navigation buttons.

Click here to configure the Page Setup settings.

Click here to configure the Print Settings.

Click here to make a print.

Figure 5.1 *The Print module interface.*

Figure 5.2 *The Image Settings panel, showing the cell policies and Stroke Border options.*

Image Settings Panel

The Image Settings provide some elementary control over how the selected image or images fill the print cell areas (**Figure 5.2**). If the Zoom to Fill Frame option is selected, the whole cell area is filled with the selected image so that the narrowest dimension fits within the widest grid cell dimension and the image is cropped accordingly. As you can see in the following steps, images that have been cropped in this way can be scrolled within the cells in the print layout. The Auto-Rotate to Fit option automatically rotates the images to fit the orientation of the print cells. For example, this option can be useful when printing a contact sheet of landscape and portrait images where you want each image on the contact sheet to print to the same size (see step 4). The Repeat One Photo per Page option is applicable if the layout you are using contains more than one cell, and you want the image repeated many times on the same page. Step 5 shows an example of a 2x2 cells template with this option selected.

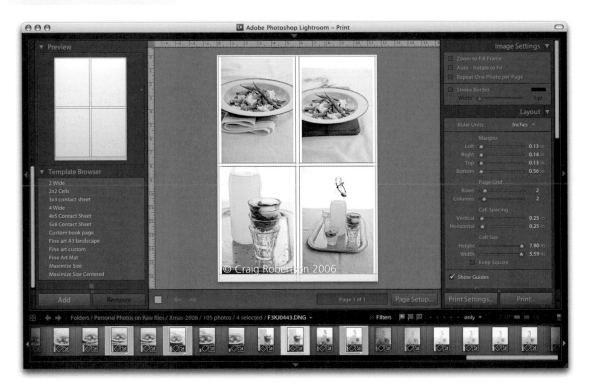

1. The images in this figure were selected from the Filmstrip and previewed in the Print module using a 2x2 cells template. No Image Settings have been selected yet.

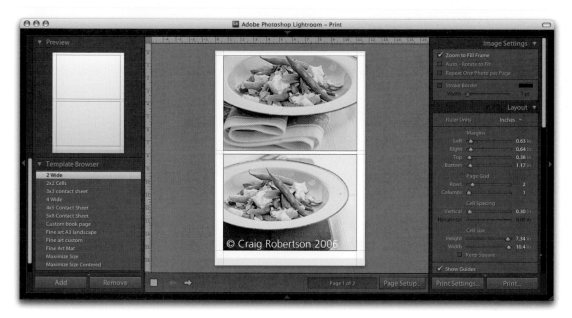

2. In this example, a 2 Wide template was used and the Zoom to Fill Frame option was selected. The two images now fill the entire area of each print cell.

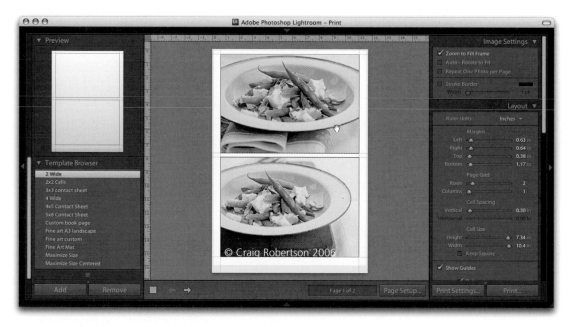

3. Even with the Zoom to Fill Frame option selected, there is still room to change image placement. If you click and hold on a print cell preview, you can scroll the image to obtain a better looking crop.

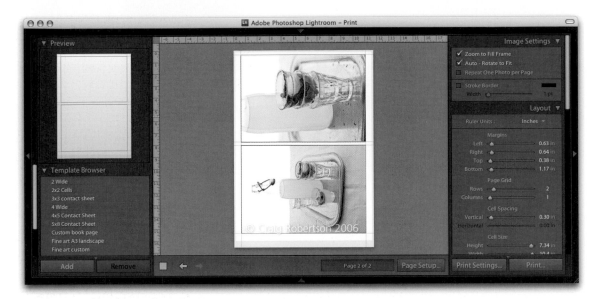

4. The Auto-Rotate to Fit option ensures that all images are rotated to best fit the cells. In this example, two portrait-oriented images are rotated to best fit the landscape-oriented cells in the 2 Wide print template.

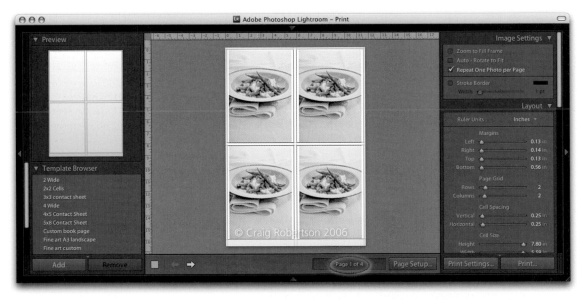

5. In this figure, I selected the Repeat One Photo per Page option, which makes each image in the current selection populate all the cells per page layout. Shown here is page 1 of 4 pages.

Layout Panel

The Layout panel lets you decide how an image (or multiple images) will be positioned in a page layout. Scrolling through the print templates gives you a quick feel for how the layout controls work. Notice how the Layout panel settings in **Figure 5.3** relate to the page layout diagram shown in **Figure 5.4**. Also note how the Margins settings take precedence over the Cell Spacing and Cell Size settings. Once the Margins have been set, the Cell Spacing and Cell Size adjustments will adapt to fit within the margins.

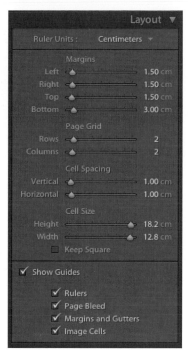

Figure 5.3 *The Layout panel.*

TIP

A quick way to adjust the margins or indeed any of these guides is to click on the guidelines in the content area and drag them manually. Note when you make layout adjustments using this method (or casually adjust the sliders in the Layout panel), the images will often auto-adjust in size as you make refinements. If it is essential that the images be a specific size on the page, using the Layout panel method is best because it allows you the most complete control over the image and layout measurements.

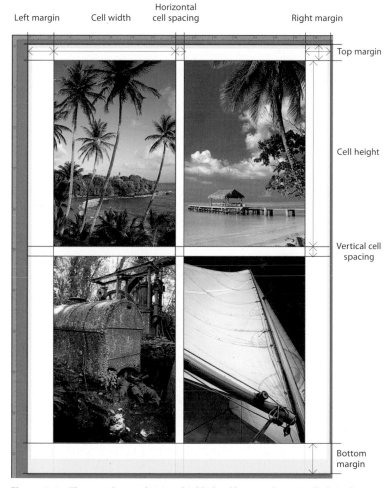

Figure 5.4 *The page layout divisions highlighted here can be controlled via the Page Layout panel.*

Figure 5.5 *You can set the Ruler Units measurements via the page Layout panel.*

Rulers

The rulers can be turned on or off by checking the Rulers item in the Layout panel. Or, you can press ⌘R (Mac) or Ctrl R (PC) to toggle ruler visibility. The Ruler Units measurements can be altered by clicking on the measurement units displayed in the Layout panel (as shown in **Figure 5.5**) and then setting the measurement units: Inches, Centimeters, Millimeters, Points, or Picas.

Page grid and cells

To place an image precisely on the page, your first step will be to set the widths of the Margins. If you want to center the photograph, make sure that the margins are set evenly, and most important, to a measurement that places the image within the widest page bleed edge. Inside the margins is the Page Grid area, which when set to a 1x1 cell, will print a single image on the page. If you want to print multiple images on each page, as shown in some of the previous examples, you simply adjust the number of Rows and Columns. The Cell Size sliders determine the size of the print cell area. If the Cell Size sliders are dragged all the way to the right, the cell sizes expand to the maximum size allowed. By making the cell size smaller, you can restrict the printable area within each cell. But note that the cell size adjustment will always be centered within the Page Grid area set by the margins, and the margin adjustments take precedence over the Page Grid area. Any readjustments made to the margins will therefore have a knock-on effect with the cell size area. The Cell Spacing sliders are only active if the page grid is set to use two or more cells. If you refer back to Figure 5.4, you will see how I was able to apply a 1 cm Vertical and Horizontal spacing to the 2x2 image layout. The guide items help you plan a page layout. The Page Bleed displays a light gray shading to represent the nonprintable areas. The Margins and Gutters and Image Cells check boxes allow you to independently show or hide these items, and the master Show Guides check box displays or hides all of the previously mentioned Layout panel guides. The following examples illustrate how these adjustments work.

1. In the page layout at the top of the facing page, the margins (which I shaded red) constrain the printable area by 2.5 cm left, right, and bottom, and by 2 cm on the top. The cell height size is set to the maximum allowed, which is 25.2 cm. But since the image width is constrained by the 33 cm cell width setting, the image does not fill the full height of the cell.

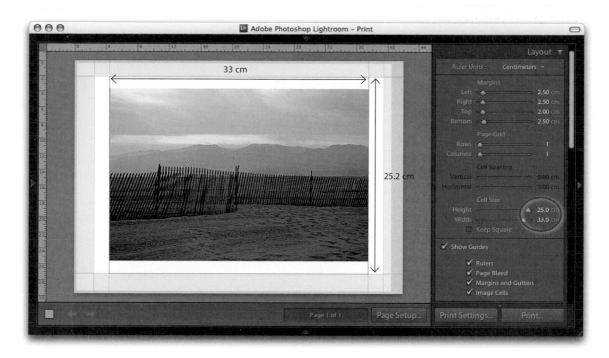

2. In the example below, the margins remained the same, but the cell height and width sizes were reduced to an A4 metric size of 21 cm x 29.7 cm.

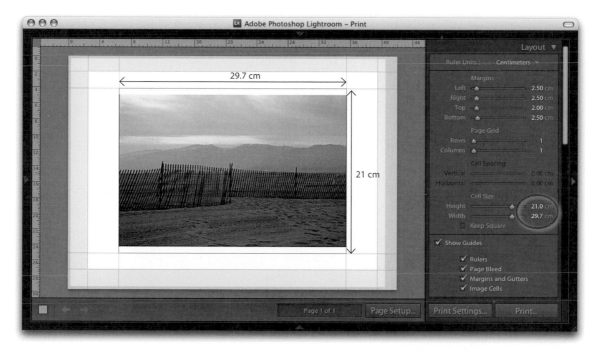

Multiple Cell Printing

When the page grid is set up to print with multiple cells, the Cell Spacing options become active and let you set the gap spacing between each cell. The Cell Size and Cell Spacing settings are interdependent, so any adjustment you make to one always affects the other. In **Figure 5.6**, I created a custom 3x3 contact sheet template in which the Cell Spacing was set to 0.5 cm for the Vertical and the Horizontal spacing. These adjustments made to the Cell Spacing had a knock-on effect with the settings for the Cell Size. So remember, if you adjust one setting, the other will compensate.

Notice that the Keep Square option was left unchecked. For some contact sheet template designs it can be useful to check this item because it ensures that both landscape and portrait images are all printed at the same size on the page and are always printed upright without having to rotate the images for the best fit within the cells.

A multiple cell printing template is ideal for generating contact sheet prints from a large selection of images. And when more images are selected than can be printed on a single page, the extra images will auto-flow to fill more pages using the same template design. It is possible to generate as many contact sheet prints as necessary, even from a big shoot, but be warned that the Print Job settings will have a major impact on how long it takes to render the pages. For fast contact sheet printing, I suggest you always choose the Draft Mode Printing option in the Print Job panel. When this is selected, Lightroom renders the contact sheet images based on the high-quality preview images that should already have been generated. I say "should have" because it is something you may have to check before you click Print. Whenever a new batch of images are imported, Lightroom automatically generates the thumbnails followed by Standard previews and then the high quality, 1:1 preview images. If you have just imported a large number of photographs into Lightroom, it may take a little while to generate all the Standard previews, and until Lightroom has done so, Draft Mode Printing may result in some images appearing pixelated (because they will have been rendered from the thumbnails). It is therefore a good idea when you are in the Print module to run a quick preview check of all the pages that are about to be printed and check if the image previews look like they have all been fully processed. If you see the ellipsis warning indicator in the top-right corner, it means Lightroom is still busy rendering a preview (see the callout in Figure 5.6).

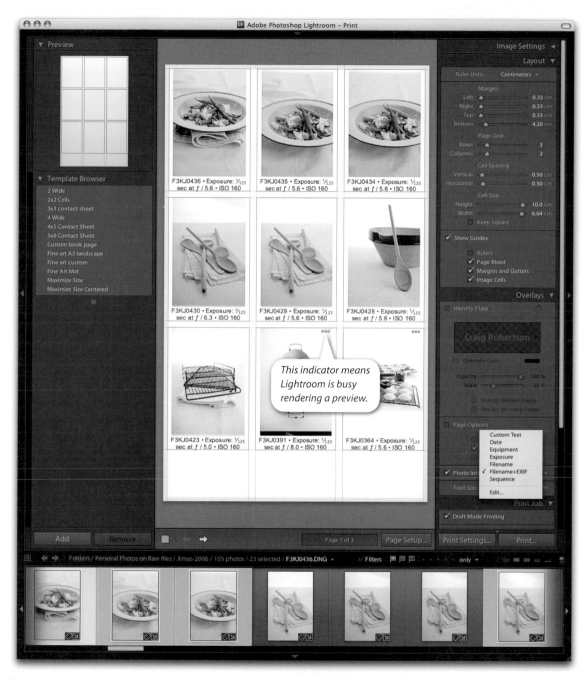

Figure 5.6 *An example of a 3x3 contact sheet template showing the page Layout tools and Overlays panel settings.*

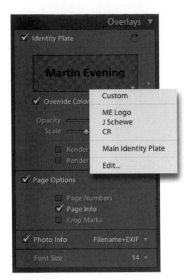

Figure 5.7 *The Overlays panel showing the Identity Plate menu.*

The Overlays options determine which extra items are printed (**Figure 5.7**). When the Identity Plate option is selected, you can click in the Identity Plate preview to reveal the list of Identity Plate presets, and select Edit to open the Identity Plate Editor dialog. In this dialog you can choose between a styled text name plate or adding a graphical logo. Then use the controls in this upper section to set the Opacity and Scale. In the steps that follow, I used the Scale slider to set the size of the Identity Plate to 72%, but you can just as easily do this by clicking and dragging on the corner or side handles of the box. You can also rotate the Identity Plate logo by clicking the Rotate button. If you want to repeat your logo in a multiple grid cell layout, use the "Render on every image" option. And there is also an option to Print behind image, which is of limited use really. You could fill the Page Grid area with a styled text Identity Plate and place it behind the image. Or, you could conceivably scale a graphical template logo. But considering that an Identity Plate logo can be no more that 60 pixels, the image quality will certainly suffer somewhat when scaled to fit a normal sized print!

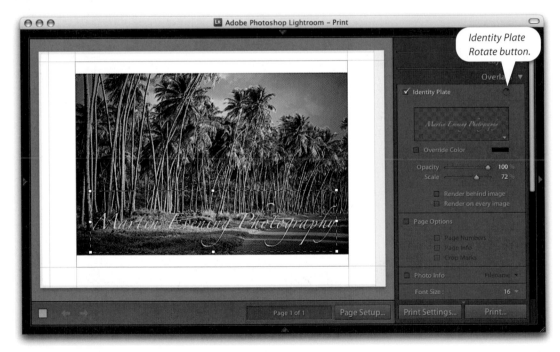

1. When the Identity Plate option is enabled, the current Identity Plate can be added as an overlay in the print layout.

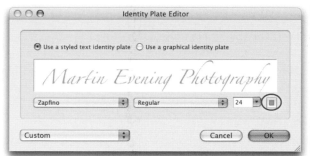

2. If you want to change the Identity Plate settings, click the Identity Plate preview (Figure 5.7) and choose Edit. The Identity Plate Editor dialog opens and lets you choose an alternative font and font size. To change the font color, click on the font color swatch and edit the color using the color picker that comes with the operating system.

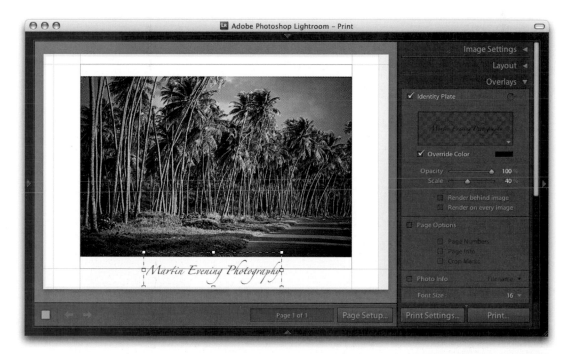

3. Back to the Print module. In this example, I clicked on the Identity Plate box and dragged to move it downwards, keeping it centered with the photograph, and then readjusted the Scale to make the Identity Plate size smaller.

TIP

You can apply a print watermark by overlaying the image with a text styled Identity Plate set to a low opacity setting.

Page Options

The Page Options allow you to add useful extras. I find the Crop Marks are useful for when I need to trim down a print in size after output. The Page Info item prints all the information relating to the print output method, which can be useful if you are running tests to evaluate the effectiveness of various profiles and print settings with the printer, profile, and sharpening method printed along the bottom. The Page Numbers option allows you to label a collection of print outputs using a specific page order.

In **Figure 5.8**, I was printing a high key photograph, so I added a thin black border (via the Image Settings panel) because it would frame the picture better. You can choose a border width setting between 1 and 20 points. If you are using the narrowest border width, make sure you set the print output resolution to at least a 300 pixels per inch output.

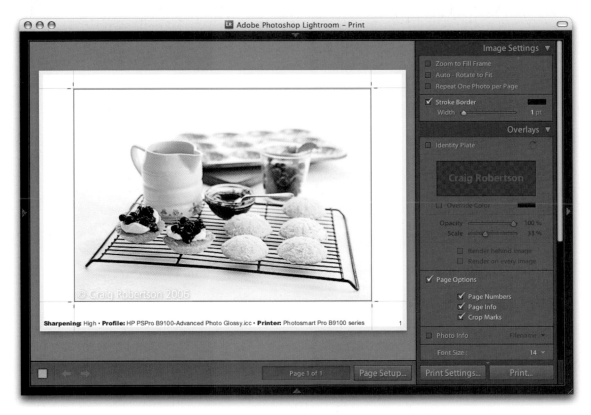

Figure 5.8 *The Overlays panel Page Options.*

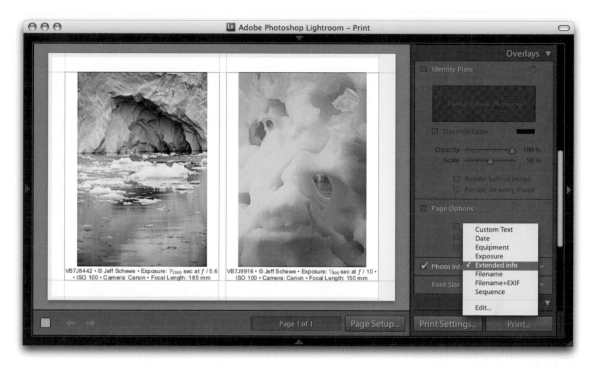

Figure 5.9 *Photo Information can be added below each frame. In this example I clicked the Photo Info menu in the Overlays panel to select a custom template that was created using the setup shown in Figure 5.10.*

Photo Info

The Photo Info section lets you add photographic information below each frame (**Figure 5.9**). Click the menu to choose from a list of basic, commonly required items such as Filename and Date, but for more extensive naming, you should choose Edit, which opens the Text Template Editor (**Figure 5.10**). This dialog lets you select tokens from the pop-up menus. Click Insert to add these tokens to the Photo Info template design. You can also add typed text and save the template as a custom Photo Info preset. You can then simply select a preset from the Photo Info menu and then choose a Font Size for the Photo Info text.

This feature has many practical uses, especially since there are many choices of photo information items that can be printed out below each picture. For example, if you are cataloging a collection of images, you may want to print out contact sheets with all the technical data included. Or, if you are sending contact sheets to a client, you may want to include just the filename, caption, and copyright information.

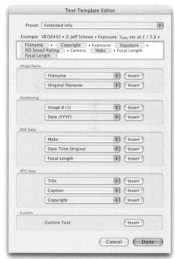

Figure 5.10 *The Text Template Editor can be used to create custom Photo Info templates. If you click to select a token and then click one of the Insert options, the selected token is changed. Otherwise, clicking Insert will add a new token.*

Page Setup

To make an actual print, you first need to click the Page Setup button on the Print module toolbar. This takes you to the Page Setup system dialogs for the Mac or PC operating systems, shown in **Figure 5.11** and **Figure 5.12** respectively. The main aim here is to establish which printer you intend to print with and enter the paper size you are about to print to, followed by the paper orientation: either portrait or landscape. The Paper Size options will most likely vary depending on which printer model you have selected. The options will be restricted to the various known standard paper sizes that are compatible with a particular printer. If the size you want to use is not listed, it is usually easy to create a new custom page size.

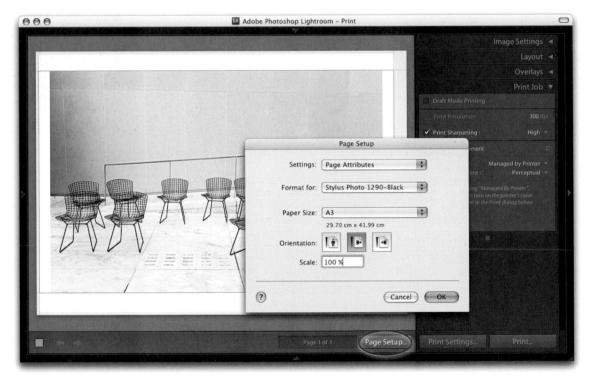

Figure 5.11 *When you click the Page Setup button in the Mac version of Lightroom, you see the Page Setup dialog shown here. You can then configure the printer to format for, the paper size plus page orientation (portrait or landscape). The Settings menu allows you to set the current Page Setup attributes as the new default page setup setting. The Scale box allows you to scale the size of the print output but I would advise you to leave the Scale set to 100% and use the Layout panel in the Develop module to scale the size of the printed image output.*

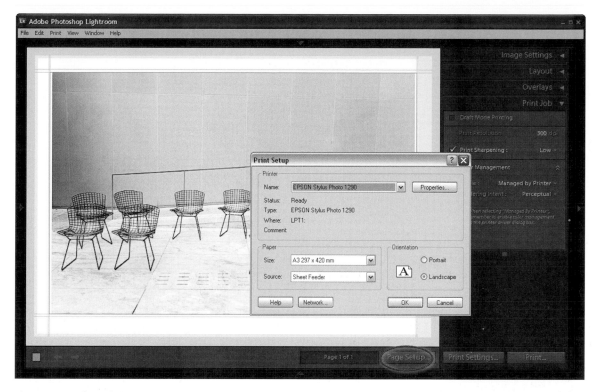

Figure 5.12 *If you click the Page Setup button in the PC version of Lightroom you see the Print Setup dialog shown here. You can choose a printer and set the paper size and orientation (either Portrait or Landscape). When you have done this, click OK to close the Print Setup dialog.*

The main difference between the PC Print Setup dialog and the Macintosh system dialog is that the PC system dialog allows you to click the Properties button and go straight to the Print Settings section of the system Print dialog, bypassing the need to go back into Lightroom and click Print Settings.

Print Resolution

In Lightroom there is no need for you to resize the image for printing. After you have configured the Page Setup settings, you can then decide what Print Resolution to use (the default setting uses a resolution of 300 pixels per inch). Depending on the resolution you select, Lightroom will either sample the image down or up in size to produce a print image with the right number of pixels to match the image dimension size that was set in the Layout panel section.

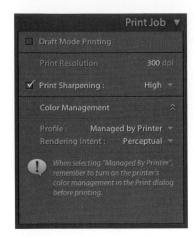

Figure 5.13 *The Print Job settings panel.*

Print Job Panel

Print job color management

The Color Management settings provide you with simple and advanced printing options. To use the simple printing method, leave the Profile set to Managed by Printer (**Figure 5.13**) and click the Print Settings button to open the Print dialog shown on the following pages. Basically, you need to check that the right printer is selected (the same one as you selected in Page Setup) and then choose the appropriate print settings such as the paper media type you are going to print on and the print quality. But most important of all, if you are using the Managed by Printer option, the ColorSync option must be checked in the Color Management section (Mac). If you are using a PC version of Lightroom, the ICM button must be checked in the Advanced Print Properties panel. After you have configured the relevant print settings, click Save to save the print settings changes.

The Lightroom printing procedure

Regardless of which print method is used, the printing procedure will always be the same. You must first configure the Page Setup on the toolbar to tell Lightroom which printer you are printing to and the size of the paper you are using. Next, you configure the print settings to tell the printer how the print data should be interpreted. Then you can click the Print button, which takes you to the final Print dialog.

The following steps show you the settings that you would use for printing to a basic Epson desktop printer. The print driver dialogs will vary from printer to printer; some offer different driver interface designs and in some cases more options. It is unfortunate that there is no easier, universal way to describe the printing steps that should be used here. But the print drivers are designed by the printer manufacturer that in turn have to work within the limits imposed by the computer operating systems. Not even Microsoft or Apple can agree on a common architecture for the print driver settings, hence the need to explain the two different approaches to the Page Setup and Print interfaces. It may be helpful to know that once you have configured the page and print settings, they can be saved permanently as a print template. Because you are able to save the page and print settings, you can lock the correct print settings to a template and avoid much frustration setting up the print driver.

Managed by Printer Print Settings (Mac)

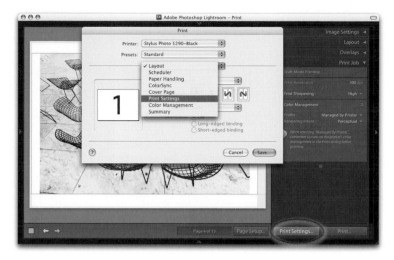

1. Click the Print Settings button in the Print module to open the Print dialog, which is shown here with the full list of settings options for the Epson Stylus Photo 1290 printer. Remember, you need to select the printer make here as well as in the previous Page Setup dialog.

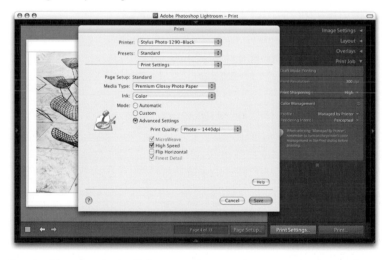

2. In this example, I will focus on the most important sections only. In Print Settings, select the media type that matches the paper you are going to print with and select a Print Quality mode. Here I chose the Advanced Settings and selected the Photo 1440 dpi Print Quality setting.

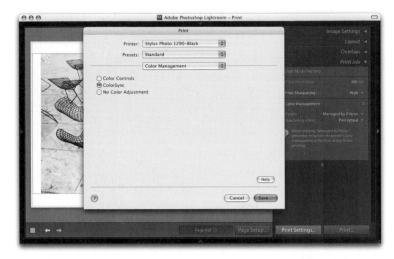

3. Although there is a panel called ColorSync, don't confuse this with the ColorSync setting in the Color Management section, which is where we need to head to next. In the Color Management panel make sure that the ColorSync option is checked. Then click the Save button to return to the Lightroom Print module.

Managed by Printer Print Settings (PC)

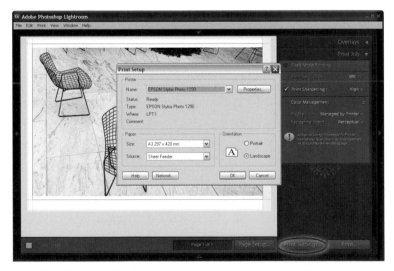

1. Click the Print Settings button in the Print module. Note that the Print Setup dialog is the same as the one you saw when you clicked the Page Setup button (you can click either the Page Setup or Print Settings to get started here).

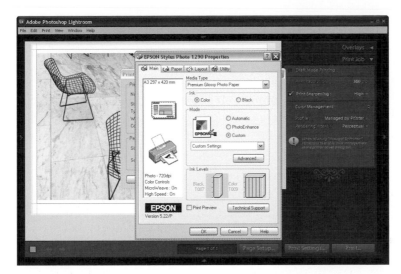

NOTE

Do not click the Print button until you have configured the Page Setup and Print Settings. You should only use the Print button after you have configured these settings.

2. Click the Properties button to open the printer Properties dialog, select the print media type, and then choose between black or color inks. Select the Custom Mode option and click the Advanced button.

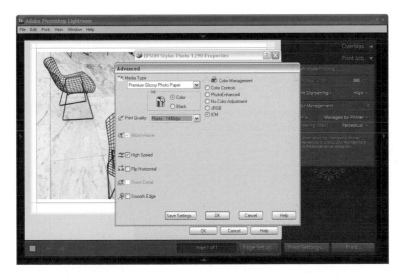

3. In the Advanced Print dialog you can now set the print quality. On a PC, choose the ICM option, which is the same as selecting the ColorSync button in a Macintosh print driver dialog. Click OK to go back to the printer Properties dialog. Click OK again to go back to the Print Setup dialog. Click OK to return to the Lightroom Print module.

TIP

The most effective way to stop the system print preset settings from interfering with the Lightroom print settings is to Alt -click the Lightroom Print button. This bypasses the system Print dialog completely and ensures that images always print with the settings that have been assigned via Lightroom.

TIP

On the Macintosh you can click the PDF options and choose Save as PDF. Instead of making a print, this will generate a PDF document from the print data, which can be used to print via another application such as Adobe Acrobat. You can also use this print method to save the print data in a form that can be sent by email to a colleague or client.

Print

After all the settings have been configured in the Page Setup and Print Settings sections, you need to send the print data directly to the printer. When you click the Print button, you won't need to adjust any settings in the dialog (**Figures 5.14** and **5.15**). The Printer model will be the same as the one you already selected, and on the Mac the Presets should be set to *Standard*. If the Presets show another selection, reset it to *Standard*. Now click the Print/OK button to print your image.

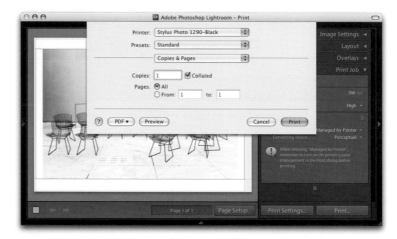

Figure 5.14 *On the Macintosh, rather than open a floating Print dialog as before, click Print to open a drop-down Print sheet from the document title bar.*

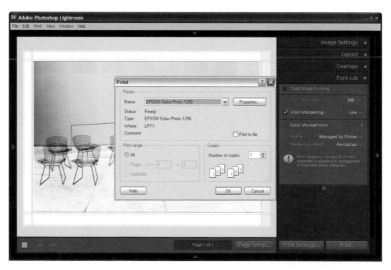

Figure 5.15 *Clicking Print on a PC reopens the Print dialog with the same settings except it just displays "Print." There is no need to make any changes. Click OK to print your image.*

Printing modes

When you click Print using the standard printing mode, Lightroom reads the image data from the original master file and resizes the image on the fly to match the print size specified in the page layout. This printing method ensures you get the highest print quality possible, whatever the print size is. However, if you are processing a large number of images to produce a set of contact sheet prints, it can very often take a long time for Lightroom to read in all the image data and resize the images. Whenever Draft Mode Printing is checked, Lightroom instead uses the image previews to generate the print files. The advantage of this is that the print processing time is pretty much instantaneous and can make a huge difference in the time it takes to generate 10 contact sheet pages from a folder of 100 raw images. In Draft Mode, Lightroom will use whatever previews it has to work with. If only the Standard previews have been generated, they will be used. It might be worth visiting the Library module and choosing Library ➩ Previews ➩ Render 1:1 Previews before making a set of Draft Mode prints.

Print Sharpening

Draft Mode Printing is perfect for any print job where speed is of the essence. But for everything else (especially when you want to produce the highest-quality prints), you will want to deselect this option. You will then be able to adjust the Print Sharpening.

A photographic image will inevitably appear to lose sharpness as a natural part of the printing process. To address this problem it is always necessary to add some extra sharpening prior to making a print. Note that when Sharpening is selected in the Print Job Settings you won't be able to preview the sharpening effect. Lightroom applies it behind the scenes to ensure that the picture looks acceptably sharp when printed. So when you are working in the Lightroom Print module, the Sharpening options are essential if you want your prints to look as sharp as they do in the screen preview. The question is which settings of the three should you use: Low, Medium, or High? In all the testing I have done, I have found the Medium setting works best when making prints that are smaller than 8 x 10-inches and the High setting works well with any print you make that is bigger than 8 x 10.

Figure 5.16 *Here is the Print Job panel with High sharpening selected. You should adjust the sharpen setting to match the size of your output. For bigger prints use the High setting and for smaller prints use the Medium setting.*

Managed by Printer Settings for Hewlett-Packard

While researching this book, I was able to test Lightroom printing using a Hewlett-Packard Photosmart 9180 printer. What impressed me most about this printer is its built-in spectrophotometer that automatically calibrates the print output during the setup procedure. The other feature I liked was how the available color management settings in the print driver responds to the Lightroom Print Job settings. I also liked how the Mac ColorSync settings were integrated with the print settings in a single section. Overall, the print driver is adequately foolproof. **Figures 5.17** and **5.18** show how the "Managed by Printer" setting works with the Photosmart 9180.

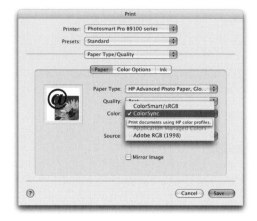

Figure 5.17 *On the Mac, select the Managed by Printer option in the Lightroom Print Job panel. In Page Setup choose the printer and the paper size. When you click the Print Setup button, all the required settings can be entered via the Paper Type/ Quality section of the dialog. When you are finished, click Save.*

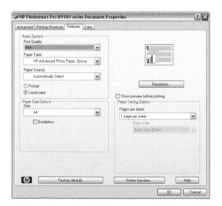

Figure 5.18 *Here are the print settings on the PC. You can configure the media settings via the Features panel and then click on the Color panel to choose ICM Color Management.*

Custom Profile Printing

The simple print method allows you to make quick Draft Mode prints or high-quality prints with added sharpening. If you are printing with a modern inkjet printer, you can expect to get very reasonable results when using the Managed by Printer option with the ColorSync or ICM option selected in the print driver settings. But if you want to make high-quality prints, you will be better off using Lightroom to handle the printer color management. To do this you need to deselect the Managed by Printer option and select a printer profile from the Profile menu. You can choose a canned profile or a custom profile that was specially made for your printer. **Figures 5.19** and **5.20** show how I changed the Color Management Profile setting so that instead of using Managed by Printer I could choose from a list of individual printer profiles. This in turn offered me a choice of Rendering Intents for the print job (see page 256 for more about rendering intents). But if you choose Lightroom to handle the printer color management, you have to configure the print settings differently.

Before reading further, note that if you select a standard printer supplied profile, the Media Type selected in the print settings must match the selected profile. If you select a custom print profile, ensure the ensuing print settings match those used to generate the original print target. Most importantly, the ColorSync/ICM settings must be set to No Color Management, because you want to avoid double-color managing the print image data.

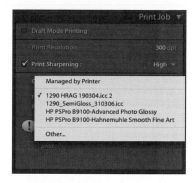

Figure 5.19 *When you click the Profile menu in the Print Job panel, you can choose a custom profile from the pop-up menu.*

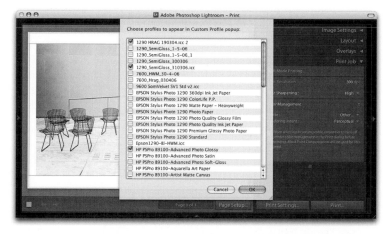

Figure 5.20 *The sheet menu in the Profile list displays only the profiles that you want to see. To edit the profile list, select Other. Choose the profiles you want to have listed. On a Mac you will see a sheet menu (on a PC you will see a floating dialog).*

Managed by Lightroom Print Settings (Mac)

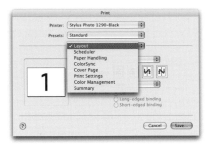

1. The steps outlined here are more or less the same as those described in the previous "Managed by Printer" examples. Click Print Settings in Lightroom to open the Print dialog, which is shown here with the full list of settings options for the Epson Stylus Photo 1290 printer.

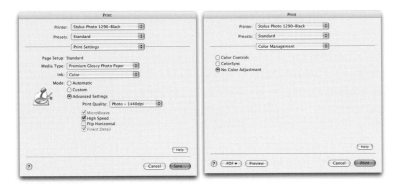

2. Once again, the Print Settings and Color Management are the most critical sections. Let's say I had selected an Epson 1290 Premium Glossy profile in the Print Job settings, using the standard print profile supplied by Epson. In this example, I need to ensure that the Media Type selected matches the profile that was chosen in Lightroom, and that I have the correct matching paper loaded in the printer. The Print Quality settings will normally be governed by the choice of Media Type. I selected the desired print resolution and print speed quality and then moved on to the Color Management section where the No Color Adjustment option must be checked. This ensures that the printer color management is disabled. If you are using a custom profile generated from a print test target, make sure you enter the exact same print settings as were used to print the target. Now click the Save button to save the settings.

Managed by Lightroom Print Settings (PC)

NOTE

For those who are interested in knowing how the print color management is applied in Lightroom, the Adobe color engine (ACE) is used to carry out the conversions, and black point compensation is activated whenever Managed by Printer is deselected.

1. When you click Print Settings in the PC Lightroom Print module, the main Print Setup dialog opens. Click the Properties button to open the Printer Properties dialog and select the print media type. Then click the Advanced button.

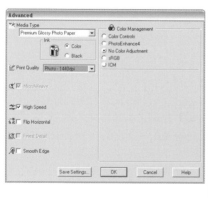

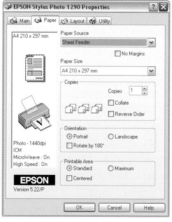

2. In the Advanced dialog you can set the Print Quality and this time check the No Color Adjustment option. Click OK in the Advanced dialog to go back to the printer Properties dialog. Click OK to go back to the Print Setup dialog. Click OK to save the new print settings and return to the Lightroom Print module. You can then click the main Lightroom Print button to make a print.

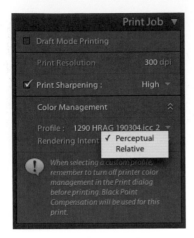

Figure 5.21 *When you click Rendering Intent, you can choose between Perceptual or Relative for the print output.*

Rendering Intent

Whenever you deselect the Managed by Printer option and select a custom print profile in Lightroom, you have two choices of Rendering Intent: Perceptual or Relative (**Figure 5.21**). Unfortunately, there is no means in Lightroom to preview what the outcome will be onscreen when either of these rendering intents are selected, so you may have to apply a little preknowledge when trying to decide which one to use.

The Relative (also referred to as Relative Colorimetric) rendering intent maps all the colors in the source image to the nearest equivalent in-gamut color in the selected print profile print space, but at the same time clips those colors that fall outside the gamut of the print space. The Perceptual rendering intent will map all the colors in the source image to fit smoothly within the destination print profile space. When Perceptual is used, all color differentiations are preserved. So, the brightest colors in the source image maps to the brightest printable colors in the print space and all the other colors will be evenly mapped within the gamut of the print space. The difference between these two rendering methods is most obvious when comparing an image that contains bright, saturated color detail, such as a photograph of a flower. With Relative rendering, the brighter colors may get clipped. With a Perceptual rendering the bright color detail will be preserved in the print.

Some people may point out that the downside of Perceptual rendering is that it has a tendency to unnecessarily desaturate the colors in an image where there were no out-of-gamut colors in the first place. In these situations, a Relative rendering produces a better result. Others argue that if the print does not look good when printed using a Perceptual rendering intent, it may be because you haven't fully optimized the image in the Develop module. Personally, I find that I use both renderings. If the image is normal without large areas containing bright color detail, I often use Relative, especially if I am printing to glossy media with the wide gamut inks that are used in the latest inkjet printers. However, some printers will have a more limited gamut. This is especially true when printing to matte art papers using photo matte black inks. For instance, I have an older Epson 1290 printer that has a limited color gamut in the shadows compared to more recent printers such as the HP Photosmart 9180. With a Relative rendering intent, I may well see noticeable gamut clipping in the shadow areas. I therefore find I get smoother tonal renditions in the shadows if I use the Perceptual rendering intent when printing images with a lot of dark colors.

Saving a Custom Template

After you have set up the page layout design and configured the Page Setup and Print Setup settings, you can save the print setup (including all the print settings) as a custom template. In the Template Browser panel (**Figure 5.22**), click the Add button to add the current print setup as a template and give it a name. To delete a template, select the template name in the Template Browser and click the Remove button.

As you update the layout or print settings relating to a particular template, you can easily update the settings by right-clicking on the template name and choosing Update with Current Settings. Refer to the Appendix to see how to load or share print template settings with other Lightroom users.

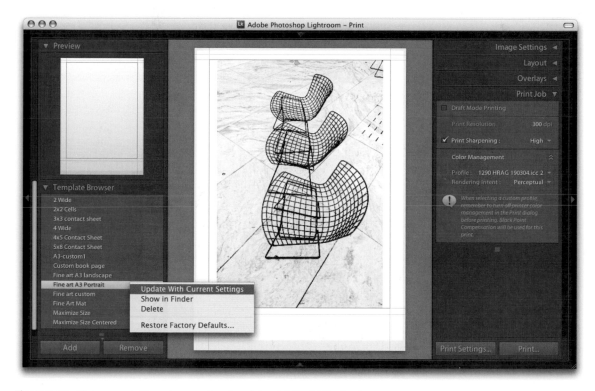

Figure 5.22 *To save a print layout as a custom template, click the Add button just below the Template Browser and give it a name. You can update existing settings by holding down the* Ctrl *key (Mac) or right-clicking to reveal the contextual menu and Select Update with Current Settings.*

Getting the Most Out of Lightroom Printing

What I like most about the Lightroom Print module is the way it allows you to set up the print layout and see a decent-sized preview in the content area of how the pictures you plan to print will look. It is also easy to select a group of images, select a print template, and process a whole batch of photographic prints at once. The print templates provide a robust mechanism for storing the printer settings. If you have grown accustomed to getting your fingers burnt through temperamental print driver behavior, this can take a little getting used to. But once you click Save or OK in the print driver dialogs via the Page Setup and Print Settings in Lightroom, these settings will remain as is until you decide to change them. These settings can be saved permanently when they are stored as part of a print template in Lightroom.

Color management is only as good as the paper profiles that are available for your particular printer. As mentioned earlier, these days printers have much better print quality consistency and the canned profiles work well. For example, you can obtain some high-quality Epson printer profiles via the Epson Web site, and you can access optional profiles, including those made by photographer Bill Atkinson, that are vastly superior to the canned profiles that ship with the printer products. At the Photokina show in Germany 2006, Hewlett-Packard unveiled the latest Z range of inkjet printers, which have built-in Gretag Macbeth calibrators that can help maintain closed-loop color accuracy. The Z range wide format printers, which also include a 12-ink printer model that uses red, green, and blue color inks, offer an even wider color gamut output. This is where it helps that the native color space in Lightroom uses a wide gamut color space, because there is no chance that the print colors will ever be clipped by the program's RGB color edit space.

Print resizing and sharpening are all taken care of directly by the Print module. Lightroom automatically resizes your images and applies the necessary degree of sharpening for any size print output. The Print module is still in its infancy. It would be nice to see other refinements such as soft proofing capabilities, but for now it has proven to be a pleasure to work with compared to most other print management interfaces.

Troubleshooting Tips for Printing

Printing is a complex subject in which much can go wrong. Here are some of the most common printing problems with my suggestions on how to troubleshoot them.

Printer Hardware

Many printing problems can be attributed to a problem with the printer connection or printer status. If nothing happens after you select Print, make sure that the printer is properly connected and check to see if any of the ink cartridges need replacing. Also check to see if a red light is flashing, indicating that a sheet of paper is stuck, or you need to click a button to feed a sheet through the printer to clear it.

It may also be worth checking that the print queue is clear. Go to the system print preferences and check the print queue status. You may see your print job sitting in a queue with the print job put on "hold" status. If you click to resume printing, the printer should spring to life again. If you are printing over a network, check the print spool status of the main computer that the printer is connected to.

Getting Colors to Print Consistently

If the colors in the print don't match what you see on the screen, here are a few things you need to check for:

* Make sure you have calibrated and profiled the monitor recently. The screen colors will shift over time, and it is essential that your monitor profiles are kept up to date.

* Make sure you followed the correct print procedure in Lightroom. Go back and check that you are using the right print settings and that they match the type of paper you are printing on. If you are color managing by the printer, is ColorSync/ICM selected? If you are color managing via Lightroom, is ColorSync/ICM deselected? As mentioned earlier, you can often select a preset setting only to find the settings have not actually changed. Double-check that the settings are correct.

* Check that the paper you are printing with is the correct type and that the paper is loaded the right way. Most papers are designed to be printed on one side only.

* Whenever you see sudden shifts in print color, it is a sure sign that one or more cartridges may have run out of ink, or more likely, an inkjet head has become clogged. If this might be the cause of the problem, run the nozzle check and head cleaning utilities to make sure the heads are all functioning normally.

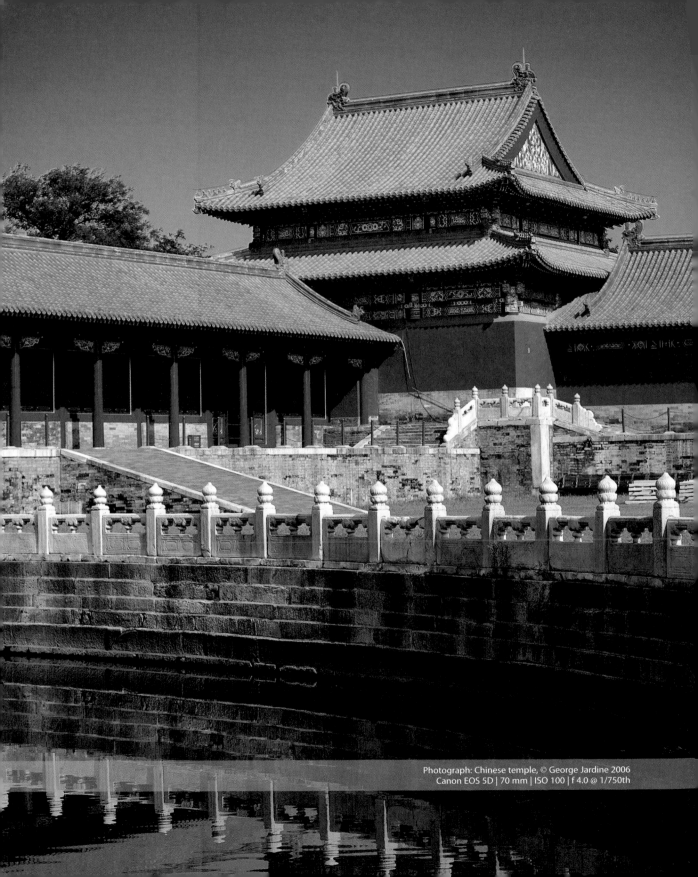

6 | **Presenting Your Work**

Despite the popularity of print, it is interesting to pause for a moment and speculate about just how few of the photographs we shoot actually do end up being printed. There was a time when people would take their films to the local photo lab to be processed and every picture was printed. These days, most people shoot with digital cameras, so you are more likely to see people's holiday snaps sent as email attachments or on a Web gallery rather than as a set of prints.

This final chapter is therefore all about how to present your photographs so that they look their best when viewed on the screen. Lightroom's Web module helps you create an instant Web site of your pictures. After you have configured the settings the first time you upload a Web gallery to the Internet, you can then create and upload more galleries with relative ease. But first let's take a look at how to create smart-looking slideshow presentations that can be displayed on your own computer or exported as self-contained presentations for business or personal use.

NOTE

Whenever you launch an impromptu slideshow, the currently selected slideshow template will be used.

The Slideshow Module

The Slideshow module lets you create onscreen presentations of your library collections in two ways: as a Lightroom slideshow or as a PDF export (**Figure 6.1**). You can play slideshows directly from the Slideshow module, but you can also initiate an impromptu slideshow while in the Library, Develop, or Print modules by pressing ⇧Shift ←Return. Any time you want to exit a slideshow, just press Esc.

The Slideshow Options panel controls how the images are presented in the individual slide frames and offers the ability to edit the Stroke Border styles and Cast Shadow options. The Layout panel is similar to the page layout tools in the Print module and can be used to set up the margin widths for the slide frames. The Overlays panel is similar to the one in the Print module. You can add elements to a slideshow template design, such as a custom Identity Plate and rating stars information. When you enable the Text Overlays option, you can add custom text objects with full text editing control and optional drop shadows. The Backdrop panel lets you set a backdrop color and color wash effect, or you can choose to add an image from the Filmstrip as the backdrop. The Playback panel provides playback duration, image fade and randomize options, plus the ability to select a music sound track for the slideshow.

As with most of the other modules, the Slideshow settings can be saved as a custom template setting via the Template Browser. Notice that as you roll over the listed presets you will see a quick preview generated in the Preview panel using the current, most selected image in the Filmstrip selection as a guide to the slideshow template's appearance. The playback controls in the toolbar area can be used to switch to the Preview mode in which you can preview how the slideshow will look in the content area before clicking the main Play button.

If you create a collection in the Library module first and then use the Slideshow module to apply a slideshow template (or create a new template setup), the slideshow settings will automatically be linked to that collection. Slideshows can also be exported as self-contained PDF documents. Click the Export button or choose Slideshow ⇨ Export Slideshow or press ⌘ J (Mac) or Ctrl J (PC). You can then use the Export Slideshow as PDF dialog to create a PDF document.

As you roll over the Template Browser the Preview shows a low-resolution preview of the template layouts.

The Template Browser lists the saved Slideshow presets.

The Options panel controls the image appearance within the slideshow frames.

The Layout panel sliders control the margin widths.

Use the Overlays panel to choose how the Identity Plate and custom objects are displayed.

Add Text to Slide button.

The Backdrop settings let you adjust the appearance of the backdrop.

Use the Playback settings to adjust slide and music playback options.

Slideshow playback controls.

Slideshow Export and Play buttons.

Slideshow images can be selected via the Filmstrip.

Figure 6.1 *The Slideshow module.*

The Slide Editor View

The most selected image appears in the content area, which is used to display a Slide Editor view of the slideshow layout. You can change the image view by using the left and right arrow keys to navigate through the selected images in the Filmstrip (**Figure 6.2**).

As adjustments are made to the Slideshow settings in the panels on the right, these changes are reflected in the Slide Editor view. As with the other Lightroom modules, you can toggle between showing and hiding the toolbar using the T keyboard shortcut.

Figure 6.2 *The Slideshow module showing a view of the slideshow layout in the content area and the Filmstrip below it.*

Layout Panel

The Layout panel lets you edit the slide layout by specifying the margins for the image content. **Figure 6.3** shows the layout guides in red. You can adjust the margins by dragging on the slider controls or by double-clicking the fields in this panel to enter a precise pixel value and then fine-tuning this value using the up and down arrow keys. A single arrow click increases or decreases the pixel dimensions by one unit. To shift the dimensions 10 units at a time, ⇧Shift–click with the arrow keys. If you just hover the mouse over one of the field boxes, a scrubby slider will become active, and you can then drag the mouse right or left to increase or decrease a value. Note that the unit dimensions have linking check boxes next to them, which means that when two or more boxes are checked, as you adjust one value, the other field values are linked to it. For example, in Figure 6.3 I checked the boxes for just the left and right margins, so that only they were linked as I adjusted the margin width on either side of the frame area. You can hide the slide layout guides at any time by unchecking the Show Guides box in the Layout Panel or by pressing ⌘⇧Shift H (Mac) or Ctrl ⇧Shift H (PC).

NOTE

The proportions of the Slideshow view will always be relative to and dictated by the proportions of the monitor display you are working on. This can have ramifications for how you export a slideshow. I will discuss how to address this in "Exporting a Slideshow," later in the chapter.

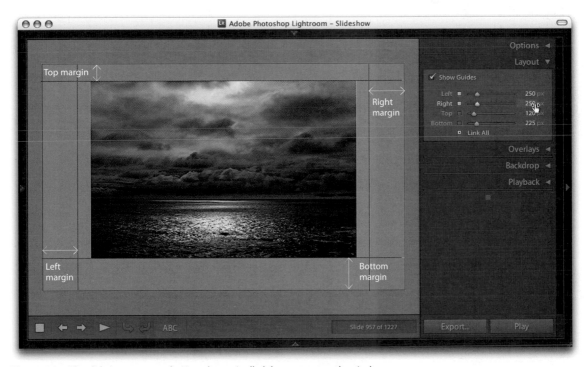

Figure 6.3 *The slide Layout controls. Note that as I rolled the mouse over the pixel size field, the scrubby slider became active, allowing me to drag left or right to adjust the pixel size widths of the margins.*

Figure 6.4 *The color picker dialogs for the Stroke swatch (Mac, top, and PC, bottom).*

Options Panel

Now let's look at how the individual photographs will appear in the slide frames. At the top of the Options panel is the Zoom to Fill Frame check box. In **Figure 6.5** this option is deselected, and as you can see in the Slide Editor view, the slideshow photographs always fit centered within the margins (as specified in the Layout panel). **Figure 6.6** shows that if the Zoom to Fill Frame option is checked, the slideshow photographs resize and expand to fill the available space. You should be aware that when you select this option, the Zoom to Fill Frame action automatically centers each image in the slideshow as it applies the necessary cropping to the picture. If you look closely at Figures 6.5 and 6.6, you will notice that in Figure 6.6 the cropped view is aligned to the bottom edge of the frame. This happened because I clicked on the slide preview image and dragged it upwards to preserve the bottom edge of the photograph. This tweaking overrides the automatic cropping and is applied on a per-image basis. In other words, you can pre-edit a selection of pictures that will be included in a slideshow and customize the cropping in each picture. Do be aware that these adjustments will be lost as soon as you make a new selection of images. It only makes sense to spend time making custom tweaks to a slideshow presentation in this way if your goal is to export the slideshow as a PDF presentation. In Figures 6.5 and 6.6 I checked the Stroke Border option to add a light gray stroke to the slideshow frame images (the stroke border will always be 1 pixel thick). If you want to change the stroke color, double-click the color swatch to open a system color picker dialog, which will look something like either of the dialogs shown in **Figure 6.4**.

If you select the Cast Shadow option, you can add drop shadows behind the photographs that appear in the slideshow. The Cast Shadow mode is locked to Multiply blend mode, so it is strictly a shadow creation tool (you can't change the blending to Screen mode to produce a glow instead). But by adjusting the Opacity, Offset, Radius, and Angle sliders (or angle wheel), you can customize the shadow effect any way you like. Notice that as you adjust the angle setting, the shadow preview temporarily hardens to a flat shape, but as you release the adjustment controls, the shadow rerenders in the Slide Editor view.

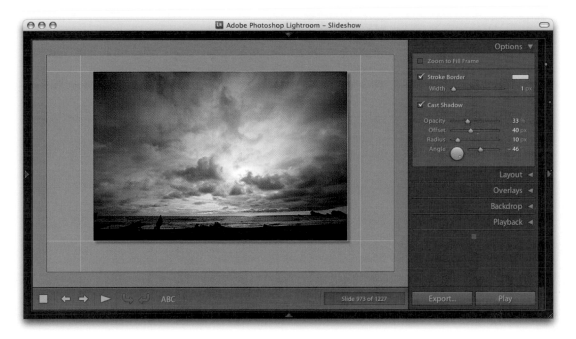

Figure 6.5 *The Options panel is shown here with the guides visible but all other objects hidden. I left the Stroke Border option checked and customized the Cast Shadow settings.*

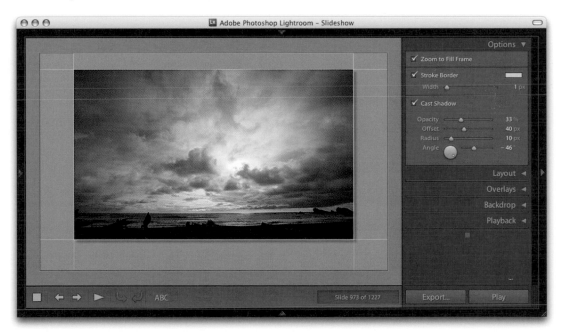

Figure 6.6 *In this next example, I checked the Zoom to Fill Frame option. Note how the same image expands to fill the area within the frame margins.*

Figure 6.7 *The ratings color swatch selector dialog (Mac and PC).*

Overlays Panel

Having established the layout margins and image placement, you can begin adding extra content to the slide frames. If you enable the Identity Plate option, you can select a custom preset template by clicking on the Identity Plate preview, or choose Edit to create a new one. The Opacity and Scale properties will let you customize the Identity Plate appearance and decide whether you want the Identity Plate to be on top or placed behind each slide photograph. Once enabled, the Identity Plate can be repositioned by simply clicking and dragging it anywhere inside the slide frame area. In this respect the Identity Plate is just like any other custom object. The Rating Stars options let you display the current image star rating plus set the color and scale size (**Figure 6.7**). But as with all custom objects, you can scale each object by dragging on a corner or side handle. The Text Overlays check box toggles displaying all other objects apart from the Identity Plate and ratings. For example, in **Figure 6.8** this option is checked, and you will see a filename text object displayed centered below the image. The Shadow check box lets you apply a drop shadow effect to each overlay object and apply independent shadow settings to each. I will discuss working with Text Overlays shortly, but let's take a quick look at the Identity Plate options first (**Figures 6.9** and **6.10**).

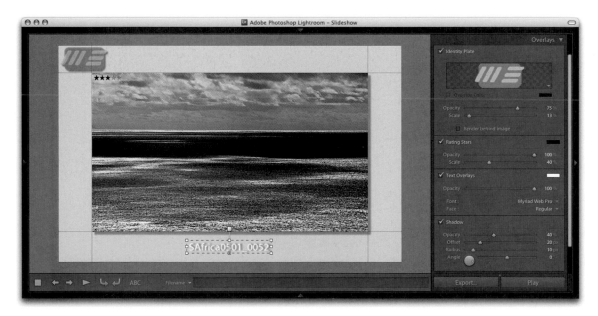

Figure 6.8 *The Overlays panel can be used to add an Identity Plate, rating stars, and custom text objects with or without drop shadows.*

Creating a custom Identity Plate

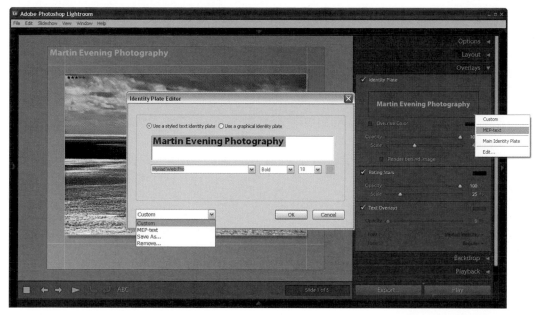

Figure 6.9 *To open the Identity Plate Editor, click on the Identity Plate preview in the Overlays panel and choose a pre-saved Identity Plate setting or select Edit. In this step I chose the "Use a styled text identity plate" option, modified the typeface, and saved it as a new Identity Plate preset.*

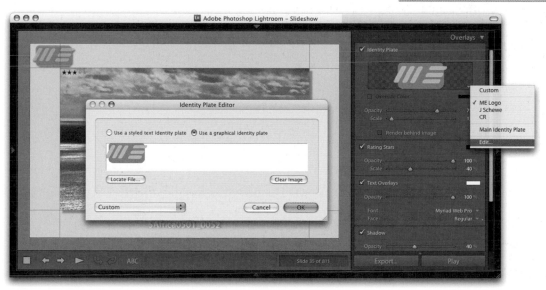

Figure 6.10 *Alternatively, you can choose the "Use a graphical Identity plate" option, as described in Chapter 2, "Importing."*

Adding custom text overlays

To add a custom text overlay, click the Add Text to Slide button on the toolbar (**Figure 6.11**). The Custom Text box appears next to it in the toolbar. You can at this stage simply start typing in your name or other text. After you press Enter, the text appears as a new text overlay in the Slide Editor view. You can also click Custom Text or the triangle next to it to open the menu and select an item from the list such as Date or Filename. Or, you can choose Edit, which opens the Text Template Editor (**Figure 6.12**), or press ⌘T (Mac) or Ctrl T (PC). This allows you to add various metadata items as tokens. Click one of the Insert buttons to add tokens to a template design and combine these with custom text to create your own custom text overlay presets. For example, in **Figure 6.13** I show how you could create a text overlay that includes text such as *Date of Shoot,* followed by a "Date (Month, DD, YYYY)" token. You can add as many text overlays as you like and reedit them. Click to select a text object in the Slide Editor view and edit the content by typing in new custom text, or select a new item from the text menu. You can use the Rotate buttons on the toolbar to rotate a text overlay. To remove an overlay, highlight it and click Delete. The steps that follow show the process.

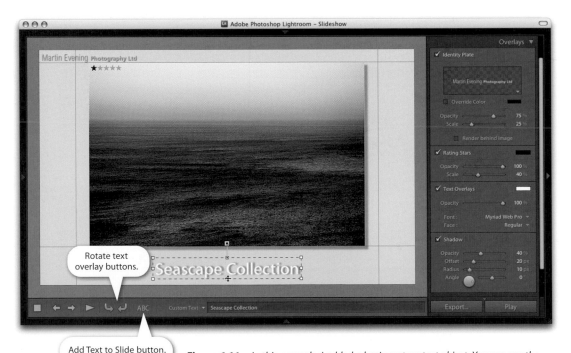

Rotate text overlay buttons.

Add Text to Slide button.

Figure 6.11 *In this example, I added a basic custom text object. You can use the various anchor points (I have shown all of them here) to help align a text overlay.*

Figure 6.12 *To add other types of text overlays you can click on the menu and select a text object preset, or click the Edit menu item to open the Text Template Editor and create a template design of your own.*

Figure 6.13 *Here are some views of the Text Template Editor. The Date token options (left) can be used to apply different date and time formats. The token options (middle) include items relating to the camera capture data. The IPTC Data token options (right) include items relating to the IPTC metadata (see Chapter 3, "Managing the Library").*

1. To add a custom text overlay, I clicked the Add Text to Slide button, which then revealed the Custom Text options. I then clicked to show the menu and chose Edit. The Text Template Editor appears.

2. I clicked on the top pop-up menu in the IPTC Data section of the Text Template Editor to select Creator Website, and then clicked Insert. This added a creator Website token, and I saved it as a "Website" preset.

3. After exiting the Text Template Editor, a new text overlay is created. I used the Text Overlays options to set a font and type style.

4. A text overlay can be positioned in the Slide Editor view with the help of the anchor point guides (note that I have overlaid this particular screen shot with a map of all the available anchor points in this Slide Editor view). You can adjust the placement of a frame anchor point by clicking to select it and dragging it to a new position. Here, I placed the text in the middle of the frame. The text opacity was set to 17% to produce a watermark effect.

TIP

Don't forget that as with all changes you make in Lightroom, changes made to the Slideshow settings and those made in the Slide Editor view can be undone using Edit ⇨ Undo or ⌘ Z (Mac) or Ctrl Z (PC).

Backdrop Panel

The backdrop appearance can be modified via the Backdrop panel. The Color Wash controls are a nice touch, because you can set up different color scheme combinations using the Color Wash and Background Color swatches and then adjust the Opacity and Angle sliders to fine-tune the effect. You can also place an image as a backdrop. The first time you check the Background Image option you won't see anything happen, because you must select a photograph from the Filmstrip first and drag it into the backdrop area (or Background image preview) for a background image to register. After that you can use the check box to toggle the backdrop image. Notice how the color wash colors can also be combined with the applied backdrop image and used to mute the backdrop image contrast. Whenever an image is applied to the backdrop, you still retain full control over the Color Wash color, Background Color, and Color Wash settings, and you can mix them any way you like to achieve a desired look for the backdrop. Remember also that all the settings, including those in the Backdrop panel, can be saved as a template. So you can create Backdrop panel designs that use different background images and save these as separate templates. The following steps show the color effects possible.

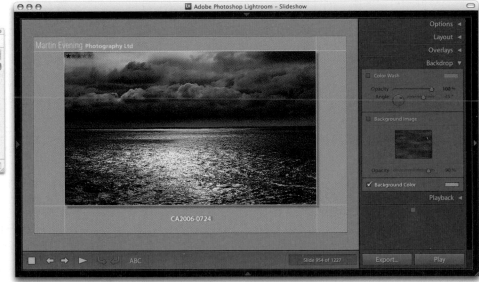

1. The default backdrop color for this template design is black, but when the Background Color option is checked, you can click the color swatch to choose an alternative backdrop color.

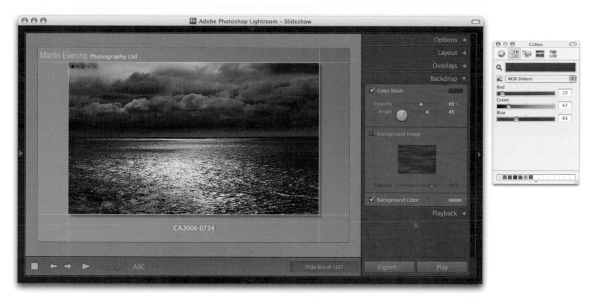

2. When the Color Wash option is checked, you can introduce a secondary color to apply a gradient wash across the backdrop.

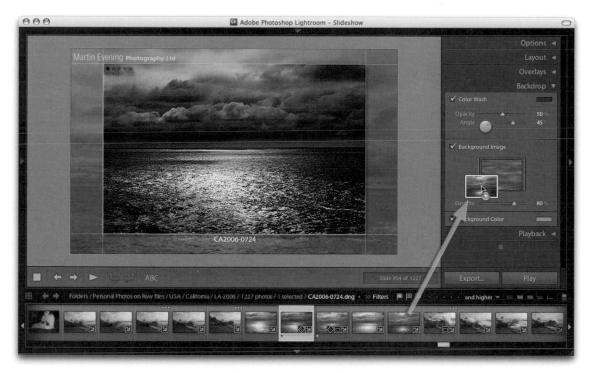

3. An image can be added to the backdrop by dragging an image from the Filmstrip into the slide Background Image preview area.

Figure 6.14 *The Playback settings panel.*

Figure 6.15 *As you add new playlists in iTunes, you need to choose the Refresh Playlist from iTunes item in the Playback settings panel to make the new playlist visible in the Lightroom Playback settings panel.*

Playback Panel

When all the slide settings are configured, you will almost be ready to start playing the slideshow. But before doing so you need to visit the Playback panel and set the duration of the Slides and the length of time for the Fades between each slide (**Figure 6.14**). If you want the slideshow to run at a fast speed, you can try selecting shorter slide and transition duration times. But bear in mind that the ability to play back at a faster speed is governed by the size of the master library image files and whether they have all been fully cached yet, and the performance power of your computer. Should you be so inclined, you can check the Random Order option at the bottom to shuffle the play order.

If the Music option is checked, Lightroom looks to see if you have any software capable of playing MP3 tracks, such as Apple's iTunes, and displays the music library and any collection lists via a drop-down menu (**Figure 6.15**). On the computer setup in my office, I maintain a complete MP3 music library and have created several customized music lists (**Figure 6.16**). I can choose a specific music track to accompany an image slideshow. When I press Play, the selected music track starts playing in the background, commencing with the first track in the selected list. When you have a list of favorite tracks, you need to drag them to rearrange the order of the music tracks to match the desired mood for your slideshow. I recommend making selections of a small number of tracks that blend well together, and in iTunes choose File ⇨ New Playlist from Selection and name this as a new playlist selection. You will then need to choose the Refresh Playlist from iTunes option in the Playback panel to make the new playlist visible, and select it when choosing a playback track.

NOTE

Apple iTunes is a free MP3 player program available for Mac and PC. To download the latest version, go to www.apple.com/itunes/.

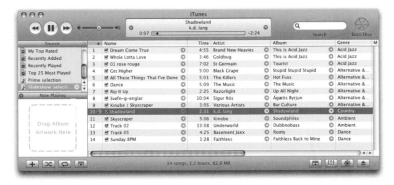

Figure 6.16 *The iTunes program interface showing a playlist selection titled "Slideshow selections."*

Template Browser Panel

After going to all the trouble of designing a slideshow layout with measured margins, Identity Plate, customized text objects, and a backdrop image, it makes sense to save it as a template setting that can be used again later. When you work on a slideshow layout design, you can select Slideshow ⇨ Save Slideshow Settings or press ⌘ S (Mac) or Ctrl S (PC) to quickly save the current slideshow settings without saving them as a specific template. As you select other presaved templates and compare the look of different layouts, you can select Slideshow ⇨ Revert Slideshow Settings to instantly return to the current temporary slideshow layout.

But to save a slideshow as a template, click the Add button in the Template Browser panel and give the template a descriptive name. **Figure 6.17** shows the saved the template that I created over the last few pages as *Fineart show*. As you roll over the other template presets in the list, you will see a preview based on whichever is the most selected image in the Slide Editor view. When you save a template that includes a specific backdrop image and for whatever reason that image is no longer available in the library, you may see an error warning in the preview. However, if you do select a template in which the backdrop image is missing from the library, Lightroom will likely substitute the last used backdrop image.

You can see how social and wedding photographers might find it useful to take a standard layout design and save variations of this template with alternative music playback settings to suit the music tastes of different clients. Art photographers might also find it useful to create custom slideshows for exhibition display on a large screen.

As with the other Lightroom modules, you can remove a template by highlighting it and clicking the Remove button in the Template Browser panel. You can also update the settings for a particular template by right-clicking (also available as Ctrl-click on a Mac) and choosing Update with Current Settings. It is worth knowing that the slideshow settings will also be remembered and associated with a particular collection in the Library module. If you go to the Collections panel, select a collection, and then select a slideshow template to use, this slideshow template will be designated as the one to use whenever that particular collection is selected again via the Collections panel in the Library module.

Figure 6.17 *The Template Browser plus template preview. Note: If you save a slideshow setting that includes a backdrop image, the backdrop image must be present in the library in order for the template to work.*

NOTE

There is no nesting capability built into the Template Browser panel. To be honest, it is not something that you are likely to need because there should be enough room to accommodate all the slideshow templates you might use.

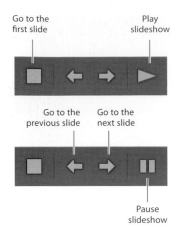

Go to the first slide Play slideshow

Go to the previous slide Go to the next slide

Pause slideshow

Figure 6.18 *The Slideshow Preview mode playback controls, showing the slideshow controls in both Play and Pause mode.*

NOTE

If you want to run an impromptu slideshow in any of Lightroom's modules, press ⌘ ←Return **(Mac) or** Ctrl ←Return **(PC).**

Preview and Play

You are now ready to play the slideshow. Choose Slideshow ⇨ Run Slideshow or click the Play button in the bottom-right corner. You can also press ←Return to launch a full-screen slideshow using the currently selected slideshow template settings (you can use this method to run a slideshow from any module). When you switch to full Play mode, the screen fades out to black and then fades up to display the slides in sequence. To stop a slideshow, just press the Esc key.

If you just want to see a quick preview of the slideshow, click the Play Slideshow button on the toolbar (Alt ←Return) to see the slideshow play within the content area (**Figure 6.18**). **Figure 6.19** shows a slideshow being previewed (the background is dimmed to black in the content area). The main advantage of running a slideshow in Preview mode is that the slideshows will typically start running a lot sooner (depending on the size of your slideshow images). While in Preview mode you can interact with the slideshow using the navigation keys located on the toolbar (see Figure 6.18 for descriptions of the buttons). But note that you can also manually override a slideshow sequence by using the left and right arrow keys to go backward or forward through the sequence, and you can pause a slideshow by pressing Spacebar. Press Spacebar again to resume playing.

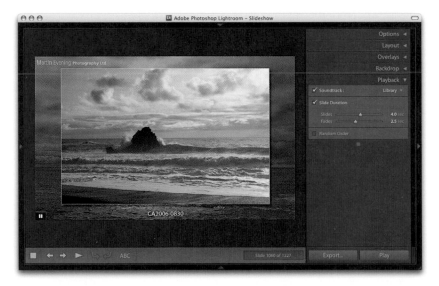

Figure 6.19 *If you want to check how your slideshow is looking without playing the full-screen version, click the Preview button. You can pause a slideshow by pressing the Pause button or hitting* Spacebar *.*

Exporting a Slideshow

All the slideshow features discussed so far apply when you are working in Lightroom only. But you can also export a slideshow as a self-contained slideshow in the Adobe PDF format, which can be played via the freely available Adobe Acrobat Reader program or any other program that is capable of reading PDF files (such as Apple Preview). Choose Slideshow ➩ Export Slideshow, or press ⌘J (Mac) or Ctrl J (PC). The Export Slideshow to PDF dialog opens (**Figure 6.20**). Choose a destination where you want to save the exported PDF. At the moment, PDF is the only output format available, but below this you have all the PDF export options. The Quality slider sets the amount of compression used, and the Width and Height sections let you determine how large you want the slideshow document to be. You need to take into account the likely screen size of the computer the exported slideshow will be played on. The format of the slideshow slides will have already been influenced by the computer display you are working with. For example, most Macintosh computers are hooked up to a display that uses a wide-screen format ratio of something like 16:9. If you want to scale down the slide size but preserve the full slide area, the size dimensions must match the ratio of the current pixel width and pixel height of your display. The "Automatically show full screen" option determines whether the slideshow will start playing in full-screen mode whenever you open the exported slideshow PDF document.

NOTE

Adobe Acrobat Reader is a free PDF player program for Mac or PC. To download the latest version, go to www.adobe.com/products/acrobat/ and look for a link to download the Acrobat Reader program.

Only the latest versions of Adobe Acrobat Reader are able to play a slideshow with transition dissolves, and even then they will be of a fixed speed.

TIP

When you play back a PDF slideshow in Adobe Acrobat using the full-screen mode, the default view fills the entire screen. This is fine if you make the slideshow match the full-screen pixel resolution. However, if you want to play the slideshow at the actual pixels resolution, press ⌘1 (Mac) or Ctrl 1 (PC) in Adobe Acrobat Reader.

TIP

PDF slideshows are ideal for sharing, but the compression settings should be adjusted according to how you intend to use a slideshow. If your PDF slideshow will be distributed on a CD or DVD, use a full-screen size and the best quality compression setting. If you are sending a slideshow by email, keep the pixel size and compression settings low enough so you don't send attachments that are too large.

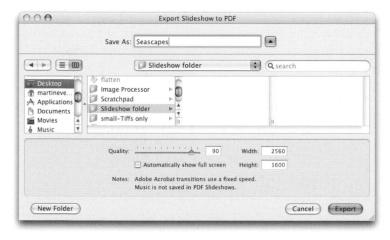

Figure 6.20 *The Export Slideshow to PDF dialog.*

NOTE

Photoshop has long had the ability to let you create Web Photo Gallery Web sites of your work. Yet it has often surprised me just how few photographers were using this feature, or even knew that it existed. Web galleries are incredibly useful if you need to quickly publish a collection of images on a Web site. You can use them to show photographs from a shoot you are working on to get feedback and approval from a client. Or you can use Web galleries for fun, to share pictures with your friends and family.

The Web Module

The Web module in Lightroom helps you publish photo collections as Web sites with as little fuss as possible (**Figure 6.21**). The main difference between the Web module and the Slideshow module is that you only have a small amount of control over the Web gallery designs there is more emphasis on being able to customize the content information. The Web module works by using the library image previews and builds a Web site on the fly as you adjust the Web module settings. What you see in the content area is not just a preview but the Web gallery as it might look when viewed via a Web browser. And as you adjust the Web module panel settings, the changes you make are constantly updated in the content area. As with the slideshow, a Web gallery can be generated from a selection of images such as a collection, a filtered library selection, or a subselection of images made via the Filmstrip.

In the Gallery panel you can choose between a Flash Gallery and an HTML style layout. Depending on which basic gallery style you select, it in turn affects the options that are subsequently made available in the other remaining panels. In the Labels panel you can enter custom information such as the site name and your contact details. With the Color Palette panel you can edit the color scheme for all the Web gallery design elements, and in the Appearance panel you can customize the appearance of the layout design for the HTML or Flash Gallery styles, deciding on elements like how many rows and columns will be used in a thumbnail grid. The Output Settings panel is used to set the thumbnail and preview image sizes, to set the image quality, and to add a copyright watermark to the Web gallery images. The Image Settings panel lets you customize the content that appears beneath or alongside the individual gallery images and provides the opportunity to add multiple items of relevant data information.

At this stage you can either click the Export button to save the Web gallery to a named output folder or click the Upload button to upload the Web gallery using a preconfigured server setting. There is a link option in the Output panel header that lets you preview the Web gallery site in the default Web browser program first. Below that are the aforementioned FTP Server settings, where you select the presaved FTP server settings and upload the gallery directly to a specific server without having to use a third-party program to do that for you.

Custom Web gallery configurations can then be saved via the Template Browser panel. Quite a few templates are provided to help get you

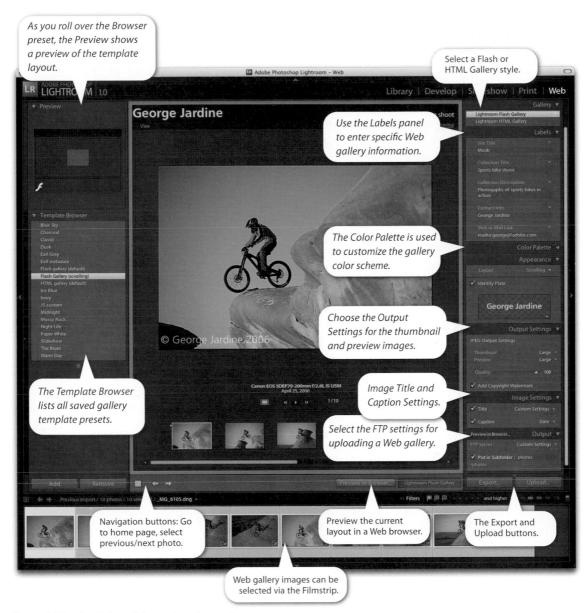

As you roll over the Browser preset, the Preview shows a preview of the template layout.

Select a Flash or HTML Gallery style.

Use the Labels panel to enter specific Web gallery information.

The Color Palette is used to customize the gallery color scheme.

The Template Browser lists all saved gallery template presets.

Choose the Output Settings for the thumbnail and preview images.

Image Title and Caption Settings.

Select the FTP settings for uploading a Web gallery.

Navigation buttons: Go to home page, select previous/next photo.

Preview the current layout in a Web browser.

The Export and Upload buttons.

Web gallery images can be selected via the Filmstrip.

Figure 6.21 *The Web module panels and controls.*

started and show the full range of what you can achieve with the Web module. With a little patience and practice you can easily adapt the basic templates and customize them to create your own Web gallery design layouts.

Figure 6.22 *The Gallery panel.*

Figure 6.23 *Adobe Flash Player Update warning dialog.*

Gallery Panel

The Gallery panel is located in the top-right panel section (**Figure 6.22**). Like the Histogram panel in the Library and Develop modules, all the other panels scroll down or roll up beneath it.

The Lightroom HTML and Flash Galleries

The Web module offers two choices of gallery styles. The Lightroom HTML Gallery style is based on a classic HTML-coded template design that can be used to produce a simple Web gallery that has two viewing levels. Thumbnail images are displayed in a grid on the main index page, and when you click one of the thumbnail cells, a single large image view displays with room to include a list of metadata information in the caption area. From there you can click on the main image to return to the index page thumbnail view. Because the Lightroom HTML Gallery uses classic HTML code, it is probably a more compatible layout style to use for most visitors who want to view a gallery on the Web. The custom options will let you make some basic modifications, such as the size of the large image view, the metadata display options, and the color scheme, but it is otherwise quite a rigid style.

The Lightroom Flash Gallery style builds a gallery that uses Adobe Flash (formerly Macromedia) code, which can render smooth, animated slide transitions between images. Flash-based Web sites are all the rage these days. They look cool and are a great way to present your images, but visitors to a site built using the Lightroom Flash Gallery style must have the latest Flash player installed to view the Web gallery contents. In fact, when you select a Flash Gallery style, you may see the warning dialog indicating that you need to install the latest Flash 9 player (**Figure 6.23**).

However, the Flash Gallery style does offer more options for customizing a gallery layout. When a Flash Gallery style is selected, you have a choice of different layout modes, such as the Scrolling layout (which is shown on the next page), where the large images are displayed in the main index page with the thumbnails below. Other options include a Paginated layout view where the main image is shown on the right with paginated thumbnails on the left; a left scrolling view where the thumbnails run down the side; and a slideshow layout where single images are displayed large in the window and you can view them as a continuous slideshow. The following steps show differences in HTML and Flash Galleries.

HTML Gallery

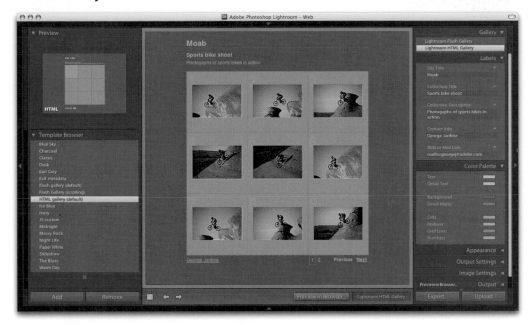

1. The main index view of the default HTML Gallery style displays a cell grid of thumbnail images that is not dissimilar to the Grid view in the Library module.

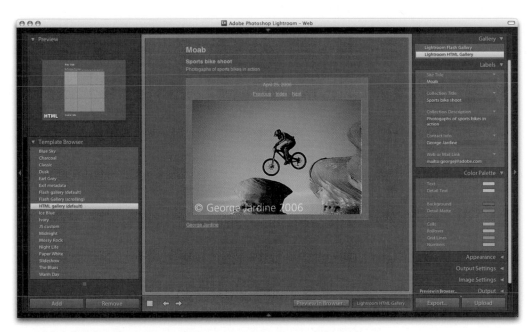

2. Click on a thumbnail to go to the main image view. Click on the image to go back to the index view.

Flash Gallery

1. The default Flash Gallery style displays an index page with scrollable thumbnails at the bottom. Click to select an image, and click the Slideshow icon to go to the next view mode, or choose Slideshow from the View menu at the top.

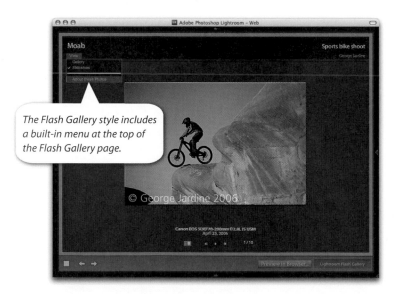

The Flash Gallery style includes a built-in menu at the top of the Flash Gallery page.

2. You can run the slideshow in autoplay mode or use the left/right arrow keys to navigate the gallery collection.

Labels Panel

The Lightroom HTML and Flash Gallery styles provide the core Web gallery structure. The gallery style you select will slightly affect the range of options that are available in the panels that appear under the Gallery panel. These additional panels allow you to customize the Web gallery content. Let's start by looking at the Labels panel (**Figure 6.24**). Here you can complete the various fields that are used to either describe or provide information about the Web gallery images.

The arrangement and purpose of the labels is as follows. The Site Title is used as the main heading in the template design. When an HTML Gallery style is chosen, the Site Title is also used for the title that appears in the Web browser title bar. The Collection Title is like a subheading to the main title. For example, if you were preparing Web galleries of a wedding, the main title would probably be a general description such as "Jones wedding" and you might then prepare several galleries with different collection titles. One gallery might be for the ceremony, another for the family groups, and another for the reception. In the Collection Description you can write a slightly longer summary description of the Web gallery contents. When an HTML Gallery style is used, this information appears just below the Collection Title header. If a Flash Gallery style is used, this information can only be viewed when visitors select View ⇨ About these Photos, shown in step 2 on the previous page. Note that this same built-in menu also allows visitors to switch from the Gallery to the Slideshow viewing mode, although they can probably do this more easily by clicking the badge icon next to the slideshow controls.

You should enter your own name into the Contact Info box, and then use the Web or Mail Link box to enter a link that you want to associate with the contact info. If you want to create an email link here, it must be entered using the standard HTML code *mailto:* followed immediately by your email address (there should be no space between *mail* and *to*). When you do this, the contact info appears at the bottom of the page (HTML) or in the top-right corner (Flash). When a visitor clicks this link, it automatically launches their email program and prepares a new email that is ready to send with your email address placed in the *To:* header. Instead, you can insert a Web URL that takes visitors to your Web site. Just remember that the full URL must be entered, including the *http://* at the beginning of the Web site address URL.

Figure 6.24 *You can use the Labels panel to add information relating to the gallery page. Note that if you click the triangles, you can access the most recent list of data entries.*

NOTE

When Photoshop first introduced the Web Photo Gallery feature, the site title would always default to "Adobe Web Photo Gallery" unless you entered a name for the banner. Try doing a Web search using the above term (inside quotation marks) and watch as you get half a million or more results revealing the private photo galleries of Photoshop users who forgot to give their Web gallery a name!

Figure 6.25 *The Color Palette panel for the Lightroom HTML Gallery.*

Figure 6.26 *The Color Palette panel for the Lightroom Flash Gallery.*

Figure 6.27 *When choosing a color scheme for a Web Gallery layout, you may want to set the color picker to display a "Web Safe Colors" palette.*

Color Palette Panel

The Color Palette panel can be used to customize the gallery interface. The items in the Color Palette panel will be different, depending on whether the Lightroom Flash Gallery or Lightroom HTML Gallery is selected. **Figure 6.25** shows the Color Palette in HTML Gallery mode, which is the color scheme used in the *Ice Blue* HTML template design. In this example, the Text and Detail Text colors are dark blue and are offset against a light blue Background and pastel shades of blue/lilac used for the thumbnail Cells, cell frame Rollover colors, cell frame Numbers and Grid Lines. Note that you need to switch to the main image detail page view when choosing a Detail Matte color, because it is not part of the thumbnail page view.

Figure 6.26 shows an example of the Color Palette appearance when a Lightroom Flash Gallery style is selected. Here, I have shown the settings used for the *Mossy Rock* Lightroom Flash Gallery. In this example, the Text, Header Text, and Menu Text colors are all a light gray, and the Header, Menu, Background, and Border are all shades of green. The Header is the top bar that contains the site title and collection title, and the Menu is the bar that runs just beneath it. The Background is everything else in the background of the gallery layout, and the Border is the edging that defines both the main image and thumbnail list sections. The Controls colors are the colors used for the Flash Gallery playback controls at the bottom.

Choosing a color theme

With so many color choices, which should you use? There is a definite art to picking colors that work well together. The safest thing to do would be to select one of the gallery templates listed in the Template Browser—such as a Web-safe color palette—or stick to designing a layout that uses a neutral range of colors (**Figure 6.27**). Many photographers prefer to keep the color accent neutral since the presence of colors can be a distraction when evaluating color photographs.

But you may also want to check out a new technology from Adobe called *Kuler*, which at the time of this writing is a Web-hosted application that enables you to explore, access, and share color harmonies. It is currently available as a free evaluation service and can be downloaded at http://kuler.adobe.com. This link may possibly change at some later date, but do check it out; it is a very cool service!

Figures 6.28 and **6.29** show other Color Palette choices.

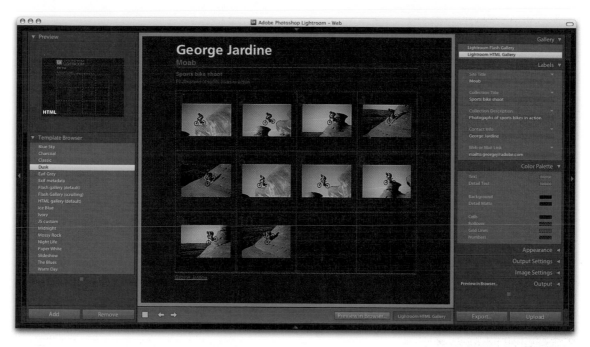

Figure 6.28 *A Lightroom HTML Gallery template in the "Dusk" color scheme.*

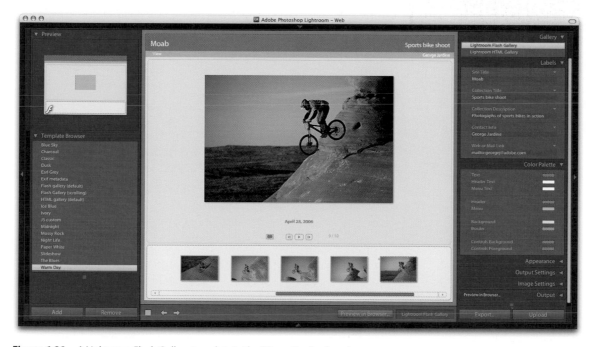

Figure 6.29 *A Lightroom Flash Gallery template in the "Warm Day" color scheme.*

Figure 6.30 *The HTML Gallery Appearance panel.*

Appearance Panel

The Appearance panel offers some additional control over the layout appearance of the two different gallery styles, plus the option to include an Identity Plate that links to a Web page (**Figure 6.30**).

Appearance settings for the HTML Gallery

The grid layout must have a minimum of three columns and three rows. You can customize the design layout by clicking anywhere in the grid to set the grid cell range (**Figure 6.31**). When you create a gallery with more images than can fit the grid layout, they will overflow into successive, numbered index pages. If you have a saved collection of pictures and are creating a Web gallery of the entire collection, it can be useful to check the Show Cell Numbers option, because this may make it easier for people to identify a particular image by using the cell index number rather than the filename.

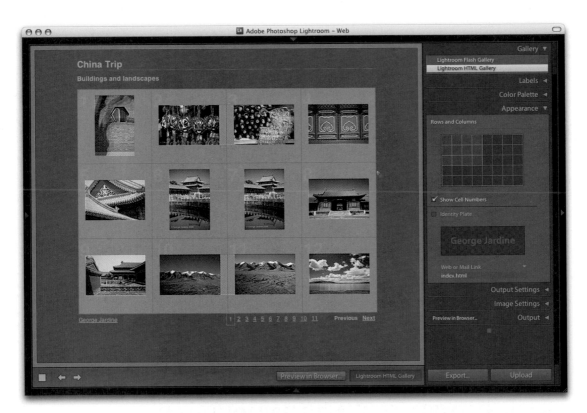

Figure 6.31 *In this example, the Appearance panel was set to use a 3x4 grid in a Lightroom HTML Gallery style layout.*

Appearance panel settings for the Flash Gallery

The Appearance panel for the Flash Gallery shows four different layout options (**Figure 6.32**). The default Flash Gallery layout shown in **Figure 6.33** uses a Left scrolling thumbnail layout, in which the main image is displayed with a strip of thumbnails running down the left side of the layout with a scroll bar to navigate through the thumbnails (see also **Figure 6.37**). Individual images can be selected by clicking on a thumbnail or by using the right/down arrow keys to navigate forward through the pictures, or the left/up arrow keys to navigate backward one at a time. You can also use the slideshow navigation buttons to progress through the images in the gallery (**Figure 6.34**). The Scrolling layout is similar except the thumbnails are displayed in a horizontal row in the lower section with the scroll bar at the bottom (**Figure 6.35**). The Paginated layout presents the index page in two halves with the main image displayed in the right section and the thumbnails shown on the left inside a paginated grid (**Figure 6.36**). The layout of the grid will adapt to the overall size of the content area. This is how the final Flash Gallery will behave as well. Whenever you create a Paginated Flash Gallery, the cell layout automatically adapts as you resize the window of the Web browser. The Slideshow Only view displays the images without the thumbnails (**Figure 6.38**).

Figure 6.32 *The Flash Gallery Appearance panel.*

Figure 6.34 *The Flash Gallery slideshow navigation controls.*

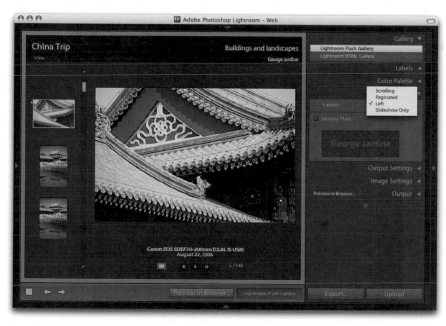

Figure 6.33 *A Flash Gallery style using a Left scrolling style.*

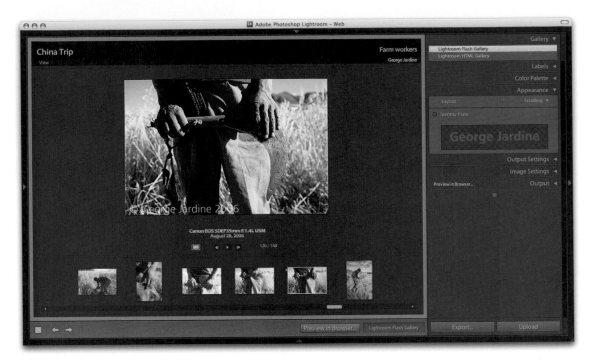

Figure 6.35 *A Flash Gallery style using a Scrolling layout.*

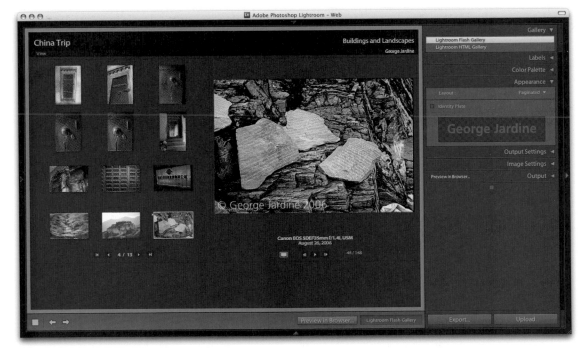

Figure 6.36 *A Flash Gallery style using a Paginated layout.*

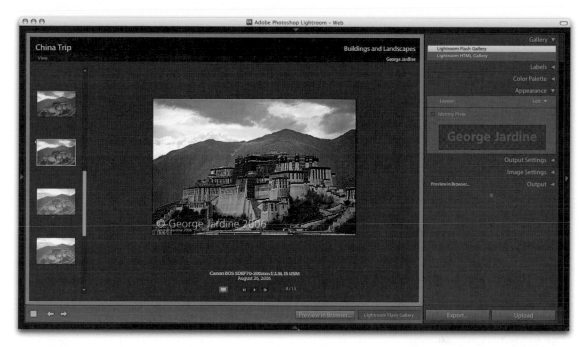

Figure 6.37 *A Flash Gallery style using a Left scrolling layout.*

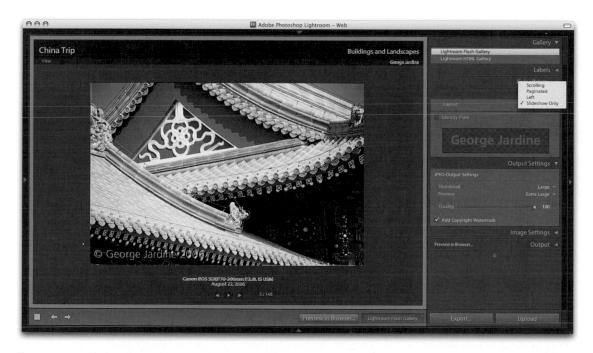

Figure 6.38 *A Flash Gallery style using a Slideshow Only layout.*

Figure 6.39 *The Appearance panel showing the Identity Plate options.*

Figure 6.40 *The Flash Gallery Output Settings panel.*

Figure 6.41 *The HTML Gallery Output Settings panel.*

NOTE

As you adjust the Quality slider, give Lightroom a chance to refresh the images so you can accurately preview the effects of the compression setting used.

Identity Plate

At the bottom of the Appearance panel is the Identity Plate section (**Figure 6.39**). If you refer back to "Creating a Custom Identity Plate" earlier in this chapter, you can read through the steps required to select an Identity Plate and how to edit the Identity Plate and create a new setting. When working with the Web module, the only real options you have here are to enable or disable an Identity Plate from appearing at the top of the Web gallery interface (in place of the Site Title). Unlike the Slideshow module, there are no further options that allow you to alter its position in the site layout or add a drop shadow.

Output Settings Panel

The Output Settings panel can be used to customize the image sizes in a gallery layout, change the image quality, and add a copyright watermark. In the Flash Gallery Output Settings you can choose from one of several preset sizes for the Thumbnail and Preview images: Small, Medium, Large, or Extra Large (**Figure 6.40**). In my opinion, the Small and Medium thumbnail sizes are too small to be of much use, so the choice here is mainly between Large or Extra Large. For the main preview image, I would also suggest you pick between the Large and Extra Large settings. When an HTML Gallery layout is selected, the thumbnail sizes are locked to fit within the fixed size used for the cell layout (**Figure 6.41**), but you have the ability to use a slider to adjust and set the size for the main preview image, which can be anywhere from 300 to 2071 pixels along the widest dimension of any gallery image. **Figures 6.42** and **6.43** show how size choices appear in an HTML and Flash layout. This feature makes the HTML Gallery layouts particularly useful for the creation of review gallery Web sites where you may want to create a Web photo gallery that contains extra large images. When you initially increase the preview size, the image may at first appear pixelated, but don't worry. Once Lightroom has had a chance to refresh the Web gallery images, you will see revised versions of all the images in the gallery pages. The Quality slider is used to set the amount of compression that is applied. The Web gallery images that you are previewing on the screen are all JPEG versions of the master images. The JPEG file format uses a lossy method of compression to reduce the physical file size, so that the JPEG images are small enough to download quickly. The choice boils down to high quality with minimal compression or lower quality with greater compression. The Add Copyright Watermark option adds whatever text is entered in the copyright metadata field as text in the bottom-left corner.

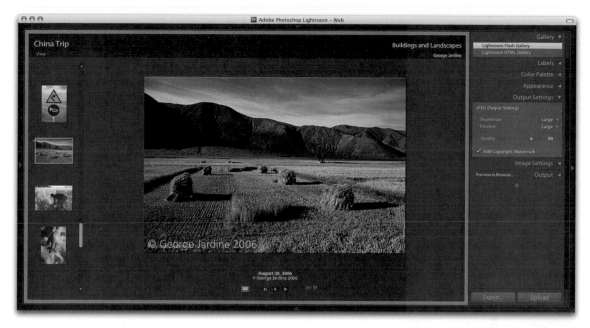

Figure 6.42 *This example shows a Flash Gallery style in which the Output Settings were adjusted so that the main preview image and thumbnails were displayed using the default "Large" setting.*

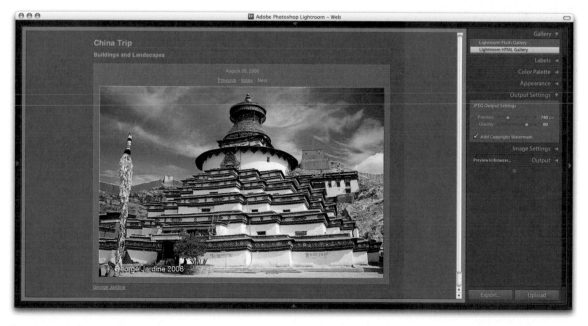

Figure 6.43 *This example shows the Output Settings for an HTML Gallery main page view in which the Preview size was adjusted to 740 pixels along the widest dimension.*

Figure 6.44 *Here is a view of the Image Settings panel where the Custom Text item was selected for the Title, and I typed into the Custom Text box.*

Figure 6.45 *Here is a view of the Image Settings panel where I clicked on the Caption menu and selected Date from the list.*

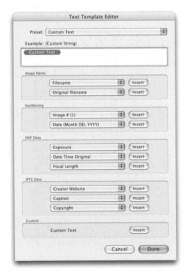

Figure 6.46 *The Text Template Editor.*

Image Settings Panel

Adding titles and captions

The Image Settings panel has a Title and Caption section where you can add image-related information to the main image views. In an HTML Gallery style, the Title section appears above the main image in the main image view. In a Flash Gallery layout, the Title is displayed using a bolder typeface as a heading. In an HTML layout, the Caption section will place text below the picture in the main image view. And in a Flash Gallery layout, the Caption section adds text just below the Title, using a lighter typeface.

To create a custom setting, the simplest way is to click the triangle to the right of the current setting and select an item from the pop-up menu. For example, in **Figure 6.44**, I chose Equipment from the menu as Caption and entered custom text for Title. **Figure 6.45** shows in detail the custom text options available for Title and Caption. **Figure 6.47** shows a typical layout for an HTML Gallery that was customized with the Image Settings options selected in Figure 6.44. You can see that the Custom Text I entered for the title appears in the matte frame just above the image. The caption is placed beneath the image and displays the name of the camera and lens used. In **Figure 6.48** you can see how the Title and Caption information in a Flash Gallery layout are displayed together just below the main image in this slideshow view.

Customizing the title and caption information

When deciding what to add to the Title and Caption menus, you can choose from a limited number of items. But if you choose Edit in the Image Settings panel, the Text Template Editor opens (**Figure 6.46**). This dialog is identical to the one shown earlier in the Slideshow module section and allows you to insert metadata tokens from the pop-up menus and combine these with custom text. In **Figure 6.49** (on page 296), I show how you can use the Text Template Editor to create a new custom preset that can be added to the panel's menu. Although the presets you can create cannot be formatted in any particular way, the information displays as a continuous flow of text in the Title or Caption fields.

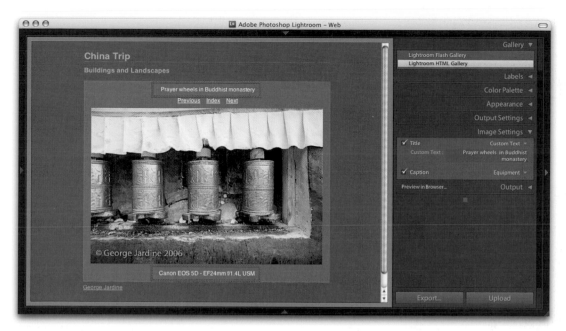

Figure 6.47 *This shows how the Title and Caption information is displayed in the HTML Gallery style view using the Image Settings shown in Figure 6.44. I have highlighted the Title (top) and Caption (just below the image).*

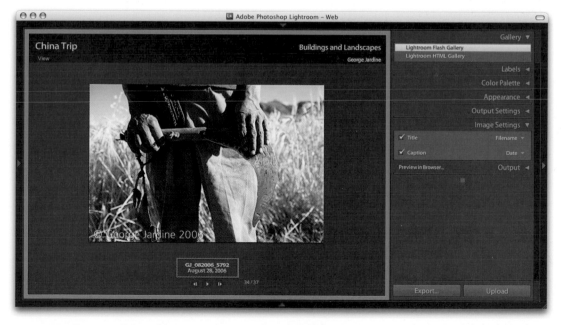

Figure 6.48 *This shows how the Title and Caption information is displayed in a Flash Gallery style page view using the Image Settings shown in Figure 6.45. I have highlighted the information items, which are displayed directly below the image.*

However, if you choose the EXIF Metadata template, it includes a built-in custom setting where some of the camera EXIF metadata information is presented in a formatted way in the Caption section (**Figure 6.50**). You can't actually edit this setting, and the only way to access it is by selecting the EXIF Metadata HTML Gallery template.

Figure 6.49 shows a progression of screenshots of the Text Template Editor, in which I created a new preset to use as a Caption, although it can be used in the Title fields as well (**Figure 6.51**). If you select a preexisting preset and choose Edit to make changes to the layout via the Text Template Editor, the preset name is marked as an edited version. If you want to update the preset settings, don't forget to choose Update Preset from the Preset menu.

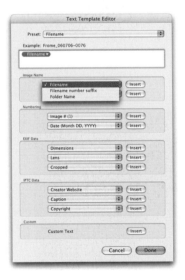 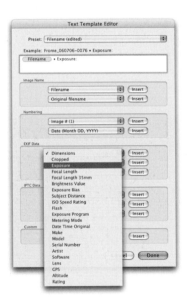 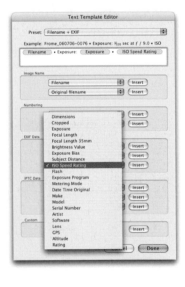

Figure 6.49 *Here are some views of the Text Template Editor. I started by clicking the Custom menu and choosing Edit. I then clicked one of the Image Name pop-up menus and selected a Filename token. This action added a Filename token to the editor window above. I added some plain text and clicked one of the EXIF Data menus to add an Exposure token. I went to the EXIF Data section again and added an ISO Speed Rating token. I then clicked the Preset menu and chose Save as New Preset. I named the preset Filename + EXIF and clicked Done. The new preset was applied to the Caption field and would now always be available as a new preset in the Image Settings menus.*

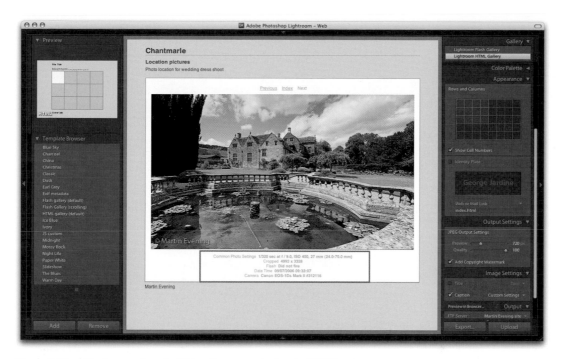

Figure 6.50 *This shows a view of a Web gallery created using the EXIF Metadata template, which features a built-in (noneditable) EXIF Metadata image setting for the Caption section.*

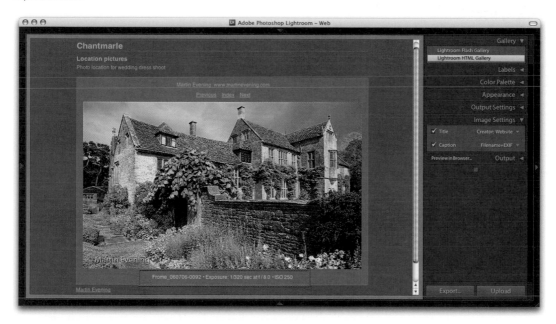

Figure 6.51 *Here is how the Caption information appears on an HTML detail page when using the custom Filename + EXIF preset I created in Figure 6.49.*

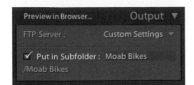

Figure 6.52 *The Output panel is used for configuring the upload settings. Click the Preview in Browser button to preview a Web gallery in the default Web browser program on your computer.*

Output Panel

One of the benefits of working with the Web module is that the content area gives you an exact preview of how the Web gallery looks, because the content area is presented to you in a Web browser view (**Figure 6.52**). Even so, this might not exactly be how everyone will see your Web site after it has been uploaded. There will always be a number of unknown factors such as the variability of the monitors used to view your pictures (see the sidebar "Image Appearance in Slideshow and Web Modules"). But in addition to previewing the gallery pages in the content area, you can also check how a site will look on your computer using a Web browser application by clicking the Preview in Browser button that appears in the Output panel header, or click the larger button on the toolbar. Lightroom then creates a temporary export of the gallery and previews the result in whichever Web browser program is set as the default Web browser on your computer.

NOTE

Raw file previews are always in Adobe RGB. Non-raw (rendered) files such as TIFF, JPEG, or PSD use their native RGB space to generate the previews.

Image Appearance in Slideshow and Web Modules

Slideshow Module Colors

Lightroom uses a large, wide-gamut RGB space to carry out its image processing calculations. For screen presentation work, the color space needs to be tamed to something more universally recognizable. When you create a slideshow, Lightroom utilizes the JPEG previews that it has already generated to preview the library images onscreen. These preview images are typically created in the Adobe RGB space and for slideshow work, the onscreen previews are always preserved in this space. The Adobe RGB is optimal for making screen presentations because it prevents any unexpected shifts in the colors or contrast.

Web Module Colors

When you output images for the Web, you are usually heading into unknown territory. After images are published on the Web, you have absolutely no way of knowing how other people will view your photographs, because it is fair to assume that most people will be viewing them with monitors that are uncalibrated. Some Web browser programs such as Apple's Safari are able to color manage images that have an embedded profile, but most will not. For these reasons, the Web module converts the image previews on the fly to the universal sRGB, which is an ideal choice for all Web output.

Exporting a Web gallery

You can upload a Web site in two ways. One method is to click the Export button just below the Output panel, or press ⌘J (Mac) or Ctrl J (PC). This automatically opens a navigational dialog in which you need to provide a name for the Web gallery you are about to export and then select a destination folder to save the Web site to. Click the Export button to save the complete Web gallery files inside a folder of the same name. Then locate the saved folder to preview the saved site offline. If you are familiar with FTP software, you can then manually upload the saved site folder to your server space.

NOTE

There are various File Transfer Protocol (FTP) programs that you can choose from. Fetch from www.fetchworks.com is a popular program for the Mac. If you are working on a PC, I recommend using WS_FTP Pro (www.ipswitch.com) or Flash FXP (www.flashfxp.com).

Whichever platform you use, establishing an FTP connection will be the same. For the host, you will need to enter the server URL, the User ID, and password. Your Internet service provider will be able to supply you with all this information (assuming your Internet account includes some server space).

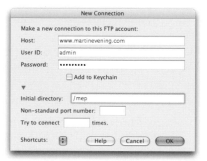

1. To save a Web site, click the Export button. Then choose a destination folder and save the Web site to it.

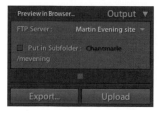
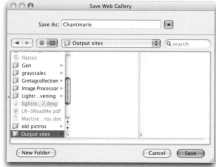

2. A self-contained folder holding all the Web site elements is created. You can preview the site offline by opening the *Index.html* file within any Web browser program. You can also upload the folder site contents manually using a program like Fetch for Mac OS X. The URL path used to access the site depends on where you upload the site to and how your server site space is configured.

Uploading a Web gallery

Exporting a gallery is more for those times when you need to manually edit a site before uploading it, or you want to back up and store a gallery site offline. But in all other circumstances, you can let Lightroom upload the files directly for you, bypassing the need for separate FTP software.

1. In the Output panel, click the FTP Server preset menu and select Edit.

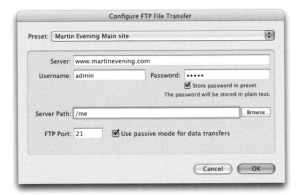

2. To create a new custom preset, enter all the information that is required to access your server space (if in doubt, check with your Internet service provider). The Server address is usually the first part of the Web URL. The Username and Password can sometimes be the same as those you use for your email account. The Server Path is used to set the folder location to place the Web folder you are about to upload. Again, talk to your provider, because there may well be a root level name that has to be entered to access the server space allocated to you; otherwise, the connection won't work. In this example, I entered /me as the root level directory. Note that it is important to always place a forward slash at the beginning of the server path.

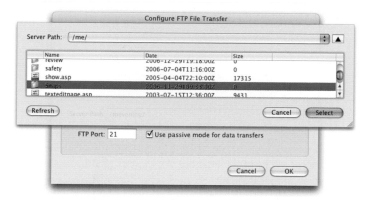

TIP

If you are uploading Web gallery files to an existing Web server space that already contains your Web site, be careful that the subdirectory you choose does not conflict with existing folders. For example, it is not a good idea to upload new Web galleries to a folder called "images," because it is highly probable that your Web site already uses a folder of that name. Try using more unique and descriptive names for the folder locations, such as "client-review" or "snaps."

3. You don't necessarily have to memorize the structure of your server directory or type in the server path. Click the Browse button in the Configure FTP File Transfer dialog and Lightroom will scan the server to reveal a folder view of the server directory. Here, I created a preset that automatically uploads to a specific folder. For the preset, I clicked the Snaps folder and then clicked Select.

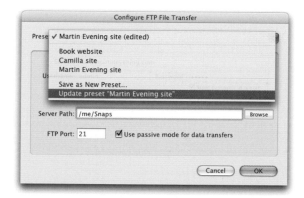

4. In the Configure FTP File Transfer dialog you can see that the server path directory has been automatically updated to point to the Snaps folder. You can use the Browse feature in this way to access different folders or subfolders on the server and save these as different upload presets. If you experience problems getting a connection when you click the Browse button (or later when you try to upload), it could be because of the firewall software on your computer system or router. If this is the case, try checking the "Use passive mode for data transfers" option. Also, if you change any of the settings here, you need to go to the Preset menu and choose Update Preset. Now click OK.

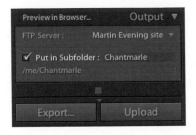

Figure 6.53 *One of the reasons you are always required to enter a new server output path in the Output panel is to avoid uploading and overwriting a previous Web folder upload. If you enter a folder name destination that already exists, Lightroom warns you before letting you continue with the new upload. If you are reediting an existing gallery, you will see this warning each time you refresh the gallery contents on the server, so in these circumstances, it is be safe to click Continue.*

5. This takes you back to the Output panel where the Put in Subfolder field must be filled out. The folder name you enter here completes the server path directory. The reason this section is left blank is because you must apply a unique name to the Web site folder you are about to create. Since the currently selected FTP Preset points to the /me/Snaps directory, all I need to do here is type in a name for this particular Web gallery. In this example, I typed in *Chantmarle* as the next part of the server directory. Note that there is no need to add a forward slash at the beginning of this section of the path or after. Lightroom adds this automatically, because the complete path I have created is in fact */me/Snaps/Chantmarle/*. Click the Upload button and Lightroom automatically uploads the site to this location.

TIP

This tip has nothing to with Lightroom, but I find a preconfigured email signature useful in lots of ways. I can use preformatted replies to do things like summarize an outline of basic services and cost, or as shown in step 6, send an email with instructions on how to view a Web link.

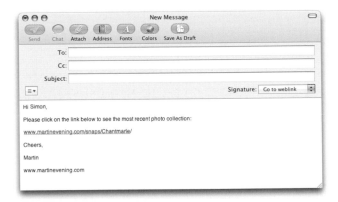

6. Now you will want to let people know how to access the Web site. The best way to do this is to send people a link via email. But to make things even easier I suggest you create a template email that contains a brief message and the first part of the server link (note that in this example the */me* section of the path is hidden and must therefore be omitted from the final link), and save this as a signature. In the email message shown here, I selected a presaved signature with a readily composed email and simply added the person's name and name of the output folder (both highlighted in red).

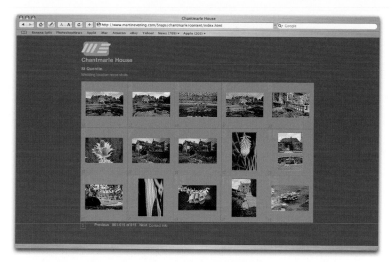

NOTE

Lightroom provides you with a simple way to upload Web sites, but the downside is that there is no way to remove them easily! Bear in mind that server space costs money and that there may be a capped limit on how much space you have available, or there may be a surcharge if you exceed your limit. You will therefore still need access to FTP software in order to carry out general house-keeping maintenance of the server space and delete Web galleries that no longer need to be hosted.

7. When recipients of the email click the link, it automatically launches their Web browser and takes them straight to the uploaded Web site on your Web server.

Template Browser Panel

As mentioned earlier, you can easily end up putting a lot of time and effort into designing a customized Web gallery template, so it makes sense to save any template designs that you work on via the Template Browser panel in the Web module (**Figure 6.54**). To add a new preset, click the Add button, or press ⌘N (Mac) or Ctrl N (PC), and enter a new name for the template. To delete a preset, highlight the name in the Template Browser and click the Remove button. Most likely you will continue to refine the design of your templates, so don't forget that as you select a preset, you can right-click (Ctrl–click on older Macs) to access the contextual menu and select "Update with current settings." When you roll over the presets in the list, the Preview panel shows previews of the gallery page layout presets. The previews display the gallery showing the layout and colors used and also indicate if the gallery preset is a Flash or HTML layout design. You can select Web ⇨ Save Web Settings, or press ⌘S (Mac) or Ctrl S (PC), to quickly save the current Web settings without saving them as a specific template. As you select other presaved templates to compare the look of different layouts, you can always go to the Web menu again and choose Revert Web Settings to instantly return to the current, temporary Web layout.

Figure 6.54 *The Web Module Template Browser panel lists all saved gallery templates and shows previews of the layouts in the Preview panel above.*

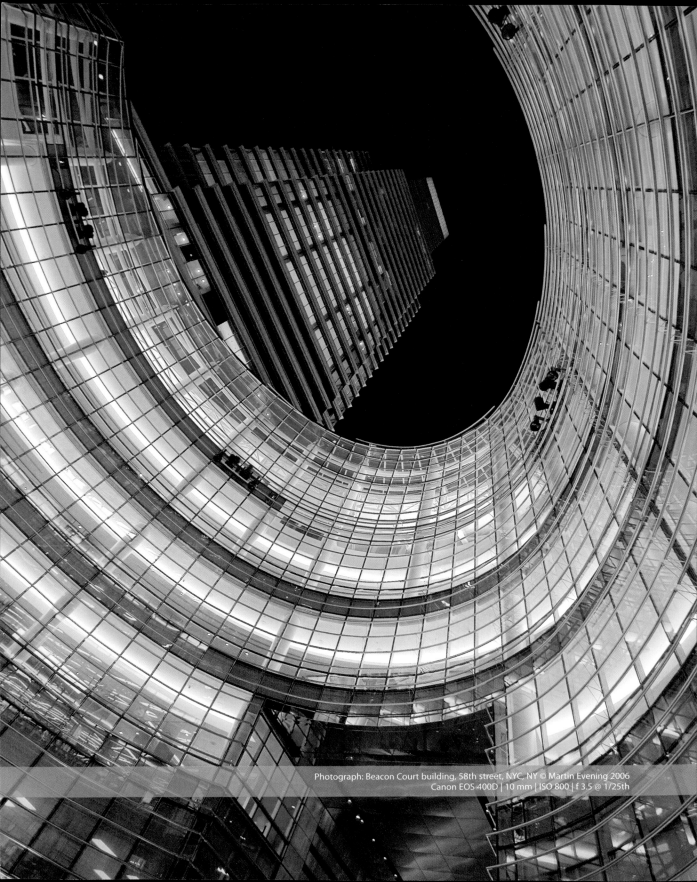

Photograph: Beacon Court building, 58th street, NYC, NY © Martin Evening 2006
Canon EOS 400D | 10 mm | ISO 800 | f 3.5 @ 1/25th

Appendix

I reserved the Appendix as a special section of the book that would allow me to go into more detail about certain aspects of Lightroom, including how you can customize the program to suit specific ways of working. I decided to keep these topics separate, mainly because I did not want to clutter the earlier chapters with information that might have been too distracting. This is an unashamedly technical section aimed at advanced users, although I have tried to keep the explanations as clear and simple as possible.

The contents of this Appendix are placed in no particular order. Some of the information and tips mentioned here are likely to go out of date as later updates of the program are released, so please bear this in mind as you read through the following pages. But if you are keen to find out more detailed information about specific areas of Lightroom or want to explore some of the customization options, read on.

TIP

The Application Data folder on a PC computer is normally hidden. To reveal the folders, go to the Explorer Tools/Folder Options and navigate to the View tab where you will see an option to show hidden files and folders.

Lightroom Settings and Templates

The Lightroom Preference File

The Lightroom preference file keeps a record of all your custom program settings. On a Mac, the Lightroom preference file is named: com.adobe.Lightroom.plist and is located in the Username/Library/Preferences folder. On a PC, the Lightroom preference file is located in the Local Disk (C:)\Documents and Settings\Username\Application Data\Lightroom\Preferences folder (**Figures A.1** and **A.2**). If the Lightroom program is behaving strangely and you have reason to believe that the preferences might be corrupt, simply delete this file. Lightroom will generate a new preference file the next time you launch the program.

Figure A.1 *The Adobe Lightroom preference file for a PC is located in the Local Disk (C:)\Documents and Settings\username\Application Data\Adobe\Lightroom\Preferences folder.*

Figure A.2 *The Adobe Lightroom preferences file for Mac OS X is located in the Username/Library/Preferences folder.*

Accessing Saved Template Settings

When you save a setting in any of the Lightroom modules, the template settings are stored in the Username/Library/Application Support/Adobe/Lightroom folder (Mac) or Local Disk (C:)\Username\ Application Data\Adobe\Lightroom folder (PC) (**Figures A.3** and **A.4**). Inside this folder you will see a set of subfolders that contain all the saved settings (and default settings) for the various Lightroom modules. For example, in Figure A.3, I highlighted the Develop Presets folder, which contains a list of the Develop preset settings. These files all have the *.lrtemplate* extension. These settings can be copied and shared with another system. For example, you can make copies of these files and distribute them as preset settings for other Lightroom users to install on their computers, which they can do by dragging and dropping them into this same folder.

TIP

During the Lightroom beta program, members of the public forums were happily sharing preset settings for the Develop module. As a result, Richard Earney hosts a Web site that lists various Develop module presets at www.method-photo. co.uk/lightroom/. This is only a provisional site (and not affiliated with Adobe), so the link may well change in the future. It should also be pointed out that the develop controls changed about a lot during the beta and therefore some presets may need to be updated.

NOTE

On a PC system the file extensions are often hidden by default, so you may only see the file extensions mentioned here, such as .lrtemplate and .lrdb, on a Macintosh system.

Figure A.3 *The Adobe Lightroom template settings folder (PC).*

Figure A.4 *The Adobe Lightroom template settings folder (Mac OS X).*

The Lightroom Library Folder

The first time you launch Lightroom a Library folder titled *Lightroom* is automatically placed in the username/Pictures folder (Mac OS X) or the My Documents\My Pictures folder (PC). This folder will contain the following: a Lightroom Library.lrdb database file and a Lightroom Previews.lrdata file that contains all the thumbnail previews and library image metadata information. The Library folder also contains a Backups folder that is used to store backup Library database files (**Figures A.5** and **A.6**). But let's first take a look at what the files and folders do.

The Library Database File

The Lightroom Library.lrdb database file is written using the SQLite3 database format. This is a robust database format that keeps all the library data in a single file, which is easily transferable for cross-platform use. This file is used to store a database of information relating to all the images in the Lightroom Library, such as the metadata information, the Develop settings for each image, and which folder and/or collection the file belongs to. Depending on the overall size of your image library, the Lightroom Library.lrdb file can grow to be quite large in size.

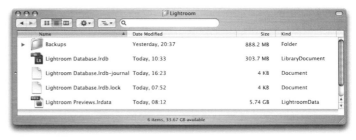

Figure A.5 *The Lightroom Library folder contents in Mac OS X.*

Figure A.6 *The Lightroom Library folder contents in Windows XP.*

If you perform a new install of Lightroom or upgrade the program, a new database Library file (containing all the current data about the library) will be generated, and the old one will be saved to the Backups folder (**Figure A.7**). If you have the General Lightroom preferences configured to automatically create backup copies of the Lightroom database (see "Installing Lightroom" in Chapter 1), the backup will normally be saved to the Backups folder, but you can also choose an alternative location (**Figure A.8**).

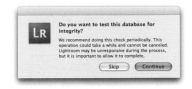

Figure A.7 *In the Backup Library dialog there is an option to test the integrity of the current database file. Depending on the size of your library, running an integrity check may take quite a few minutes to complete. If you do come across any errors, replace the current Library database file with the most recently saved database file.*

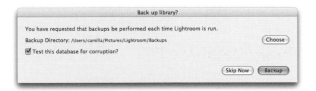

Figure A.8 *In the General preferences you can schedule how often Lightroom makes a backup copy of the Lightroom database. The first time Lightroom backs up the database, this dialog appears and offers you the option to choose an alternative destination to save the backup.*

Figure A.9 shows how several older library files have been saved automatically as backup copies. If for some reason you encounter a problem with the current database when you launch Lightroom or after running an integrity test, you can replace the main Lightroom Library.lrdb file with the most recent backup version. The Library file is a precious component of the Lightroom folder, and you need to safeguard it as you would a financial account file or any other important data document. Saving a copy to the Backups folder is a wise precaution. Treat the Library database file with care, and remember to perform regularly scheduled backups to a secondary storage system.

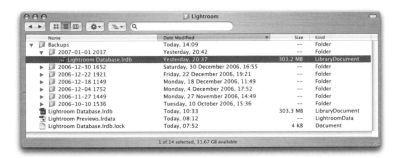

Figure A.9 *The Lightroom folder showing an expanded view of the Backups folder contents.*

Figure A.10 *A question mark icon in the top-right corner of the grid cell indicates a broken link between the image thumbnail referenced in the Library file and the master image it refers to. To restore a link, click the question mark icon to open the missing image dialog shown here. Click the Locate button and navigate to find the missing image. Once you have restored the link for one image, all the remaining links for that shoot will be repaired as well. Notice that any folders with missing links are highlighted red in the Folders panel.*

If you want to select a new Library file or need to check that the correct Library database file is selected, you can do so by holding down the [Alt] key (Mac) or [Ctrl] key (PC) while restarting Lightroom (**Figures A.10** and **A.11**). When you do this, the Select Database dialog appears on the screen and allows you to navigate to the correct Lightroom Library.lrdb file. Or, you can click the Create New Database button to select a location where you want to create a new Lightroom Library database. It is possible to have any number of separate Lightroom databases. For example, some people might like to keep separate libraries: one for work and one for personal photographs. When several people are sharing one program, such as in a college environment, each student can maintain his or her own separate library, most likely on a removable hard disk.

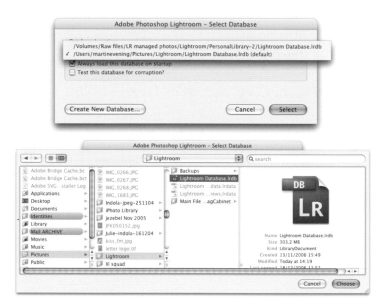

Figure A.11 *If you hold down the [Alt] key (Mac) or [Ctrl] key (PC) as you launch Lightroom, the Select a Library navigation dialog appears onscreen, allowing you to select the Lightroom Library file.*

Journal File

The Lightroom Database.lrdb-journal file is a temporary file that you may see while Lightroom is processing library information. This is an important, internal work file that appears briefly and then disappears again. If your computer crashes, do not delete a journal file because it may contain important data that can help Lightroom recover recently modified data information.

Lightroom Previews Data

The Lightroom Previews.lrdata file is a self-contained file that holds all the previews and thumbnail data. In **Figure A.12**, I used the contextual menu to show the package contents of the Lightroom Previews.lrdata file. This particular package is just over 5.74 GB in size, and as you can see, holds a total of 10,572 items with a *.preview.noindex* extension. These are all the thumbnail and preview cache files that are used by Lightroom, and the size of the thumbnail cache depends on how you set the File Management preferences (**Figure A.13**). If you want to keep the Lightroom Previews.lrdata size to a minimum, select the Automatically Discard 1:1 Previews and then choose the After One Day or One Week option. If you don't mind it growing in size, select After 30 Days or Never. The choice is yours, but as long as you have plenty of hard disk space, I suggest you choose the After 30 Days option. Otherwise, Lightroom constantly rerenders the 1:1 previews for the most commonly visited folders.

Figure A.12 *A package contents view of all the .preview.noindex files that are contained in the Lightroom Previews. lrdata file.*

Figure A.13 *The Lightroom File Management preferences.*

Thumbnail Processing Routines

When you first import any images into Lightroom, the Import dialog offers the option Render Standard-Sized Previews (**Figure A.14**). In some instances it may be preferable to disable this option, because Lightroom uses whatever previews are available as it imports all the images, utilizing either the embedded JPEG previews or sidecar file previews to quickly build a thumbnail display in the Library Grid. The embedded previews are usually fine as a rough visual of how the image looks. They don't always offer much in the way of detail, because they are normally the small-size JPEG previews that were embedded in the imported file and will appear very pixelated if you immediately try to view such an image in Loupe view or as a large thumbnail in Grid view. The color appearance of an embedded preview is always likely to change after Lightroom has built a proper preview from the image data.

After the initial import, Lightroom makes a second pass in which it processes the raw data using its internal color engine to build the standard-size previews. These previews let you see a greater level of detail when displaying large thumbnails in the content area or at a fit-to-view Loupe magnification. Lightroom makes a third pass in which high-quality, 1:1 resolution previews are generated (**Figure A.15**). If the Render Standard-Sized Previews option is selected at the Import Photos stage, Lightroom avoids using the embedded previews altogether and renders the standard previews directly.

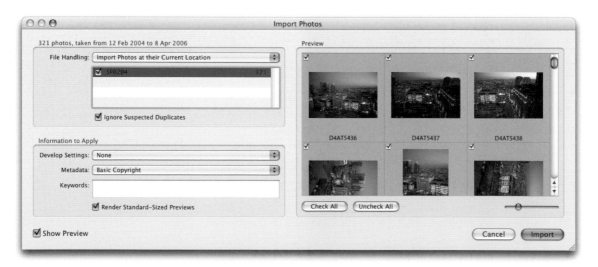

Figure A.14 *The Import Photos dialog offers the option of using the embedded previews or rendering 1:1 previews during the import process.*

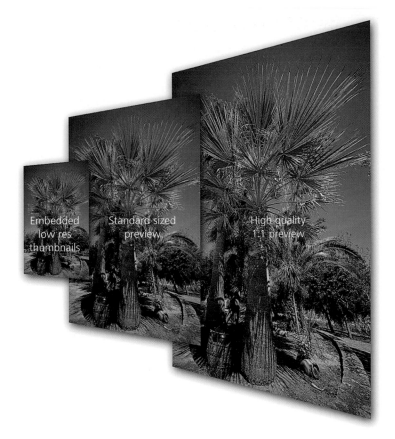

NOTE

One of the problems associated with building previews from raw files is that the raw file contains a color preview that was generated by the camera software at the time of capture, and the preview that Lightroom generates will definitely look different. If you shoot raw, there is no way that Lightroom can instantly match the appearance of the original thumbnail preview. It can be argued that it is, like the original embedded preview, just another initial interpretation of the image and is the starting point for you to make further develop adjustments. The thumbnail and preview generation can take time—it really all depends on the size of your files and how many are waiting to be processed. Lightroom tries to let you start working on an image as soon as you select it. This forces or diverts Lightroom to process this image first, before it resumes processing the remaining files in the background.

Figure A.15 *Lightroom builds progressive quality thumbnails and previews. It starts by utilizing the low-res embedded thumbnail already contained in the image or sidecar file, followed by a standard-sized preview that is suitable for large thumbnail or standard Loupe mode viewing, and finally, a high-resolution 1:1 preview.*

The advantage of this three-pass approach is that you won't get confused by seeing low-resolution previews that show one color interpretation (the embedded preview version), only to be replaced shortly by a new color interpretation (the Lightroom processed standard-size preview version).

Whenever you launch Lightroom, it initially loads all the low-resolution thumbnails, and within 30 seconds or so, starts running checks on the current library contents, checking the thumbnails in order of quality. Lightroom will look to see if any of the standard resolution thumbnails need to be rebuilt first before going on to build the high-resolution, 1:1 previews for these images. At the same time it checks the existing thumbnail previews against their modification dates. If any file has been modified since the last time a preview was built, Lightroom

<div style="border: 1px solid #ccc; padding: 10px;">
TIP

The Medium Quality setting is a good setting to choose for the preview quality. This is because I find there is not enough of a significant difference between the Medium and High settings to justify increasing the size of the Lightroom Previews.lrdata file.
</div>

rebuilds a new set of previews, starting with a standard preview, followed by a high-quality 1:1 preview (**Figure A.16**). In the General preferences you can set the size the standard-size previews should be. If you have a 30-inch screen, you should choose the 2048 pixels option. If you are working from a laptop computer, the 1024 pixels setting will be more appropriate.

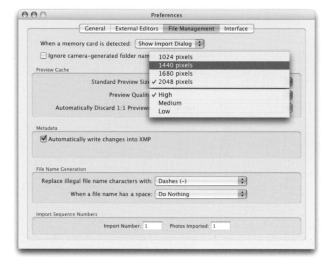

Figure A.16 *In the General preferences you can control the size of the standard previews and image quality.*

Customizing the Lightroom Contents

The Adobe Lightroom application is made up of modular components. Version 1.0 of Lightroom consists of the Library, Develop, Slideshow, Print, and Web modules. If you want to peek inside the Lightroom Application folder, follow the instructions shown in **Figure A.17** and **Figure A.18**. After you have revealed the package contents you can see the various folders and components that make up Lightroom. In both screen shots I have expanded the Plug-ins folder to reveal the individual module components. Now that you know where the modules are kept, you can customize the program by temporarily removing specific modules from the program contents. For example, if you choose Show Package Contents on the Mac, open the Plug-ins folder, remove the *Slideshow.agmodule* folder, and relaunch, Lightroom will open with the Slideshow module missing. Similarly on a PC, you can

remove the *SlideshowModule* file to eliminate it from the program. The Mac package contents will even let you access the graphic files (which are located inside the various Resources folders). This gives you the opportunity to sneakily customize the interface. But obviously you want to be careful when playing around with the program components, because it is quite easy to damage or remove components that shouldn't be messed with. You can also cause problems that can only be addressed by carrying out a fresh reinstall of the program.

Figure A.17 *On the Mac OS X system you can reveal the package contents by right-clicking or* Ctrl *-clicking the Adobe Lightroom icon and selecting Show Package Contents from the fly-out menu. This allows you to inspect the program's file contents.*

NOTE

Note that the Scripts folder in the Mac OS X Lightroom package contents is a Lightroom-only Scripts folder. Should you want to add custom scripts, these should be placed in the Username/Library/Application Support/Adobe/Lightroom folder (Mac) or Local Disk (C:\)\Username\ Application Data\Adobe\Lightroom folder (PC). Alternatively, go to the Scripts menu next to the Help menu and choose the Open User Scripts folder.

Figure A.18 *On a PC, go to Local Disk (C:)\Program files\Adobe\ to locate the Adobe Lightroom folder. There you will find the Lightroom application program along with various files relating to the program's contents.*

Sharing Metadata Between Programs

My thanks go to Jeff Schewe and Tom Hogarty for helping me write
this particular section of the Appendix and making sure that the
information presented here is up to date for the final release version of
Lightroom 1.0.

You may not always see all the metadata that is contained in the library
image files, especially if the files in the Lightroom Library have had their
metadata modified recently via Bridge (or some other program). If you
want to ensure that the metadata information in a Lightroom folder is
fully updated, select Metadata ⇨ XMP menu and choose Import XMP
Metadata from file. This forces Lightroom to read in the XMP metadata
from the files in a chosen folder and import all the metadata. If you are
using Lightroom 1.0 in conjunction with Photoshop CS3 and ACR 4,
there is no reason for metadata not being read fully on import. If you
are working with older versions of Photoshop and ACR, you may need
to rely more on the Import Metadata command.

If you export the XMP metadata, it is possible for the metadata that is
applied in Lightroom to be read by other metadata-aware programs.
Bridge 2.0 and ACR 4 can read all exported Lightroom 1.0 metadata.
However, with external programs that predate Lightroom 1.0, they will
mainly be restricted to seeing and recognizing the IPTC and keywords
metadata. Writing changes into XMP is the first step towards making
edit data in Lightroom more easily transferable. It means that instead of
all the Lightroom edit information residing in the central database file
only, it can also be stored locally, inside or alongside the actual files,
in their respective folders. However, if you want the changes made in
Lightroom to be updated when the same file is read by Camera Raw
or Bridge, the only way to achieve this is to choose Metadata ⇨ XMP
⇨ Export XMP Metadata to file. Of course, only those using Lightroom
or the latest Photoshop CS3 program with Bridge 2.0 and Camera
Raw 4.0 will be able to read the Develop settings info that is stored
in the XMP data. Even so, other programs will certainly be able to use
all the other metadata information added via Lightroom, such as the
keywords, IPTC metadata, and image ratings information.

Other third-party applications that read XMP and DNG should be able
to display all the XMP metadata and read the DNG preview to show
what the Lightroom settings are supposed to look like. For example,
iView Media Pro should be able to see the correct DNG preview,
but would not be able to render the Lightroom Develop settings of

non-DNG raw files. Applications like these will only see the EXIF JPEG preview inside the raw file.

If you go to the File Management Lightroom preferences shown in **Figure A.19**, you can also check the "Automatically write changes into XMP" box. Then, whenever you do any kind of editing in Lightroom, the XMP section in the header of a file (such as a JPEG, TIFF, PSD, or DNG file) is updated automatically. Otherwise, an XMP sidecar file will be created and added alongside the images in the library folders. The XMP data stores all the Lightroom Develop settings as well as the EXIF and IPTC metadata. For performance reasons, checking "Automatically writing changes into XMP" may be suboptimal because every setting, keyword, and IPTC metadata has to be written to a file each time a change is made. Alternatively, if you need to ensure that XMP sidecars are created, you can do so folder by folder (or file by file) using the Export XMP Metadata to file command.

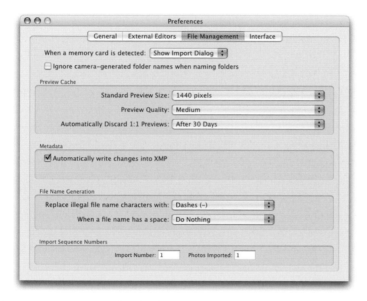

Figure A.19 *The Lightroom File Management preferences. Checking "Automatically write changes into XMP" auto-exports the XMP metadata as you work, but can also slow down Lightroom's performance.*

The Lightroom RGB Space

As you have probably gathered by now, there are no RGB workspace color settings options in Lightroom as there are in Photoshop. The reason for this is because the ICC-based color management system was introduced in Photoshop at a time when color management was not well understood. It was therefore necessary to incorporate a color management system in a way that could satisfactorily allow Photoshop users to accommodate their existing non-ICC color managed workflows. The RGB spaces that were recommended for use as an RGB workspace in Photoshop were mostly quite conservative.

Lightroom has largely been freed from these constraints. It is safer these days to assume that most photographers are now working with RGB files that have embedded profiles. Since Lightroom is mainly intended as a tool for editing digital capture images, these images will certainly be imported into Lightroom either as profiled JPEGs, or as raw files (in which case the Adobe Camera Raw color engine will know how to interpret the colors, based on the embedded white balance information). When an RGB file is missing a profile completely, Lightroom assumes an sRGB profile to assign when performing the image processing calculations.

Lightroom carries out the image processing calculations in its own RGB space, which uses the ProPhoto RGB coordinates but has a gamma of 1.0 instead of 1.8. The 1.0 gamma was chosen with raw image processing in mind, because all raw files have a linear gamma of 1.0 and Lightroom can therefore process raw images in their native gamma without converting them first to a gamma of 1.8 or 2.2. The ProPhoto RGB coordinates describe a massively large color space (so big it includes colors that are invisible to the human eye). The gamut of ProPhoto RGB is certainly large enough to include every possible color that any digital camera can capture, which means that the RGB space used by Lightroom never clips any important colors when carrying out its calculations. Also, bear in mind that the image processing is carried out mostly in 16-bits per channel (some specific processing is even done in 32-bits). Because Lightroom uses a 16-bit RGB edit space, it is able to preserve all of the levels that a digital camera can capture. For example, a typical digital SLR captures up to 12-bits of levels data per channel. When a raw file from one of these cameras is edited in Lightroom, the 16-bit edit space is able to process the raw image data without losing any of the levels information. The deep-bit editing space should also allay any concerns about the risks of banding that might

be caused by gaps in a color value representation between one level's data point and the next. I have to say that even with an 8-bit edit space, these initial concerns have been overstated. I do accept now that it is safe to work with ProPhoto RGB, even if the final destination space will be in 8-bits per channel. But obviously, if you are able to make all the principal image edits using all the captured levels data in a wide gamut RGB space (as you are forced to do in Lightroom), so much the better.

Keeping Lightroom's image processing in the native gamma of the raw capture files is better because Lightroom processes the raw data directly without applying a gamma conversion to the raw data. It is also better because it can provide smoother blending when you perform certain types of image processing adjustments.

But let's take a look at why raw images are in a linear gamma space to start with. All digital images, whether they are scans or captures from a digital camera, contain data that is a linear representation of the light hitting the sensor. As the light intensity doubles, a sensor records a brightness value that is two times higher. This all appears to make sense, but when you actually view an image that has been recorded in this way, you begin to realize that human vision perceives things quite differently to the way a sensor sees the world. This is because our eyes (unlike a scanner or camera sensor) compensate for increasing levels of brightness in a nonlinear fashion. When we see something that is two times lighter, our eyes distinguish an object as being twice as bright, but our eyeballs do not literally record the light levels hitting our retinas as being twice the brightness. Human vision is able to adapt to widely changing light levels by constantly compensating for extremes in light levels. So if we compare the way a sensor records light and represents the captured image data, we see an image that looks very dark, even though it may in fact be perfectly exposed and contain a full range of usable tones from the shadows to highlights. To get a normal digital capture to look right to our eyes, the linear data must be gamma corrected (effectively lightened at the midpoint). After a gamma curve has been applied to the linear capture data, the captured image looks more representative of the scene we perceived at the time the photograph was taken.

NOTE

Non-raw images will be processed via the same Lightroom RGB space as the raw files. As long as the image you are editing has a profile attached, Lightroom will recognize this, preserve the master file in its original RGB space, and use this space to calculate the histogram and display the image previews in Lightroom (except the Develop module). But Lightroom will carry out all calculations in the linear gamma Lightroom RGB space. If an image is missing a profile, Lightroom will assume the image should be in sRGB whenever it carries out an on-the-fly conversion to the Lightroom RGB space for the Lightroom image processing. Note: Lightroom does not actually assign a profile to an unprofiled master.

TIP

For a more detailed explanation of working in linear gamma, download the "Raw Capture, Linear Gamma, and Exposure" white paper written by Bruce Fraser (www.adobe.com/digitalimag/ps_pro.html).

RGB Previews

Lightroom generates preview images, which in the case of raw images are converted directly from the Lightroom RGB workspace. This conversion creates Adobe RGB space previews and thumbnails (non-raw images use their own RGB space when generating previews). Adobe RGB is a good choice for previewing photographs, since it has already proved to be a popular RGB space for photographic image editing work. It can also contain the gamut of most CMYK colors and match the color gamut of some of the latest high-end LCD monitors. Basically, you are unlikely to see any color shift surprises when you export an image from Lightroom in ProPhoto or Adobe RGB. But you may see some color clipping if you export using sRGB, because sRGB has a smaller color gamut than Adobe RGB.

Tone curve response

There are clear advantages to working on raw data in a native, linear gamma edit space, but a linear gamma is not good when making direct image edit adjustments. When you edit an RGB image in Lightroom, there are two things going on. First, the Develop controls used to adjust the image processing do so filtered through an sRGB response curve where the data points in the underlying Lightroom RGB edit space are distributed evenly so that the Basic and Tone Curve adjustments applied in Lightroom correspond to a more balanced tone scale (the sRGB response curve is also used to generate the histogram display and color readout values seen in the Develop module). What you see in the histogram is effectively the Lightroom ProPhoto RGB space in linear 1.0 gamma with an sRGB response curve applied to it. **Figure A.20** shows a plot of the sRGB curve (in black), which matches closely to the 2.2 gamma curve (shown in pink). I had to show this graph quite big so you could see the subtle difference between these two curves. But note that the sRGB curve comes up from 0,0 and away from clipping just a little sooner than a pure 2.2 gamma curve. The 2.2 curve hugs the y axis high enough that several potential values very close to black (in the linear space) are crushed to black. The sRGB curve leans away from the y axis much sooner, and you maintain at least a tiny bit of differentiation between those very dark values. So in the transformation from the linear space to the sRGB space, the sRGB curve is just a bit less draconian in where it leaves values in the very dark shadows.

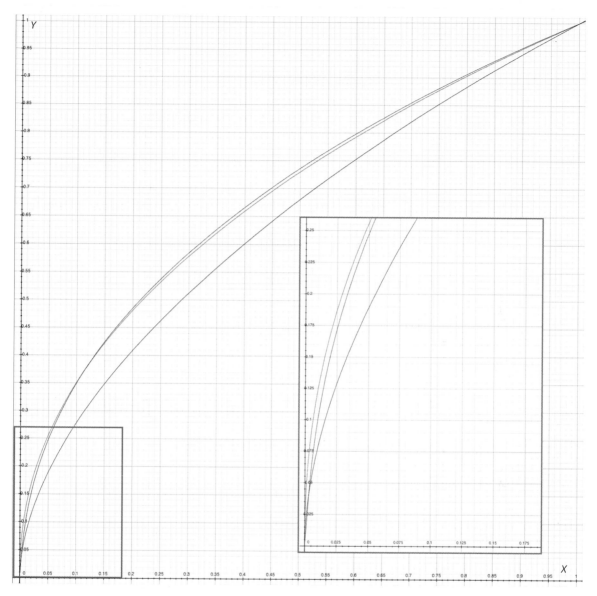

Figure A.20 *This graph shows a plot for the sRGB response curve (black) as used in Adobe Lightroom, plotted against a standard 2.2 gamma curve (pink) and a 1.8 gamma curve (blue). Note the description in the main body text, which describes the subtle difference between the sRGB and 2.2 gamma curve shapes. The inset box shows a close-up view of the bottom end of the gamma curves.*

Balancing the tone curve

Figures A.21 and **A.22** explain why it is necessary for Lightroom to use an sRGB response curve to filter the linear RGB data before it reaches the Develop controls. Remember, you are in fact editing 1.0 gamma data, and the sRGB response curve is only there to make the Develop adjustments easier and more logical to control. Even so, you will still notice an element of asymmetric response when adjusting the Blacks slider. For example, have you ever noticed how small incremental adjustments to the Blacks have a far more pronounced effect than similar adjustments made with the Exposure slider?

Figure A.21 *The problem with trying to edit the linear, 1.0 gamma directly is that the midtones are all condensed in the left portion of the tone curve (shown here as a continuous gradient). If you were forced to directly edit an image with a 1.0 gamma, any attempt to make small adjustments in the shadow to midtone region would be very much amplified in the midtone to highlight regions. As shown here, it would be a bit like trying to balance a seesaw with an offset fulcrum point.*

Figure A.22 *When a tone response curve is applied to the underlying linear gamma data, such as is the case with Lightroom when an sRGB response curve is applied to the Lightroom RGB space, the tones on the tone curve are more evenly distributed. This provides an image editing environment in which you are able to edit linear 1.0 gamma image data in a more balanced nonlinear editing environment.*

The Ideal Computer Setup for Lightroom

To repeat a point made earlier in Chapter 1, the ideal computer setup for Lightroom depends on the size of the files you intend working with. The raw file captures you can work with in Lightroom may vary from 5–22 megapixels, and the larger files will place more demands on your computer resources. So when looking for an ideal computer to run Lightroom, you will definitely need to take the image file size into account. The most important factors affecting Lightroom performance will be the processor speed and the amount of RAM memory that is available for Lightroom to use. This is followed by the speed and size of the hard disk, and then the type of graphics card.

At a minimum, you need a Macintosh G4 with a 1 GHz processor and 768 MB RAM, running Mac OS X 10.4.3 or later. And on the PC side, you need an Intel Pentium 4 with a 1 GHz processor and 768 MB RAM, running Windows XP Pro or Home Edition with Service Pack 2. Lightroom is optimized to run on the latest Intel computer processors, and from the testing I have done so far, it does seem to run very fast on the latest high-end Core 2 Duo, Intel-based Macs.

RAM Memory

You will benefit from having as much RAM as possible and should take into account that the operating system and any other open applications will also consume some of the RAM. For example, if you happen to have just 1 GB of RAM installed in your computer, the operating system may use about 256 MB, and another 50 MB might be used up by various utilities. And that is before taking into account any other, more memory-intensive applications that may be running in the background. So if you doubled the amount of memory installed on the computer to 2 GB, you could easily triple the amount of RAM that is effectively made available to Lightroom. Keep in mind that you are limited to installing 3 GB of RAM in most laptops. But if you have a desktop machine, you can probably install a lot more. Judging by the reports from various power users, you will see significant benefits in performance if you install up to 4 GB of RAM on a fast desktop computer.

> **NOTE**
>
> Megapixels has become better understood by digital photographers over the last five years or more as this is at least a consistent term for describing file size. Coincidentally, a raw file is usually the same number of megabytes as the number of megapixels, but this will fluctuate image to image.
>
> The number of megapixels always refers to the absolute number of pixels in an image. A 6 megapixel image will contain 6 million pixels, and when this is converted to an 8-bit per channel, RGB mode flattened image, it will be equivalent to an 18 MB file.

Graphics Card

The graphics card does not play a vital role in Lightroom's overall performance. You need a graphics card that is capable of running the screen display at its native resolution, but unless you intend to use your computer for editing movies or playing games, you don't really need an ultrafast graphics card. For example, all the latest Apple Mini and MacBook computers, with the Core 2 Duo processor, use 64 MB of the system RAM to run the graphics display. As long as you have a substantial amount of memory installed, the amount of memory the graphics card uses should not limit the speed with which you can work in Lightroom.

Hard Drives

A default Lightroom installation chooses the main computer hard drive to store the Lightroom library files. On both the Macintosh and the PC, the Lightroom library is stored inside the users' Pictures folder. The Lightroom library files contain all the Lightroom metadata information plus standard and 1:1 previews. The library files will increase in size as your library grows bigger, although there are options in the preferences to limit the growth of how many 1:1 previews exist at a time by automatically deleting them after a certain number of days.

The main considerations when selecting a hard drive are the interface type, hard drive configuration, speed, and buffer memory. All these factors affect the overall speed. Let's start with the interface connection. Internal drives usually offer a fast ATA interface connection, so one option would be to add more internal drives. I have learned from experience to be wary of relying too much on working files being kept on an internal hard drive. Twice I have had an internal power unit die and had to physically remove the drives and place them in a temporary drive housing in order to access the data. For this reason I prefer to store all the Lightroom library image folders on fast, external drives. This allows me to free the main computer hard drive from an accumulating library of image folders and has the added benefit of keeping the library portable so I can, if necessary, switch computers and use Lightroom on another machine to access the same photo library. However, with some of the newer computers it is actually quite easy to swap out the internal drives and move them from one machine to another. So I am now more inclined to use internal drive units because of their faster internal interface connection speeds.

Several external connection types are available. A USB 1 connection limits the data transfer rate and should be avoided. Instead, choose a USB 2 or a FireWire 400/800 connection. You can now also buy Serial ATA (SATA) drives that promise very fast rates of data transfer, but you might need a PCI card to provide a SATA connection from your computer. The hard drive spindle speed determines how fast data can be written to and retrieved from the disk drive unit. Most 3.5-inch desktop drives have a spindle speed of 7200 RPM, whereas the smaller 2.5-inch drives found in laptops and portable bus-powered drives mostly run at a speed of 4200–5400 RPM. You can get 7200 RPM 2.5-inch drives, but they are more expensive and are usually only offered as a custom option when buying a laptop. Extra disk buffer memory helps take the pressure off the disk drive activity and also leads to improved drive performance.

Drive Configurations

It is tempting to look for a solution whereby all your data can be stored in a single location, such as a RAID system capable of storing a large amount of data on a single volume drive. A simple way to explain RAID is that it allows you to treat multiple drives as a single drive volume to provide increased data integrity, capacity, transfer rates, or fault-tolerance compared to a single volume. How it does this depends on the RAID level you choose. You need a minimum of two disks to configure a RAID system, and most off-the-shelf RAID solutions are sold as a bay dock that can accommodate two or more drives with a built-in RAID controller. With RAID it is possible to store several terabytes of data on a single volume with built-in mirroring backup, but such systems do come at a very high price. Not only that, but they can also be quite noisy and are not particularly energy efficient. For some businesses, RAID is the perfect solution; for small photography businesses it can be overkill. But let's look at some of the more popular RAID configurations and how they might suit a digital photography computer setup.

Striped RAID

With a striped, RAID 0 setup, two or more drives can work together to create a single, large-volume drive. RAID 0 is useful when you require fast hard-drive access speeds, because the drive access speed increases proportionally to the number of drives that are added. So if you have four 200 GB drives as a RAID 0 system, you will end up with a single

800 GB volume, and the hard-drive access speed will be four times that of a single 200 GB drive. This setup might seem like a good idea for speeding up the data access speeds, but the disadvantage of such a setup is that if a single drive should fail, the entire RAID system will fail and all data will be lost. A RAID 0 setup is ideal for use as a Photoshop scratch disk.

Mirrored RAID

A mirrored, RAID 1 system stores an exact duplicate of all the data on a backup drive. So as data is written to one drive, a copy of the data is also written to the other drive. The main advantage of a RAID 1 system is that should any single drive within the system fail, you can swap it with a new one and the data stored on the mirrored drive automatically rebuilds a copy of the data on the replacement drive. RAID 1 therefore offers you the most secure method for storing important data such as an image archive. The downside is that you need double the disk size to store all your data. For example, a mirrored 2-terabyte RAID 1 drive setup only allows you to store up to 1 terabyte of data.

RAID 5 has gained in popularity more recently. A RAID 5 setup requires a minimum of at least three drives and allows you to store data more securely and more economically through "parity striping." In practice, a RAID 5 configuration allows you to use the full drive storage capacity, less the capacity of one of the single drive units, and provides complete data backup should any single drive fail. So a 2-terabyte RAID 5 using four 500 GB drives, is able to store up to 1.5 terabytes of data. RAID 5 offers the most economical form of storage that can withstand a single drive failure, but the write speeds are necessarily slow.

A mirror of stripes

Another alternative is a RAID 0+1 setup, which requires four disks. The first two disks are configured using RAID 0, creating a single volume but with twice the disk access speed of a single disk. The other two disks are configured to create an overall RAID 1 setup, in which the data on the RAID 0 volume is safely mirrored across the two backup disks. This RAID system is both fast and secure. Mirroring can provide security against immediate drive failure, but it does not offer a complete backup protection solution. Mirrored drives are necessary for businesses that must have absolute access to the data 24 hours a day, 7 days a week. But mirrored systems don't necessarily provide the full data security you would expect, because if the directory becomes

corrupted, the continuous mirroring copies the corruption to the mirrored drive, before you could become aware of the problem, which could lead to loss of data. For absolute protection, scheduled backups need to be carried out to a secondary storage system, which should be kept off-site.

Just a bunch of disks

There are varied opinions about which is the best way to manage a photography archive storage system. In my view, RAID storage is ideal but is not always the best solution for all photographers. A perfect solution would be to have a high-capacity RAID drive system that is capable of storing all your images securely on a single RAID unit. I have seen photographers work with such setups, but even so, it is quite costly to have a multidrive unit that holds all your data running continuously and consuming lots of power, so that once or twice a year you can dig up a file you shot six years ago. If you analyze your storage requirements, most likely you will find that the vast majority of the files you access are no more than 12 months old. When you think about it, the files you need to work with on a regular basis can probably be accommodated on a standard single-drive unit. This leads to a simpler solution known as "just a bunch of disks," or JBOD for short. With a JBOD setup you can have a file storage system that is scaleable to meet your expanding storage needs, that is economical to maintain, and runs as well as being reliable, providing that you maintain a proper backup strategy. At my office, I have nine external hard drives that store over 3 terabytes of image data. I have two 500 GB SATA drives: one is used to store the Lightroom library where I copy all my raw files to and the other is used to store all the recent exported files that are then edited in Photoshop and later reimported into the Lightroom library by reference. These two drives are housed in a single SATA unit and offer me 1 terabyte of storage space that is immediately accessible when working in Lightroom. The other drives are 250 GB units and are used to store all of my older raw and master file images dating back over the last 13 years. Most of the time I only need to have the two 500 GB drives running. Whenever I need to access older images, I switch on the necessary hard drive, as directed by Lightroom. JBOD can never be as foolproof as a RAID system, but it may be more appropriate for those photographers who think it would be an acceptable solution for their storage needs.

TIP

When assessing your overall storage requirements, don't try to build a system to last you the next five years. Buy the storage system you need today, but make it expandable for the future.

Figure A.23 *If the image you are trying to open is not immediately accessible, Lightroom informs you which hard drive or other disk media the image was last located on. Connect and switch on the relevant hard drive, (or insert the named CD) and the files will open as normal.*

TIP

If for some reason you appear to have lost your library, restart Lightroom using the method described in the "Working with more than one library" section and click the Choose button to do a manual search for the correct Lightroom Database.lrdb file.

NOTE

The .lrdb file extension that is mentioned here will always be seen on a Macintosh system. On a PC system the file extension is often hidden by default, so you may or may not see the extension name, depending on how your PC system preferences are configured.

Distributing the Library Over Several Disks

Lightroom can access library images from any number of hard drives. If an image you want to select from the library is not immediately available, Lightroom informs you which media source the file was last located on (see **Figure A.23**). As was pointed out earlier, if you are running out of space on a particular drive, you can simply move the folders and files to a new hard disk and Lightroom keeps track of them on the new drive location. But note that image folders used by the library cannot be stored on a network drive or stored on a read-only data disk.

Working with more than one library

Lightroom does not restrict you to keeping all your library files in a single library. It is possible to maintain several separate libraries using the program. For example, each member of your family could use Lightroom and have his or her own library collection. You can add a new library by holding down the Alt key (Mac) or the Ctrl key (PC) when launching the program. Click the Create New Database button to select a location where you want to add a new Lightroom database (**Figure A.24**). After you have created a new library, you can access it by launching Lightroom and clicking the Choose button to select an existing database file (look for a file called *Lightroom Database. lrdb*) or choose the Database Location menu to select from the list of most recently used Lightroom database files. Alternatively, go to the Lightroom preferences and under the Default Library section on the General tab, choose a default library to use the next time you launch Lightroom. You can also set the preferences here to prompt you to select a library every time you launch the program.

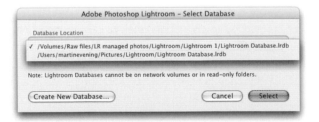

Figure A.24 *If you hold down the Alt key (Mac) or the Ctrl key (PC) when launching Lightroom, this dialog opens. You can then select a most recently used library location, create a new database, or click Choose and do a search.*

Backing up the library

An option in the General preferences allows you to create an automatic scheduled backup of the master Lightroom library file at a frequency of your choosing. I would strongly advise you to select one of these options because it provides an extra level of built-in backup security that may well prevent you from losing valuable library data information (**Figure A.25**).

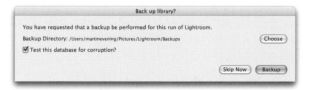

Figure A.25 *The Back up library dialog.*

Backup Strategies

Earlier I made the distinction that a mirrored RAID system was essential in a mission-critical environment to ensure continuity of data access. But this does not amount to the same thing as having a fail-safe backup strategy. For that you need to perform scheduled backups to a secondary set of drives, which should be stored in a safe location such as a fire-proof safe or somewhere off-site. In a simple office setup, you could use one external drive to hold the main Lightroom image library and a duplicate drive of similar capacity to keep a regularly backed up copy of the data. The important feature of this kind of setup is that backups can be scheduled manually. If a problem were to occur on the master disk, such as an accidental file deletion or a directory corruption, you have the opportunity to rectify the problem by copying data from the backup drive. And because you are keeping the data on a separate drive, it can be stored in a separate location away from the main computer. Running scheduled drive backups in the manner described reduces the chances of losing data. But as long as the files are stored on read/write disk media, they will always be vulnerable to accidental erasure or a virus attack that could infiltrate from the masters to the backup drives. To reduce the risk further, make DVD copies of your files and keep them in an appropriate storage location. Of course, it would be a pain to have to reload all the data from DVDs again, but writing data to DVD ensures that the data is free from virus attack or human error. A DVD is the most economical removable media storage offered at present. But keep an eye out for newer media systems such as Blu-ray that are bound to become more affordable and practical for storing larger amounts of data on single disks.

NOTE

When you select a scheduled library backup option, the Back up library dialog appears each time you are due to carry out a scheduled backup. You can select a location where the backup library file should be stored as well as select an option that runs a test to see if there are any corruptions in the database. If so, you will have the opportunity to replace the current (corrupt) database with the previously backed up database copy file.

NOTE

It is also a good idea to go to the File Management preferences and switch on the "Automatically write changes into XMP" option. This causes Lightroom to push the metadata information such as the Develop settings and other metadata information into the file (or sidecar file). This means that the files contain a backup of the information that is also stored in the central Lightroom library file.

Backup software

You can use various programs to carry out data backups. On the Macintosh platform, I like to use ChronoSync from Econ Technologies (www.econtechnologies.com) because it is simple to use and very effective at synchronizing all the files on a backup disk with the master disk (**Figure A.26**). I usually set up backup settings for my main work data drives such as the primary hard disk, plus the two other main drives that are used to store most of the raw file data and working files. Whenever I want to back up any data, I switch on a backup drive and run the backup process. I have the settings configured so that ChronoSync first compares all the data on the left target disk (the drive I want to back up) with the right target disk (the drive I want to store the backup data on) and then copies all the newly added files. I also have the Sync Deletions option checked, so that file deletions on the master disk are applied to the data on the backup disk. At the end of a synchronization I empty the Trash (or Recycle Bin in a PC backup program), and the backup is complete. Setting up backup drives and copying all the data takes a long time the first time around, but thereafter, if you carry out regular backups, like once a day or every few days, the backup procedure should only take a few minutes. If you are in the habit of leaving your drives switched on overnight, you can schedule the backups to happen in the early hours of the morning.

Figure A.26 *The ChronoSync backup program interface.*

Index